W9-BWD-569

THE WAR IN THE MEDITERRANEAN:

A WWII PICTORIAL HISTORY

This gift has been
presented to the
Silver Bay Public Library
by:

MELVIN JOHNSTON

THE WAR IN THE MEDITERRANEAN:
A WWII
PICTORIAL HISTORY

CENTER OF MILITARY HISTORY
UNITED STATES ARMY

Brassey's
Washington • London

First Brassey's Edition—1998

Previously published as *The War Against Germany and Italy: Mediterranean and Adjacent Areas* by Center of Military History, United States Army, 1988, 1951.

Brassey's Editorial Offices:
22883 Quicksilver Drive
Dulles, Virginia 20166

Brassey's Order Department:
P.O. Box 960
Herndon, Virginia 20172

Brassey's books are available at special discounts for bulk purchases for sales promotions, premiums, fund-raising, or educational use.

Library of Congress Cataloging-in-Publication Data
The war in the Mediterranean : A WWII Pictorial History /
[compiled by] Center of Military History. United States Army.—
1st Brassey's ed.
Previously published by GPO as
The War Against Germany and Italy: Mediterranean and Adjacent Areas, 1988, 1951.
p. cm. — (An AUSA Institute of Land Warfare book)
Compilers: John C. Hatlem and Kenneth E. Hunter, assisted by Margaret E. Tackley.
Originally published: Washington : Office of the Chief of Military History, Dept. of the Army, 1951. (United States Army in World War II) (CMH pub : 12–2).
Originally issued in a subseries of the first series: Pictorial record.
Includes index.
Cover title: The War in the Mediterranean : a WWII pictorial history.
ISBN 1-57488-130-2 (hardcover)
1. World War, 1939–1945—Campaigns—Mediterranean Region—
Pictorial works. 2. United States. Army.—History—World War,
1939–1945— Pictorial works. I. Hatlem, John C. II. Hunter, Kenneth E.
III. Tackley, Margaret E. IV. Center of Military History. V. Title: War in the
Mediterranean : VI. Series. VII. Series: United States Army in World War II. VIII.
Series: CMH pub : 12–2.
[D766.W28 1998]
940.54´23—dc21 97-23500
CIP

10 9 8 7 6 5 4 3 2 1

Printed in the United States of America

. . . to Those Who Served

UNITED STATES ARMY IN WORLD WAR II

Kent Roberts Greenfield, General Editor

Contents

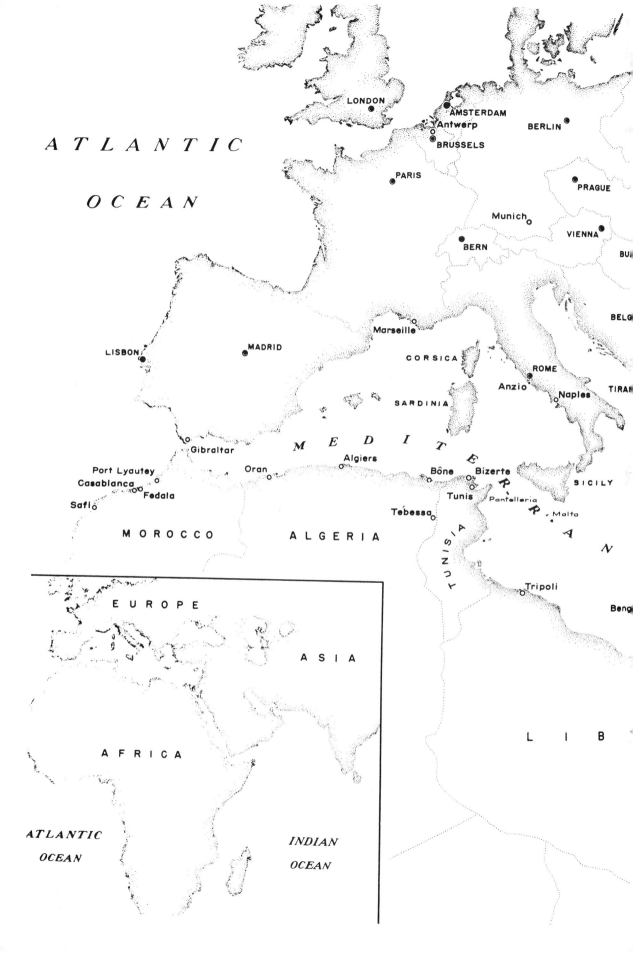

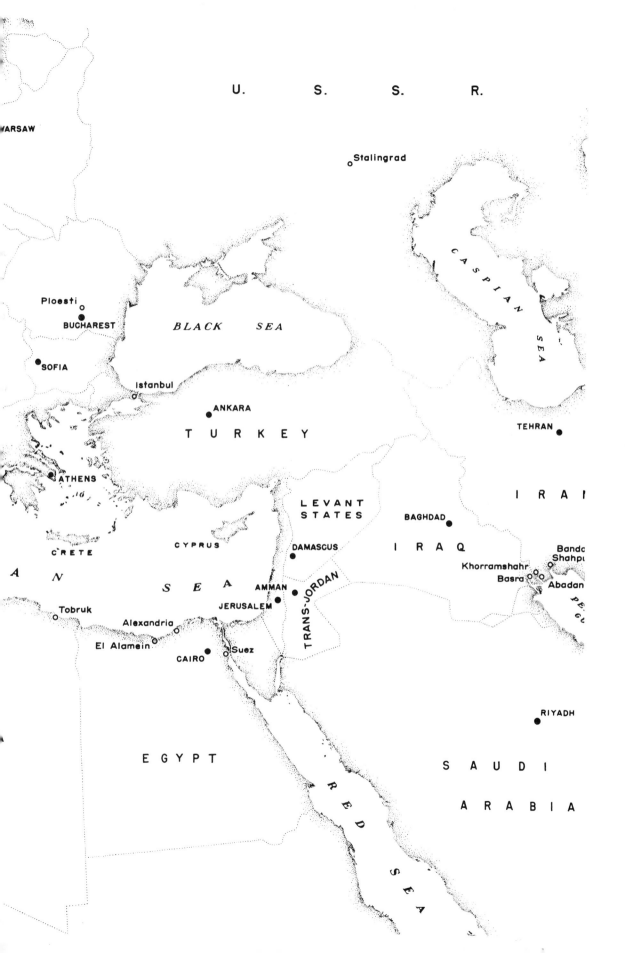

 An AUSA Institute
of Land Warfare
Book

The Association of the United States Army, or AUSA, was founded in 1950 as a nonprofit organization dedicated to education concerning the role of the U.S. Army, to providing material for military professional development, and to the promotion of proper recognition and appreciation of the profession of arms. Its constituencies include those who serve in the Army today, including Army National Guard, Army Reserve, and Army civilians, the retirees and veterans who have served in the past, and all their families. A large number of public-minded citizens and business leaders are also an important constituency. The Association seeks to educate the public, elected and appointed officials, and leaders of the defense industry on crucial issues involving the adequacy of our national defense, particularly those issues affecting land warfare.

In 1988, AUSA established within its existing organization a new entity known as the Institute of Land Warfare. ILW's mission is to extend the educational work of AUSA by sponsoring a wide range of publications, to include books, monographs, and essays on key defense issues, as well as workshops, symposia, and since 1992, a television series. Among the volumes chosen as "An AUSA Institute of Land Warfare Book" are both new texts and reprints of titles of enduring value. Topics include history, policy issues, strategy, and tactics. Publication as an AUSA Book does not indicate that the Association of the United States Army and the publisher agree with everything in the book but does suggest that AUSA and the publisher believe the book will stimulate the thinking of AUSA members and others concerned about important defense-related issues.

Foreword

During World War II the photographers of the United States Army, Air Force, Navy, Marine Corps, and Coast Guard created on film a pictorial record of immeasurable value. Thousands of their pictures are preserved in the photographic libraries of the armed services, little seen by the public.

In the volumes of UNITED STATES ARMY IN WORLD WAR II now being prepared by the Office of the Chief of Military History, Department of the Army, it is possible to include only a limited number of pictures. A subseries of pictorial volumes, of which this is one, has been planned to supplement the other volumes of the series. The photographs have been selected to show important terrain features, types of equipment and weapons, living and weather conditions, military operations, and various matters of human interest. These volumes will preserve and make accessible for future reference some of the best pictures of World War II. An appreciation not only of the terrain on which actions were fought, but of its influence on the capabilities and limitations of weapons, in the hands of both our troops and the enemy's, can be gained through a careful study of the pictures herein presented. Appreciation of these factors is essential to a clear understanding of military history.

This volume, compiled by Lt. Col. John C. Hatlem, USAF, and Capt. Kenneth E. Hunter, with the assistance of Miss Margaret E. Tackley, and edited by W. Brooks Phillips and Miss Mary Ann Bacon, deals with the Mediterranean Theater of Operations and the Middle East. It is divided into five sections: (1) North Africa and the Middle East; (2) Sicily, Corsica, and Sardinia; (3) Italy: 9 September 1943–4 June 1944; (4) Southern France; and (5) Italy: 5 June 1944–2 May 1945. Each section is arranged in chronological order. The written text has been kept to a minimum. Each section is preceded by a brief introduction recounting the major events set down in detail in the individual narrative volumes of UNITED STATES ARMY IN WORLD WAR II. The appendices give information as to the abbreviations used and the sources of the photographs.

ORLANDO WARD
Maj. Gen., USA
Chief of Military History

Washington, D.C.
1 November 1951

NORTH AFRICA

AND

THE MIDDLE EAST

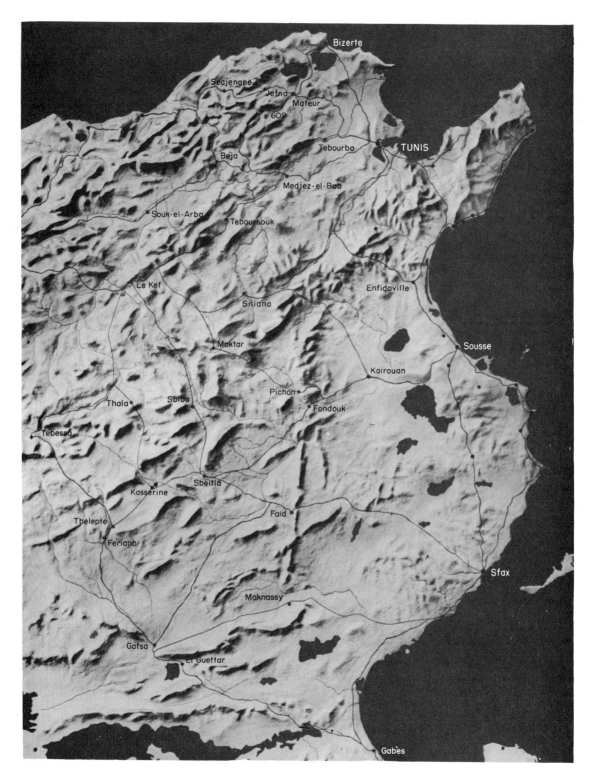

TUNISIA

SECTION I

North Africa and the
Middle East[*]

North Africa

The occupation of French North Africa by Allied troops was determined in July 1942 when the American and British Governments agreed to launch a Mediterranean operation in the fall of 1942. The invasion, designated as TORCH, was to coincide with a British advance westward from Egypt. Before American soldiers did any actual fighting in North Africa, however, and before the United States was at war, civilian and military observers had been informally attached in May 1941 to the U. S. military attaché in Cairo. This group was the beginning of a force whose primary function was to service and maintain lend-lease equipment from the United States, instruct the British in its use, and report on how it stood up under battle conditions. The U. S. Air Forces also was performing missions in Egypt several months before the Allied landings in North Africa. All these activities contributed to the British victory at El Alamein in October 1942.

Allied troops sailed for North Africa from ports in both the United States and the United Kingdom. The U. S. Navy and the Royal Navy shared in supplying transports and naval escort and were able to prevent any serious losses through enemy submarine action. Vital air support was at first provided from aircraft carriers of both Navies and later by land-based planes of the Allied air forces utilizing recently captured airfields.

The Allies hoped to avoid French resistance to the landings by arranging for the assistance of patriotic Frenchmen ashore and by the participation in the operation of Gen. Henri Giraud, a French military leader and former Army commander of great prestige who had

*See George F. Howe, Operations in Northwest Africa, 1941–1943, in preparation for the series U. S. ARMY IN WORLD WAR II; and T. H. Vail Motter, *The Persian Corridor and Aid to Russia*, Washington, 1951, in the same series.

escaped from France. These plans were only partly successful. The landings on the early morning of 8 November at beaches near Algiers, Oran, Casablanca, Port-Lyautey, Fedala, and Safi met resistance at all objectives. The opposition at Algiers and Safi collapsed quickly. Oran could be occupied only after considerable fighting. French forces, especially naval elements, in the neighborhood of Casablanca resisted strongly, but yielded on 11 November, a few minutes before the final assault on the city itself was to start. After a brief period of neutrality, most of the French forces in northwest Africa joined in the war against the Axis.

The Axis reacted to the Allied invasion by rushing troops to Tunisia by air and sea, and captured the local airfields and ports without opposition. British, American, and French troops drove eastward and at the end of November and in early December launched their attack against the Axis bridgehead. The Allied advance, however, was stopped short of Tunis. Air superiority for the moment lay with the Axis. Lack of means to overcome the increased resistance, in addition to weather conditions which interfered with transport and flying, forced the postponement until 1943 of a renewed advance over the difficult terrain of northern Tunisia.

Meanwhile, the British Eighth Army was pressing German and Italian forces back from Egypt through Libya and reached the southern border of Tunisia in January 1943. Plans could then be perfected for a co-ordinated attack against the remaining Axis forces in North Africa by the British Eighth Army in the south and the Allied troops in the north consisting of the British First Army, the American II Corps, the French XIX Corps, and Allied air forces. Attack by Axis forces at points of their own selection repeatedly interfered with Allied preparations. In February the enemy broke through Faïd Pass and in a series of attacks advanced beyond Kasserine almost to the Algerian border. These attacks were stopped on 21–22 February when the enemy started his withdrawal, destroying bridges and mining the passes behind him.

But the Allied forces were closing in. After attacking and turning the Mareth position, the British Eighth Army defeated the enemy there and pursued him along the coast as far as Enfidaville, less than fifty miles from Tunis. Accelerated Allied air and naval attacks choked off the enemy's supply and weakened his resistance. At the same time the American II Corps was shifted northwest to a new sector on the left of

the British First Army. Then after severe infantry fighting the American II Corps made an armored thrust to Mateur, and after a pause it pushed tank forces east to the sea, separating Bizerte from Tunis. Farther south the British First Army drove directly toward Tunis. On 7 May both Bizerte and Tunis were occupied and by 13 May Axis capitulation was complete. The Allies had achieved their initial objective of opening the Mediterranean route to the Middle East and seizing bases in North Africa. At the same time they had inflicted a major defeat on the Axis Powers.

Allied strength in French North Africa had been brought to a total of about a million men. Much of this strength was not intended for the Tunisia Campaign but for later operations against Sicily and southern Italy. Elaborate training establishments were developed by the American Fifth and Seventh Armies and vast supply depots established with a view to future operations from the African base.

Persian Gulf Command

In June 1942 an American theater of operations called U. S. Army Forces in the Middle East was established with headquarters at Cairo. Under this command were merged various groups and military missions that had been active in this area since the spring of 1941. American responsibilities for moving supplies to the Soviet Union led ultimately to a separation of the Persian Gulf activities of USAFIME and their establishment under an organization that was known from December 1943 to October 1945 as the Persian Gulf Command, with headquarters at Tehran, Iran.

From 1941 to 1945 the main business of the U. S. Army in the Middle East was to facilitate the supply of lend-lease goods to British and Soviet forces. This task involved the construction of docks, warehouses, shops, and highways as well as the operation of ports, a railroad, and a motor transport service in Iran. At the same time the Army constructed numerous airfields and bases, stretching across Egypt, the Anglo-Egyptian Sudan, Eritrea, Palestine, Saudi Arabia, Syria, Iraq, and Iran.

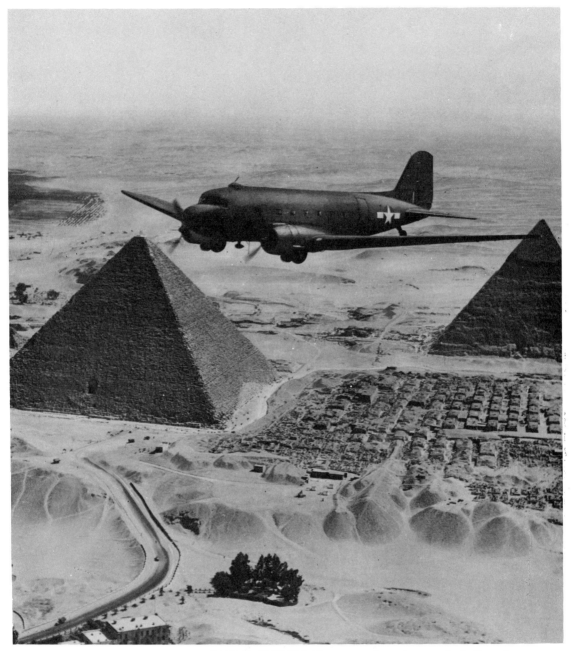

THE PYRAMIDS NEAR CAIRO, EGYPT. For more than six months before the attack on Pearl Harbor, the United States had recognized the military importance of the Middle East. Lend-lease equipment was poured into Egypt to aid the British in the western desert. The type of transport plane shown above performed constant service in the Middle East area. It was known familiarly as "the work horse of the war." (C–47 transport, Dakota.)

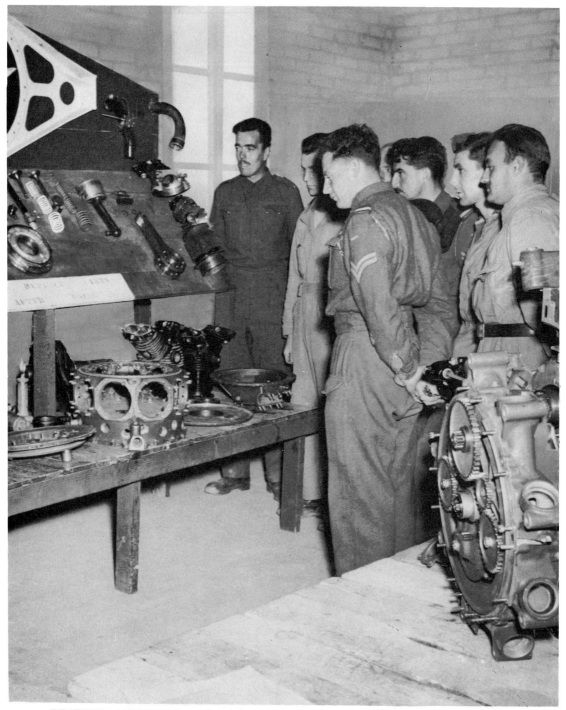

BRITISH SOLDIERS receiving instructions on an American-made engine at the
U. S. Ordnance Repair Depot at Heliopolis near Cairo.

TANKS AT THE HELIOPOLIS U. S. ORDNANCE REPAIR DEPOT. On Black Saturday, 13 June 1942, in a battle near Tobruk in Libya, British armor suffered severe tank losses inflicted by German 88-mm. antitank guns. This defeat caused a withdrawal to the El Alamein Line in Egypt. (General Grant M3.)

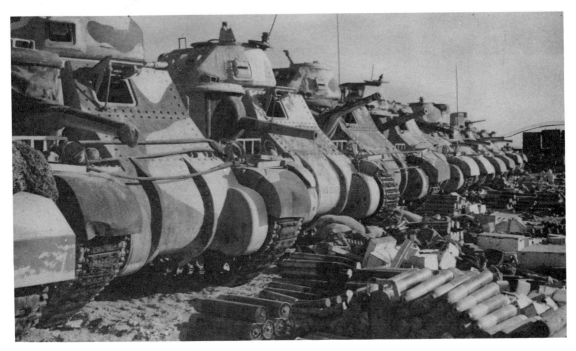

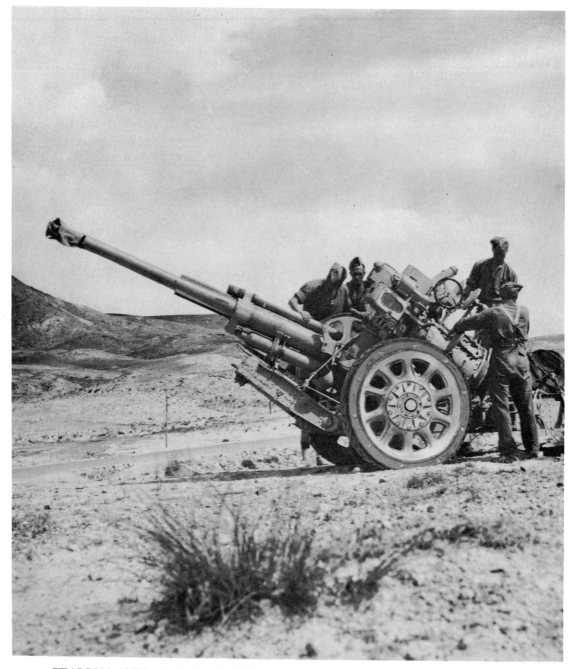

ITALIAN ANTIAIRCRAFT GUN captured by the British in the western desert
of Egypt. Before the United States entered the war, American technicians worked
closely with the British in the Middle East to obtain information on German and
Italian weapons, equipment, and methods of warfare. (Italian *Ansaldo* antiaircraft
gun, 75-mm.)

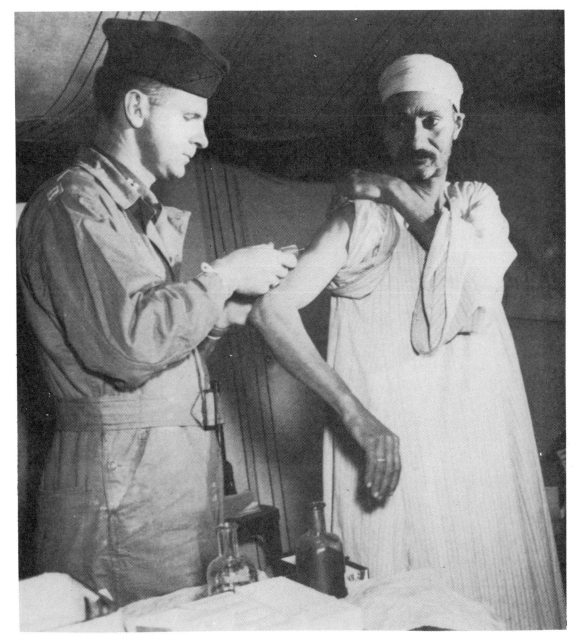

INOCULATING EGYPTIAN WORKER WITH TYPHUS VACCINE. In June of 1942 a separate command was formed in Cairo, called the U. S. Army Forces in the Middle East (USAFIME). Natives working with U. S. personnel were usually under Army medical supervision. Those handling food were subject to physical inspection and received medical treatment and whatever immunization inoculations were indicated for the locality. The use of preventive medicine stopped the outbreak of epidemics.

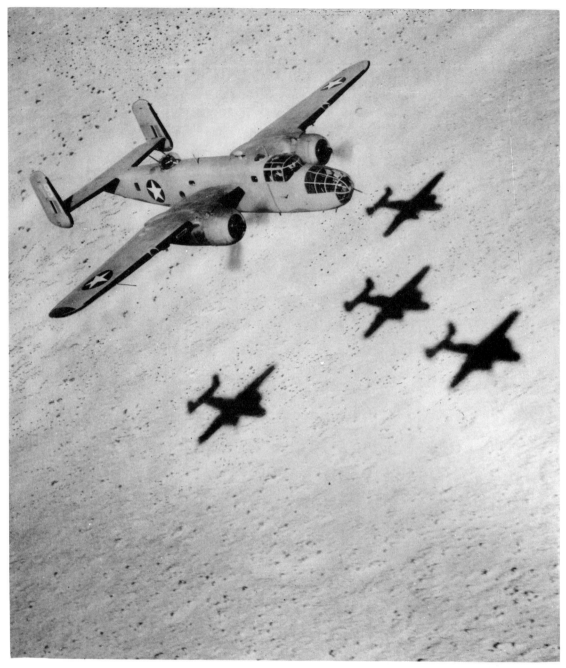

B–25'S OVER THE WESTERN DESERT IN EGYPT. The U. S. Air Forces was active in the Middle East several months before the Allied landings in North Africa. The first mission of these bombers was against the enemy-occupied port of Matruh on the coast of Egypt in July 1942. (Medium bombers, North American B–25 Mitchell.)

SELF-PROPELLED HOWITZER nicknamed the Priest. The crisis which developed when the British were forced to retreat to the El Alamein Line threatened the Suez Canal as well as the Allied air routes to Russia and India. Reinforcements and equipment were rushed to Egypt from the United Kingdom and the United States. The United States sent about 90 of the guns shown above, more than 300 General Sherman M4's, and a large number of trucks. By October 1942, the situation had improved. The British Eighth Army attacked at El Alamein and drove the enemy out of Egypt, through Libya, and into Tunisia. (105-mm. howitzer, M7 howitzer motor carriage.)

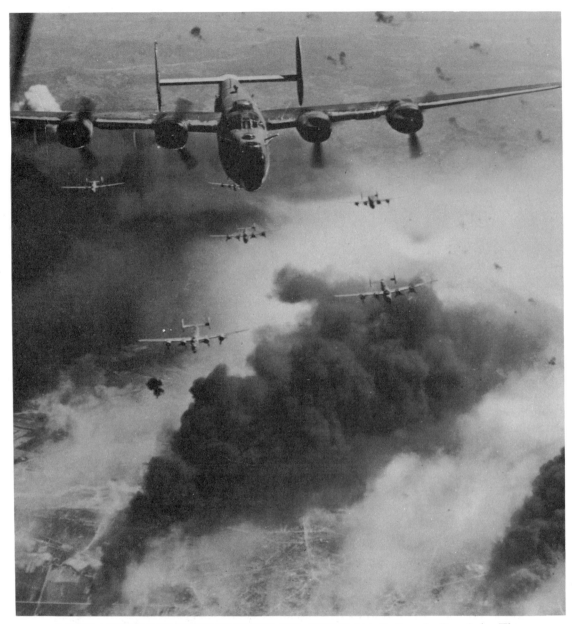

LIBERATORS BOMBING PLOESTI OIL FIELD installations in Rom\u00e2nia. The first U. S. air mission flown against any strategic target in Europe was on the Ploesti oil fields, a twelve-bomber raid by B–24's from Egypt on 12 June 1942. The next raid on this target, 1 August 1943, was a low-level attack by 177 Liberators from Bengasi in Libya with the loss of 54 bombers. Refinery production was interrupted by these raids from Africa, but was not stopped until the spring of 1944 when continuous large-scale attacks were carried out from bases in Italy. (Heavy bomber, Consolidated B–24 Liberator.)

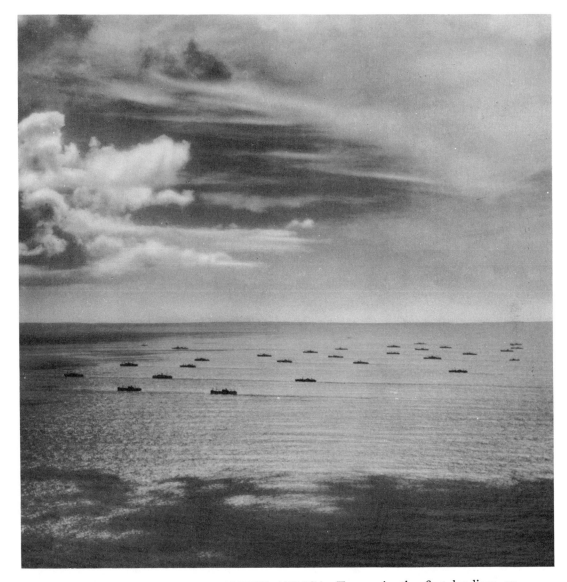

CONVOY BOUND FOR NORTH AFRICA. Troops in the first landings approached their destinations in several large convoys, escorted by aircraft carriers and other warships. The convoy to Morocco originated in several ports of the United States on 23 October 1942, and when near the African coast separated into three major parts. The convoy steaming to the vicinity of Oran and Algiers left the United Kingdom on 26 October. Before passing through the Straits of Gibraltar it separated into two parts. Inside the Mediterranean the two sections overtook slower cargo convoys and continued on a course toward Malta until sundown of 7 November. That night each section wheeled southward and separated further to reach several landing points near Oran and Algiers. Other convoys had already left both the United States and the United Kingdom before the attacks began.

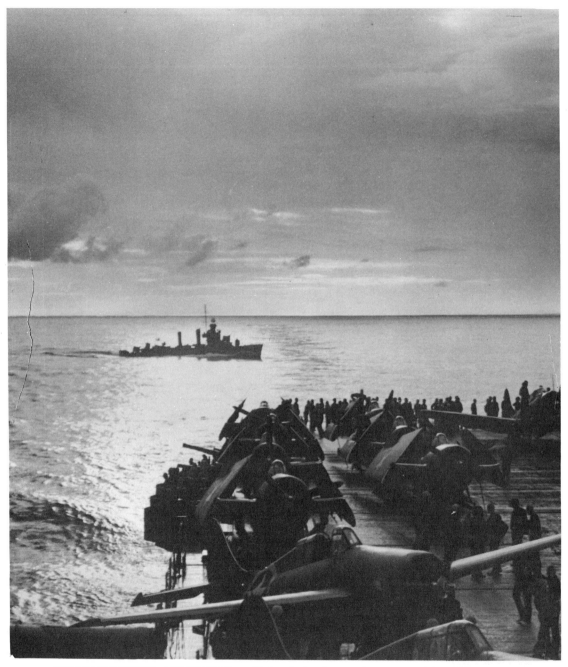

NAVY FIGHTER AIRCRAFT on flight deck of a carrier approaching the coast of
North Africa. In the background is a destroyer escort. Two to four destroyers operated
with each carrier, providing antisubmarine protection, picking up personnel from
wrecked aircraft, and augmenting the antiaircraft screen around their charge. (Grumman F4F Wildcat, single seater, carrier fighters.)

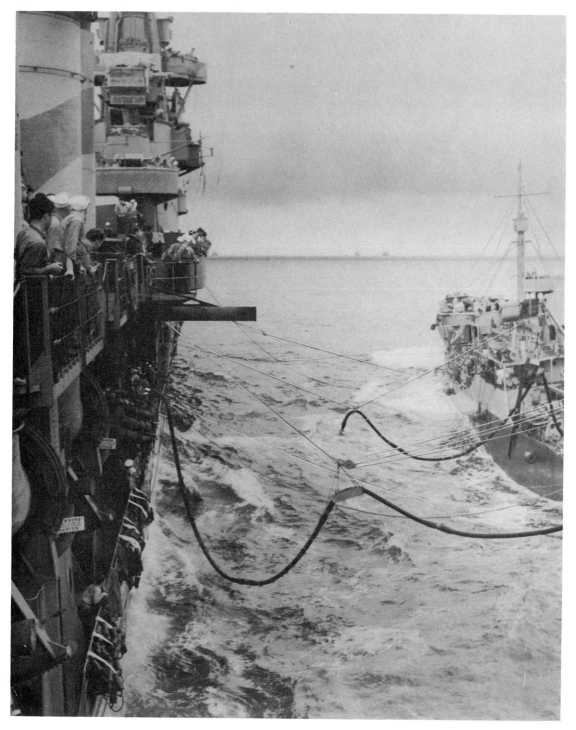

OIL TANKER refueling aircraft carrier en route to North Africa.

GUNNERY PRACTICE ABOARD A TRANSPORT. Submarines were a danger and gun crews were constantly on the alert. (Left, U. S. Navy 3-inch gun; right, .50-caliber water-cooled Browning machine gun.)

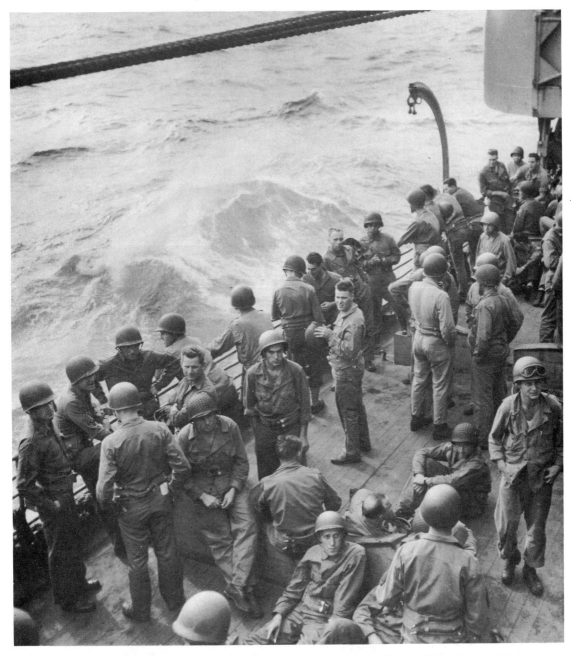

TROOPS ON TRANSPORT HEADED FOR FRENCH MOROCCO. Note rubber life belts on most of the men. These could be inflated instantly by means of gas cartridges in belts. In practice it was found that a fully inflated belt was not capable of supporting a soldier loaded down with his equipment. Men who found themselves in the water could not readily get rid of their packs and ammunition belts and several drownings occurred during the landings.

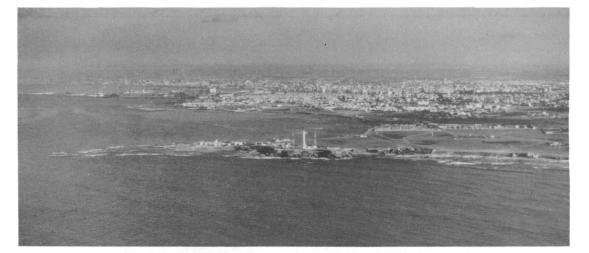

CASABLANCA, THE MAIN OBJECTIVE on the Atlantic coast of Morocco. The landings were made at Fedala, farther north, in order to attack Casablanca overland, partly because of its very strong defenses and partly because of the necessity of capturing the port in usable condition. Casablanca was a naval base. The U. S. Navy had the mission of preventing French warships from interfering with the landings. American ships came under the fire of large coastal guns on El Hank Point (in the foreground, top picture) and engaged in running battles off Casablanca. Moored in the harbor was the battleship *Jean Bart* which also fired heavy shells to drive the American ships from their protective stations. After three days, when Casablanca was about to be attacked by ground, air, and sea bombardment and occupied by tanks and infantry, the city surrendered. The harbor was put to almost immediate use.

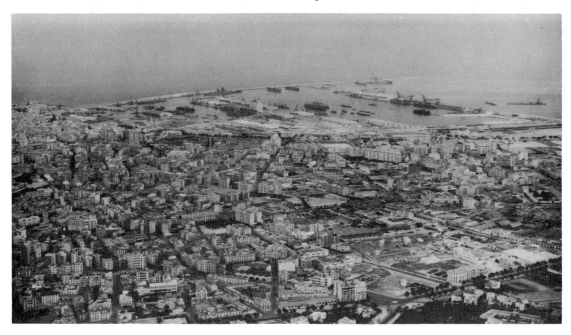

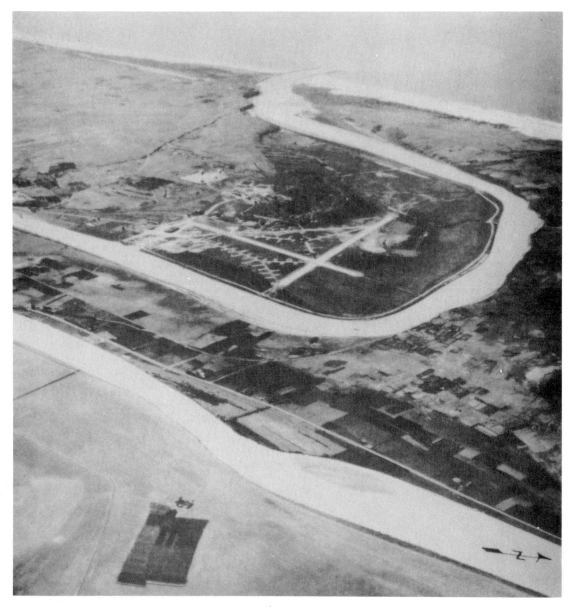

PORT-LYAUTEY AIRPORT on the Oued Sebou north of Casablanca. The Kasba, an old walled fort, is on high ground between the lagoon at upper left and the mouth of the river. Early on 8 November 1942, one landing was made on the north and two south of the river mouth. Those between the lagoon and the river were opposed by coastal defense guns and artillery from the Kasba. Hostile aircraft strafed all beaches and fighting lasted more than two days. Early on the 10th a naval party cut the cable across the river mouth and a U. S. destroyer steamed up the river under fire from the Kasba. Raiders and infantry occupied the airport at 0800 and Army fighter planes from a carrier landed by noon shortly after the Kasba surrendered.

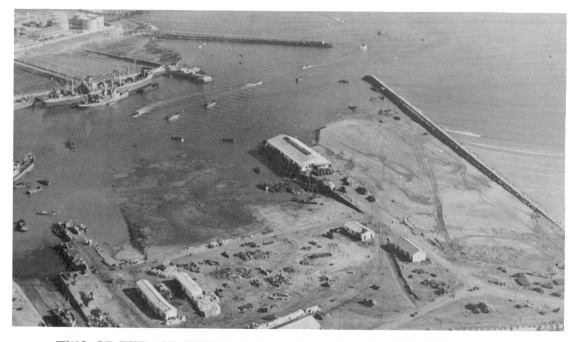

TWO OF THE ATLANTIC PORTS SELECTED FOR INVASION. The main landings on the Atlantic coast took place in the vicinity of Fedala (top). In the early afternoon on the day of invasion, Fedala surrendered and the port was put to immediate use. Two destroyer-transports entered the port of Safi (bottom), 130 miles south of Casablanca, at 0435 on 8 November. Their troops secured the harbor and key points inland while the first landings at the beaches were in progress. Shore batteries firing on the destroyers were silenced within a few minutes. By late afternoon the opposition in and around Safi came to an end. The reason for invading Safi was to obtain port facilities for unloading medium tanks.

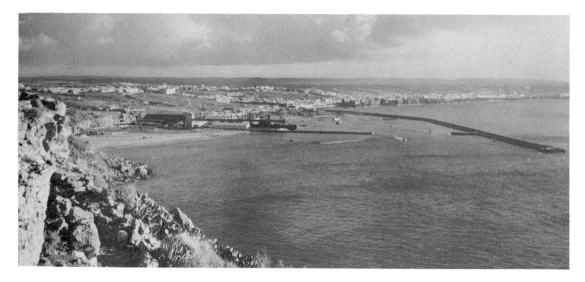

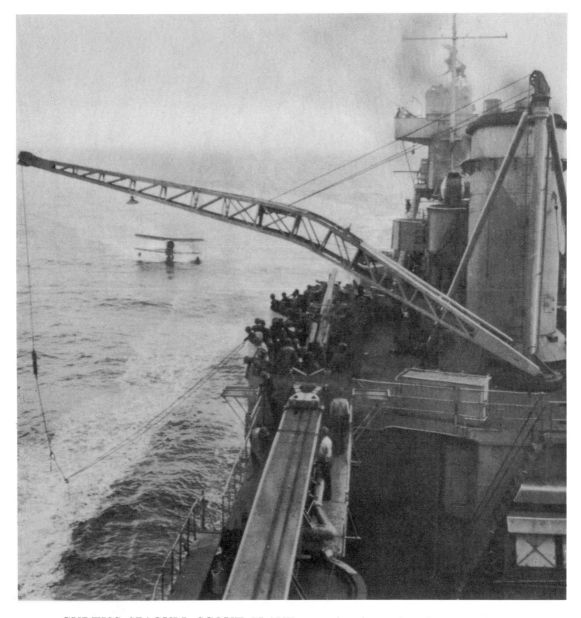

CURTISS SEAGULL SCOUT PLANE returning from observing and directing naval gunfire on Casablanca. Soon after the action started the radar on the large naval units was put out of commission by the concussion of the high-caliber guns. Spotting planes took over the task of directing fire and did an excellent job in spite of the difficulties caused by smoke over the port area. Battleships and cruisers had their own observation planes, launched by catapults and picked up by cranes. These planes assisted the infantry during the heavy fighting around Port-Lyautey by dropping antisubmarine depth charges on tanks and columns of vehicles. (Scout Observation– Curtiss SOC.)

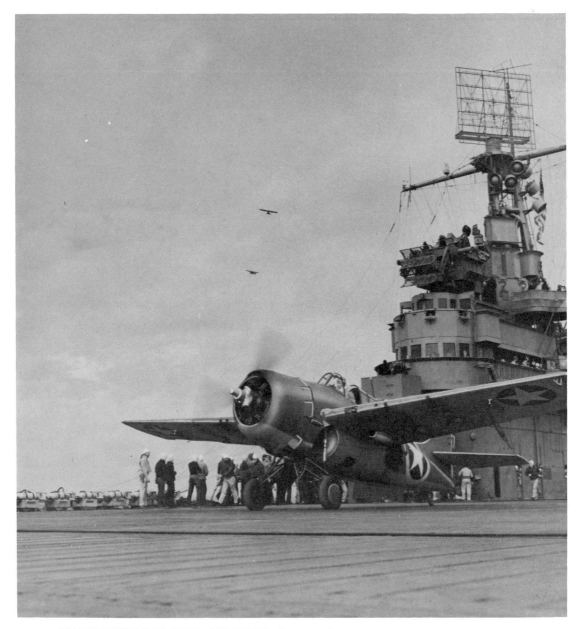

NAVY DIVE BOMBER ON DECK OF A CARRIER. In the distance are two Army cubs, artillery observation planes. Three of these were brought across on a carrier for Army use and launched from the carrier to land on the race track at Fedala. Army-Navy teamwork was excellent during the invasion. Navy planes, on Army request, broke up enemy formations, bombed and strafed road blocks and strong points, often within an hour after the call had gone out from the forces ashore. Also on Army call, naval guns shelled points along the coast and some distance inland. (Grumman F4F Wildcat.)

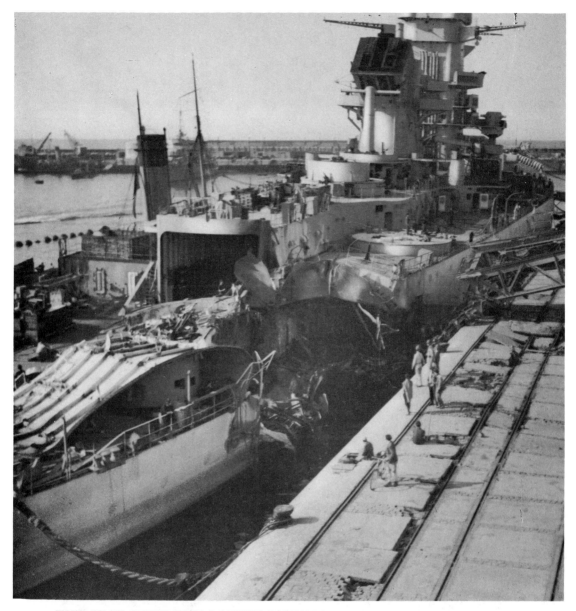

THE *JEAN BART*, THE LATEST BATTLESHIP OF THE FRENCH NAVY.
Although it was not finished at the time of the invasion and only one turret of four
15-inch guns had been installed, it opened fire on U. S. naval units at 0703 on
D Day. The fire was returned and her battery was silenced within 15 minutes;
five hits were made with 16-inch guns and the turret mechanism of the *Jean Bart*
was jammed. Her guns were again operative at the end of D Day but did not fire until
the 10th after which a 10-plane formation of dive bombers scored three hits, with
1,000-pounders. Her guns were still able to fire. Plans to bomb and shell the ship on
the 11th were abandoned because of the armistice.

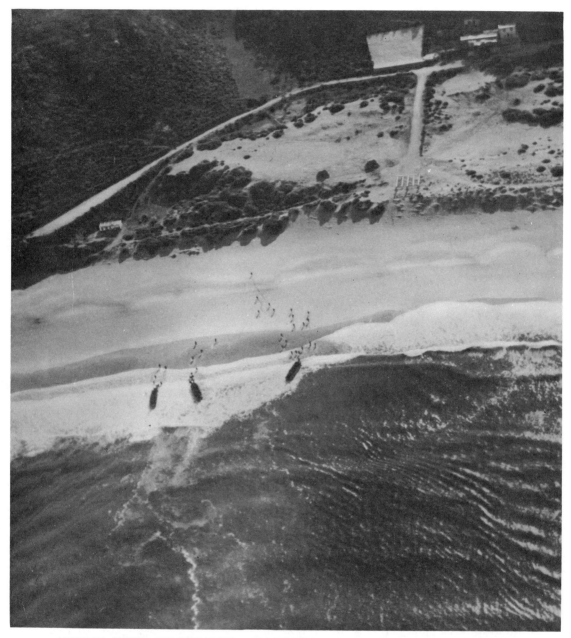

AERIAL VIEW OF INFANTRY LANDING FROM ASSAULT BOATS north of Casablanca. Note heavy surf. Many of the landing craft were damaged on the beaches for lack of facilities to remove craft from the surf line and to repair or salvage them when stranded. At Fedala, for instance, more than half of the boats were unusable after the first landings. This slowed the follow-up unloading and was a contributory cause of the torpedoing of the transports waiting offshore to be discharged.

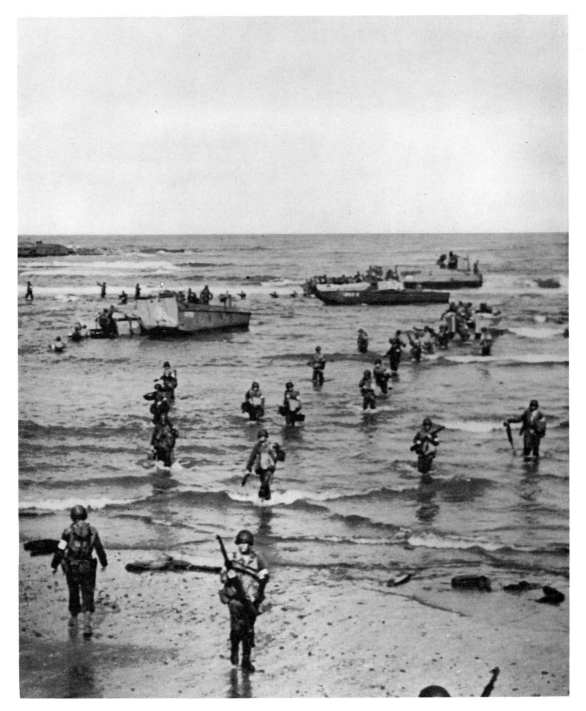

INFANTRY LANDING ON THE BEACH NEAR FEDALA. The landing itself was unopposed, but fighting developed just off the beach. (Left, landing craft, vehicle, LCV.)

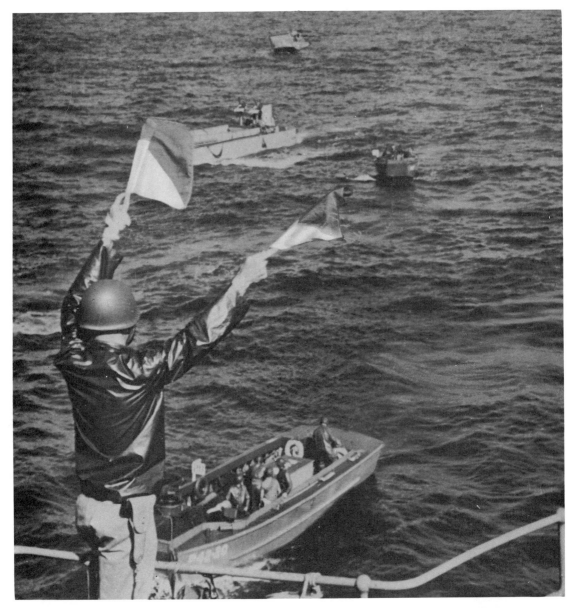

DIRECTING LANDING-CRAFT TRAFFIC OFF FEDALA by means of sema-
phore flags. The port was captured and put into operation on D Day, but because
of its limited capacity, freighters had to stand offshore awaiting their turns to discharge
cargo. In the meantime unloading of ships went on with remaining assault craft.
On the evening of 11 November a transport was torpedoed and sunk by submarine;
a destroyer and tanker were damaged. The next day three additional transports were
torpedoed and sunk. (Landing craft in picture: top center, LCV; middle left, landing
craft, mechanized, LCM(3); middle right and bottom, landing craft, personnel
(Ramp), LCP(R).)

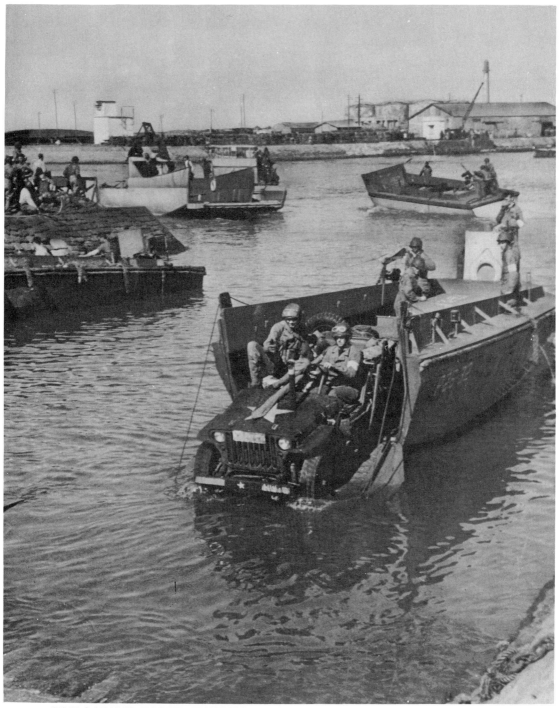

UNLOADING EQUIPMENT IN FEDALA HARBOR. Waterproofed jeep coming off LCV. Note LCM in upper left. (Craft, upper left: LCM(3) ; upper right: LCV.)

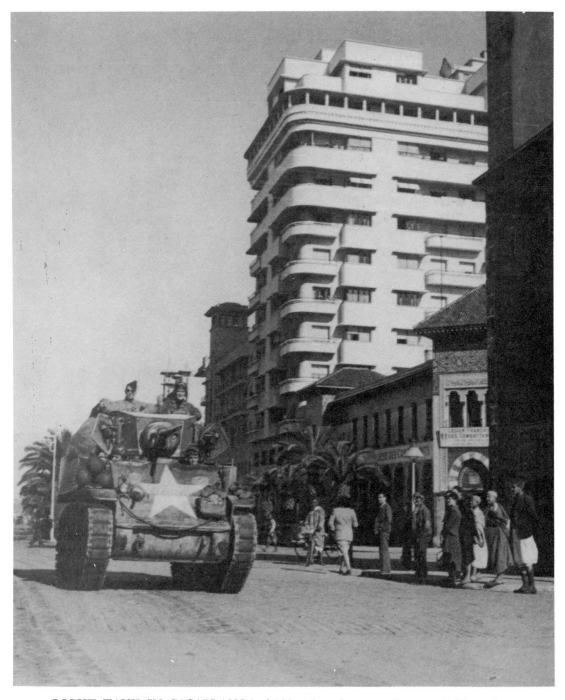

LIGHT TANK IN CASABLANCA shortly after the surrender on 11 November.
Only light tanks were brought ashore in assault craft; the medium tanks were un-
loaded in the port of Safi until D plus 2 and headed north toward Casablanca.

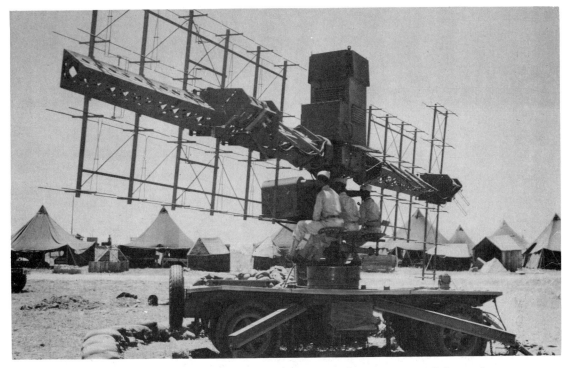

RADAR SETS NEAR CASABLANCA. This type of set was part of the equipment of the invading forces. By the end of December 1942, fifteen of these units were in operation as part of the air warning system of Casablanca. The searchlight automatically followed planes tracked by the radar. The city was almost at the maximum range of enemy bombers and was the target for few raids. (Radar set SCR 268.)

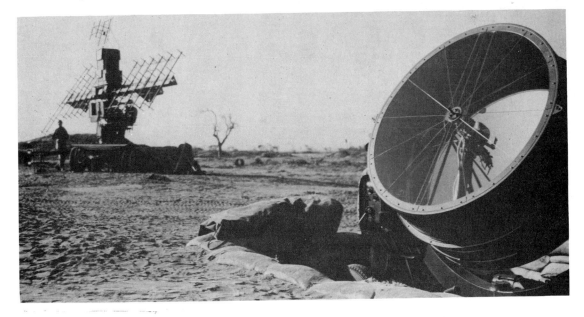

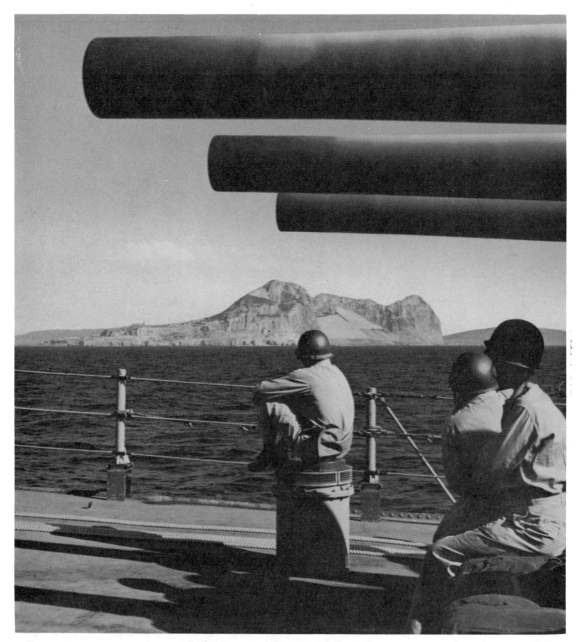

WARSHIP PASSING THE ROCK OF GIBRALTAR. This fortress was temporarily the Allied command post for TORCH. It was the only area on the European mainland under Allied control. Land-based aircraft did not take part in the beach assault phase, but aircraft were staged at the Gibraltar airport for take-off for Africa as soon as airfields there were captured. A U. S. fighter group equipped with British Spitfires landed near Oran about noon on D Day and aided in the fighting there; other planes flew to Algiers.

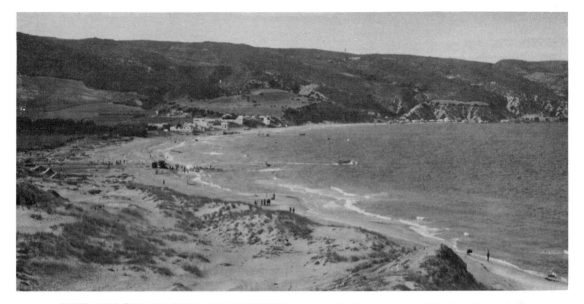

THE BEACH OF LES ANDALOUSES, west of Oran (top). The landings here were unopposed. Eastern part of Oran harbor (bottom). Early on 8 November two British ships (ex-U. S. Coast Guard cutters), carrying about 400 U. S. soldiers, entered the port between the moles shown in the distance. The ships came under point-blank fire from French naval vessels in the harbor and from shore batteries. They returned the fire but were sunk with great loss of life. When resistance in Oran ceased at noon on 10 November the port was cluttered with ships either sunk by British naval gunfire or sabotaged. Port installations had received only minor damage and were quickly put to use.

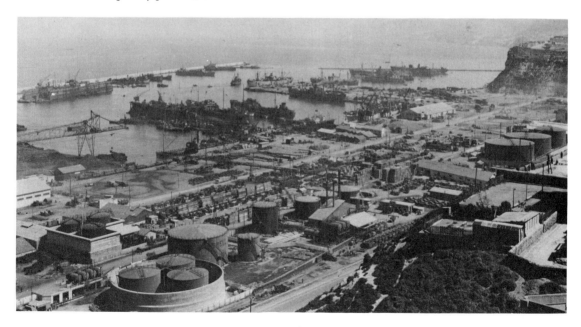

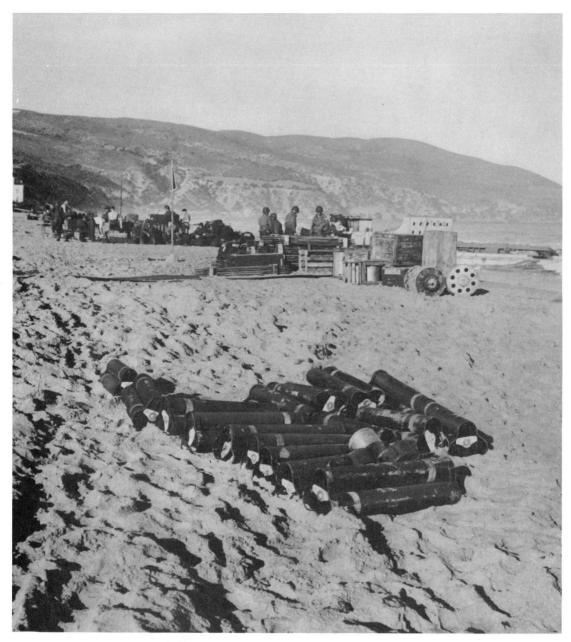

SUPPLIES ON THE BEACH OF LES ANDALOUSES ON D DAY. Most of the Allied supply problems, both on the Atlantic side and in the Mediterranean, were caused by destruction of landing craft. About 95 percent were used during initial landings leaving few reserves for the build-up. The large seaworthy LST's (landing ship, tank), which were to play a decisive role in all subsequent landings, were introduced by the British in the Oran area to carry light American tanks for beach landings.

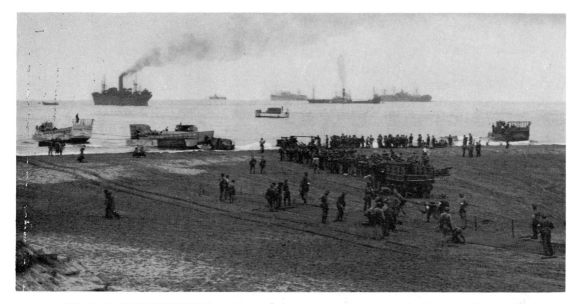

UNLOADING SUPPLIES and laying prefabricated track on the beach in the Golfe d'Arzeu east of Oran (top). Guarding French and French colonial prisoners captured in the same vicinity (bottom). The plan for the capture of Oran and near-by airfields consisted of the frontal attack on the port itself and landings on both sides of the city at Mersat bou Zedjar and Les Andalouses west of Oran, and in the Golfe d'Arzeu east of Oran. Of the beach landings, those at Arzeu were much the largest and were made with little resistance. By afternoon of D Day all opposition in the neighborhood had ceased. (Top picture: 3 LCM(3)'s on beach; at center, offshore, is an LCM(1).)

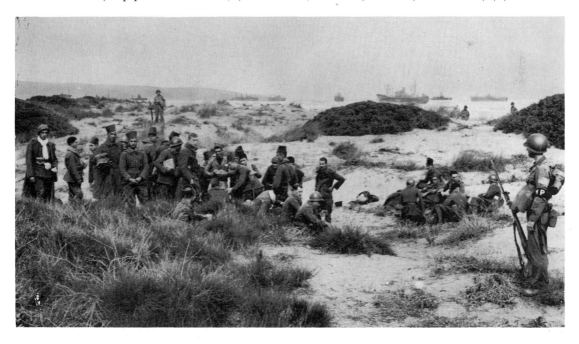

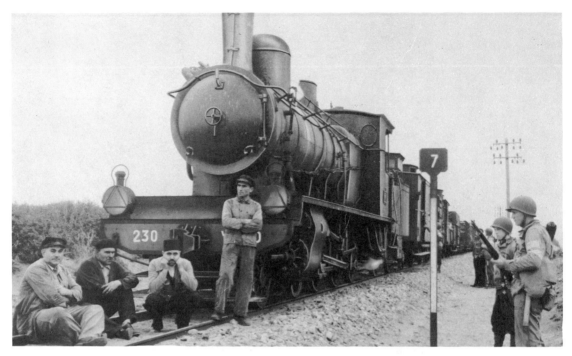

CAPTURED TRAIN AT SAINT-LEU ON THE GOLFE D'ARZEU. The railroad from Casablanca to Tunis figured prominently in the planning of the African invasion. If the forces on the Mediterranean coast were to be cut off by sea, supplies could be carried by railroad from Casablanca. During the fighting in Tunisia and the build-up in Africa for the invasion of Europe, this railroad played an important part. After its capture it was repaired and improved. Locomotives and rolling stock were obtained from the United States to speed delivery of supplies.

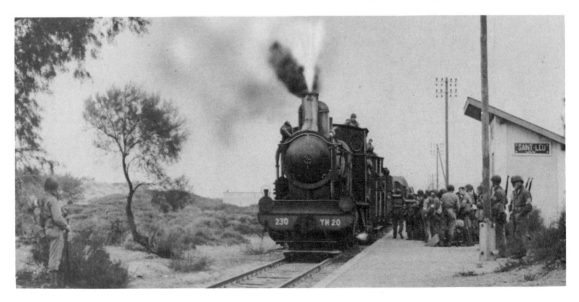

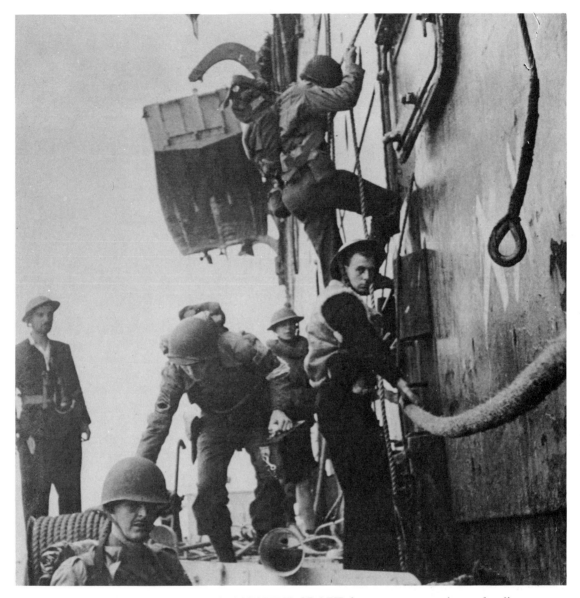

TROOPS LOADING INTO ASSAULT CRAFT from transport prior to landing
near Algiers. With minor exceptions, the landing craft were manned by Royal Navy
personnel. Landings took place on beaches on both sides of the city as well as in the
port itself. Although beach landings were not heavily opposed, one of the two British
destroyer-transports making a frontal attack on the port had three boilers damaged
by fire from shore but discharged her load of U. S. troops on a dock at 0520,
D Day. Some troops were surrounded and taken to a French military prison,
others regained the ship before she was eventually driven off. The hostilities here
ceased the same day and the soldiers were set free by the French. (On davits, center
of photograph: LCP(R).)

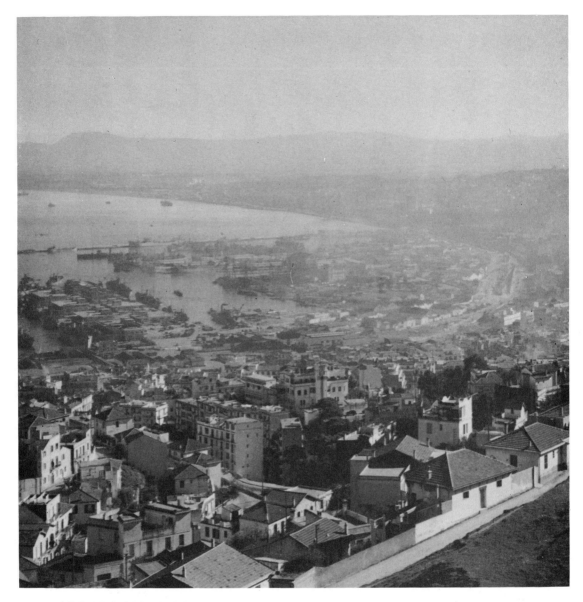

ALGIERS, THE MOST IMPORTANT OBJECTIVE of the North African inva-
sion. The ultimate goals for the operation were Bizerte and Tunis, but because of the
land-based enemy aircraft in Sardinia, Sicily, and southern Italy, it was decided to land
no troops farther east than Algiers until airports had been captured. British-American
elements at Algiers re-embarked for a movement eastward to Bougie where they
landed on 11 November. Bône was captured the following day by British
paratroopers dropped from C–47's and by seaborne forces from Bougie. From there
the advance toward Tunis started. Allied columns reached Djedeida, twelve miles
from Tunis, on 29 November 1942, but rapid enemy build-up forced the Allies to
abandon it on 13 December.

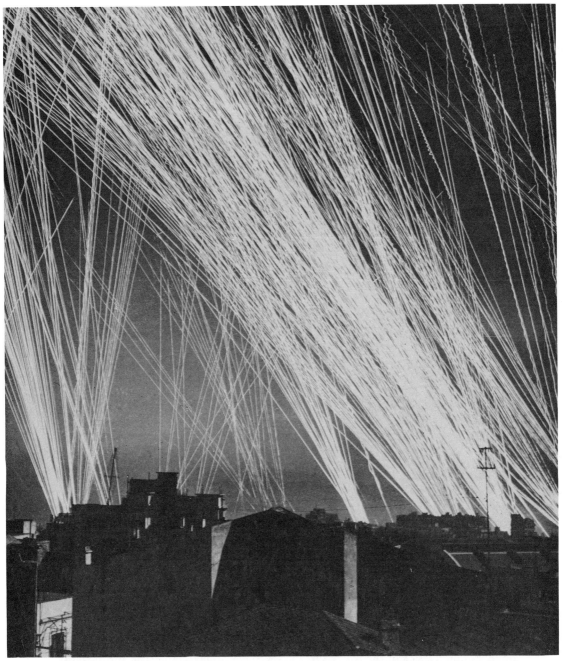

ANTIAIRCRAFT DEFENSE OVER ALGIERS AT NIGHT. The city suffered practically no damage during the invasion. On the first evening of its surrender it was bombed by enemy planes. This attack was followed by many others, mostly aimed at the concentration of shipping in the harbor. Damage was surprisingly small. Algiers became Allied Force Headquarters (AFHQ).

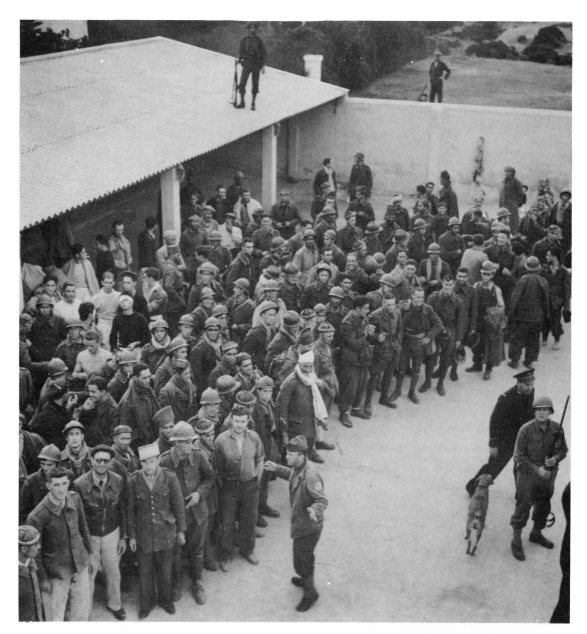

FRENCH PRISONERS OF WAR CAPTURED DURING THE INVASION. The prisoners were released shortly after the end of hostilities, 11 November, and from then on fought on the side of the Allies. On 15 November orders were issued for the movement of French troops, then at Algiers and Constantine, to protect the southern flank of the American and British units advancing into Tunisia along the northern coast The French were reinforced by U. S. troops, including tank destroyer units, and one of their assigned missions was the protection of advanced airfields in the Tébessa–Gafsa area.

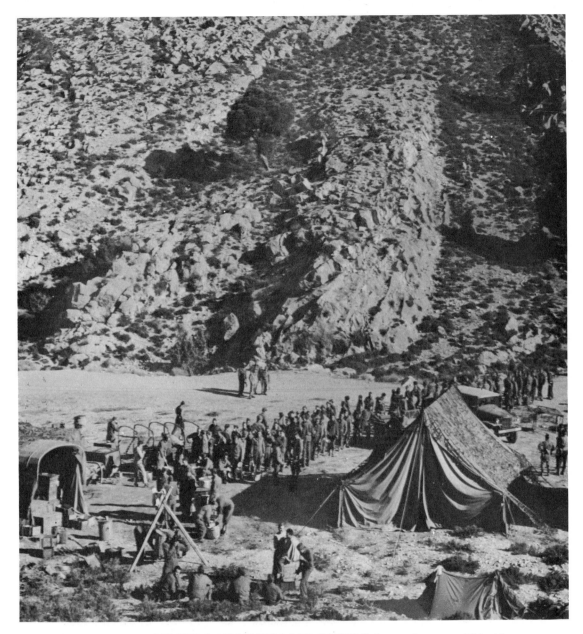

AVIATION ENGINEERS AT YOUKS-LES-BAINS lining up for mess. This Algerian airfield near Tébessa and the Tunisian border was occupied by U. S. paratroopers on 15 November 1942. It became operational for P–38 fighter planes (Lockheed Lightnings) shortly afterward. During the first few weeks there were no provisions for landing after dark and on 21 November six P–38's crashed while trying to land in the evening. It was not an improved field and there was no effective air-raid system. The first warning of enemy aircraft was frequently the strafing or bombing itself. When the rains started, operations were drastically reduced by mud.

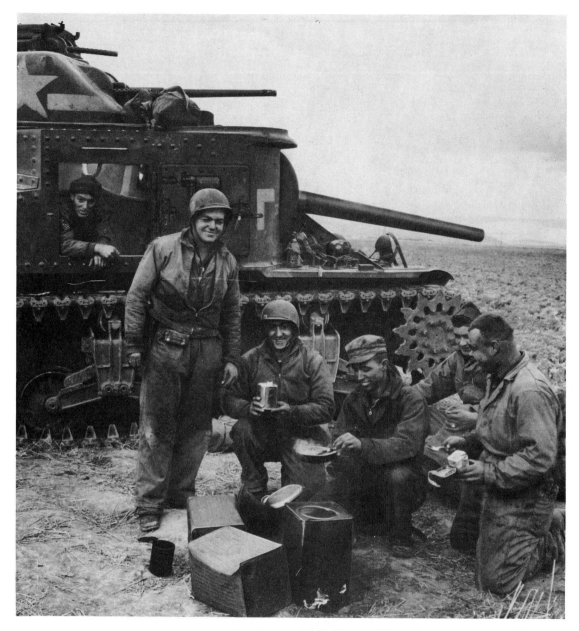

U. S. TANKERS HEATING THEIR C RATIONS, Spam and beans, over an improvised stove at Souk el Arba, Tunisia. The Souk el Arba area was taken by British paratroopers on 16 November. When the attempt to advance to Tunis was officially abandoned on 24 December, both sides started a race to build up strength for the battle to come. The U. S. troops were at first committed piecemeal in different sectors of the line as they arrived from Algeria. Much of the Allied armor was obsolete and none of it was on a par with the best German equipment. (General Grant tank M3.)

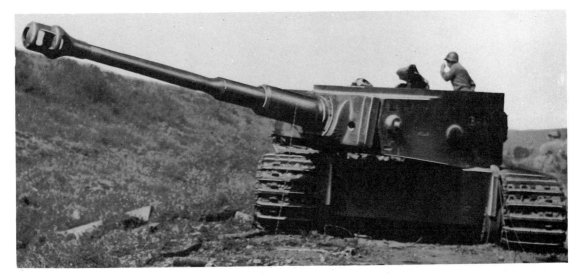

GERMAN TIGER TANK. This heavy tank was encountered early in the campaign. The German High Command was particularly concerned with the performance of the Tiger in the defense of Tunis. Its high-velocity 88-mm. gun, equipped with a muzzle-brake, could knock out Allied tanks before the latter could get within effective range; and within range, Allied tank guns could not penetrate its frontal armor. The Tiger sacrificed mobility for armor and fire power. To avoid weak bridges, it was equipped with telescopic air intake, exhaust extensions, and over-all sealing that enabled it to cross rivers fifteen feet deep, completely submerged on the bottom. The gun has a traverse of 360 degrees. Top picture is rear view of tank; bottom is front view. (*Tiger, Pz., Kpfw.*, gun 8.8-cm., *Kw. K. 36.*)

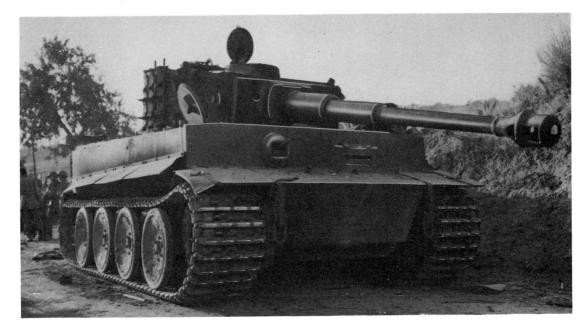

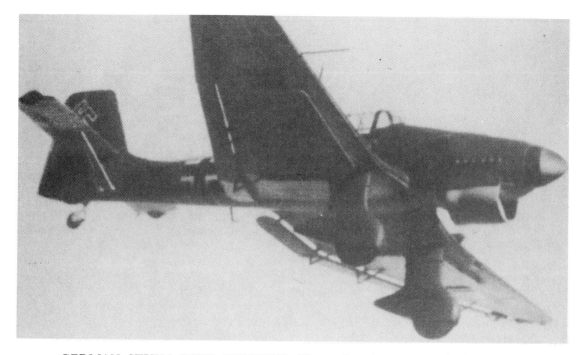

GERMAN STUKA DIVE BOMBERS. These aircraft co-operated closely with ground forces, bombing and strafing ahead of their own advancing columns in addition to roaming behind the lines disrupting traffic and creating confusion. The bombers could operate successfully only where they had air superiority. In the later stages of the Tunisia Campaign, as the Allies gained air superiority, their effectiveness dwindled. The Germans turned a number of these planes over to the Italians. Note Italian and British markings in lower photograph. This Stuka was captured by the British. (Dive bomber, German *Stuka JU–87.*)

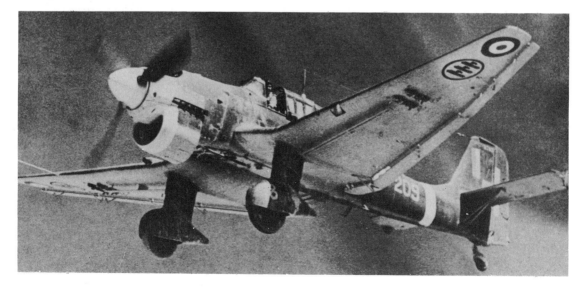

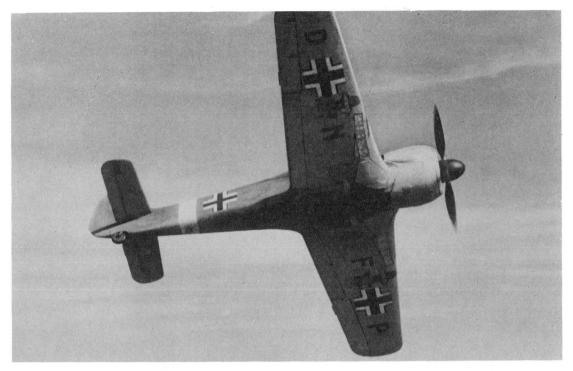

GERMAN FIGHTER PLANES. The primary mission of these planes was to inter-
cept and destroy bombers but they were also used for strafing and fighter-bombing.
The enemy used these types until the end of the war. (Top, German *Focke-Wulf 190;*
bottom, German *Messerschmitt 109.*)

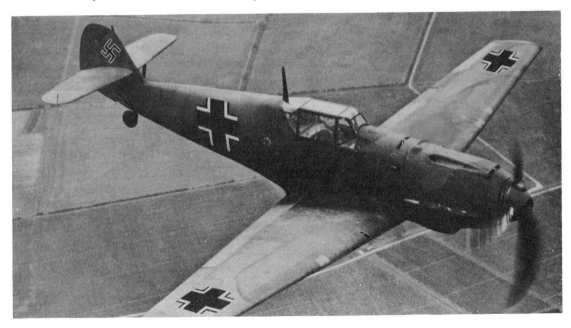

CAMOUFLAGING MEDIUM BOMBER at Youks-les-Bains airfield. Camou-
flaging for hiding purposes in olive groves or on rough terrain was relatively suc-
cessful; however, camouflaging an aircraft on a flat, featureless landing field for
hiding purposes was not practical. Camouflaging was often practiced to the extent
of deceiving the enemy about the type or serviceability of planes. Note that the
bomber above is minus both of its engines. (Martin B–26 Marauder.)

REMOVING FILM FROM FIGHTER PLANE after a reconnaissance flight. This long-range plane was adapted for photographic work by removing the armament and installing camera equipment instead. (P–38.)

LIGHT BOMBER, DOUGLAS A–20. This was a fast, versatile, and heavily armed plane used for both bombing and strafing in Tunisia. The American version was usually called the Havoc and the British version, the Boston.

HEAVY BOMBER, FLYING FORTRESS. This and the B–24 were the two heavy
U. S. four-engined bombers used in the Mediterranean area. (Boeing B–17.)

DJEBEL KSAIRA TO SFAX FAÏD GARET HADID TO SBEITLA

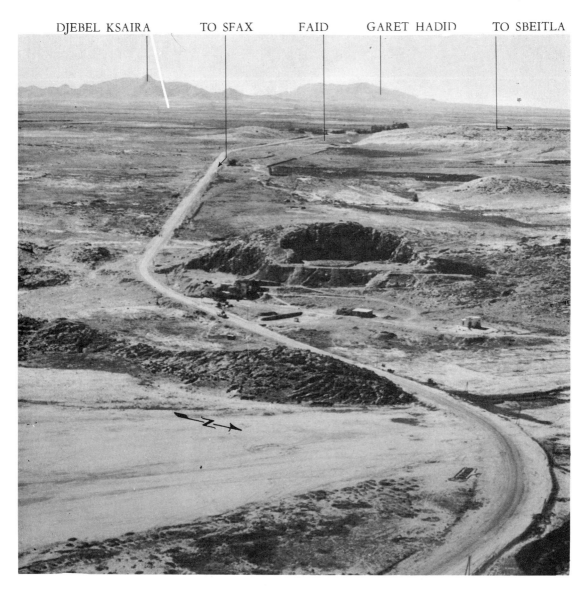

FAÏD PASS. This opening in the eastern mountain chain was taken from a weak French garrison and held against U. S. and French counterattacks, 30 January– 2 February 1943. Just before daylight, 14 February, very strong German forces came through Faïd Pass and others came from south of the pass to drive the Americans from positions to the west. The enemy cut off and isolated three groups, on Djebel Ksaira and Garet Hadid southwest of the pass, and Djebel Lessouda northwest of it. On 15 February, an American armored counterattack to relieve the troops was made in strength far inferior to that required. Most of the troops were captured trying to escape. On 17 February, the American base at Sbeitla and the airfields at Thelepte were evacuated, as all troops were pulled back into the western mountain chain. The enemy then decided to continue his attack toward the northwest.

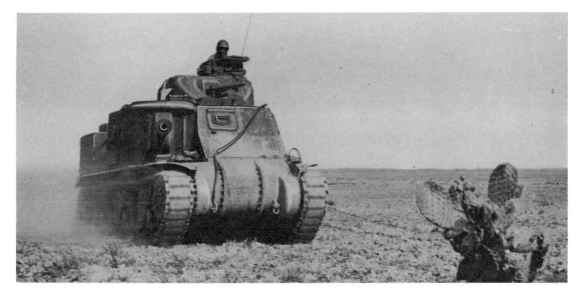

THE GENERAL GRANT TANK. These medium tanks were of the riveted hull type, later models having cast or welded armor, and were equipped with either a short-barreled (top) or long-barreled (bottom) 75-mm. gun. Principal armament was the 75-mm. cannon, in a right-hand sponson, capable of being swung in an arc of about 30 degrees. The entire tank would often have to be turned to bring the gun to bear. In a hull-down position only the secondary gun, the 37-mm. cannon in the turret, could be fired. The silhouette of the M3 was much higher than that of corresponding German tanks.

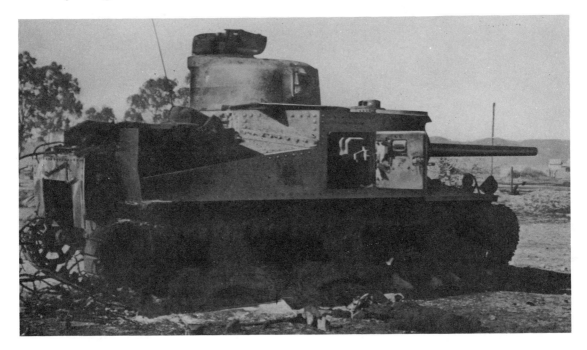

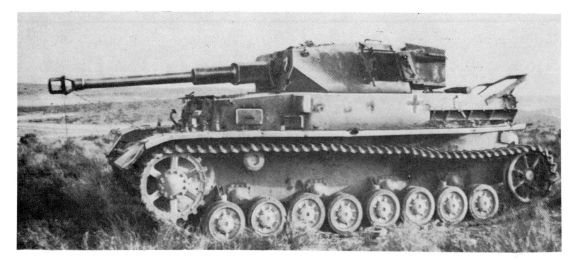

CAPTURED GERMAN ARMOR. The Mark IV medium tank (top) was equipped with a 75-mm. cannon of higher velocity and range than any of the Allied tank guns then in use. It was generally superior to Allied tanks and was probably the best tank the enemy had until the Panther made its appearance in Italy, 1944. The Mark IV was used until the end of the war. The eight-wheeled armored car with a 75-mm. howitzer (bottom) was equipped with quite thin armor which was so well angled that machine gun bullets and small fragments were not effective against it. It could be steered from both ends and had a speed of slightly more than thirty miles an hour. (German medium tank Mark IV (*Pz. Kpfw. IV*) ; German armored vehicle, 7.5-cm. howitzer.)

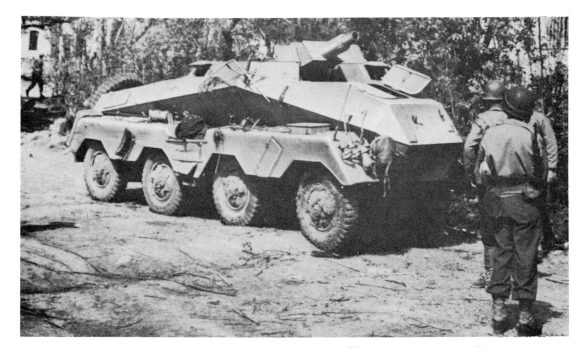

KASSERINE PASS AREA. The enemy broke out of the pass on 20 February 1943. On the 21st he headed toward Tébessa and Thala. The attack on Tébessa was halted; the main attack toward Thala made some progress. A British armored force, with heavy losses in tanks and men, delayed the enemy until U. S. artillery got into position. On the 22d the enemy pounded the defenses of Tébessa and Thala unsuccessfully. Allied planes attacked the enemy near Thala, and in the evening the Germans started to withdraw. The Kasserine push was the high point of enemy fortunes in Tunisia.

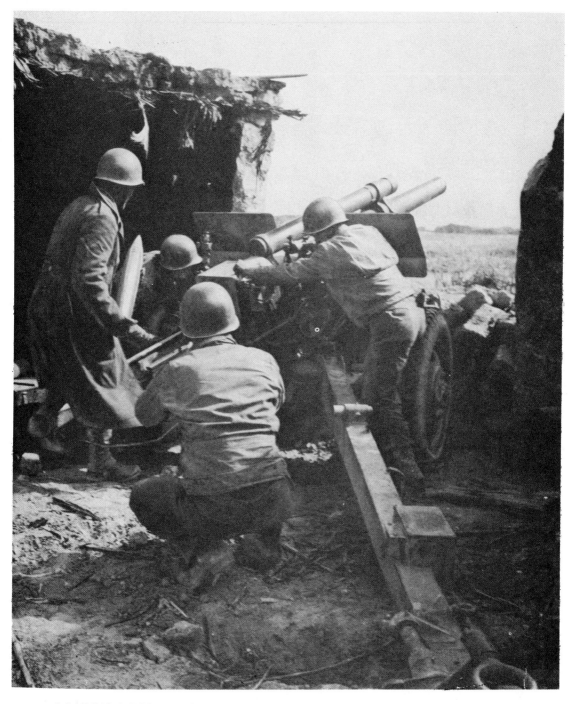

LOADING A TOWED HOWITZER. This gun was designed to give close support to the infantry. The picture was made during the February fight in Kasserine Pass. (105-mm. howitzer M2.)

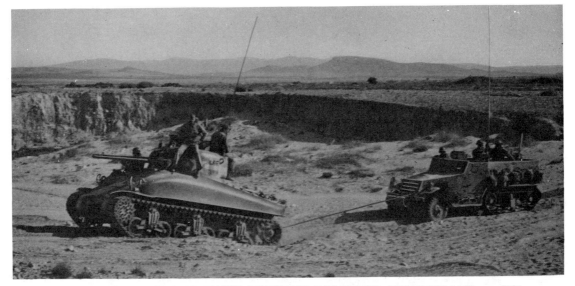

GENERAL SHERMAN TANK TOWING DISABLED HALF-TRACK at Sidi bou Zid (top). This tank gradually replaced the M3 (General Grant) in Tunisia. Its principal weapon was the 75-mm. cannon. Its turret could traverse an arc of 360 degrees in contrast to the sponson-mounted gun on the General Grant with a traverse of about 30 degrees. Reconnaissance party at Kasserine Pass on the Kasserine–Thala road (bottom). The enemy came up this road on his attack through the pass and stopped just before reaching Thala after indications of increasing Allied strength. (Medium tank M4.)

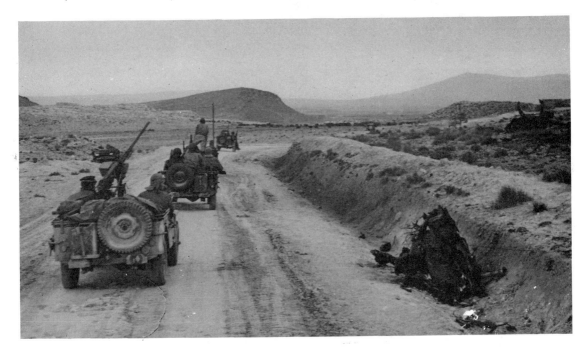

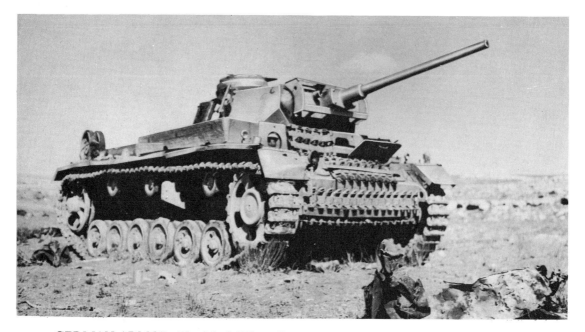

GERMAN ARMOR. The Mark III medium tank (top), the standard German tank in Tunisia, had a high-velocity 50-mm. cannon which could penetrate the frontal armor of U.S. light tanks at a thousand yards and the frontal and side armor of the General Grant at five hundred and one thousand yards respectively. The 75-mm. anti-tank and assault gun (bottom), mounted on the same chassis as the Mark III tank, was encountered early in the Tunisian campaign. Its high-velocity gun was more than a match for any of the Allied tanks. Its low silhouette, characteristic of most German armor, made it difficult to detect and hard to hit. The prototypes of both these vehicles existed in Germany in 1936 and were used until the end of the war.

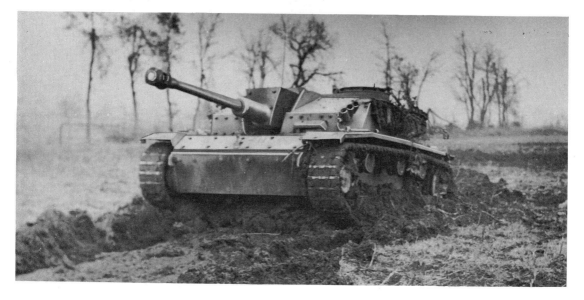

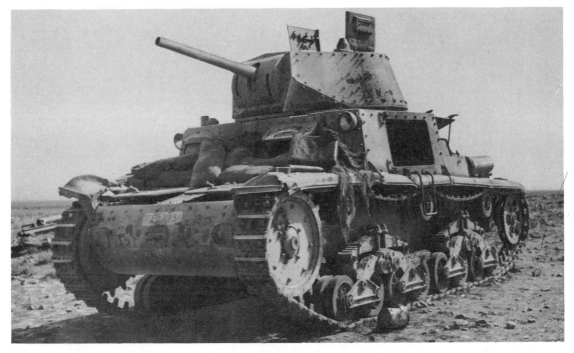

ITALIAN MEDIUM TANKS LEFT BEHIND AT KASSERINE PASS. This model
was the backbone of the Italian armor in Tunisia. By Allied standards it was inferior
in practically every respect, but it was the best the Italians had. (Italian medium tank
M13/40 with 47-mm. cannon.)

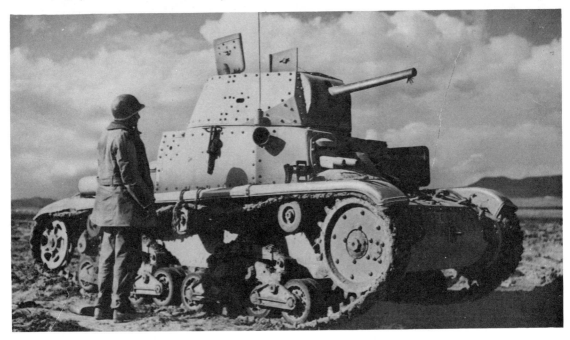

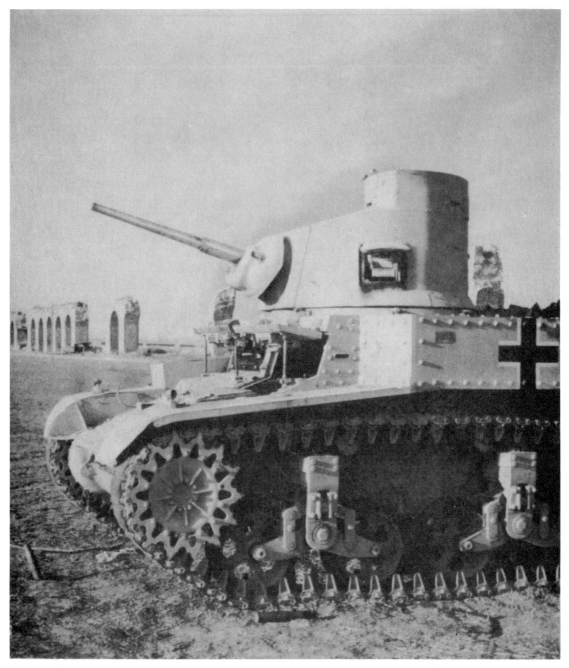

U. S. LIGHT TANK, captured by the Germans. The main weapon of this tank was the 37-mm. gun. Its armor was light and riveted together as was the armor on the first models of the medium tanks. A glancing shell could rip off the outside heads of the rivets and send the rivets ricocheting through the interior of the tank with the velocity of bullets. Note German markings on this vehicle. (U. S. light tank M3.)

U. S. TANK DESTROYERS. The combination truck and 37-mm. antitank gun (top) could not stand up against any type of armor the enemy had. The tank destroyer (bottom) was introduced in Tunisia after the Kasserine fight. The chassis was that of the General Sherman tank, the gun having a higher velocity than that of comparable Allied tank guns. The first time it saw action was in the vicinity of Maknassy during the middle of March 1943. The village of Maknassy was occupied by U. S. forces on 22 March 1943.

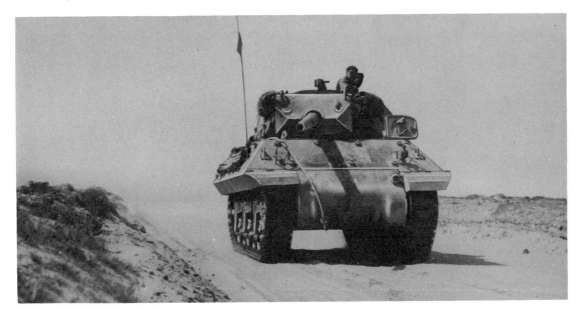

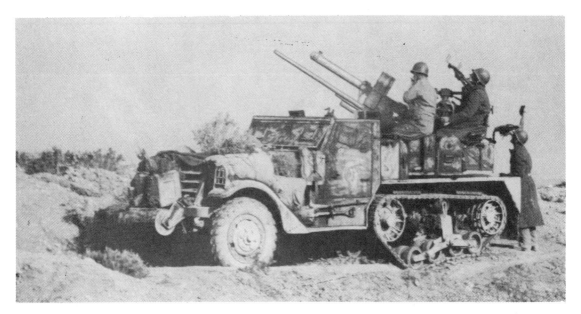

U. S. HALF-TRACK USED AS A MOBILE ANTIAIRCRAFT UNIT (top). AA units like this cut down the effectiveness of the Stuka dive bombers. Half-tracks proved practical for many purposes not originally intended. First designed as a cavalry scout car, it became, with modifications, a gun carriage mounting anything from a 37-mm. cannon to a 105-mm. howitzer, a personnel carrier, an ambulance, or just a truck. The standard half-track had armor protecting the crew. Long Tom or 155-mm. rifle towed by standard caterpillar (bottom). This was the heaviest piece of Allied artillery used during the Tunisia Campaign. (Top: multiple-gun motor carriage with 37-mm. cannon and .50-caliber water-cooled Browning machine gun.)

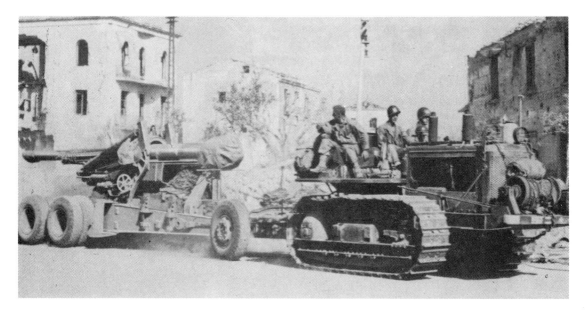

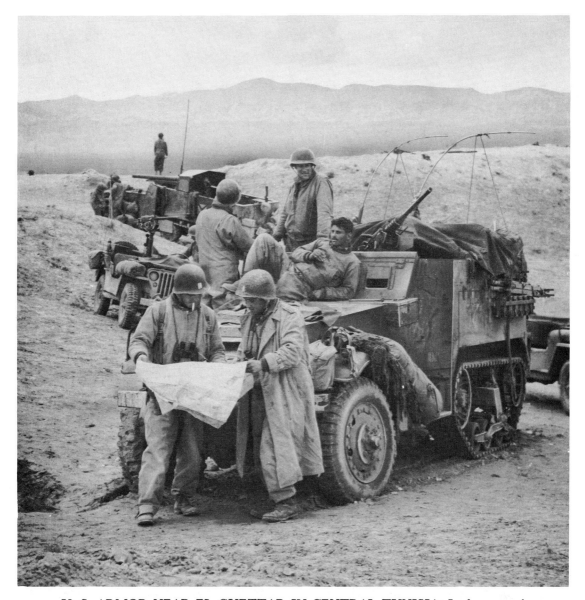

U. S. ARMOR NEAR EL GUETTAR IN CENTRAL TUNISIA. In foreground is a radio-equipped half-track personnel carrier, in background a 75-mm. gun motor carriage M3. The latter, lightly armored, was an antitank vehicle with great mobility. The enemy developed a healthy respect for the hit-and-run tactics of U. S. forces using this weapon. The vehicle would wait until enemy armor came within range, get off as many shells as possible, and withdraw. U. S. forces pushed eastward from the Gafsa area to draw enemy units from the Mareth Line then under attack by the British. On 23 March 1943 severe fighting broke out southeast of El Guettar and a German armored division was repulsed by U. S. forces with heavy tank losses to the enemy.

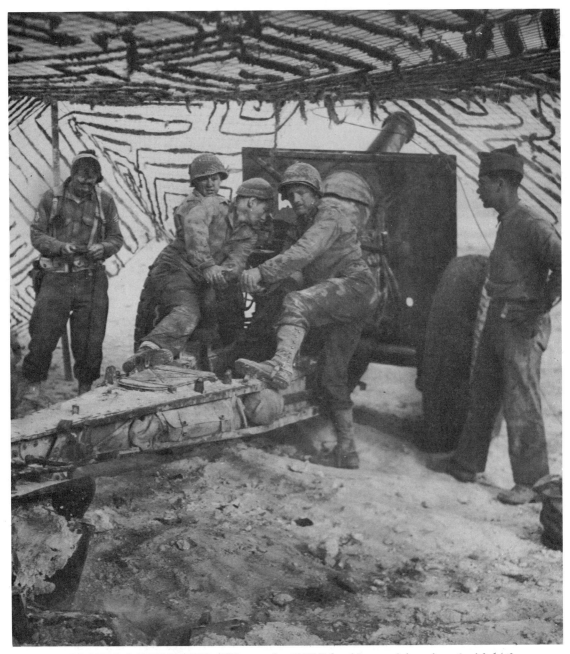

LOADING A HOWITZER. This was the 1918 Schneider model equipped with high-speed carriage. The action shown above took place during the enemy counterattack starting on 23 March 1943 east of El Guettar. Although the enemy attack was stopped, U. S. advance toward the coast halted for several days. During this action Allied fighters and light bombers accounted for much damage done to enemy armor and other vehicles along the Gafsa–Gabès road east of El Guettar. (155-mm. howitzer.)

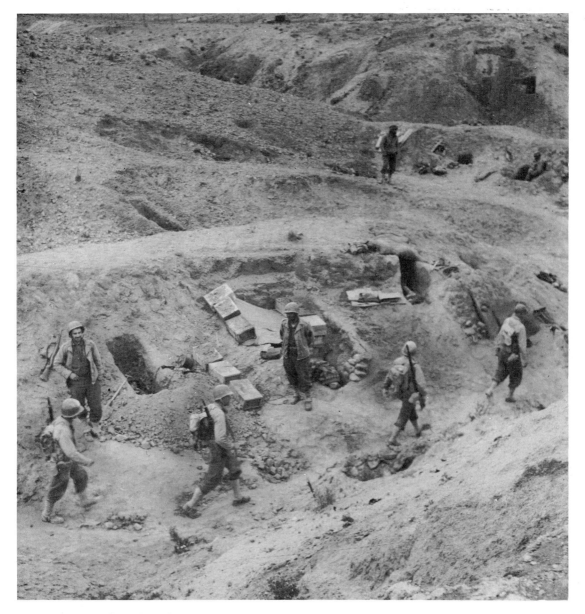

INFANTRY NEAR EL GUETTAR. After the enemy attack in this area on 23 March, the front became almost stabilized until the British Eighth Army broke through Oued el Akarit defenses along the coast north of Gabès on the night of 6–7 April. The junction between the forces fighting in Tunisia and the British Eighth Army from the Middle East took place on the Gafsa–Gabès road on 7 April when a U. S. armored reconnaissance unit made contact with elements of the British army. The British Eighth Army had started its drive westward from El Alamein in Egypt on the night of 23–24 October 1942 and when the junction was made had traveled about 1,500 miles.

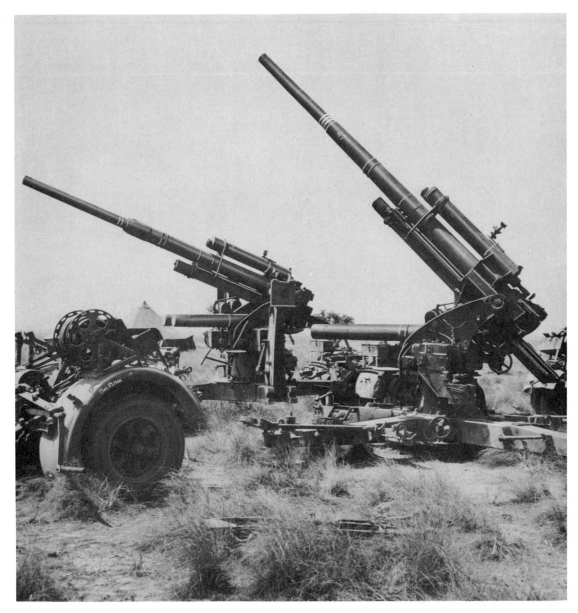

THE FAMOUS GERMAN EIGHTY-EIGHT. The original weapon, an Austrian 88-mm. cannon, was used in World War I. Restrictions imposed by the Allies after that war limited German experimentation on conventional offensive artillery but not on defensive artillery such as antiaircraft types (in photograph). With different sets of aiming fire instruments this antiaircraft gun could be used as an antitank gun or a conventional piece of artillery. It was tested as an antiaircraft gun under battle conditions during the Spanish Civil War in 1936. Encountered throughout the war in increasing numbers, it was probably the most effective all-around piece of artillery the Germans had. (Left: 8.8-cm. *Flak 36;* right: 8.8-cm. *Flak 18.*)

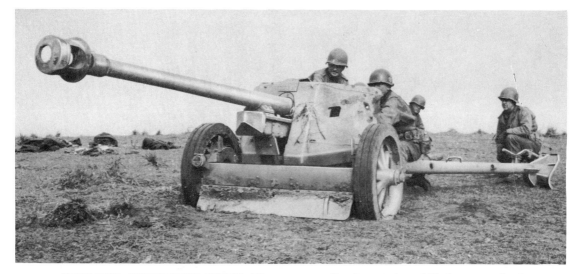

GERMAN ANTITANK GUNS. These guns, effective against Allied armor, fired armor-piercing shells loaded with high-explosive fillers designed to burst inside the armor and to set the tank on fire. Antitank gun (top) could penetrate the armor of any Allied tank, front, side, or rear. Both U. S. and British armor-piercing shells were solid and did not fire the tanks; thus the Germans were able to salvage damaged armored equipment to a greater extent than were the Allies. It was not until well into the Italian campaign that armor-piercing shells equipped with fuzes and high-explosive fillers became available to Allied forces. (Top: German antitank gun, 7.5-cm. *Pak. 40;* bottom: German antitank gun, 5-cm. *Pak. 38.*)

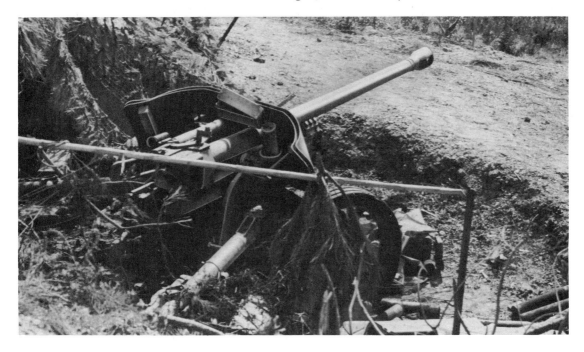

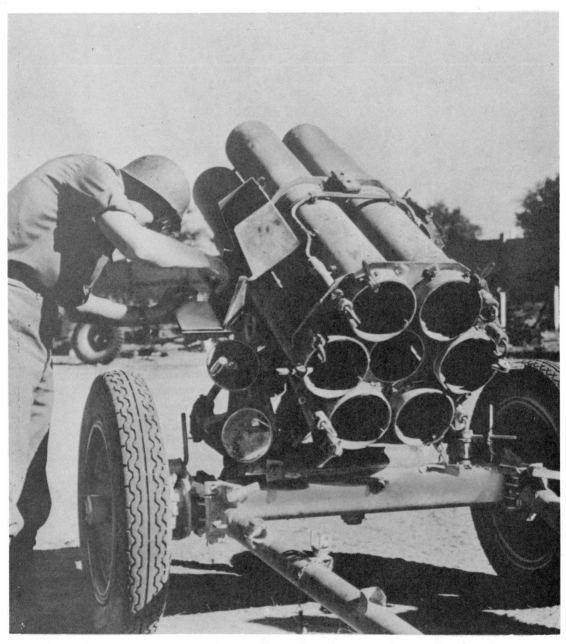

GERMAN SIX-BARRELED ROCKET LAUNCHER. This weapon fired high-explosive, incendiary or smoke rockets and was light enough to be moved with ease. The screaming sound of the rockets had an adverse psychological effect on troops at the receiving end and the rockets were nicknamed "screaming meemies." Artillery sound-ranging equipment could not locate the rocket launchers because firing did not cause a report. The enemy used this type of weapon until the end of the war. (15-cm. *Nebelwerfer, 41.*)

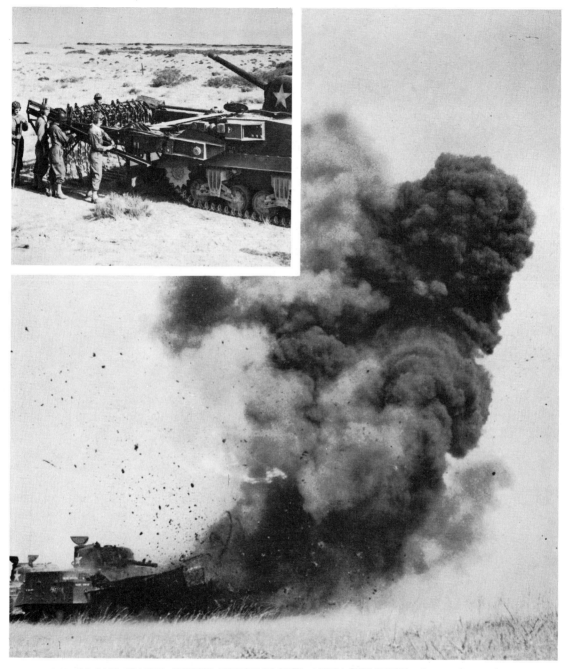

SHERMAN TANK WITH "SCORPION" ATTACHMENT, detonating mines
during a test. The Scorpion was a revolving drum with chains attached (insert);
when in motion it acted as a flail and could clear a path through a mine field for
infantry and other tanks to follow. It was developed by the British and used extensively
by them in desert warfare.

THE S-MINE. This German antipersonnel mine was used profusely and very effectively in Tunisia. It was nicknamed the Bouncing Betty because when stepped on it would bounce a few feet in the air before a secondary fuze set off the main explosive charge scattering some three hundred steel balls in all directions. The suspected presence of these mines naturally retarded troop movements during an advance. When retreating, the enemy would frequently use this mine to booby-trap buildings, dugouts, or equipment left behind.

DJEBEL TAHENT IN NORTHERN TUNISIA, known as Hill 609. The British Eighth Army advancing northward along the coast replaced the U. S. II Corps in the Gafsa–Gabès area in April 1943. The corps then moved northward about 150 miles and went into position from Béja to Cap Serrat. French forces along this coast came under U. S. II Corps, which advanced in two groups, a northern wing astride the Sedjenane road and a southern wing along the Béja road, both converging on Mateur. The hill shown above was a natural fortress blocking the approach to the plains of Mateur. On 28 April 1943 artillery pounded enemy positions and on the next day the infantry attack started. After a three-day infantry fight, supported by tanks, the hill fell on 1 May.

DJEBEL EL AZAG JEFNA DJEBEL EL AJRED MATEUR

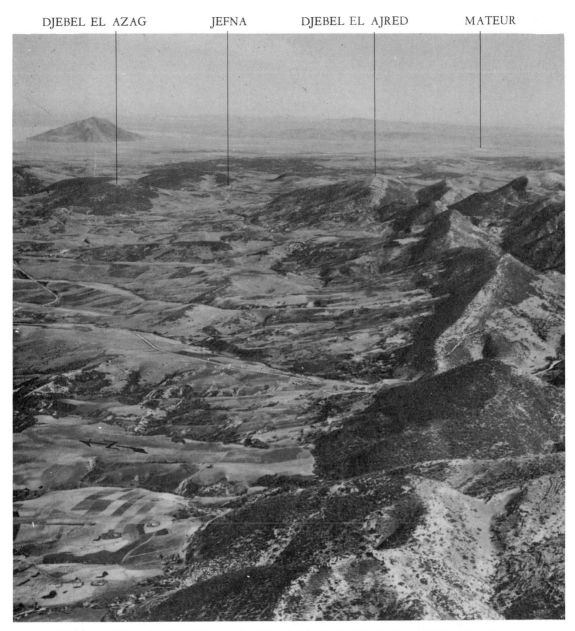

JEFNA AREA, LOOKING EAST TO THE PLAINS OF MATEUR. The Jefna position, on the Sedjenane–Mateur road, was one of the strongest German defenses in northern Tunisia and included two heavily fortified hills commanding the road to Mateur: Djebel Azag (Green Hill) on the north and Djebel el Ajred (Bald Hill) on the south. On 13 April 1943, U. S. forces relieved the British and took positions on both sides of the road and the mountains along the valley. The fight for the two hills lasted until 3 May when the Jefna positions were outflanked by U. S. and French forces advancing toward Bizerte and the Mateur plain north of Jefna.

INFANTRY AND ARMOR ADVANCING ON MATEUR. After the fall of Hill 609 the enemy pulled back leaving the road to Mateur open. This small village in the middle of a plain was the center of enemy road communications in the U. S. zone of attack. Its occupation on 3 May opened the way for the advance on Bizerte, the main objective of the U. S.-French drive. (Bottom: General Sherman M4A1.)

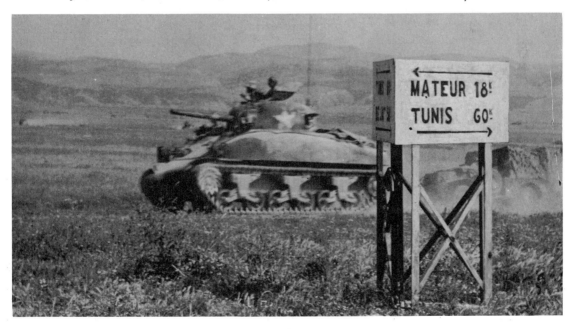

GERMAN SIEBEL FERRIES. These diesel-powered, ponton-raft ferries were used to transport supplies from Italy and Sicily. They usually traveled in convoys and were often heavily armed with 88-mm. antiaircraft guns when moving toward Tunisia as well as with the lighter protection which they retained for the return trip. Of shallow draft, they could unload directly onto the beach, a factor which became especially important after the Allies had gained control of the air and subjected the Tunisian ports to severe bombing.

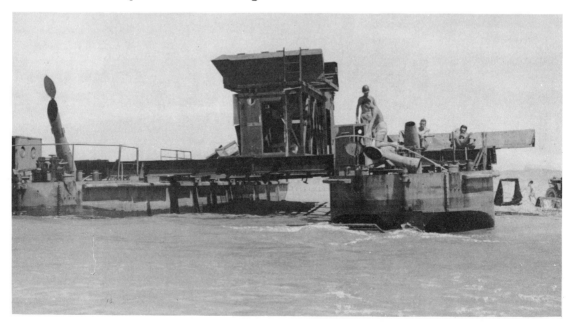

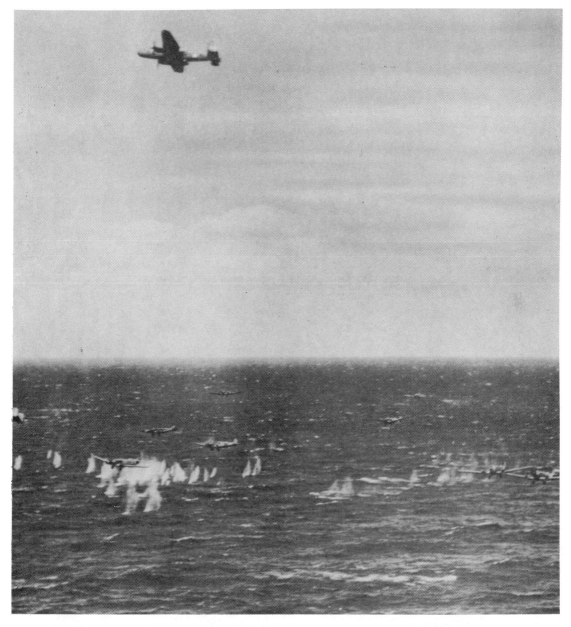

GERMAN TRANSPORT PLANES, *JU–52,* under fire from Allied aircraft. Toward the end of the Tunisia Campaign, the Germans received reinforcements by air from southern Italy and Sicily, using several hundred transports in daylight flights. The Allies gradually built up a force of planes within striking distance of the Sicilian straits and on 5 April the planned attack on the aerial ferry service started. By the 22d the enemy had lost so many planes that daylight operations were discontinued; however, some key personnel and a limited amount of emergency supplies were flown in by night. (Upper left: medium bomber B–25.)

LA GOULETTE WITH TUNIS IN DISTANCE. These two cities fell to the British on 7 May. The port of Tunis had been heavily damaged by Allied bombers, but damage in the city itself was small. La Goulette, at the entrance to the channel leading to Tunis, housed oil storage and general ship repair facilities which were put to immediate use by the Allies.

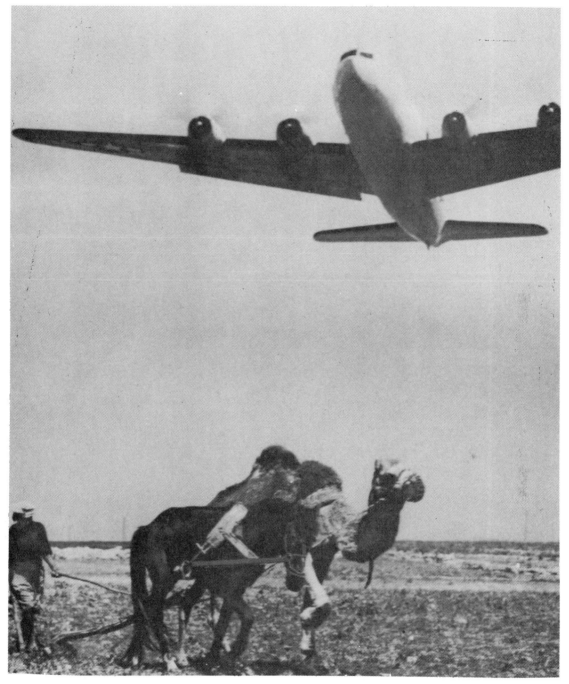

TRANSPORT TAKING OFF from a field in French Morocco for the Middle East. After the conquest of most of North Africa a string of airports became available. While the fighting in Tunisia was still going on, regular flights between the west coast of Africa, the Middle East, and India were being established. (Douglas C–54.)

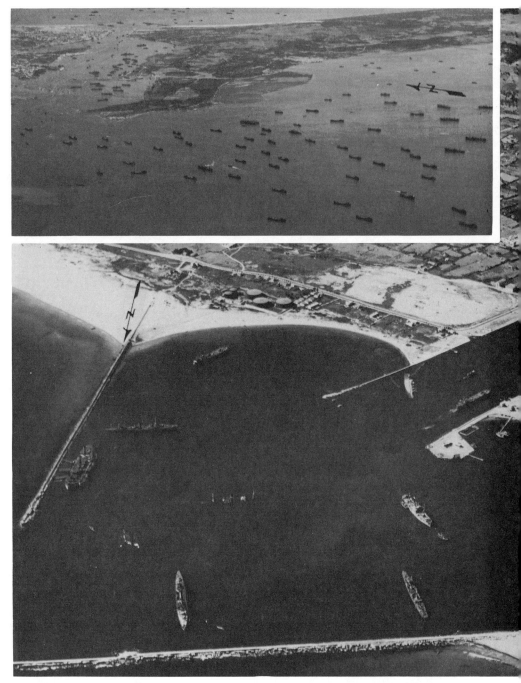

BIZERTE, THE MAIN OBJECTIVE of the French and U. S. forces of II Corps, fell on 7 May. Bizerte's harbor and the important naval repair facilities at near-by Ferryville were to play important parts in future operations in the Mediterranean. The enemy had blocked the channel to the inner harbor by sinking ships at the

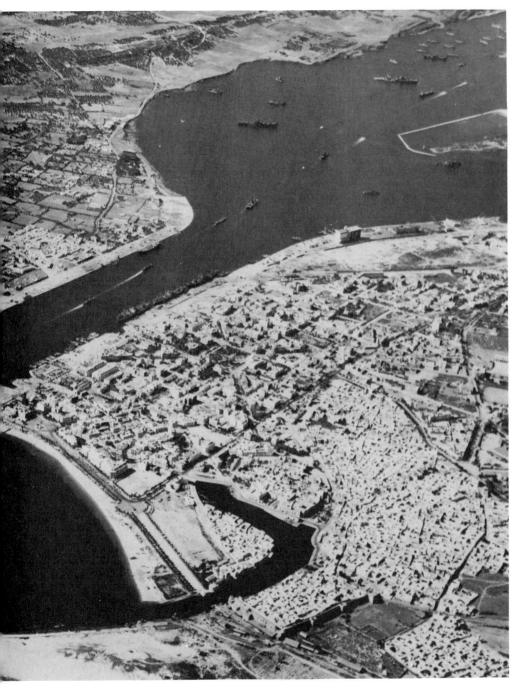

entrance and had destroyed most of the port facilities not already wrecked by Allied bombings. The port, however, became operational a few days after capture; ships and supplies were assembled here for the invasion of Sicily. Insert shows some of the ships a few days before that invasion.

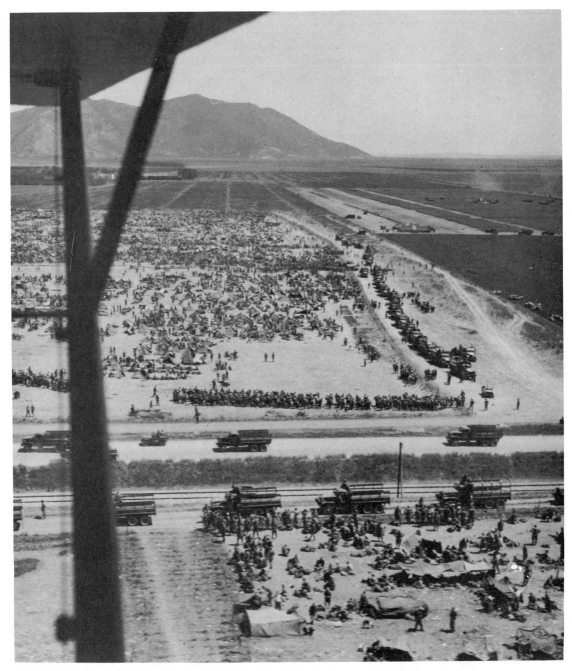

ENEMY PRISONERS NEAR MATEUR. Allied troops took 252,415 prisoners, together with large quantities of equipment and supplies, when the enemy surrendered in Tunisia on 13 May 1943. Because of Allied air and naval superiority the enemy was unable to evacuate his troops. Of those captured, the Germans were among the finest and best trained troops the enemy had and he could ill afford to lose them.

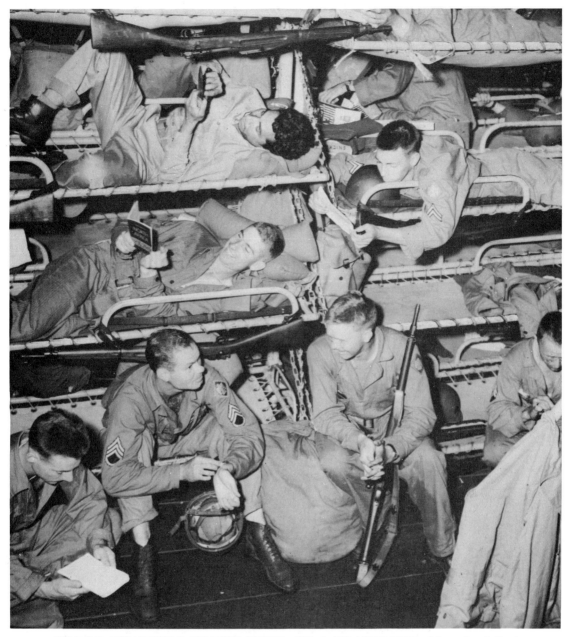

TROOP QUARTERS IN THE HOLD OF A TRANSPORT. After the fall of French Morocco and Algeria and while the fighting in Tunisia continued, men and supplies poured into the Mediterranean for use in Tunisia and in the assaults on Sicily and Italy. Bunks were placed in tiers everywhere possible in the transports. The convoy traveled blacked out, with port holes closed. Because of the overcrowded conditions, seasickness was practically universal during the first few days out of port. The men spent as much time as possible on deck.

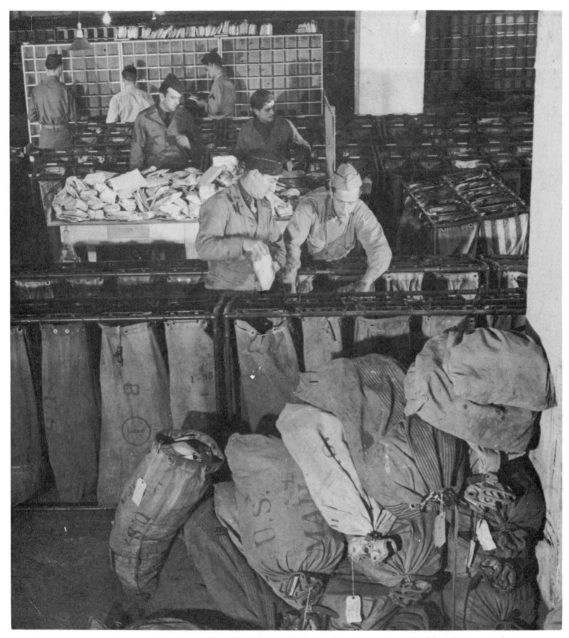

ARMY POST OFFICE AT ORAN. Mail from home was probably the most important of all morale factors and usually had first priority in spite of the fact that it occupied valuable shipping space needed for materials of war. Cargo space was saved with the V-Mail system by which letters were written on a special form, photographed on 16-mm. film at certain centers in the country of origin, then printed overseas. To encourage its use, V-Mail was sent by the fastest means available. Letters from men in the services, other than those by regular air mail, were sent free of charge.

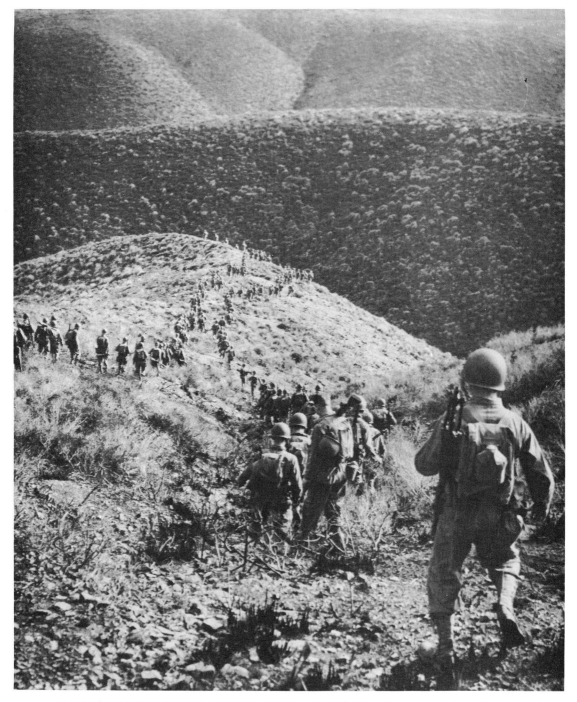

INFANTRYMEN IN TRAINING NEAR ORAN. Training centers for all arms were opened in French Morocco and Algeria soon after the end of hostilities there in November 1942.

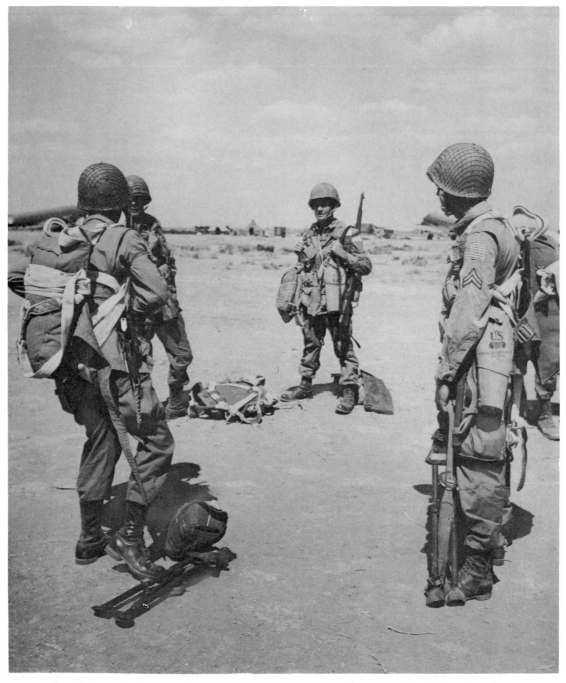

PARACHUTE TROOPS CHECKING EQUIPMENT before boarding planes for practice jump. These troops were essentially infantrymen and were armed with infantry weapons. Their boots, higher than the infantry shoes, were constructed to give ankles a maximum amount of protection when landing.

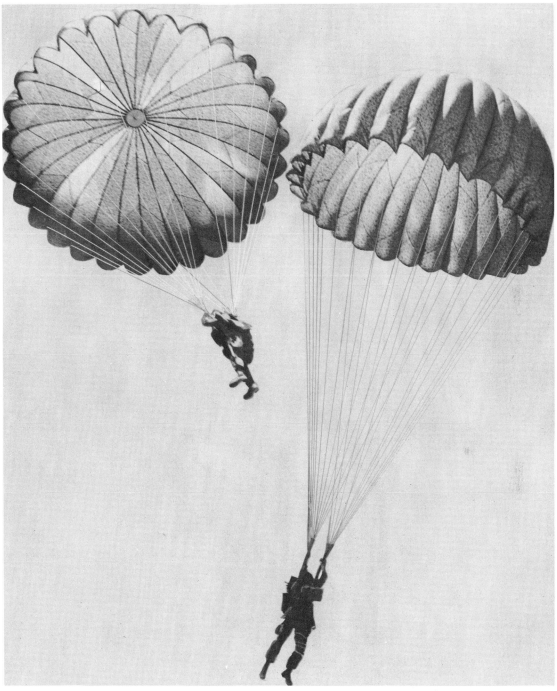

PARATROOPERS DURING TRAINING JUMP. Light artillery, food, and light vehicles were dropped separately with different colored parachutes, or came in by glider.

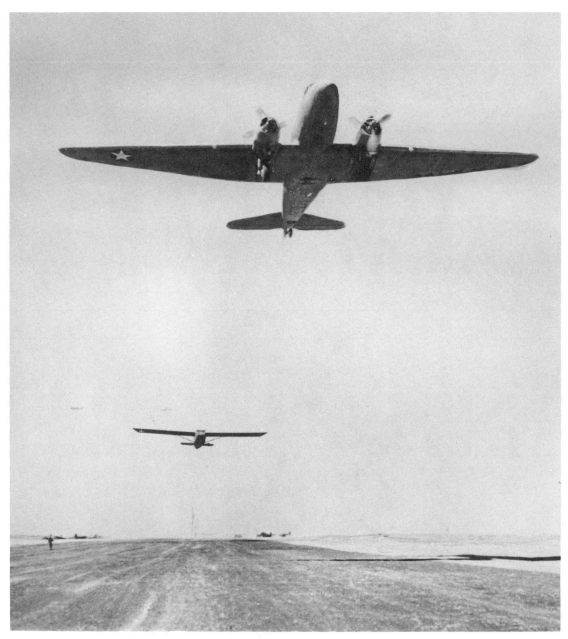

DOUGLAS C–47 TRANSPORT TOWING GLIDER. The gliders carried both men and equipment and could be landed in almost any flat pasture. The C–47 aircraft—the work horse of the war—was similar to the commercial DC–3, a standard type passenger carrier in the United States for some years prior to the war. The C–47, unarmed, was used during the war for carrying personnel and cargo of all sorts, towing gliders, dropping parachute troops, and parachuting supplies to isolated units and equipment to partisans behind enemy lines. The British called it the Dakota.

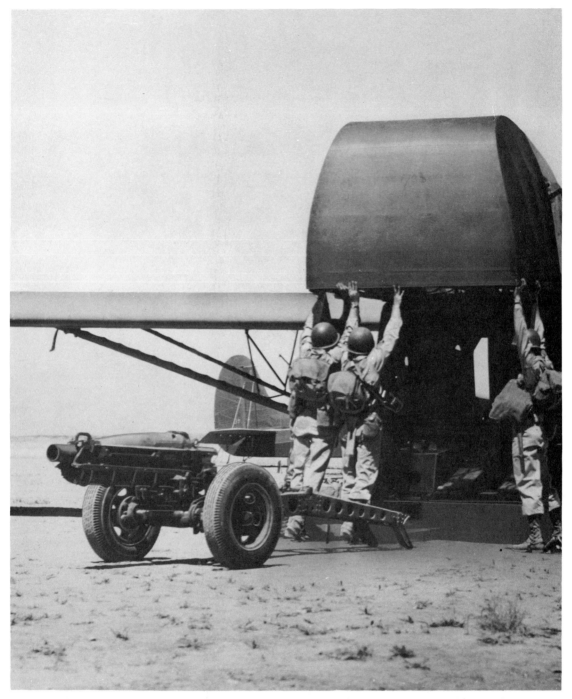

AIRBORNE TROOPS loading a 75-mm. pack howitzer into a cargo glider during training. Although this form of air transport was not used during the hostilities in northwest Africa, it was employed in subsequent operations based in North Africa.

TESTING A WATERPROOFED SHERMAN TANK on an African beach. These tanks were intended to go, during an assault, onto the beach with the infantry whenever possible. The main body of tanks would follow on LST's as soon as the beachhead had been secured. The follow-up tanks, landed from the ship via ponton piers directly to shore, were not normally waterproofed. (Sherman tank M4A1.)

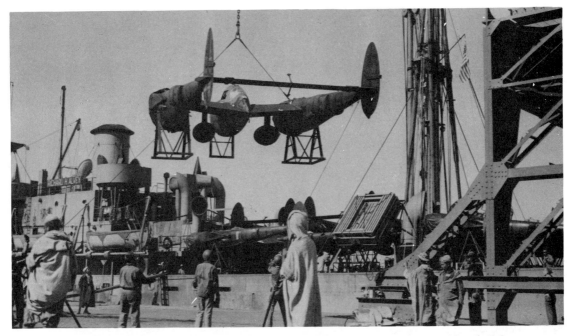

LEND-LEASE EQUIPMENT FOR THE FRENCH ARMY. Lockheed fighter plane (top) and Sherman tank (bottom). In January 1943, it was agreed that the United States would equip the French divisions formed from units then in North Africa, but comparatively little modern equipment became available for them in Tunisia until the summer of 1943. (P–38; Sherman tank M4.)

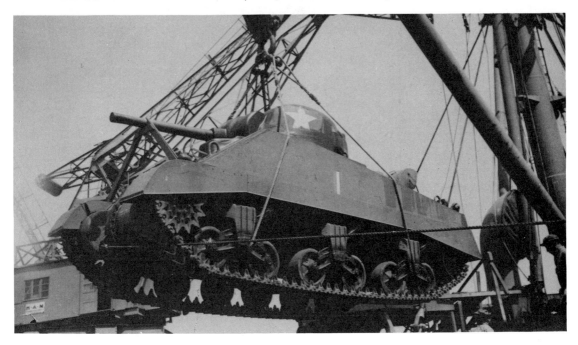

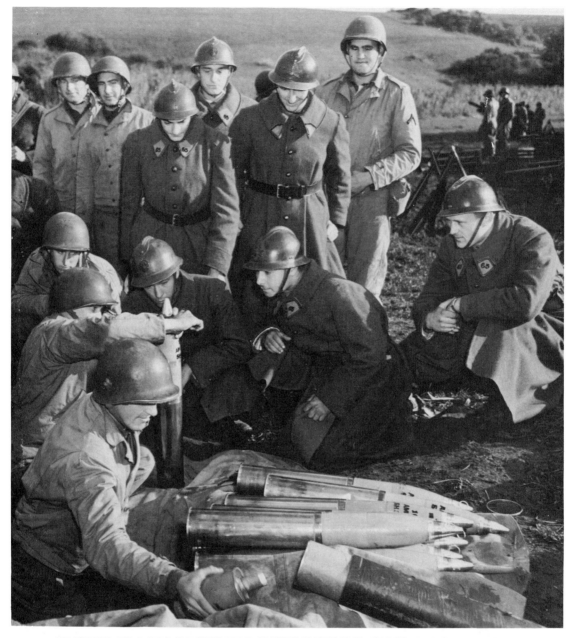

FRENCH TROOPS RECEIVING INSTRUCTIONS ON U. S. EQUIPMENT,
in this case on the 105-mm. high-explosive shell. During the summer of 1943 ship-
ments of arms and equipment for the French arrived in North African ports in
increasing volume. Training was accelerated and by the end of the year two fully
equipped French divisions were fighting side by side with the Americans and British
in Italy. As more equipment became available, additional French divisions were sent
to the front.

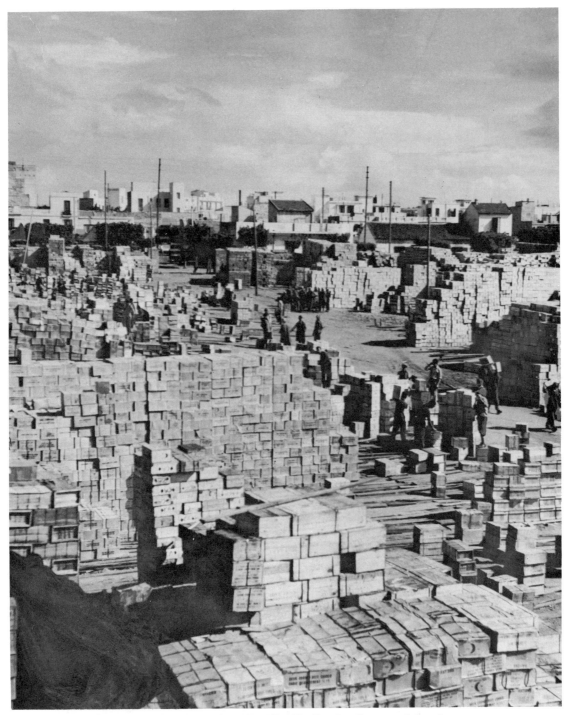

QUARTERMASTER DUMP AT ORAN. Foodstuffs, stored in the open some-times for months, suffered very little in spite of the hot African sun.

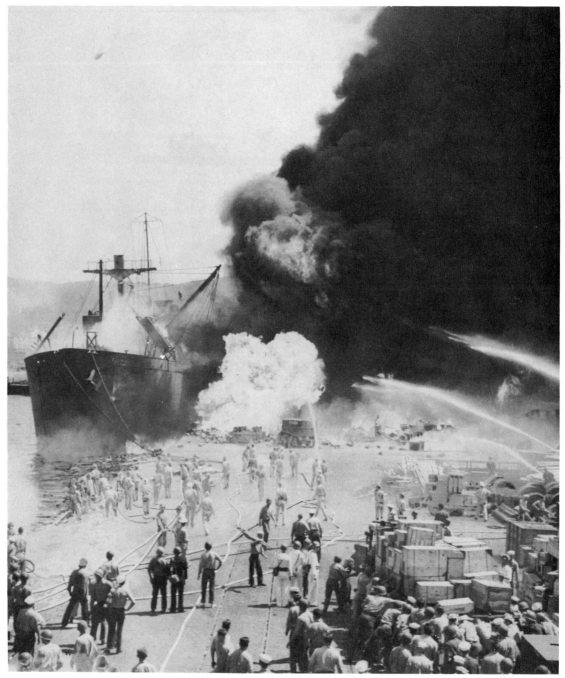

FREIGHTER BURNING IN THE HARBOR OF ALGIERS. The cause of the fire was not determined. While air raids on Algiers caused little damage to shipping and military installations, serious accidents and fires, some of which aroused suspicion of sabotage, were not infrequent.

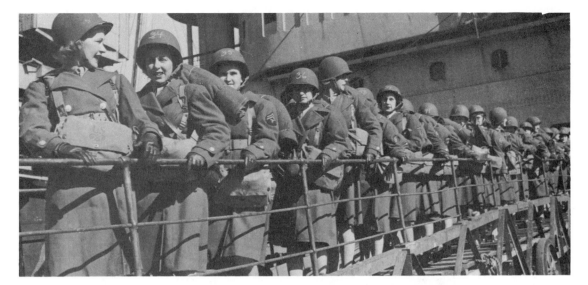

WAACS WITH FULL FIELD EQUIPMENT arriving at a North African port. The bill establishing the Women's Army Auxiliary Corps (WAAC) became effective on 14 May 1942 and on 1 July 1943 a bill changing the status of the corps from an auxiliary serving with the Army to a component of the Army, Women's Army Corps (WAC), became law. Most WAC duties in North Africa were of an administrative nature in offices of the various headquarters. Members of the Corps also worked in communications or other activities that could be handled as efficiently by women as by men.

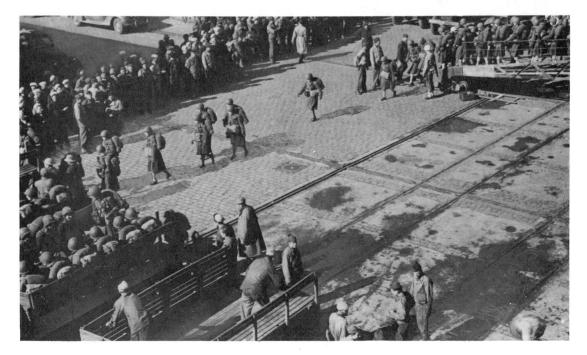

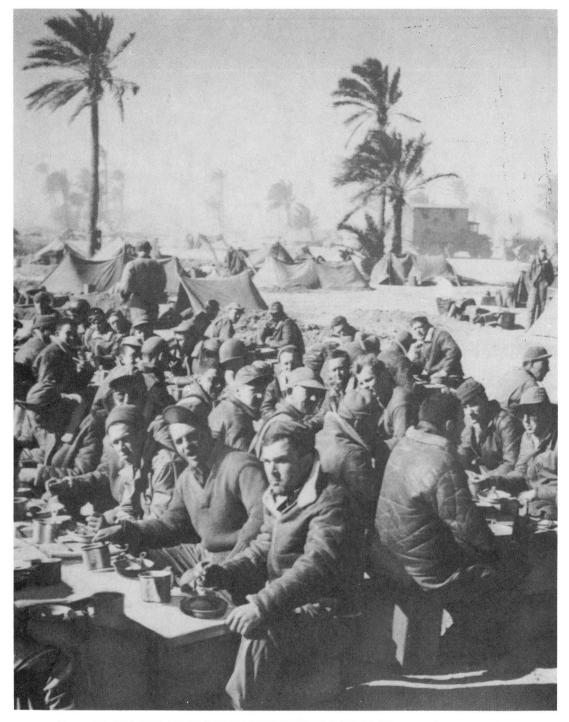

AIR FORCE MEN AT BREAKFAST IN THE DESERT. The mornings were often cold even in the summer and the men wore their heavy leather jackets.

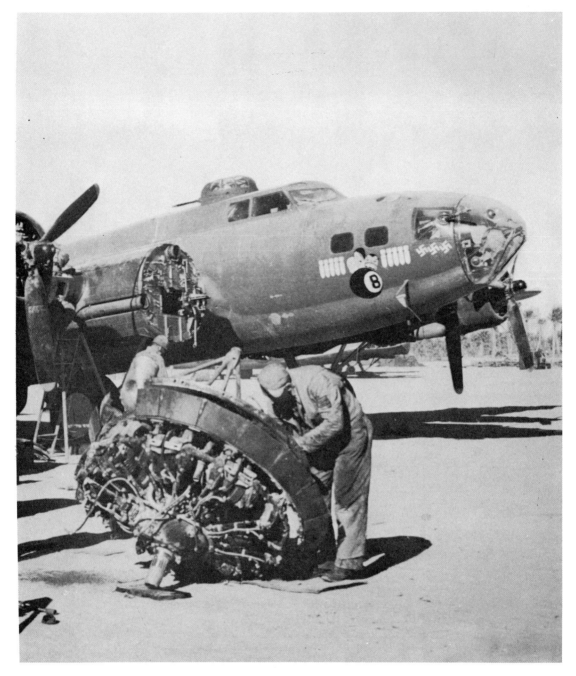

REPAIRING MOTOR OF A HEAVY BOMBER, the Boeing Flying Fortress. The sand and dust of the desert were hard on engines of all kinds. On the nose of the plane, swastikas indicate number of enemy aircraft shot down and bombs show number of bombing missions flown. (B–17.)

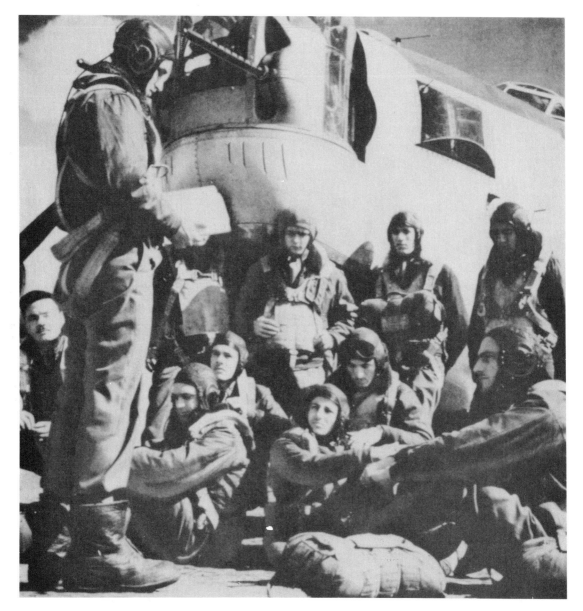

CREW OF A HEAVY BOMBER before taking off on a mission. During the first
few months after the landings, the Allied air forces were handicapped in their
operations from North African bases through lack of suitable airfields. The lack of
all-weather facilities such as hard-surfaced runways, taxiways, and hardstands was
particularly serious in the rainy winter season of 1942–43. In the area from the
Atlantic coast of Morocco to the Tunisian border, there were only four air bases with
any kind of hard-surfaced runways: Port-Lyautey, north of Casablanca; Tafaraoui,
near Oran; Maison Blanche at Algiers; and the Bône airfield on the coast near the
Tunisian border. (B–24.)

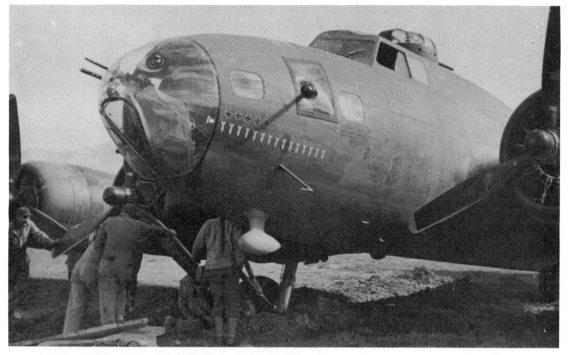

DIGGING OUT A MIRED FLYING FORTRESS from the mud of a North African bomber base.

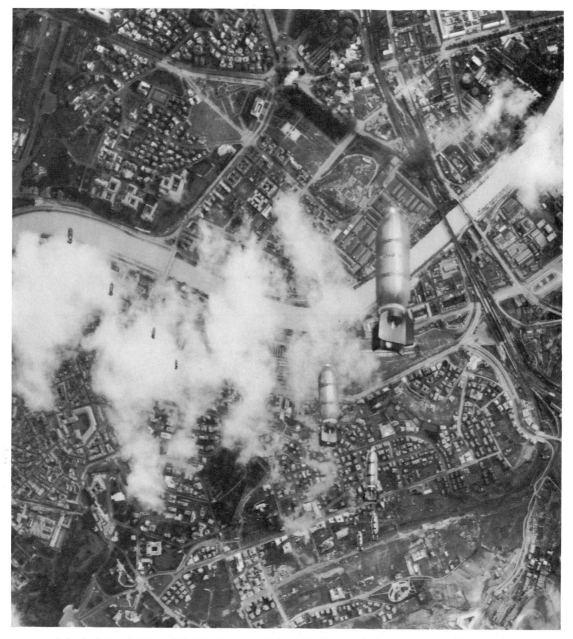

BOMBING THE RAILROAD YARDS IN ROME on 19 July 1943. Note bombs
bursting in railroad area at top of picture. More than 500 heavy and medium bombers
from bases in North Africa took part in the first bombing of Rome. The heavy bombers
concentrated on the yards in the city and suburbs while the medium bombers attacked
airfields on the outskirts. Every precaution was taken to bomb only targets of military
significance. The crews had been especially selected and carefully briefed and trained
for this mission, with the result that few bombs fell outside the target area.

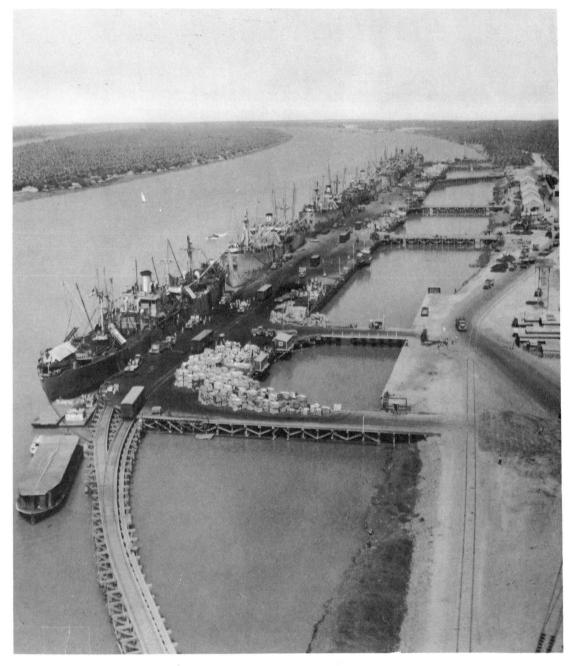

THE PORT OF KHORRAMSHAHR, one of two Iranian ports operated by the
United States, the other being Bandar Shahpur. These ports served for entry of lend-
lease supplies en route to the USSR. By the fall of 1942, ports, highways, and railroads
in Iran were sufficiently ready to handle increased traffic over the route through the
Persian Gulf. The U.S. Army also operated the lighterage port of the Cheybassi in Iraq.

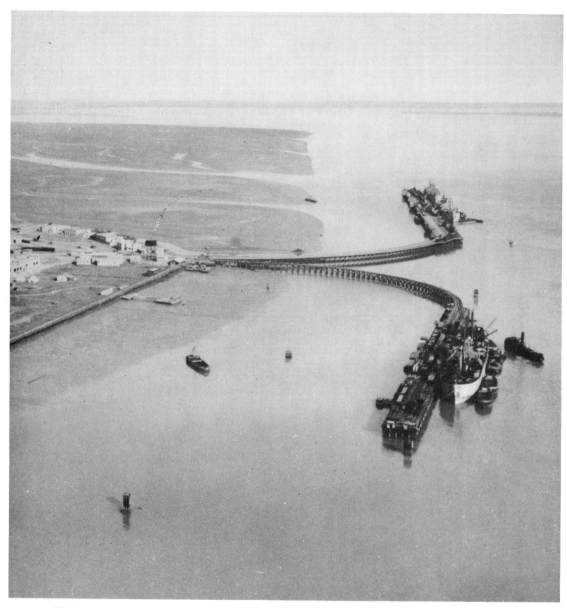

THE PORT OF BANDAR SHAHPUR on the Persian Gulf. The voyage from New York around South Africa to the Persian Gulf ports averaged 70 days. When the Mediterranean route became available in 1943, the time was shortened to 42 days. This port, built on swampy land where the river Jarrahi empties into the gulf, has a semitropical climate. Both here and at Khorramshahr much of the work was done at night, and even then the temperature was around a hundred degrees Fahrenheit from March until October. The area is subject to torrential rains in winter. Docking space at both ports was often insufficient to accommodate all ships waiting to be unloaded, which necessitated the use of lighters.

TRUCK CONVOYS WITH SUPPLIES FOR RUSSIA. From the ports on the Persian Gulf, shipments went to Kazvin and Tehran by road and rail. From these points movements were regulated by the Russians. During the entire period of active operations, from August 1942 to May 1945, more than 5,000,000 long tons of lend-lease cargo were moved through the Persian Corridor to Russia. The greatest monthly movement of freight through the corridor took place in July 1944, when approximately 282,000 long tons were delivered. The bulk of this total was moved by rail, the rest by truck and air.

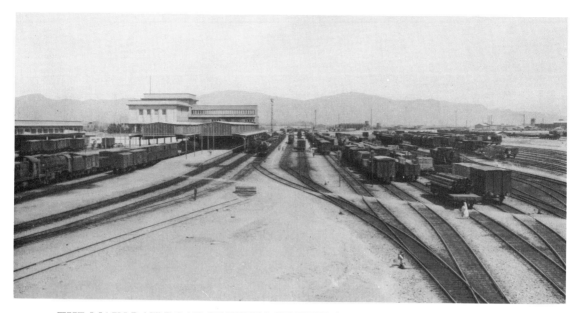

THE MAIN RAILROAD STATION AT TEHRAN (top) and freight train loaded with tanks bound for Tehran (bottom). U. S. troops from early 1943 operated the southern sector of the Iranian State Railway and the two Iranian ports. They constructed additional roads, docks, and other installations, and continued operation of aircraft and motor vehicle assembly plants. Diesel locomotives and rolling stock were brought in from the United States in large numbers.

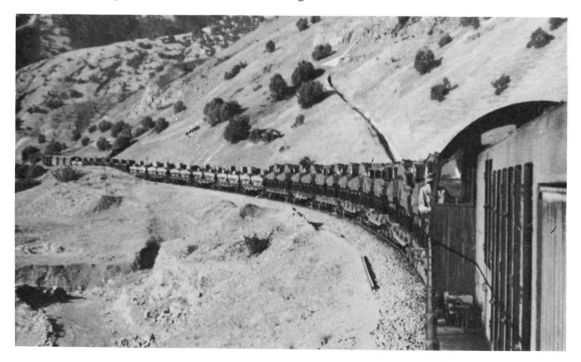

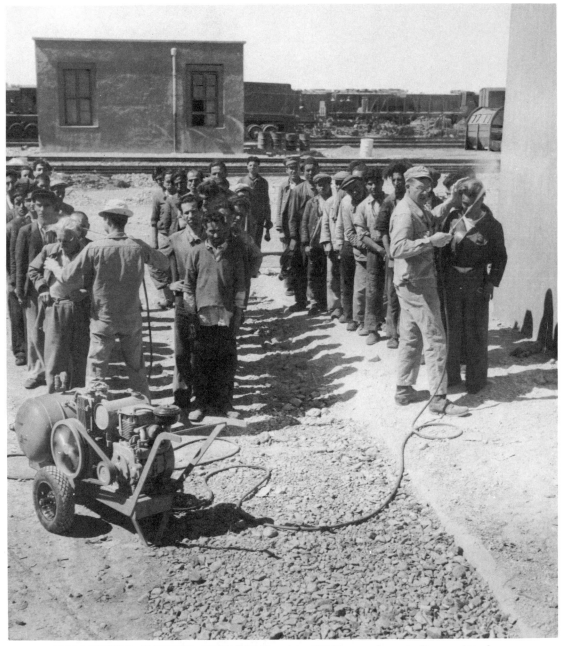

DELOUSING NATIVE WORKERS with DDT powder at Camp Atterbury, Tehran. At the peak as many as 40,000 native workers were employed by the U. S. Army, the majority as unskilled labor. American responsibility for moving supplies to the USSR led to the separation of the Persian Gulf activities of the U. S. Army Forces in the Middle East and the establishment of a separate organization called the Persian Gulf Command.

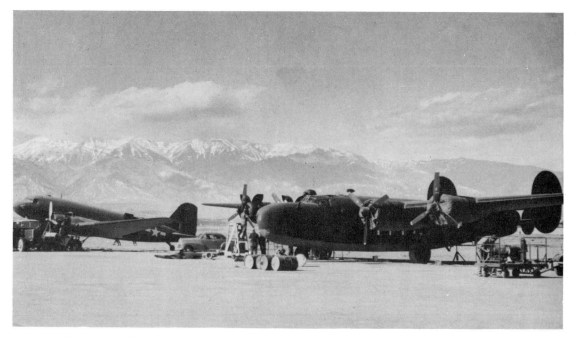

QUALEH MORGEH AIRPORT AT TEHRAN. This was jointly occupied by
U. S. and Russian air forces. Top picture shows a Douglas C–47 transport and a
B–24 bomber. Bottom picture shows a detachment of Russian soldiers marching past
U. S. transport planes.

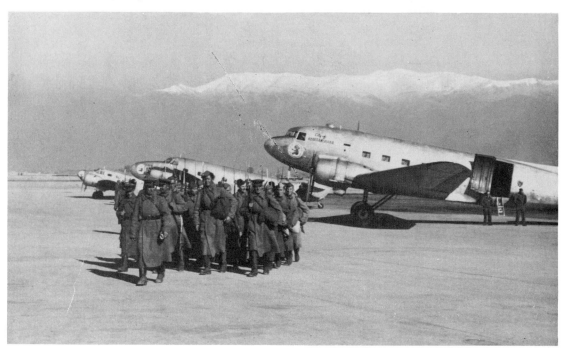

RUSSIAN PILOTS arriving at Abadan Airport, Iran. This airport, on an island in the Shatt al Arab near the head of the Persian Gulf, was the main assembly field for U. S. planes going to the Soviet Union through the Persian Corridor.

SICILY, CORSICA, AND SARDINIA

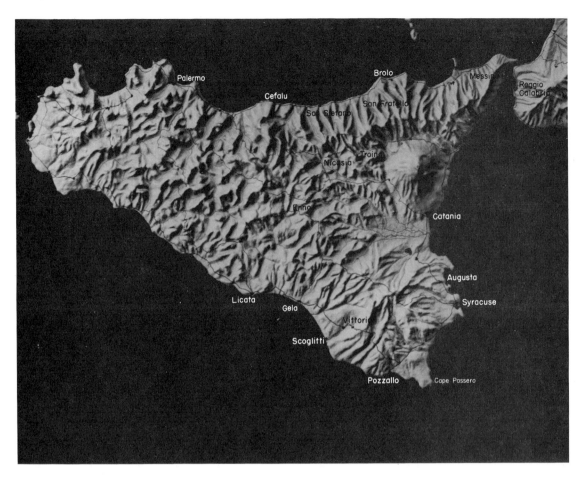

Sicily, Corsica, and Sardinia*

The decision to assault Sicily was made by the Chiefs of Staff at Casablanca in January 1943. After the conclusion of the Tunisia Campaign, plans were completed and preparations for the attack were accelerated (Operation HUSKY). The island of Pantelleria, located between North Africa and Sicily, occupied mainly by Italian troops, was bombarded by Air Forces and Navy units and fell on 11 June. Troops for the invasion were embarked from the United States, United Kingdom, Algeria, Tunisia, and the Middle East.

On the night before D Day, a high wind of near gale proportions was encountered as the convoys approached their rendezvous. Shortly after H Hour, 10 July, airborne landings, although scattered by the high wind, were to some extent successful in their effect on our beach assault. Three hours after the landing, beachheads were established from Licata to Scoglitti by the Americans and from Capo Passero to Syracuse by the British.

Despite the problem of supply during the first two days, by 12 July the Allied armies had seized the port of Syracuse and ten other Sicilian towns in addition to several airfields. By the 23d, American tanks and infantry, driving across the western end of the island, took the key port of Palermo. The enemy, in the east, lodged in rugged mountain terrain, offered stiff resistance.

On 25 July King Victor Emmanuel III had announced the resignation of Premier Benito Mussolini and his cabinet, thereby exposing the weakness of fascist Italy. Italian resistance had crumbled and in August the German army started to withdraw to the mainland across the Strait of Messina.

The British Eighth Army succeeded in taking Catania on the east coast early in August, and Messina was entered by both American and

*See Howard M. Smyth, The Sicilian Campaign and the Surrender of Italy, a volume in preparation for the series U. S. ARMY IN WORLD WAR II.

British units on the 16th. All organized resistance ceased on 17 August after thirty-nine days of fighting.

Allied Force Headquarters' plan for the occupation of Corsica and Sardinia was confirmed at the Quebec conference held in August 1943. After the withdrawal of the German forces from Sardinia, the island fell into Allied hands without a struggle. The French army, given the mission of taking Corsica, met only slight resistance from the retreating German troops in October 1943.

Air bases established on both islands provided air coverage for future operations in northern Italy and southern France.

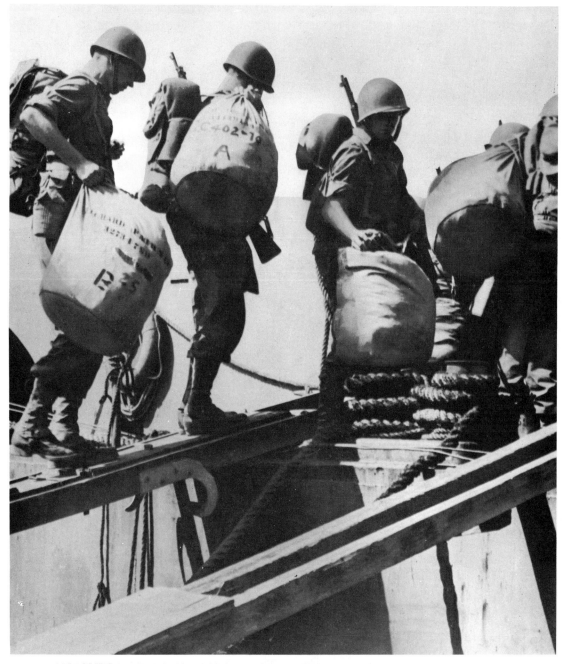

INFANTRYMEN WITH FULL EQUIPMENT boarding ship for the invasion of Sicily. Extra clothing and personal effects were carried in the unmanageable barracks bag. The only satisfactory way to carry this bag was over the shoulder, an impossible feat for a man with a pack on his back. Later the bag was redesigned; a shoulder strap and a handle on the side were added. It was then called a duffel bag.

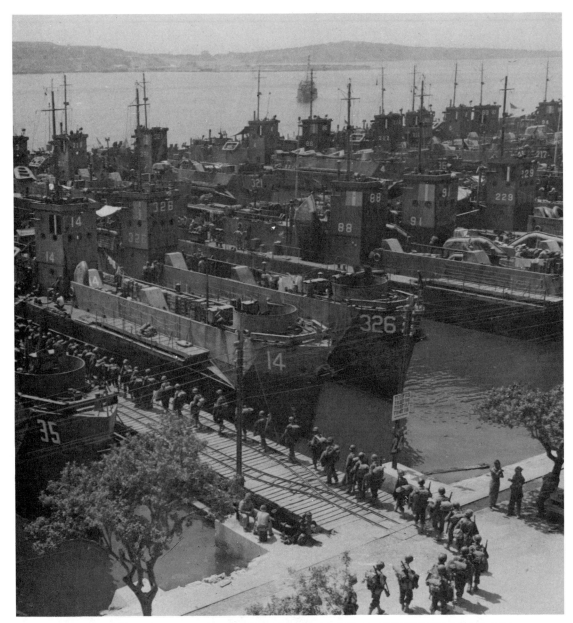

MEN MARCHING ABOARD LANDING CRAFT IN BIZERTE HARBOR. This port was one of the embarkation points for the invasion of Sicily, an island strategically important because its geographic location between Africa and Italy almost divides the Mediterranean Sea in two. In order to travel from one end of the Mediterranean to the other it was necessary to pass through the ninety-mile strait between Sicily and Tunisia. With Sicily in enemy hands, control of this strait was divided and enemy aircraft and submarines interfered with Allied shipping to the Middle East. (Landing craft, infantry, large, LCI(L).)

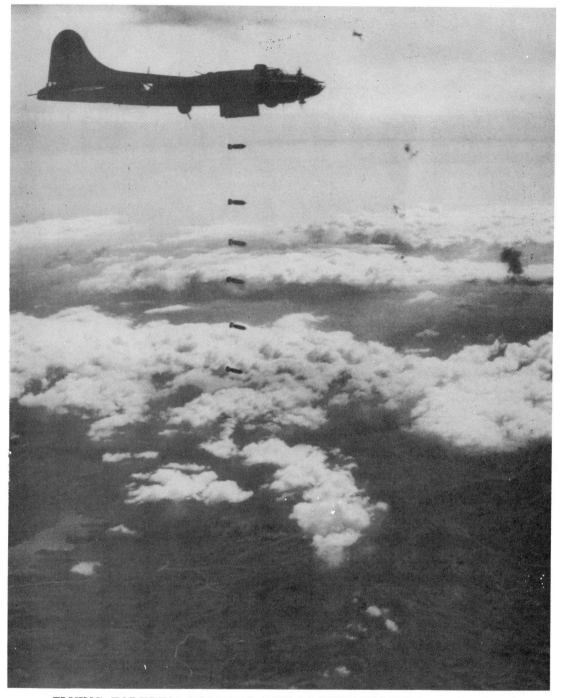

FLYING FORTRESS BOMBING ENEMY INSTALLATIONS in Sicily. For weeks prior to the invasion of the island, airfields, rail lines, and ports had been under aerial bombardment by Allied planes. Note black antiaircraft bursts.

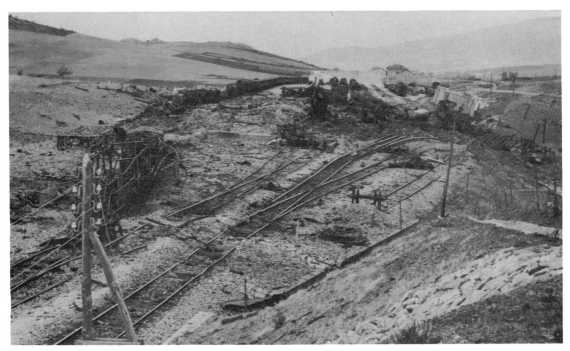

RESULT OF AERIAL BOMBARDMENT ON NAPOLA RAILROAD YARD, near Trapani in western Sicily. By the time of invasion the railroad net on the island was crippled and remained so throughout the campaign.

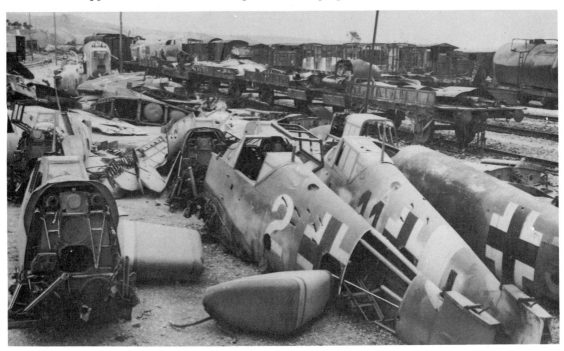

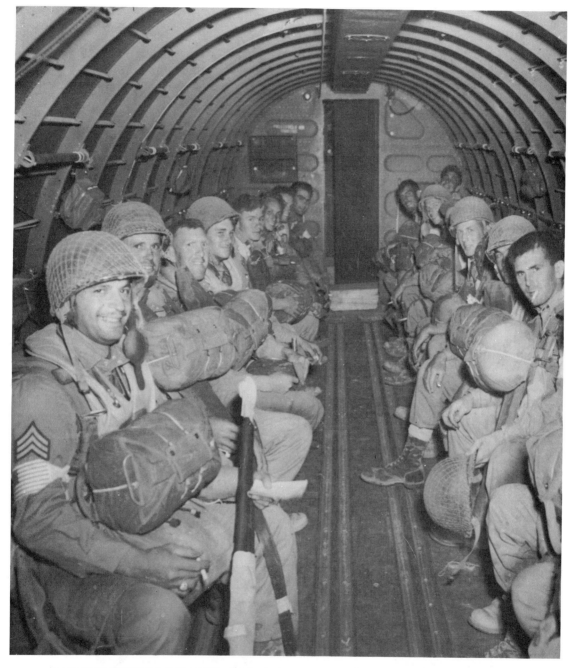

PARATROOPERS HEADED FOR SICILY. On 9 July 1943 U. S. paratroopers boarded their transports at Kairouan, Tunisia. They were scheduled to land at 2330 on that day, but a forty-mile wind blew the planes from their course, and parachutists were strewn over a large part of southeastern Sicily, but nevertheless aided in retarding the German counterattack against the beachheads. (Douglas C–47.)

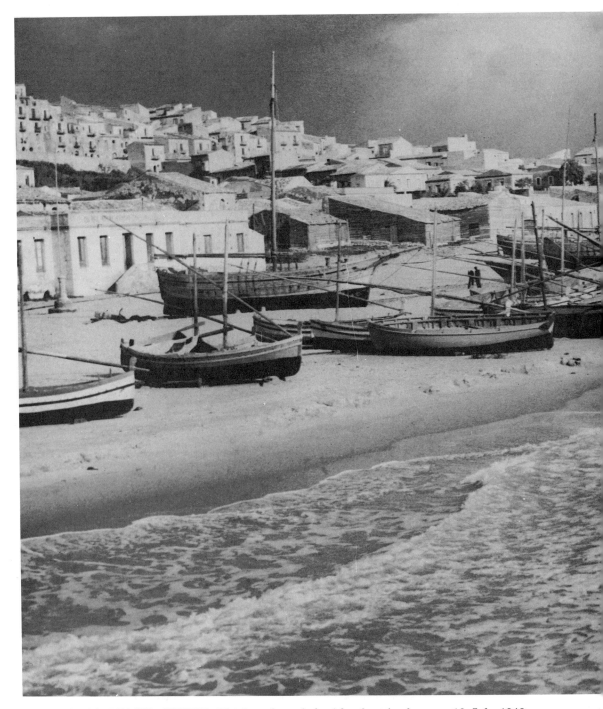

GELA BEACH, SICILY. The invasion of the island took place on 10 July 1943. Gela was the center of the American invasion area which extended from Licata on the west to Scoglitti on the east. The British Army landed in the region between

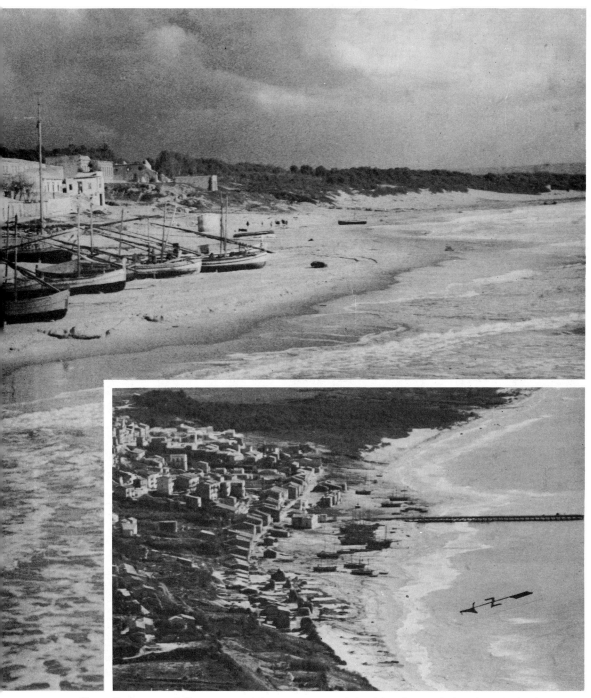

Capo Passero and Syracuse on the east coast of the island. Beach landings in both areas were preceded by airborne assaults. By sunrise, three hours after the first landings, the beaches were under control.

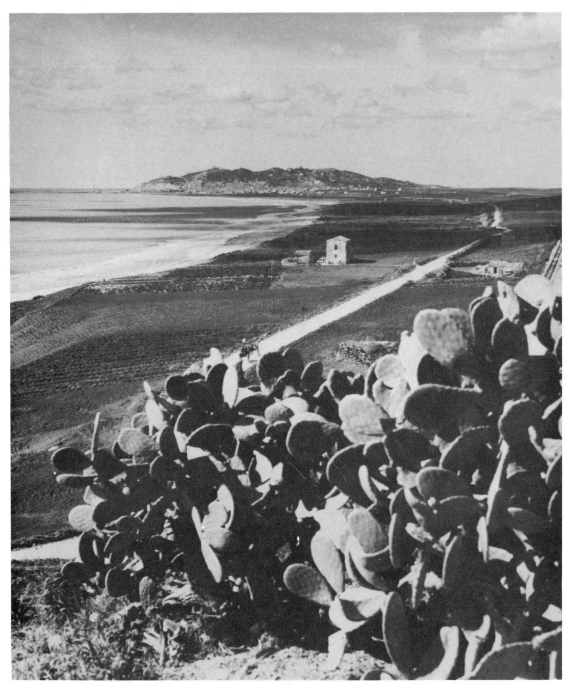

LICATA BEACHES, LOOKING WESTWARD ALONG THE COAST. The highway in the foreground is the main coastal road. This was the western portion of the U. S. assault area and Licata, located at the foot of the hill in the distance, was occupied by 1130 on D Day.

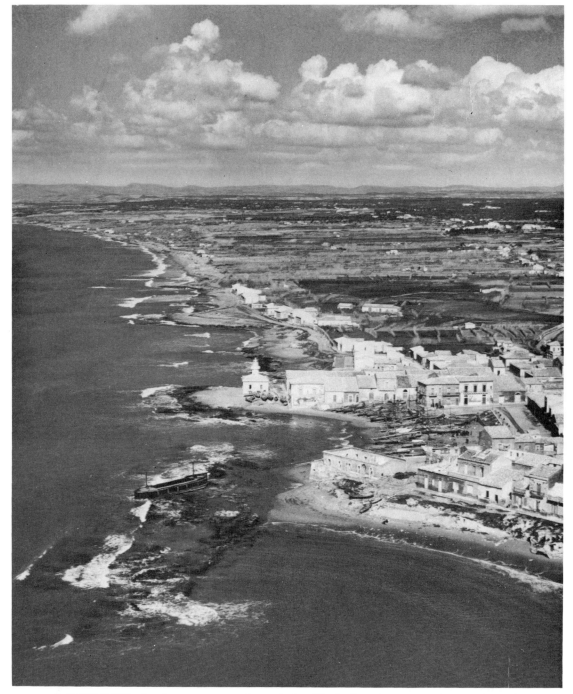

SCOGLITTI, in the eastern section of the U. S. invasion area. Troops landed here against little opposition and occupied the important town of Vittoria, a few miles inland, on D Day.

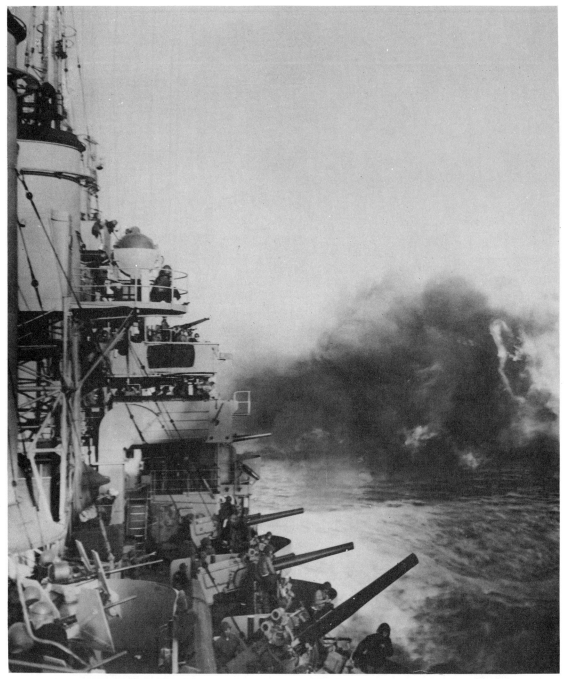

AN AMERICAN CRUISER SHELLING DEFENSES in the Gela beach area during the early morning of D Day. The naval bombardment, which started at 0345, silenced the few coastal batteries that protected the beaches. Large-scale enemy resistance on the beaches did not materialize during the landings.

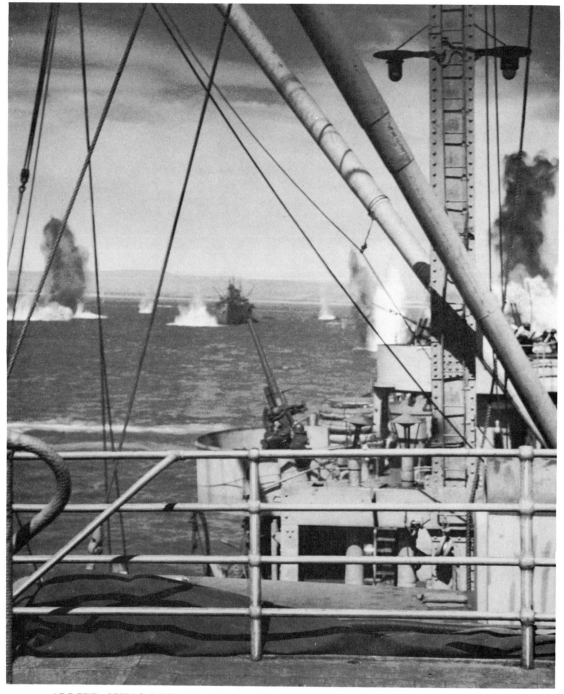

ALLIED SHIPS UNDER AERIAL BOMBARDMENT. At daybreak on D Day enemy air forces launched a series of bombing and strafing attacks on the ships offshore and on the troops along the beaches.

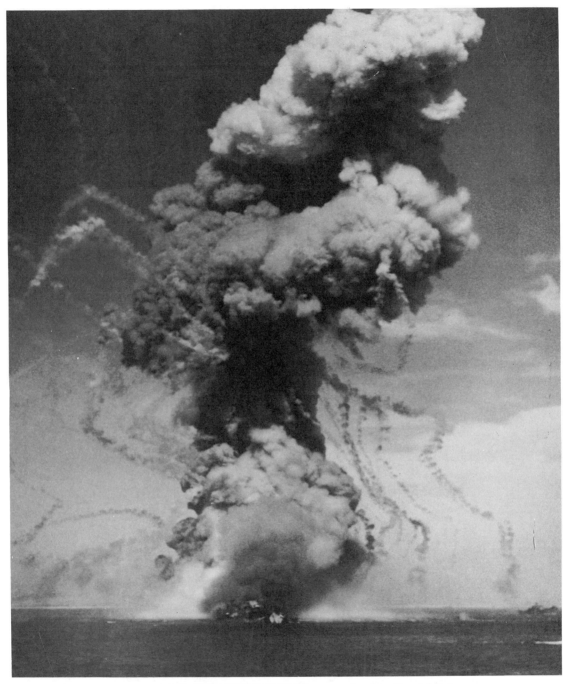

U. S. AMMUNITION SHIP EXPLODING as result of a direct hit by an enemy bomb during the late afternoon of 11 July 1943. The ship burned throughout the night, furnishing a brilliant beacon for enemy aircraft. The Allies made several attempts to sink the ship, but the water was too shallow.

LOWERING LANDING CRAFT OFF GELA BEACH. Troops boarded the craft after it was afloat. (Foreground, landing craft, vehicle-personnel, LCVP; background, LCM.)

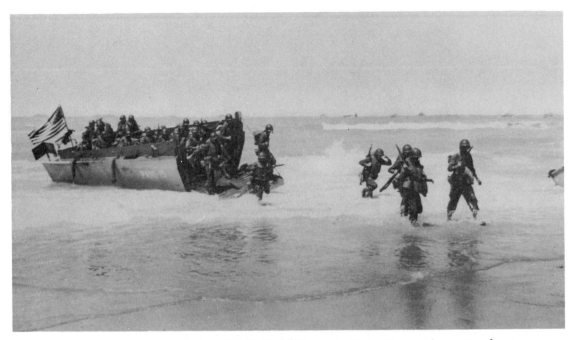

INFANTRY LANDING ON GELA BEACH (top). Unloading equipment and supplies from LCVP's (bottom); in the background are two LST's. The sea ran so high during the morning of the landings that many craft were washed up on the beach and could not be refloated in time for turn-around to mother ships. (LCVP in top picture.)

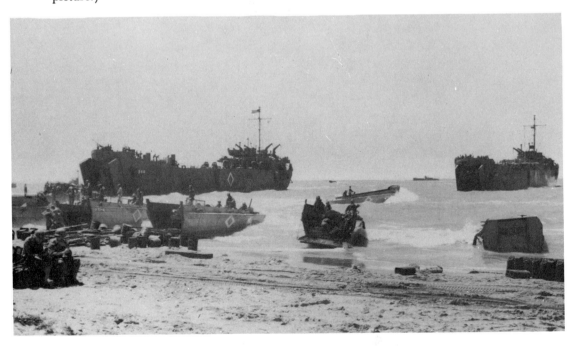

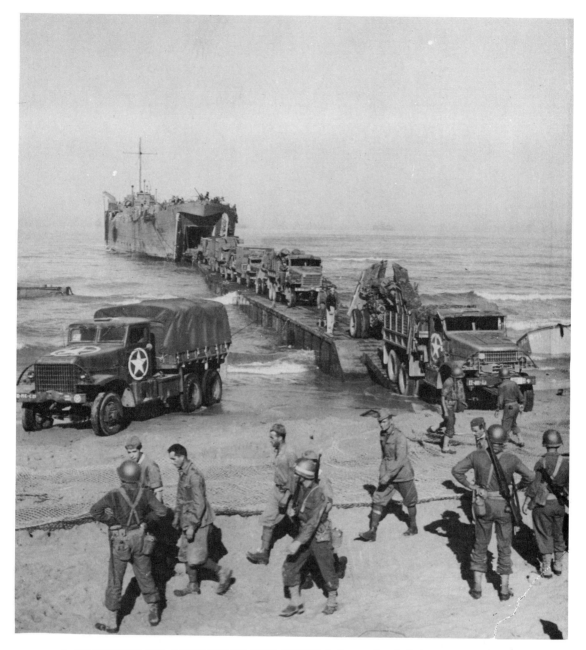

A BATTERY OF ANTIAIRCRAFT GUNS being unloaded from an LST, the largest type landing craft used during the operation. The prototype of the landing ship, tank, was built by the British and used in the invasion of North Africa. The LST shown is a seagoing ship. Its payload was from 1,600 to 1,900 tons of which 400 tons were deck-loaded. The ship could carry on each side sectional ponton ramps for inaccessible landings (in use above). The first three vehicles are 6-ton 6 x 6 prime mover trucks. (90-mm. guns.)

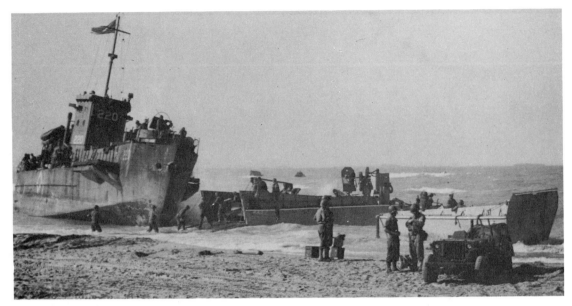

LANDING CRAFT ON BEACH. Top picture from left to right: LCI, LCM, and LCVP; on beach is a ¼-ton 4 x 4 truck, jeep. Bottom picture: in middle distance is LST, with bow doors open, ramp down, and unloading onto a sectional ponton ramp; in the foreground are two LCT's. (The LCI(L) (1–350) was an infantry carrier with side ramps which could be lowered for unloading directly on the beach. It carried a crew of 3 officers and 21 men.)

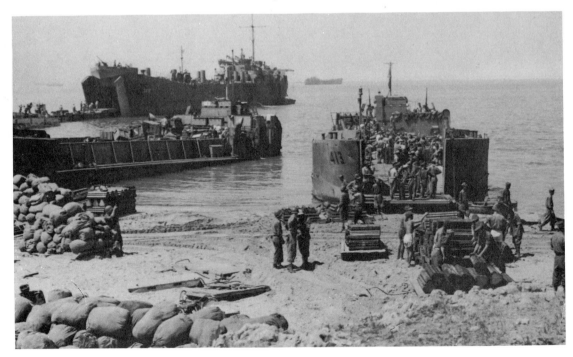

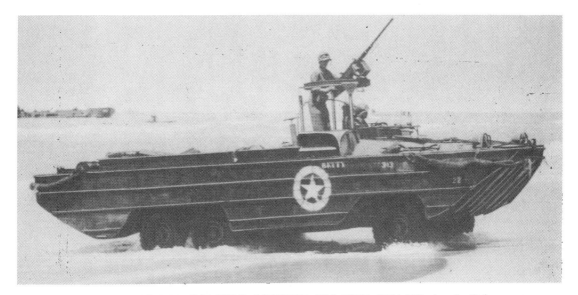

A LOADED DUKW COMING ASHORE ON THE BEACH (top). Prisoners loaded in a DUKW waiting to be evacuated (bottom). This amphibian truck, the DUKW, was one of the planned surprises of the operation. Until ports were captured and prepared for use, this means of moving all types of fighting equipment from ship to shore helped to solve a very pressing problem. (The term DUKW is the manufacturer's (GMC) code serial number which has no meaning. The resemblance to the word *duck* and the purpose for which this vehicle was used quickly brought about the common name "duck.")

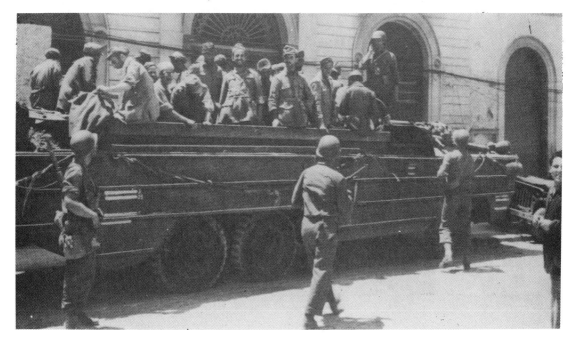

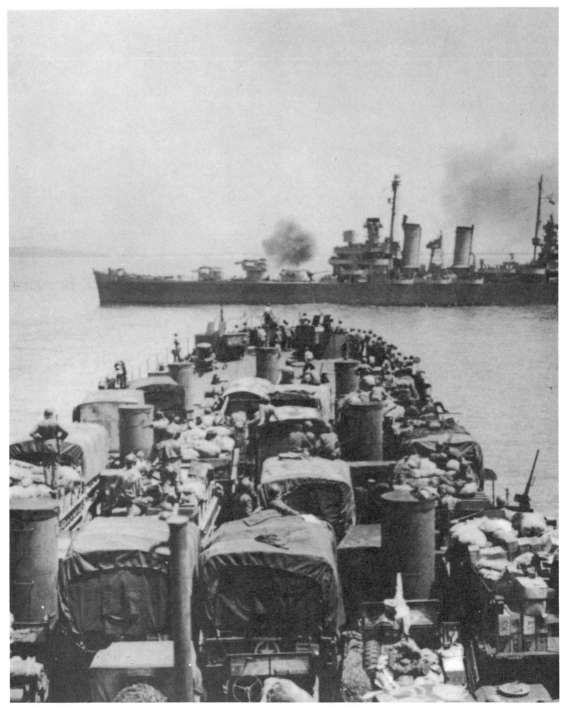

AN LST DECK-LOADED WITH MEN AND EQUIPMENT off Gela awaiting signal to approach the beach, while a U. S. cruiser fires on an enemy strong point.

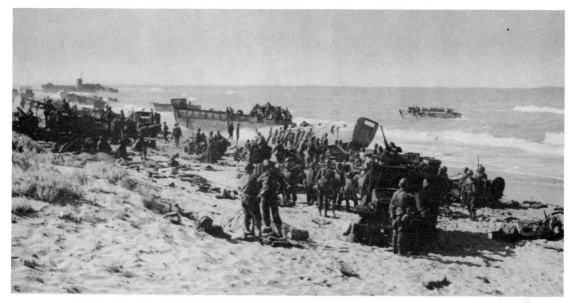

TROOPS ON THE BEACH. During the landing (top) and while troops were moving inland (bottom), the beaches were strafed sporadically. At one time, during the German tank-supported counterattack on D plus 1 in the Gela area, it looked as if the U. S. forces might be pushed back into the sea. (Top picture, left to right, center of beach, LCV, LCVP; offshore, LCVP. Bottom, a truck towing a 105-mm. howitzer is pulled through the sand by a diesel tractor with angledozer.)

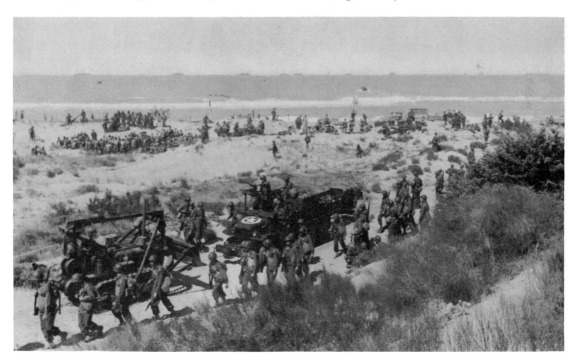

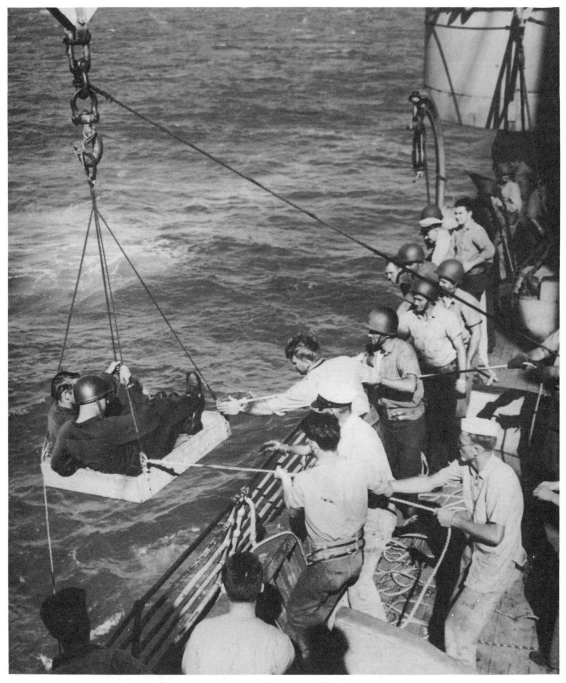

WOUNDED ARRIVING ON BOARD A TRANSPORT. During the first days of the invasion the seriously wounded were brought back to transports equipped with surgical and medical facilities. These ships would then deliver the wounded to base hospitals in Africa.

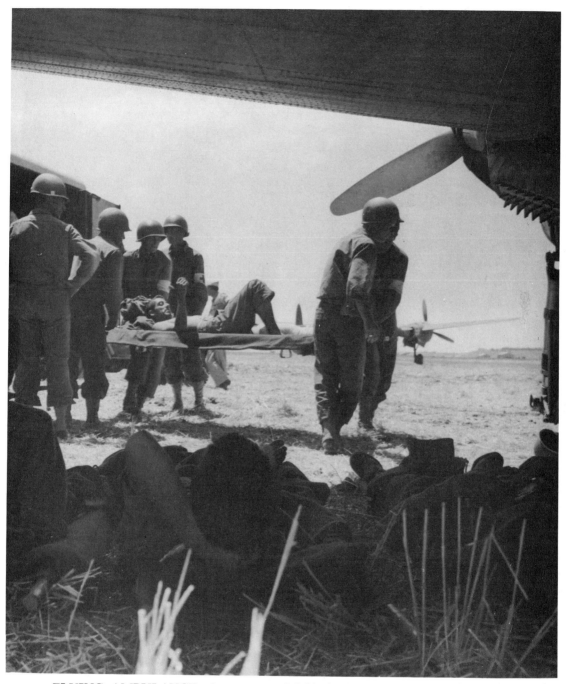

FLYING AMBULANCE. As soon as airfields had been captured many of the U. S. wounded were evacuated by planes to hospitals in North Africa. The Douglas C–47 transport was generally used for this purpose. Medical personnel accompanied wounded.

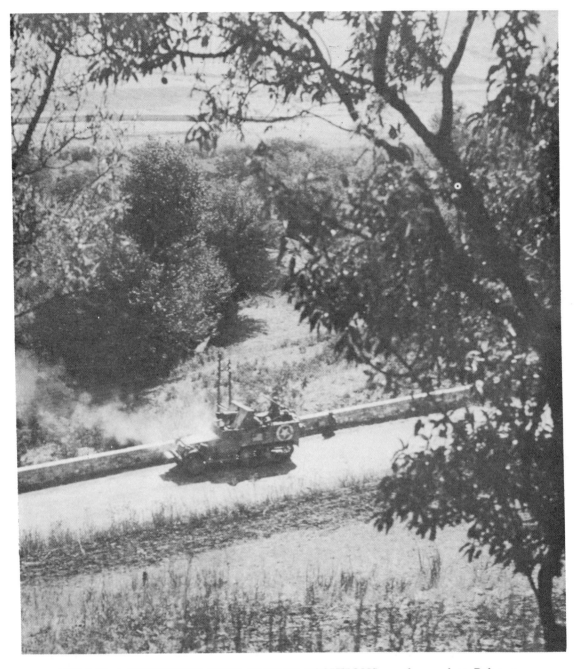

FIRING A HOWITZER INTO ENEMY POSITIONS on the road to Palermo. After securing the beaches the U. S. forces drove to the west and north and began the advance on Messina along the north coast road. Palermo, one of the most important ports in Sicily, fell to U. S. forces on 22 July 1943. (75-mm. howitzer motor carriage T30 with a .50-caliber antiaircraft gun mounted in rear.)

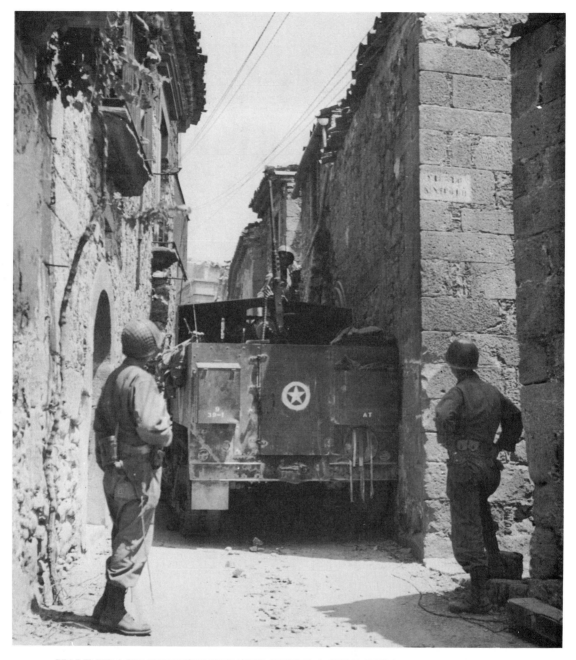

HALF-TRACK DETOURING THROUGH A SIDE STREET. When the enemy retreated through the Sicilian villages he would often blow up buildings on both sides of the main street, thus blocking the passage for vehicles. If he had time he would also mine and booby-trap the road and ruins. (The 75-mm. gun motor carriage M3 was the first standardized American self-propelled antitank weapon used in World War II.)

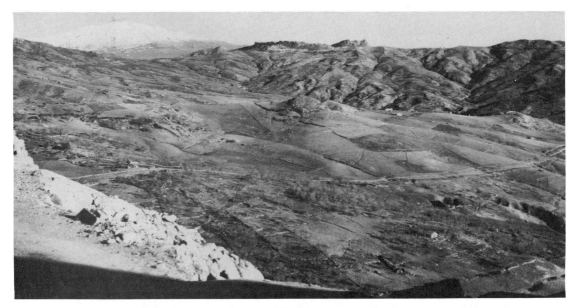

TROINA. View from the northwest with Mt. Etna in the background. The town is located on top and around the base of the hill in the center of horizon line (top). View from Troina toward the northwest showing Highway 120 winding over the hills to Cerami (upper left corner) (bottom). Troina lies at the junction of Highway 120 and the road to Adrano and Paterno. The U. S. Seventh Army took Troina on 6 August after some of the fiercest fighting of the campaign.

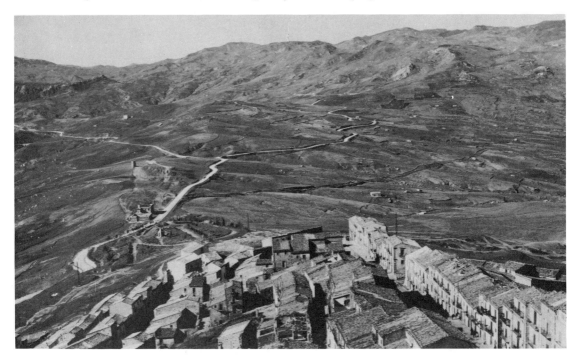

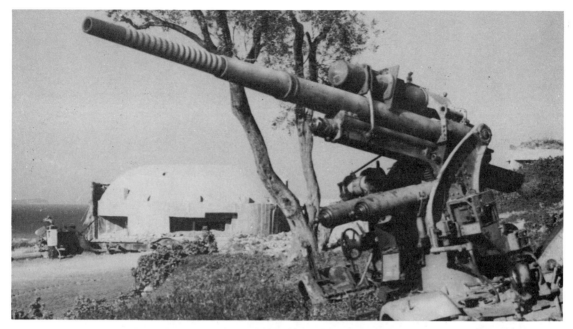

ENEMY ARTILLERY. At top is the famous German 88-mm. gun. The pillbox in the background was sited to fire both toward the sea and along the road. The coast of the island was ringed with pillboxes, some of which had not been completed at the time of the invasion. The self-propelled gun (bottom) of Italian manufacture is a 90-mm. cannon. It was used in North Africa as well as in Sicily. (Top, German 8.8-cm. *Flak 18* with single-piece barrel; bottom, *90/53 Ansaldo* self-propelled (SP) gun on redesigned *M13/40 Ansaldo* chassis.)

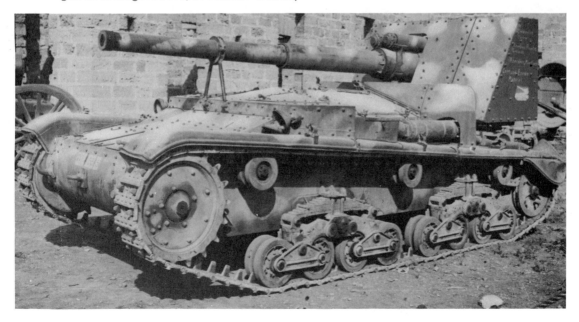

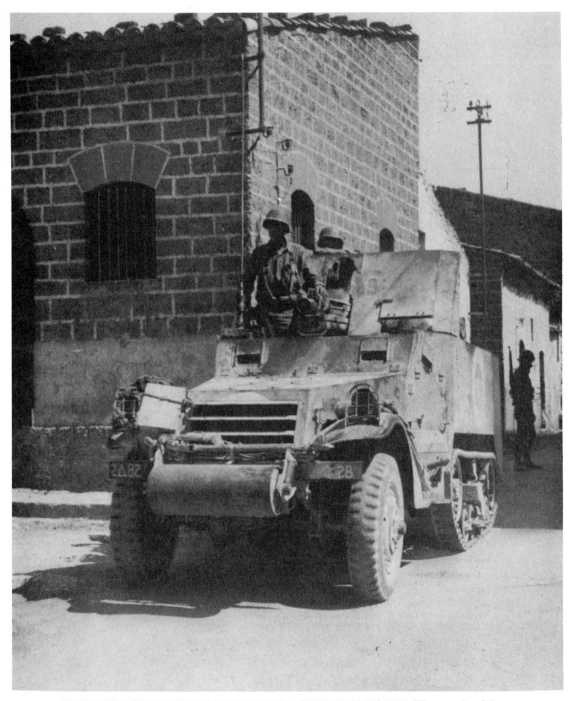

HALF-TRACK MOVING THROUGH A SICILIAN TOWN. The gun is a 75-mm. howitzer M1A1 used generally as an infantry support weapon. (75-mm. howitzer motor carriage T30.)

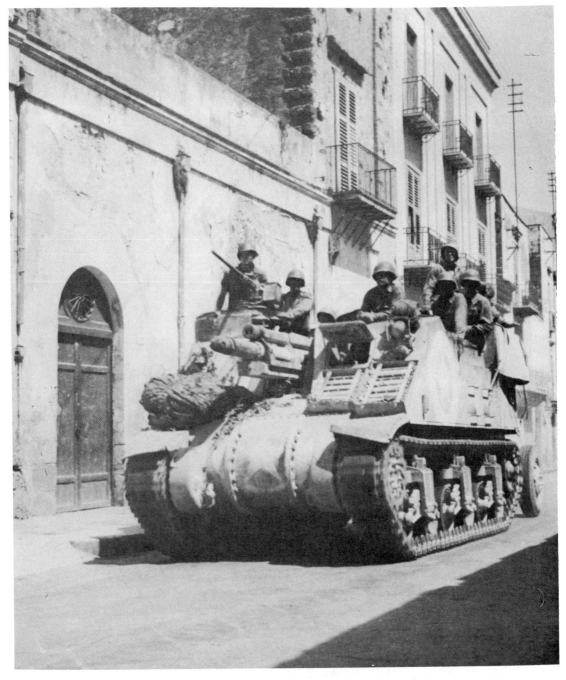

SELF-PROPELLED HOWITZER. This is the M7 howitzer motor carriage mounting a 105-mm. howitzer which was used for high angle as well as direct fire. The .50-caliber machine gun is mounted in a raised pulpit-like structure which gave the vehicle the nickname Priest. (Mounted on M3 tank chassis.)

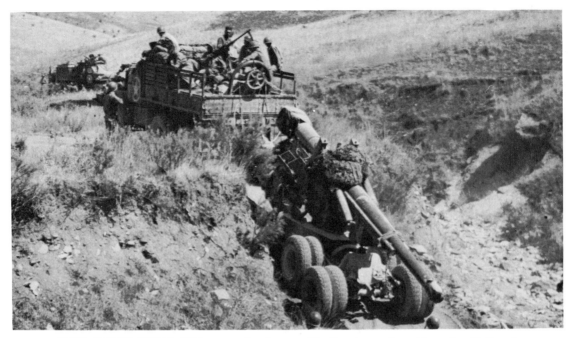

THE LONG TOM. This was the largest U. S. piece of artillery in Sicily. A 7½-ton 6 x 6 prime mover truck towing a gun into position (top). Firing from a camouflaged position in an orchard (bottom). (155-mm. gun with standard carriage.)

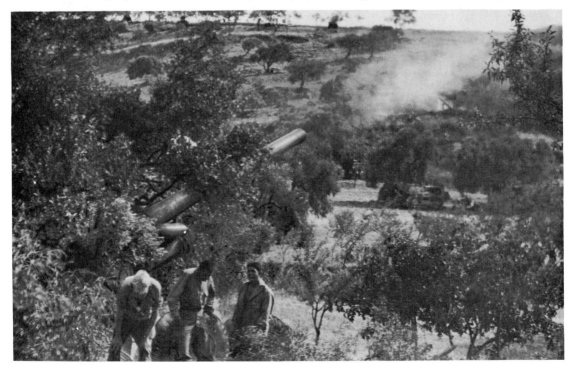

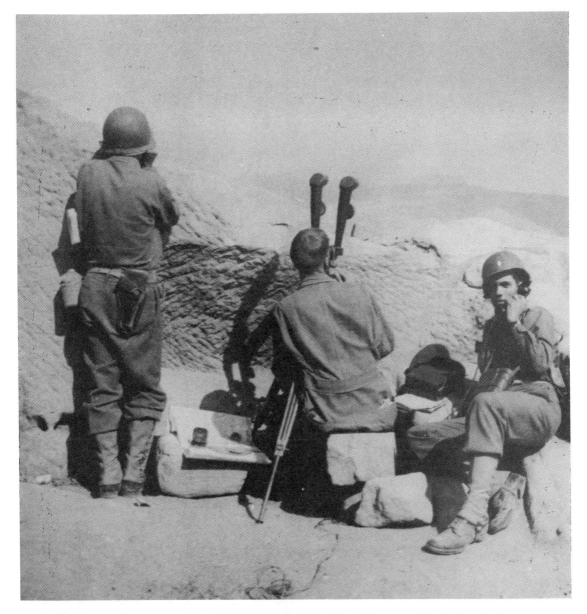

OBSERVING FIRE ON SICILIAN TOWN. The officer at right is in telephone communication with the artillery command post. The man in the center is using a battery commander's telescope (BC scope). U. S. field glasses and artillery sights of all kinds were greatly improved by the end of the Tunisian fight. Fine sand managed to work its way into the moving parts of optical equipment, obscuring the image and interfering with the mechanical operation. Moisture condensed on the inside of the lens elements and, combined with dust, cut down the optical effectiveness. Corrections were made by sealing the instruments wherever possible and by placing a moisture-absorbing chemical between the elements.

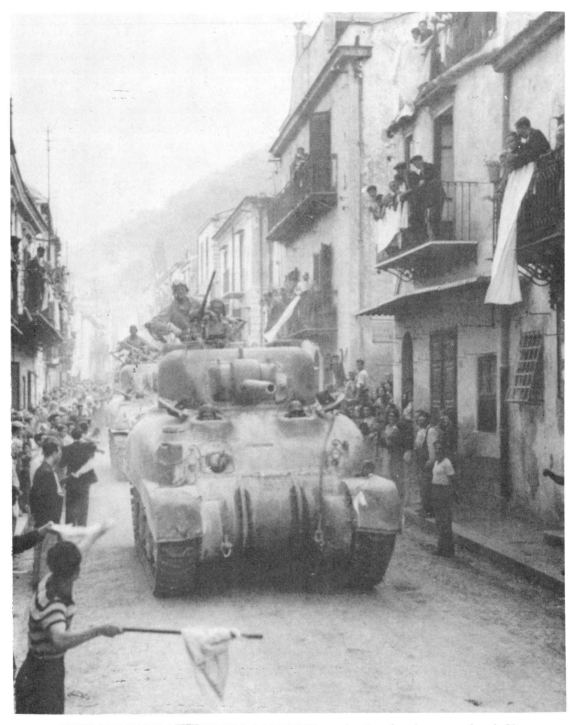

SHERMAN TANKS ENTERING PALERMO on the day the city surrendered, 22 July 1943.

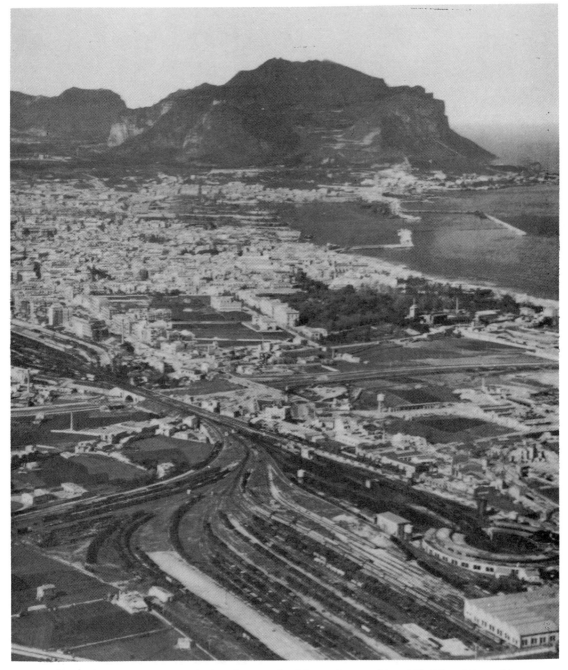

THE CITY OF PALERMO. The port had been damaged by Allied bombing raids, and the Germans before withdrawing had demolished some of the installations. After the arrival of U. S. troops the port was quickly made serviceable and was used as a supply base for troops advancing from here eastward along the coast toward Messina. It was later used as one of the embarkation ports for the invasion of Italy.

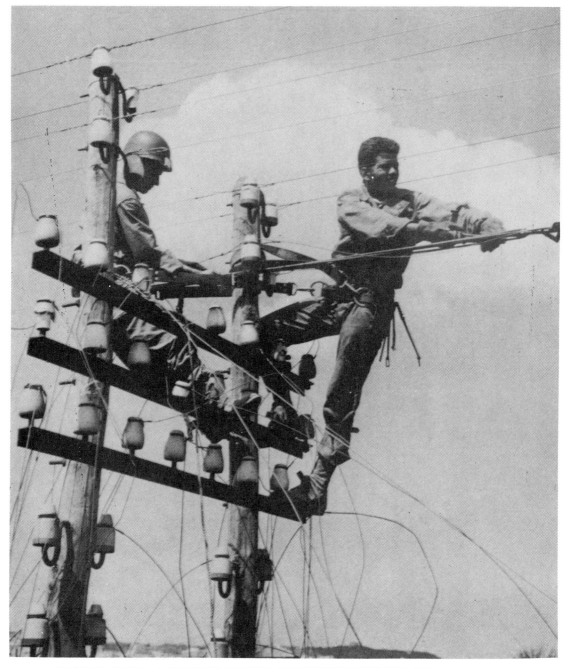

SIGNAL CORPS MEN REPAIRING COMMUNICATIONS LINES. Maintaining communications and other public utilities behind the lines were problems that fell within the scope of Allied Military Government. In Sicily the U. S. Army was called upon to furnish personnel and supplies, though native labor and materials were used whenever possible.

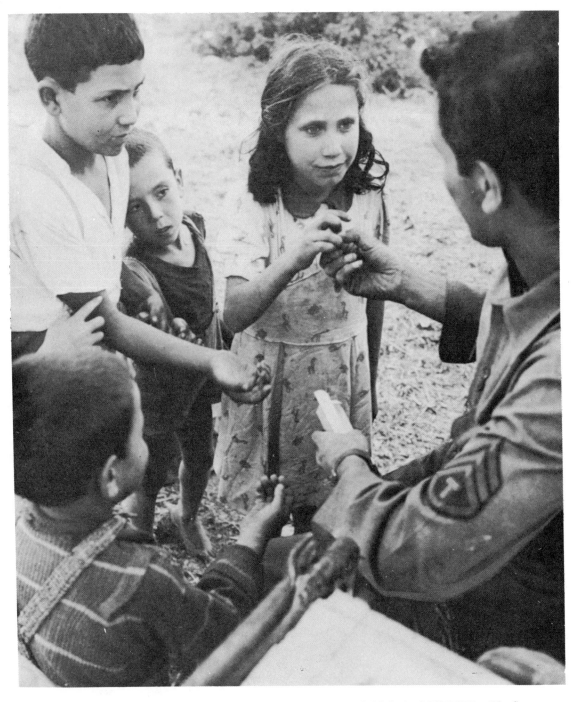

SICILIAN CHILDREN RECEIVING CANDY FROM A SOLDIER. U. S. soldiers were universally popular with children of all classes. The individual soldier gave a good portion of his ration of sweets and chewing gum to native children.

SCENE FROM THE NORTHERN COAST OF SICILY, looking toward the west. At left is the San Fratello Ridge; at right is the village of Acquedolci. The fight for the San Fratello Ridge was unusually severe. Highway 113, the main axis of advance

along the north coast from Palermo to Messina, follows the shore here. The enemy would blow the bridges, mine the approaches, and hold the top of each mountain ridge as long as possible, and then retreat behind the next ridge.

SAN FRATELLO RIDGE. Top: the ridge is in the upper left of the picture, Torrente Furiano in the right foreground; bottom: view of the ridge on Highway 113 from the northwest. San Fratello Ridge was taken on 8 August after bitter enemy resistance.

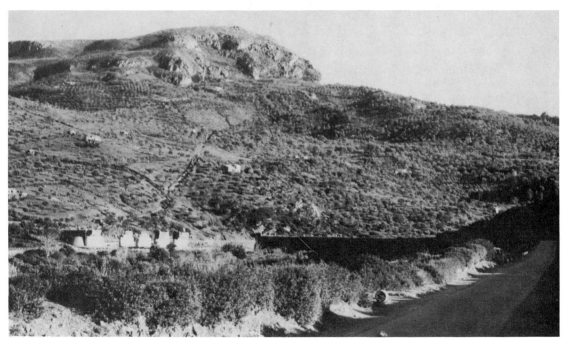

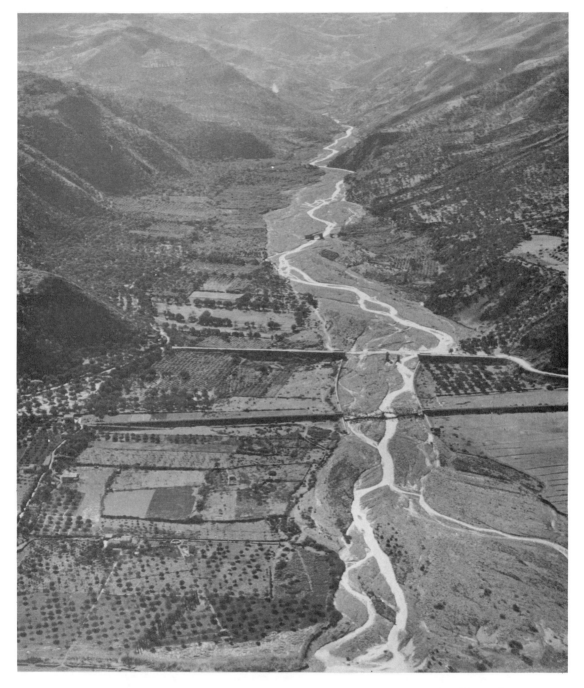

CORONIA VALLEY, typical of the valleys separating the mountain ridges along the northern coast. The valleys provided little concealment from the enemy in position on top of the ridges. The bridge spans were usually long and easily demolished. Note that both highway and railroad bridges are blown in this picture.

PROBING FOR MINES AT A BRIDGE-CROSSING SITE. The mine detector reacts to metal; whether the metal was a mine or a shell fragment had to be determined by probing and digging, usually with a bayonet. (Mine detector SCR 625.)

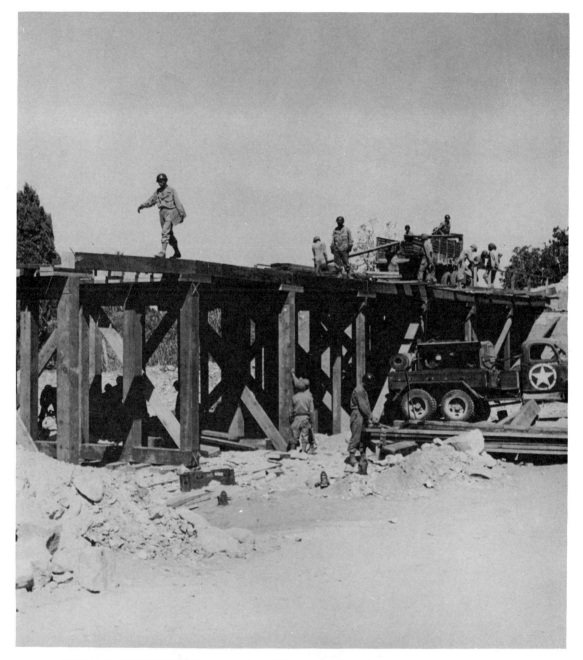

BRIDGE BUILDING. In the valleys this task presented no particular problem once the enemy had been chased off the mountain ridge overlooking the bridge site. However, near Messina, where the road in some places is hewn out of the cliffs overhanging the sea, the problem was more difficult. The air compressor (Le Roi) mounted on a 2½-ton truck (in picture above) was used for operating power-driven saws, hammers, and drills.

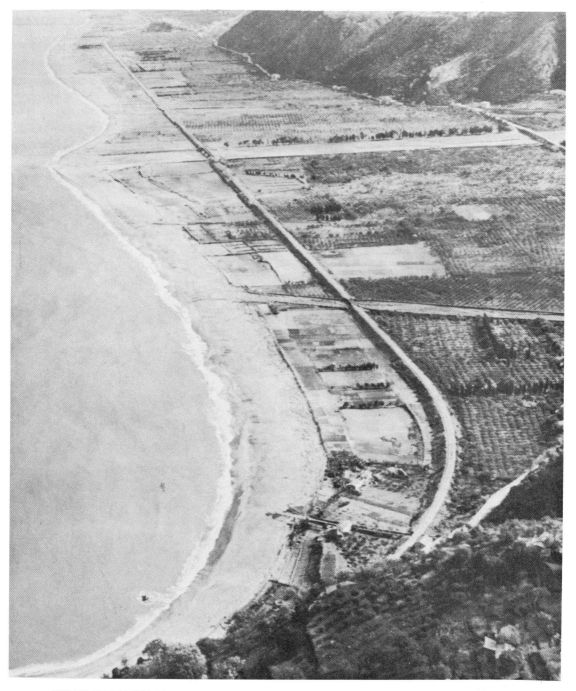

BROLO BEACH ON THE NORTH COAST OF SICILY. This is one of the several localities where U. S. forces made amphibious landings behind the enemy lines. Highway 113 runs along the hills, the railroad near the beach. The village of Brolo is at upper part of picture. The landing was supported by aircraft and naval gunfire.

ENGINEERS REPAIRING A BREAK IN HIGHWAY 113, on the north coast, caused by German demolition. The locality is Capo Calavâ where the road practically overhangs the sea.

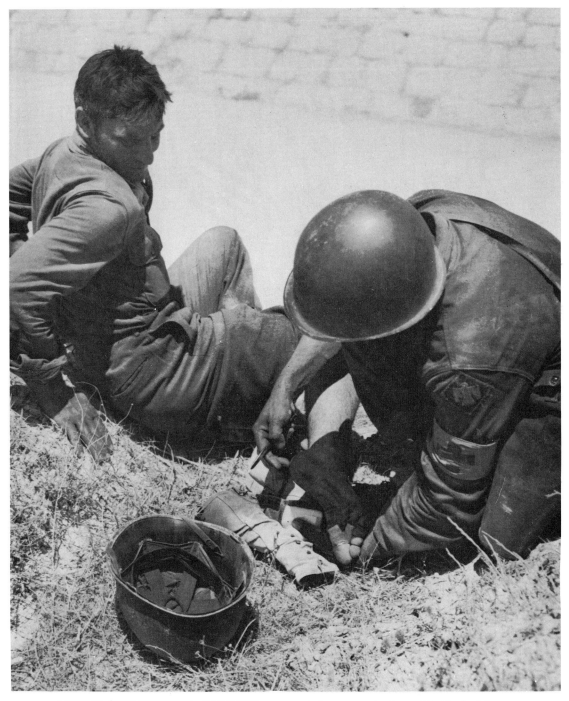

MEDIC TREATING A BLISTER on an infantryman's foot. Medical aid men were present at the scene of every action. They were unarmed and were identified by an arm band with a red cross, or a red cross painted on the helmet, or both.

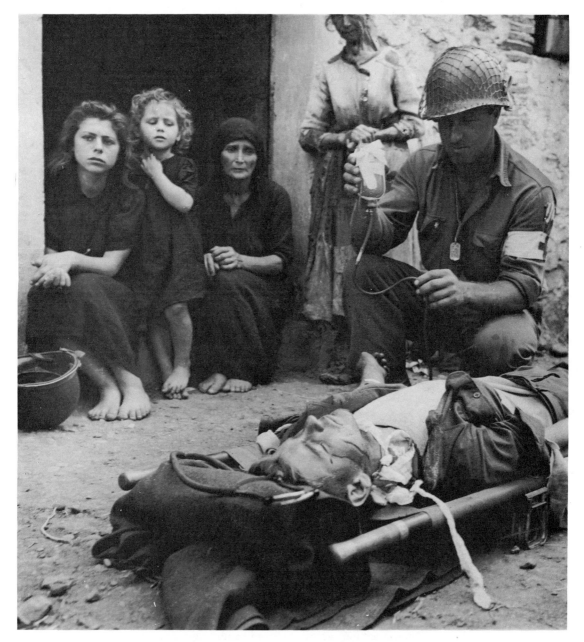

MEDICAL AID MAN GIVING BLOOD PLASMA TO A WOUNDED MAN.
Plasma was dried human blood that could be kept almost indefinitely under ordinary conditions. It was prepared for use by adding the required amount of triple-distilled water or a saline solution containing the same amount of salt as whole human blood. It was not as effective as whole blood, which retained its effectiveness for a maximum of only twenty-one days when properly stored and refrigerated. This made whole blood difficult to keep and use under field conditions.

DIGGING A FOXHOLE IN AN OLIVE GROVE using a helmet as a shovel. These holes provided excellent protection against shell and bomb fragments. The steel helmet was used for a variety of purposes besides protecting the head. It made a fine wash basin, was used as a basket to carry post exchange items (paper bags were not available), and practically everyone used it as a seat while living in the field. In some cases it was used as a cooking utensil in violation of regulations, as excessive heat took the temper out of the steel, making it useless for the purpose for which it was originally intended. (The soldier in picture is wearing the fiber liner while he digs with the steel helmet M1.)

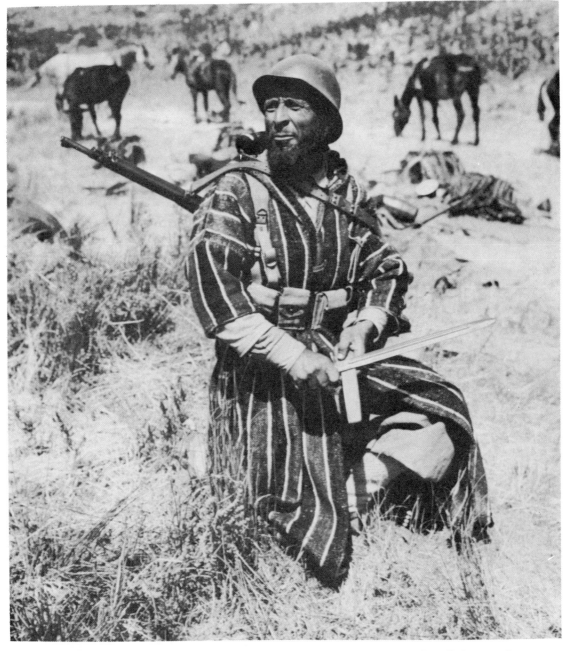

A GOUMIER OF FRENCH MOROCCO. The goumiers, generally called goums by American soldiers, formed part of the French colonial troops. Serving with the Americans in Tunisia, Sicily, Italy, and southern France, they were greatly respected for their fighting ability. (The term "goum" literally means "company," and a goumier is a member of an infantry company. Not all native infantrymen, however, were known as goumiers, the term applying only to soldiers of certain Moroccan tribes.)

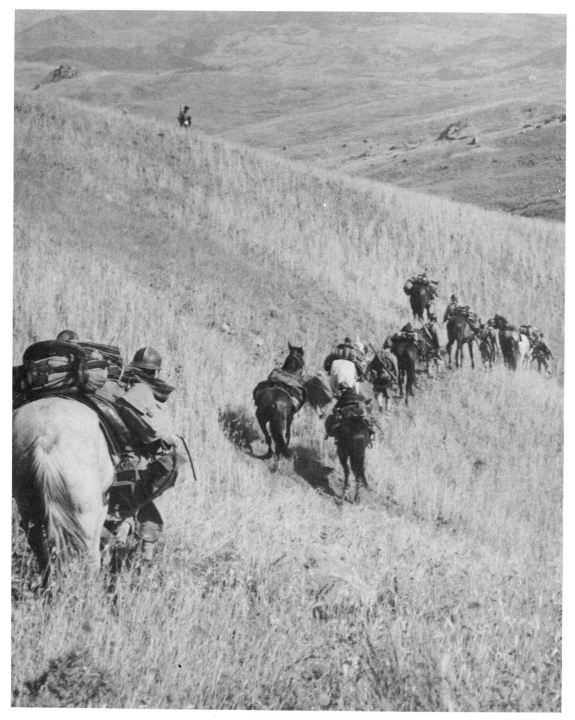

GOUMIERS ADVANCING ACROSS THE HILLS IN SICILY. Their specialty was mountain fighting, and they used horses and mules to carry supplies.

SOLDIERS STERILIZING MESS KITS AFTER EATING. When possible this was done before and after every meal. Such procedure was of the greatest importance in Sicily where sanitation as we know it was little practiced among the population as a whole. In spite of every precaution, dysentery of one kind or another was common among Allied forces.

INFANTRYMAN TURNED MULE SKINNER.

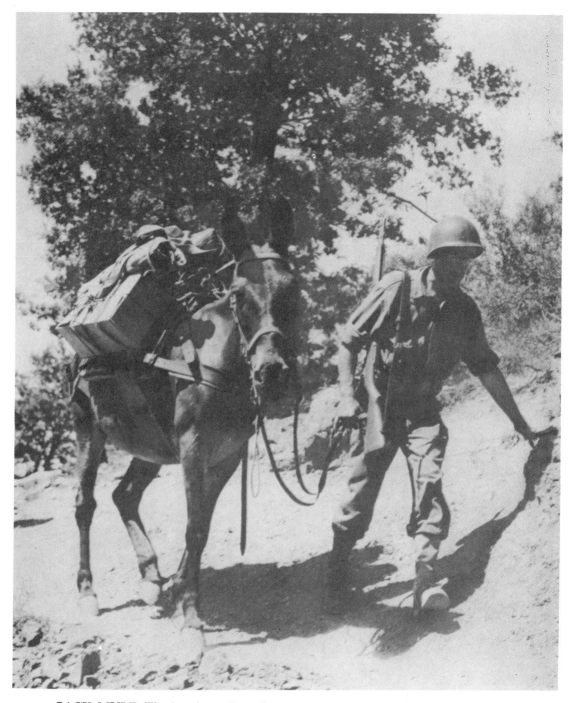

PACK MULE. The interior and northern coast of Sicily were mountainous and had few roads fit for vehicles. Mules often had to be used to bring supplies to troops in forward areas.

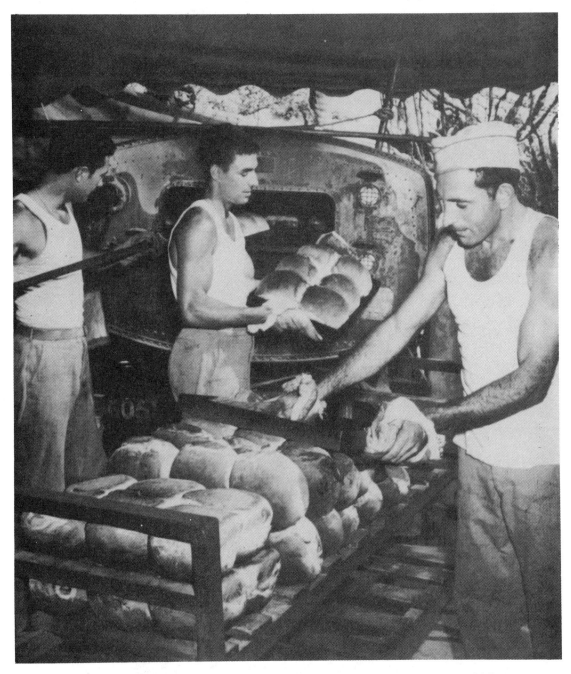

FIELD BAKERY. The men in the picture above are using a British oven which was built into a trailer. Field ovens of U. S. troops were separate units and not built in trailer form. In some instances U. S. troops obtained the British type oven when previously stationed in the British Isles. Others obtained them in Africa. Every attempt was made to vary the rations of the troops, and fresh bread was baked when possible.

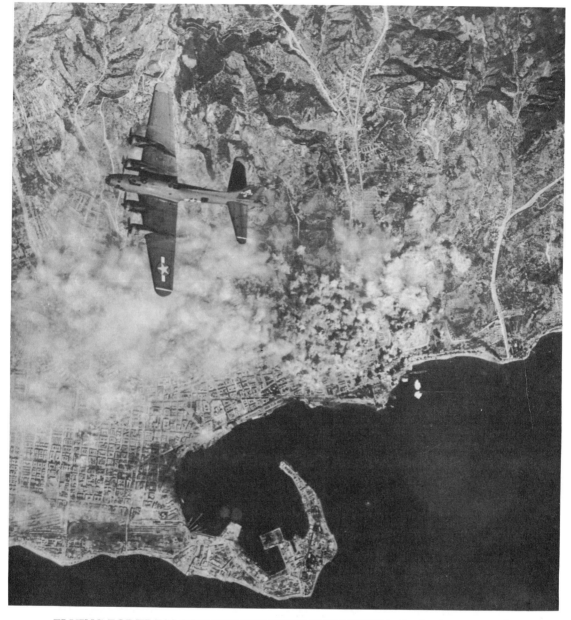

FLYING FORTRESS DURING BOMBING OF MESSINA. In the first two weeks of August the enemy started to withdraw to Italy across the narrow Strait of Messina under heavy bombing attacks. By concentrating antiaircraft guns in and around Messina as a means of combating these attacks, the Germans managed to ferry across thousands of their first-line armored and airborne troops, but much of their heavy equipment was left behind. U. S. patrols entered the city from the west on 16 August 1943 while British units entered from the south on the same day. The campaign had lasted thirty-nine days.

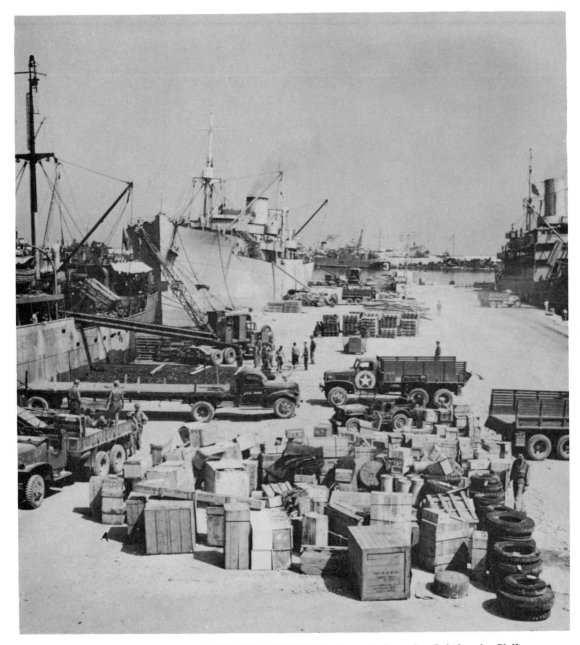

UNLOADING EQUIPMENT IN PALERMO. Even before the fighting in Sicily had ended, the build-up for the invasion of Italy started. The crane (left center) unloading pipe is a truck-mounted crane M2. Designed to handle 240-mm. howitzer matériel and 8-inch gun matériel in the field, it was a six-wheeled type with power supplied to all wheels and capable of accompanying convoy vehicles at a maximum speed of about thirty miles per hour. It was also used to facilitate unloading as above. The crew consisted of a chassis operator and a crane operator.

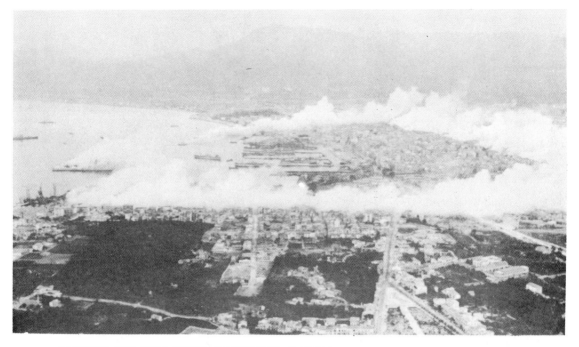

SMOKE SCREEN OVER PALERMO HARBOR AREA. This port, within easy reach of enemy bombers based in Italy, was subjected to air raids during the build-up period before the invasion of the mainland. The smoke screen obscured the port area and kept the bombardiers from aiming at any specific target.

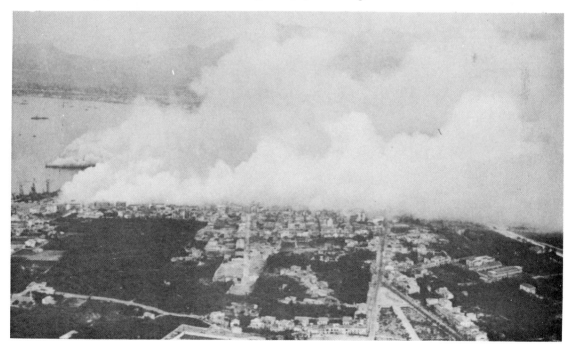

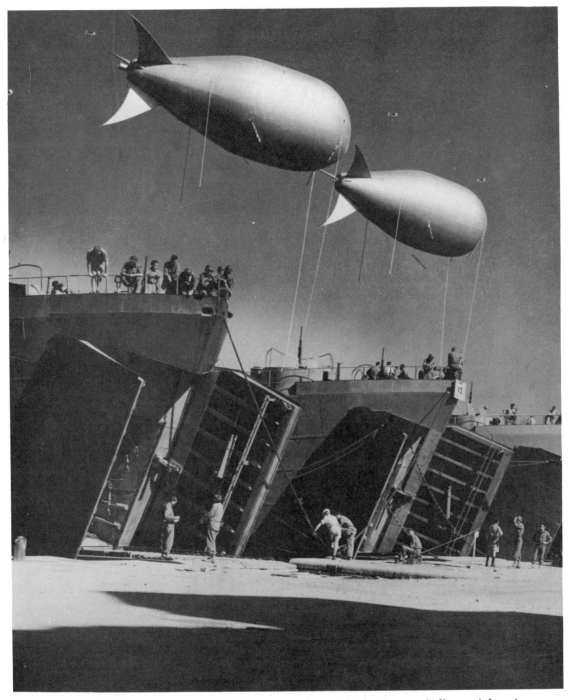

LST'S IN PALERMO HARBO. The very low altitude barrage balloons (above) protected the ships from dive-bombing attacks. They were flown at different altitudes from day to day.

AMMUNITION DUMP NEAR PALERMO during the build-up for the invasion of Italy.

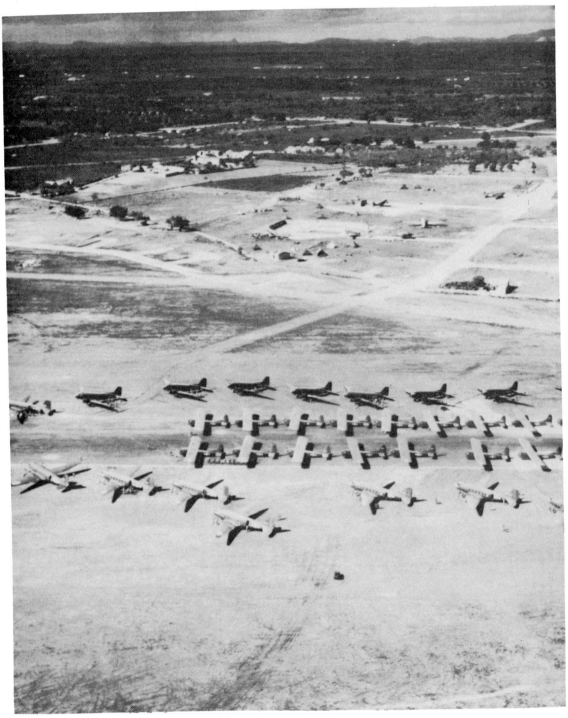

GLIDER TRAINING FIELD IN SICILY. (Douglas C–47 transport with CG–4 gliders.)

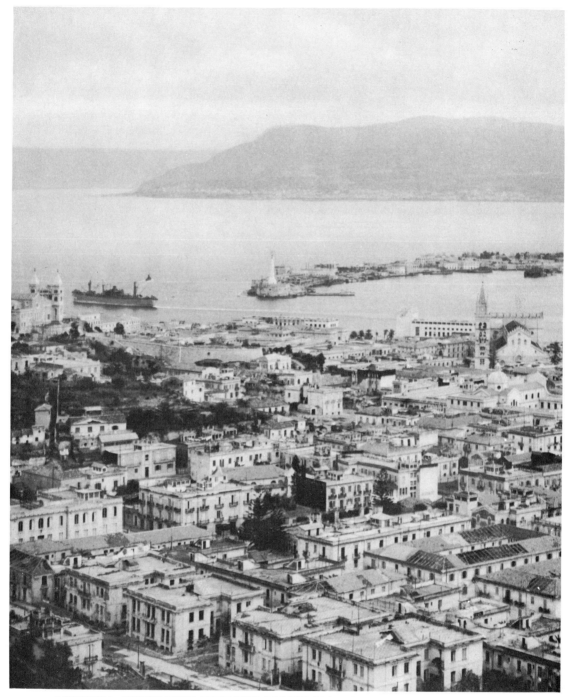

MESSINA WITH THE ITALIAN MAINLAND ACROSS THE STRAIT. On
3 September 1943 British and Canadians of the British Eighth Army crossed this chan-
nel into Italy.

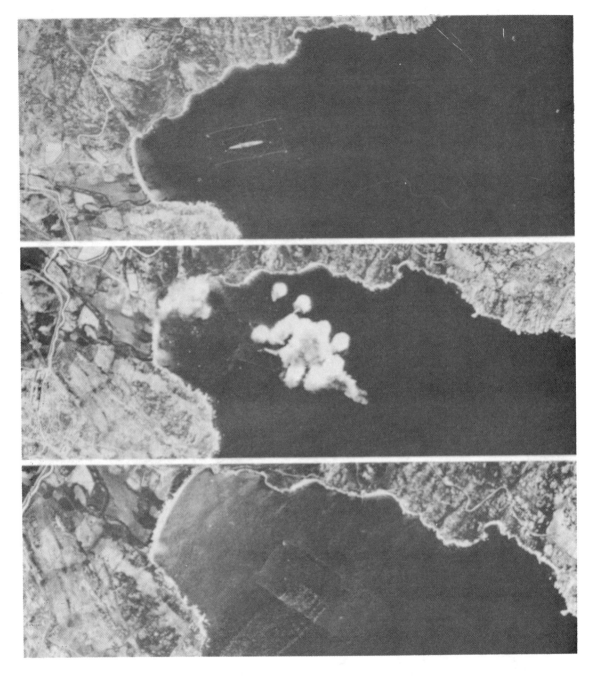

THE SINKING OF THE ITALIAN HEAVY CRUISER *TRIESTE* in Maddalena harbor, Sardinia. The cruiser was sunk by twenty-four B–17's coming from bases in Africa, 10 April 1943. (Top picture: cruiser within its protective antitorpedo net; center: salvo of bombs landing on and near ship; bottom: this photograph was made within the next few days and shows oil rising from the sunken cruiser.)

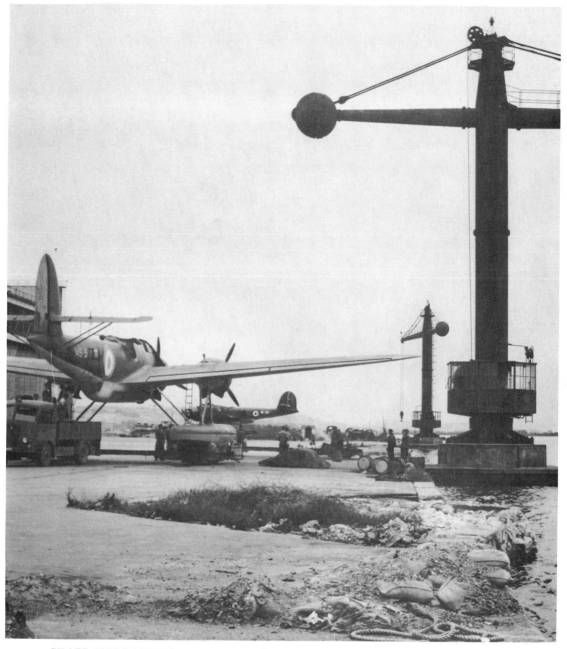

SEAPLANE BASE. The planes are captured Italian seaplanes at Cagliari on Sardinia. Sardinia was not invaded by U. S. forces, but the Germans evacuated the island in September 1943. Shortly thereafter the Allies started basing aircraft there, chiefly medium bombers. The bases were within range of all central Italy. (Top plane is an Italian *Cant. Z-506-B Airone* (Heron) three-engined bomber torpedo reconnaissance seaplane. The planes have British RAF markings added after capture.)

AIR CORPS PERSONNEL SETTING UP CAMP on the French island of Corsica. On 14 September 1943, French commandos landed to help patriots who were fighting the Germans. On 4 October the island was in Allied hands, and soon thereafter the airfields were being used as bases for fighters and medium bombers.

BOMBARDMENT SQUADRON REPAIR TENT in Corsica, riddled by bomb fragments. U. S. medium bombers based here ranged over all northern Italy and southern France. Fields in Corsica were within range of enemy planes based in the Po Valley, and were bombed and strafed periodically.

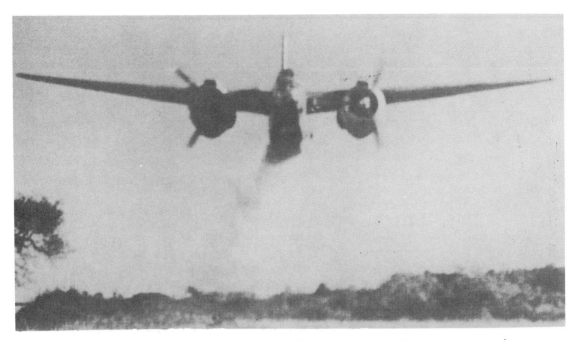

MALARIA CONTROL IN CORSICA. Throughout the Mediterranean campaign the malaria problem was ever present. Vigorous measures were taken to eliminate the disease-carrying mosquito. Douglas A–20 Havoc light-bomber (top) spreading Paris green dust over swampland near an Allied military installation; (bottom) refilling hopper of plane with dust.

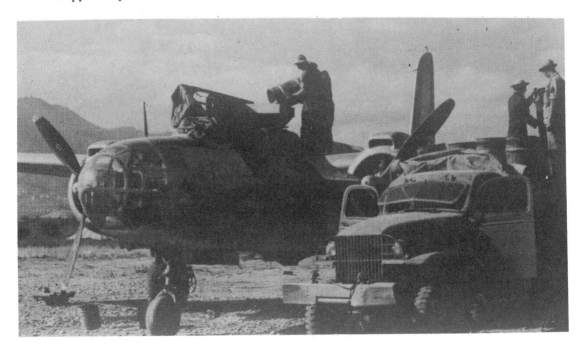

ITALY

(9 September 1943–4 June 1944)

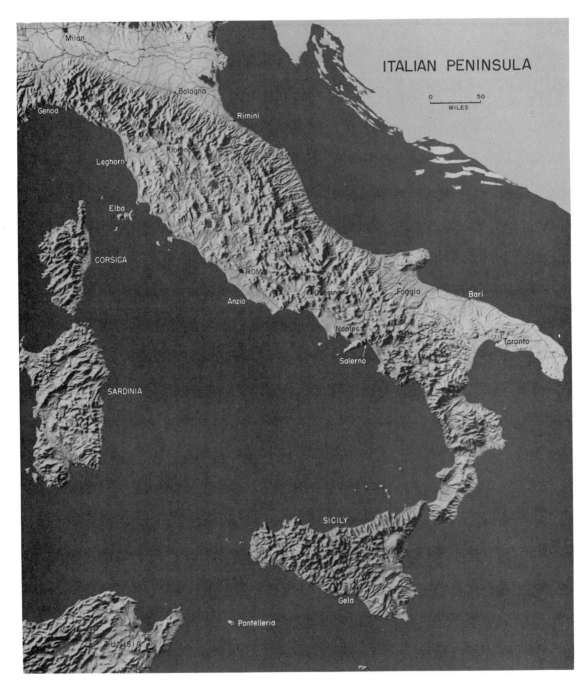

ITALIAN PENINSULA

0 50
MILES

SECTION III

Italy

(9 September 1943–4 June 1944)*

The Allied victory in Sicily helped to bring about the surrender of Italy. The terms of the Italian surrender were signed on 3 September 1943 and announced on the night of the 8th. Allied troops received the news on shipboard while under way to invade Italy. Fighting did not cease with the surrender. Instead, the Germans took over the country with troops on the spot and sent reinforcements. The defeat of the Germans in Italy would strengthen Allied control over the Mediterranean shipping lanes and would provide air bases closer to targets in Germany and enemy-occupied territory. The Allied troops in Italy would also engage enemy troops which might otherwise have been employed against the Russians.

On 3 September, elements of the British Eighth Army crossed into Italy and advanced up the Italian toe in pursuit of the retreating Germans. On 9 September the main assault was launched when an Anglo-American force, part of the U. S. Fifth Army, landed on the beaches near Salerno, south of Naples. Since the enemy had expected landings in the vicinity of Naples and had disposed his forces accordingly, the Allies encountered prompt and sustained resistance. By 15 September, however, the Germans started to withdraw up the Italian Peninsula, pursued on the west by the Fifth Army and on the east by the Eighth Army. The port of Naples fell on 1 October and the Foggia airfields about the same time.

After crossing the Volturno River against stiff resistance, the Allies advanced to the Winter Line seventy-five miles south of Rome. In bitterly cold weather the troops slogged through mud and snow to breach the series of heavy defenses and advanced to the Gustav Line. In mid-

*See Howard M. Smyth, Salerno to Cassino; Sidney T. Matthews, The Drive on Rome. These volumes are in preparation for the series U. S. ARMY IN WORLD WAR II.

January the main Fifth Army launched a new offensive across the Rapido and Garigliano Rivers to pierce the Gustav Line and advance up the Liri Valley toward Rome. Bridgeheads were secured across the rivers and footholds were obtained in Cassino and surrounding hills, but no break-through of the main German positions was.effected. A few days after the initial attack against the Gustav Line, an Anglo-American amphibious force landed at Anzio and struck inland with the purpose of compelling the Germans on the southern front to withdraw. But the Allied beachhead force was contained by the enemy's unexpectedly rapid build-up and was hard pressed to stave off several fierce German counterattacks.

After the Anzio front became stabilized and the effort to take Cassino was abandoned, the AAI (Allied Armies in Italy) regrouped and launched a new offensive on 11 May 1944. Fifth Army, led by French troops and assisted by American troops, broke through the main German positions in the Arunci Mountains west of the Garigliano River while the Eighth Army advanced up the Liri Valley. A few days later the beachhead force effected a junction with the troops from the southern front, and advanced almost to Valmontone on Highway 6 before the axis of attack was shifted to the northwest. After several unsuccessful attacks toward Lanuvio and along the Albano road, the Fifth Army discovered an unguarded point near Velletri, enveloped the German positions based on the Alban Hills, and pushed on rapidly toward Rome, which fell on 4 June 1944 with the Germans in full retreat. Meanwhile preparations were being rushed for an invasion of southern France by Allied troops, most of them drawn from forces in Italy.

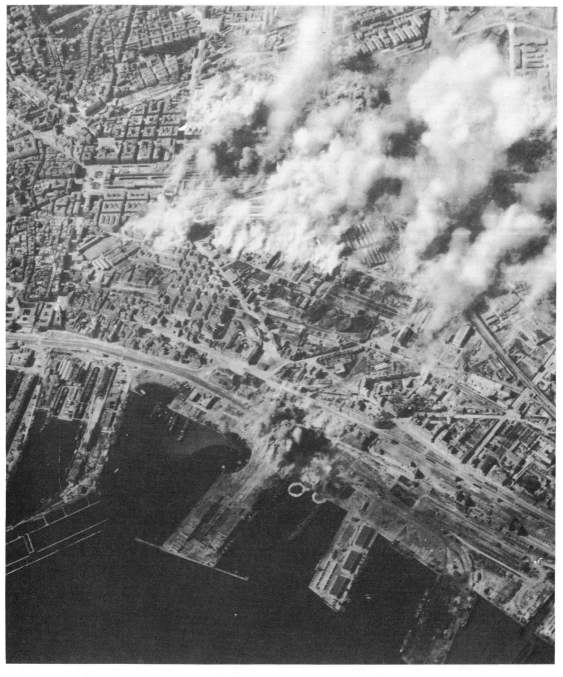

RAILROAD YARDS IN NAPLES burning after bombardment by Allied bombers from Africa. Before the invasion of Italy the bombing of enemy rail communications leading into southern Italy had high priority. Naples and Foggia were the most important rail centers south of Rome and both were heavily bombed prior to the landings.

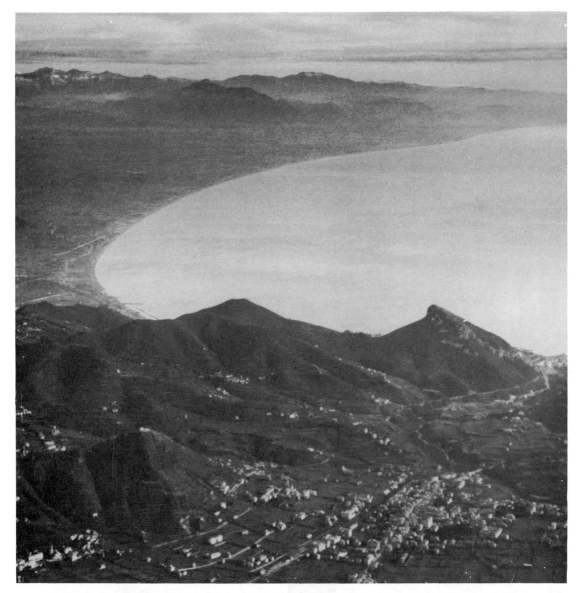

GOLFO DI SALERNO. The plain of Salerno in Italy, ringed and dominated by mountains, provided observation posts and commanding positions for the enemy. Here, on 9 September 1943, landed elements of the U. S. Fifth Army, an Anglo-American force. The British 10 Corps of this army landed on the beaches shown in the center of the picture, the U. S. VI Corps on beaches at Paestum in distance. One division of the British Eighth Army landed at Taranto in the heel of Italy simultaneously with the main landings in the Golfo di Salerno. Just six days before these landings two divisions of the British Eighth Army had invaded Italy from Sicily. These two armies were to advance northward: the U. S. army along the west and the British army along the east side of the peninsula.

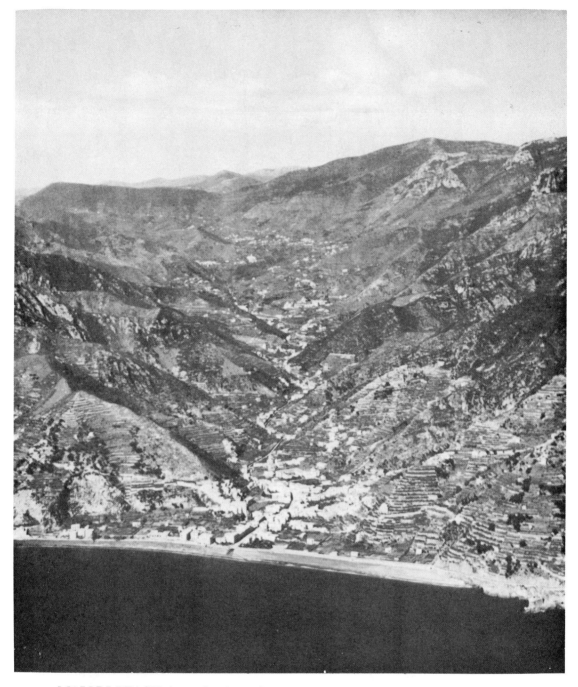

MAIORI BEACH, located a few miles west of the town of Salerno. Three Ranger battalions landed here unopposed on the morning of the invasion. Their mission to advance across the mountains and into the Nocera plain to prevent reinforcements located around Naples from reaching the invasion area was accomplished.

PAESTUM BEACH ON THE GOLFO DI SALERNO. At lower right is Paestum tower, the most prominent landmark on the beach. This beach was the scene of the first invasion of U. S. troops on the mainland of Europe. The landing took place

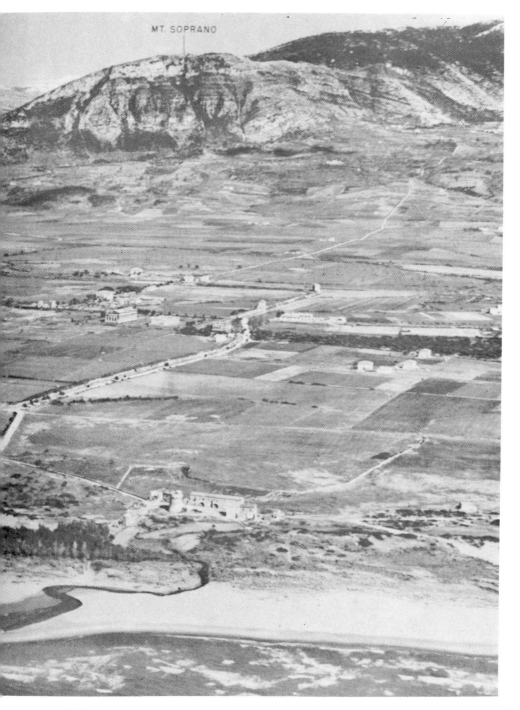

before daylight on 9 September and the troops reached Monte Soprano before night-fall. The area did not contain many fixed defenses, but the enemy had a considerable number of tanks and mobile guns.

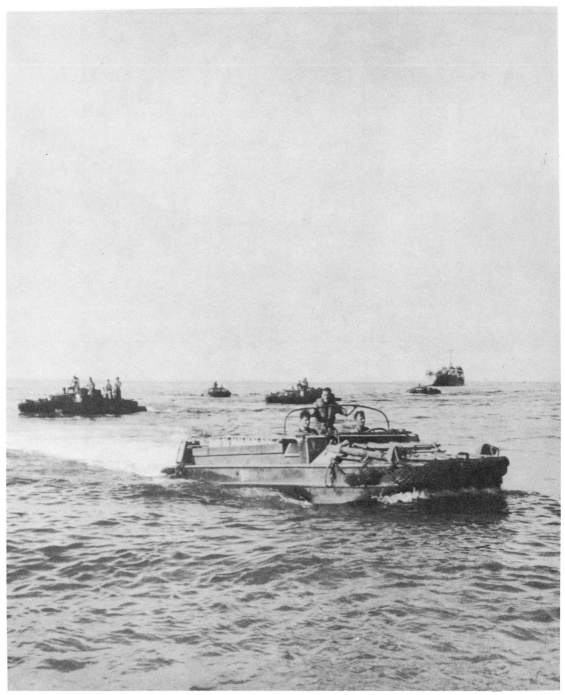

DUKW'S HEADING FOR SALERNO BEACHES. The one in the foreground is carrying gasoline in five-gallon cans. The maintenance of Allied forces for the first few days depended largely on craft such as these "ducks."

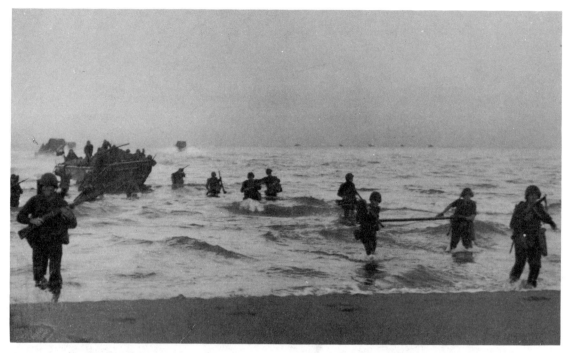

INVASION SCENES AT PAESTUM BEACH. Infantry debarking from assault craft (top) and naval personnel evacuating wounded soldiers to a transport for medical care (bottom). The landing craft shown are all LCVP's.

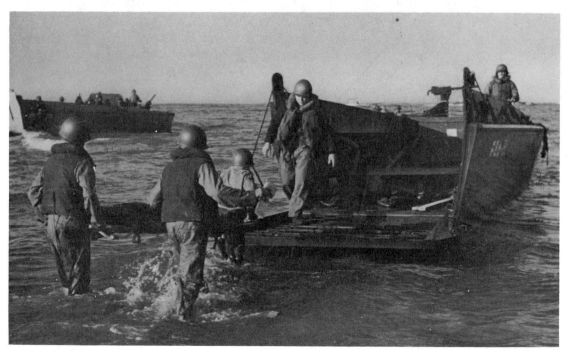

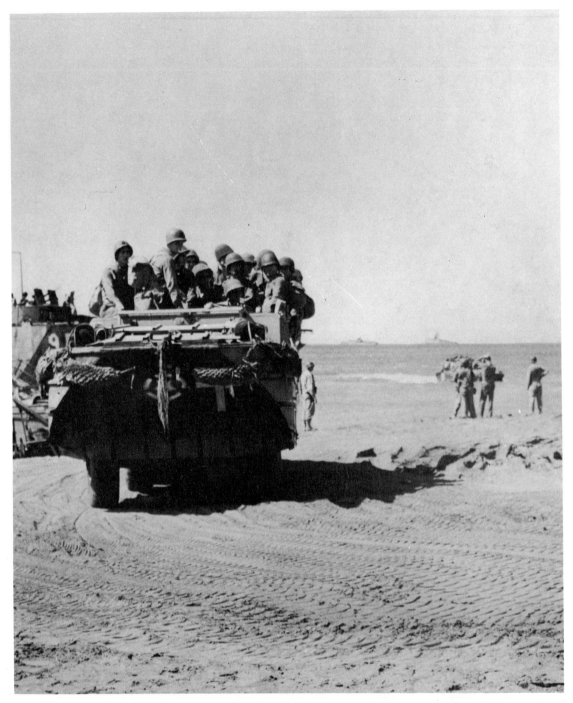

DUKW LANDING AT PAESTUM BEACH. These amphibian trucks brought light artillery and antitank guns ashore after the first assault waves had landed and, later in the day, brought men and supplies ashore.

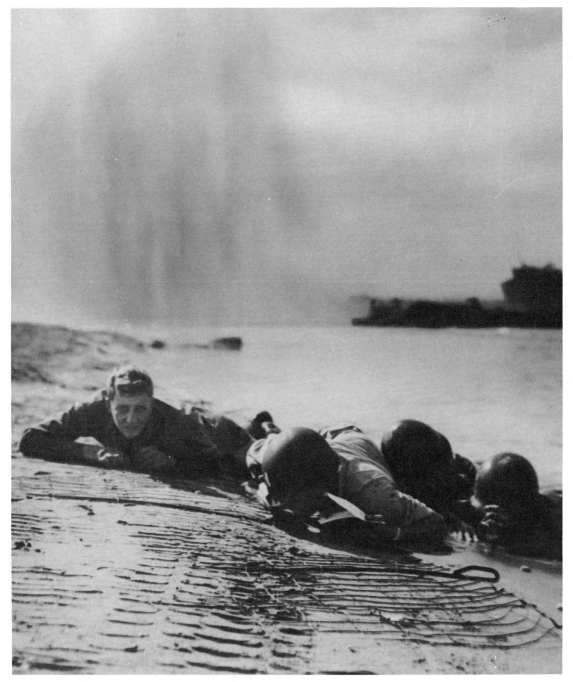

SOLDIERS HUGGING THE BEACH during air strafing and bombing attack on D Day. Five enemy air raids, each by a formation of eight fighter-bombers, were made against U. S. troops along the beach. Several smaller formations were sent against ships offshore. Casualties and damage caused were relatively slight on D Day.

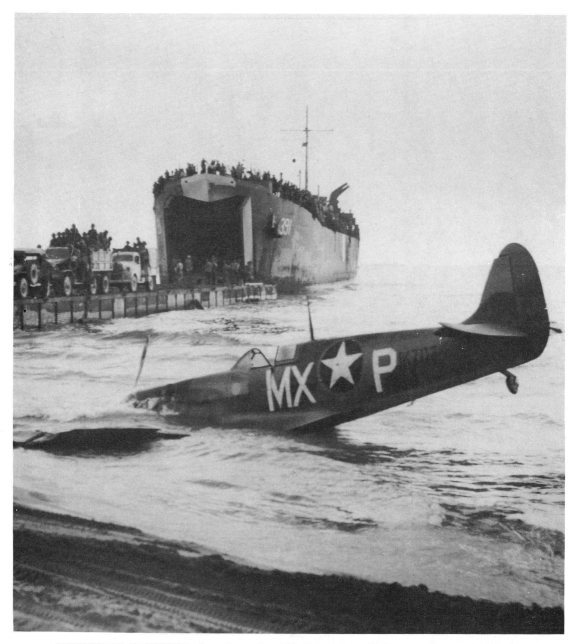

WRECKED SPITFIRE shot down by Allied antiaircraft fire over Paestum beach. As several U. S. fighter squadrons were equipped with British Spitfires, the planes bore U. S. markings. Providing air cover from the Salerno area was a difficult problem because Allied fighters were based in Sicily. The longest-range fighter, the P–38, could stay over the beaches for only one hour, the A–36 (modified North American P–51 Mustang) thirty minutes, and the Spitfire about twenty minutes. (In background: LST unloading equipment over sectional ponton ramp.)

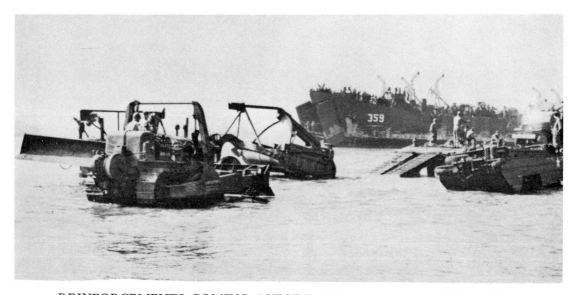

REINFORCEMENTS COMING ASHORE at Paestum beach on D Day. Top: bulldozer coming ashore—in background is a U. S. type LST, two-davit design; bottom: infantry, armor, and medical aid men—in background is British type tank landing ship (LST(1)). This ship was one of three belonging to the Boxer class. These were the first ships built specifically for tank landing purposes after the successful experimentation with the converted Maracaibo class oil tankers. They could land medium tanks over a low ramp carried within the ship and extended through low gates toward the beach. Load: thirteen 40-ton tanks or the equivalent. (A DUKW also is shown in the top picture; the tanks in the bottom picture are Sherman M4A1.)

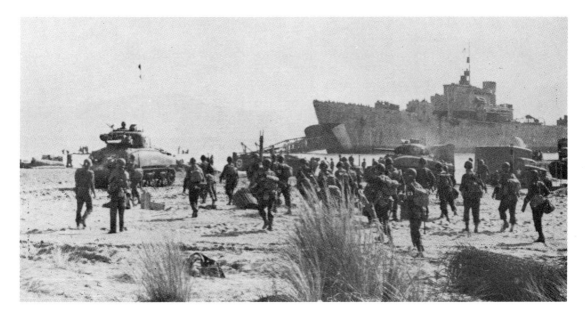

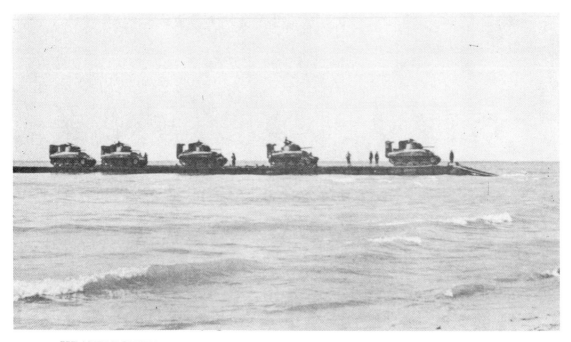

HEAVY EQUIPMENT ROLLING ASHORE ON D DAY. Waterproofed medium tanks (Shermans) rolling toward shore across sectional ponton ramp from LST (top), and LST discharging fully loaded trucks (bottom).

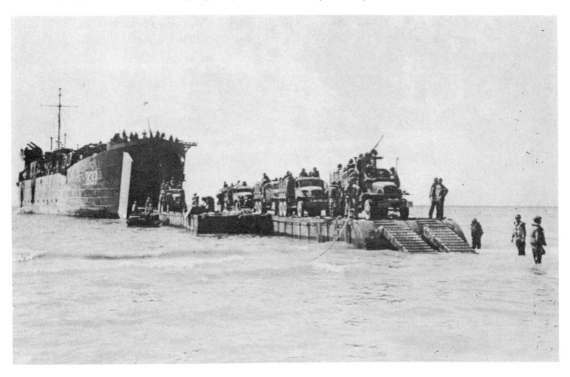

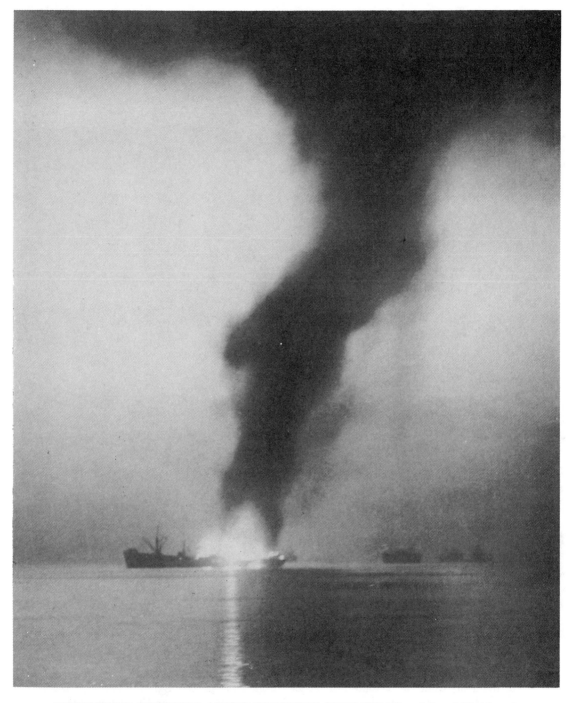

FREIGHTER BURNING AFTER BOMBING ATTACK. The night of 10–11 and the day of 11 September saw the greatest enemy air activity. During that time about 120 hostile aircraft raided the beaches and the transport area.

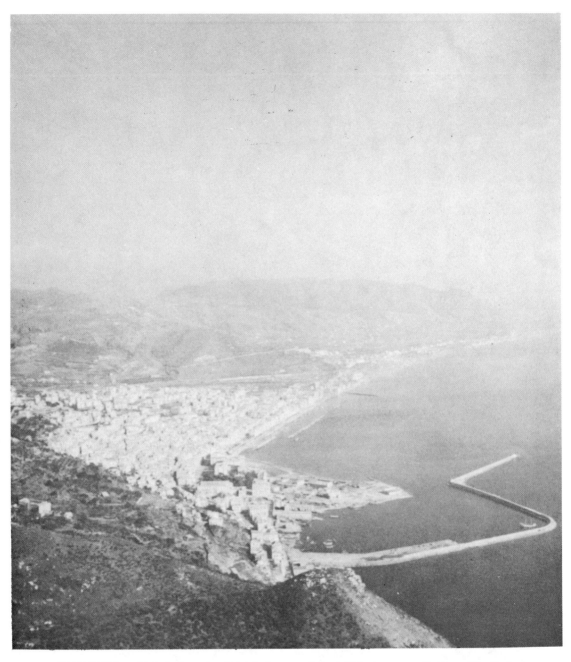

SALERNO, which fell to the British forces of the Fifth Army on D Day. Until the port of Naples, which fell on 1 October, was cleared, all reinforcements and supplies for the army came in over the beaches or through the port of Salerno. On 19 September the entire Salerno plain was securely in Allied hands. The German counterattacks which had started on 12 September had been checked by the 15th. On the 17th the Germans started to withdraw from the area.

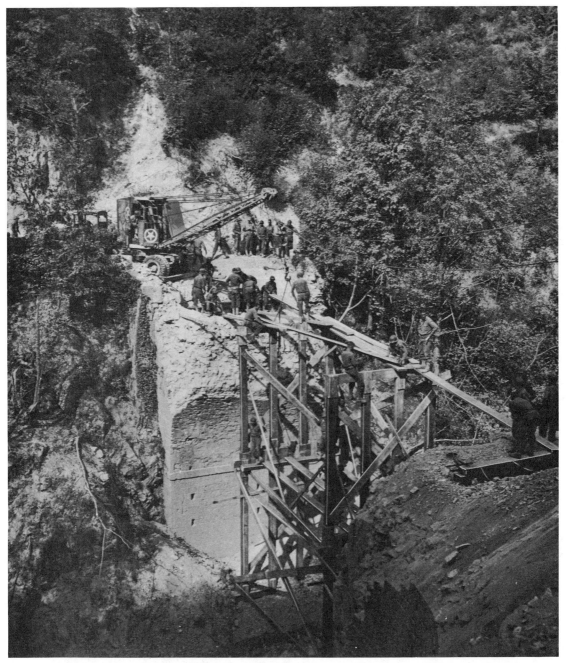

ENGINEERS REPAIRING A BRIDGE NEAR ACERNO. While part of the invading forces advanced westward toward Naples, part proceeded toward Benevento to the north. The enemy retreated slowly toward the river Volturno, the next natural line of defense, leaving rear guards to delay the advance, mine the roads, and blow the bridges.

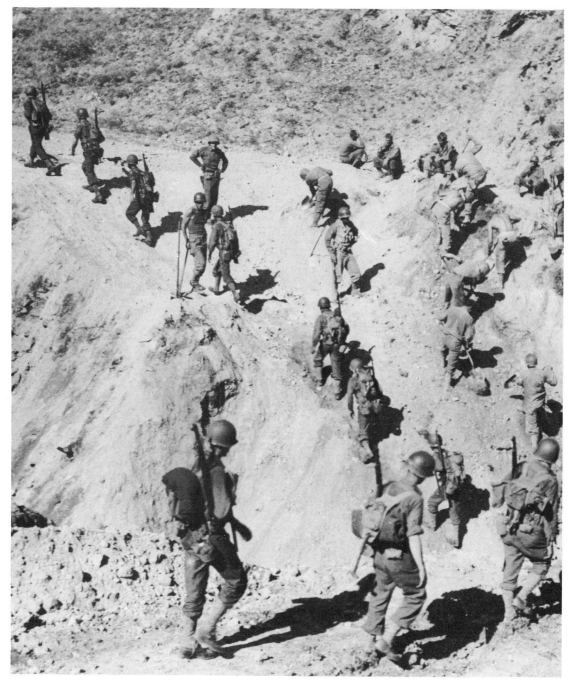

INFANTRY ADVANCING ACROSS BYPASS TO BRIDGE near Avellino on the way to the Volturno River. Blown bridges caused much delay; infantry, after crossing, generally ran into opposition that required the use of tanks, which had to wait until the engineers could rebuild the bridges.

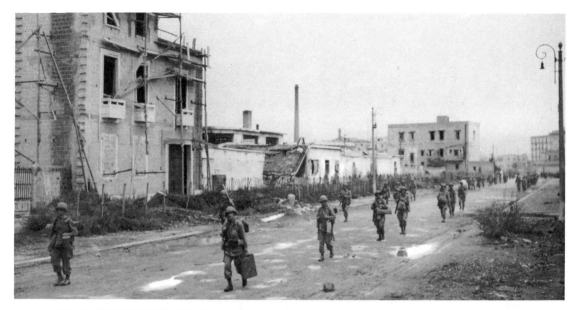

U. S. TROOPS IN NAPLES. The city fell to the British 10 Corps, assisted by elements of some U. S. units, on 1 October 1943. When Naples fell, the Allies were in possession of three of Italy's best ports, Naples, Bari, and Taranto, as well as two of the most important airport centers, the Naples area on the west and the Foggia area on the east of the peninsula. The latter had fallen to the Eighth Army on 27 September and soon became the base for the biggest concentration of Allied bombers in the entire Mediterranean theater.

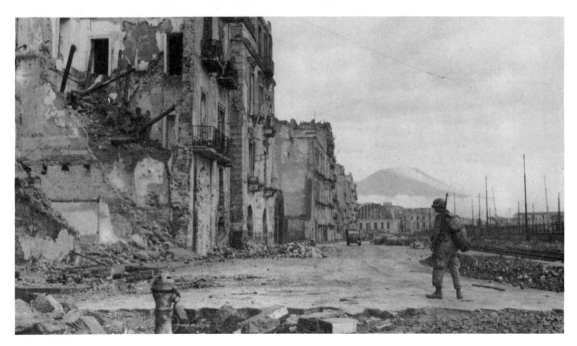

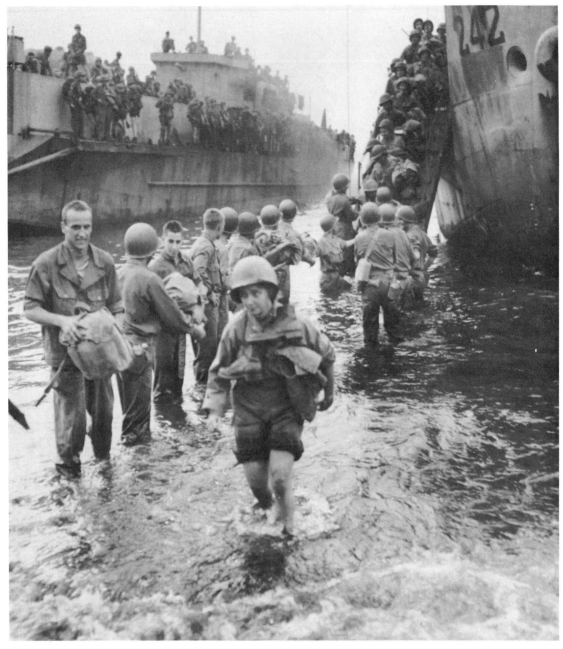

U. S. NURSES DEBARK FROM LCI in the Bay of Naples. Port facilities in the city had been heavily bombed by the Allies for months before the invasion and the damage had been increased by the Germans as they retreated. Much of the cargo coming into the harbor had to be discharged over beaches in the bay. However, twelve days after the capture of the city the unloading facilities were beginning to function and that day 3,500 tons were discharged.

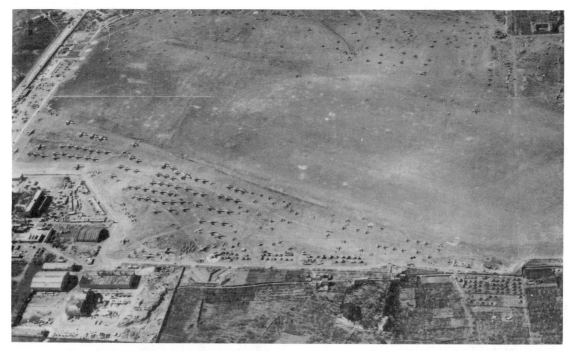

AIRFIELDS NEAR NAPLES. Capodichino (top) and Pomigliano (bottom) after they had been put to use by the Allies. Both fields had been severely damaged by Allied bombers before the invasion.

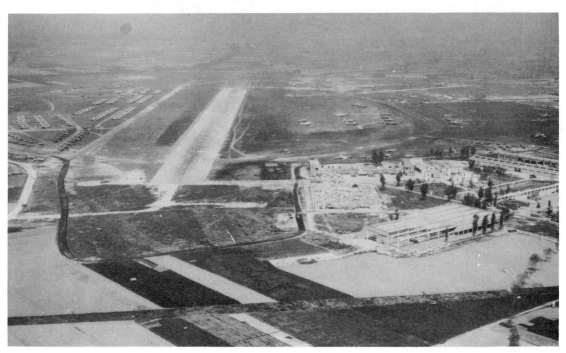

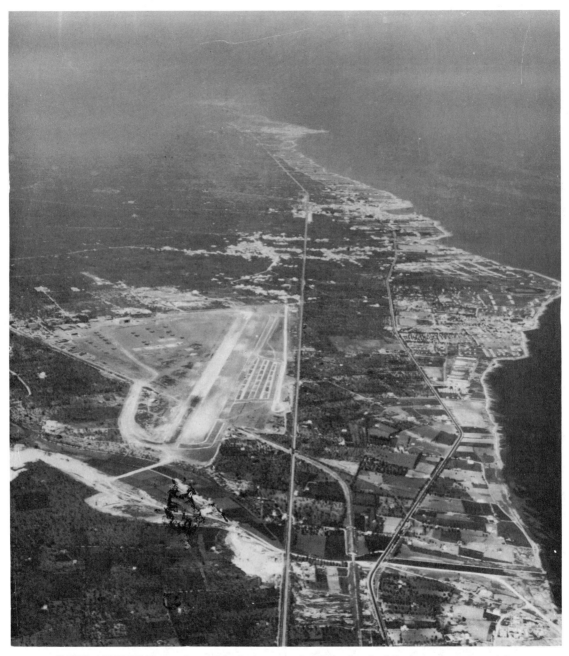

BARI AIRPORT, on the Adriatic just north of the heel of Italy, was captured by the British on 22–23 September 1943. The enemy had used this airport as a transport base and for staging fighters on the way to Africa. The near-by town of Bari became headquarters for the heavy Allied bombardment units based at several airfields on the Foggia plain. Both the town of Bari and the Bari airport were subject to attack by enemy aircraft.

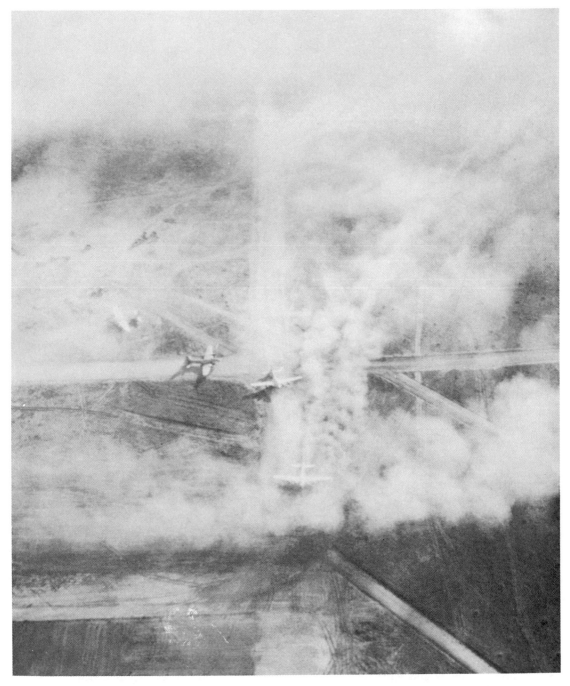

FLYING FORTRESSES taxiing out to runway to take off on a mission. This picture
was taken early in the Italian campaign, before this airfield in the Foggia area had
been improved. Soon after the Foggia airfields had been captured, Allied bombard-
ment groups started to move from the African bases.

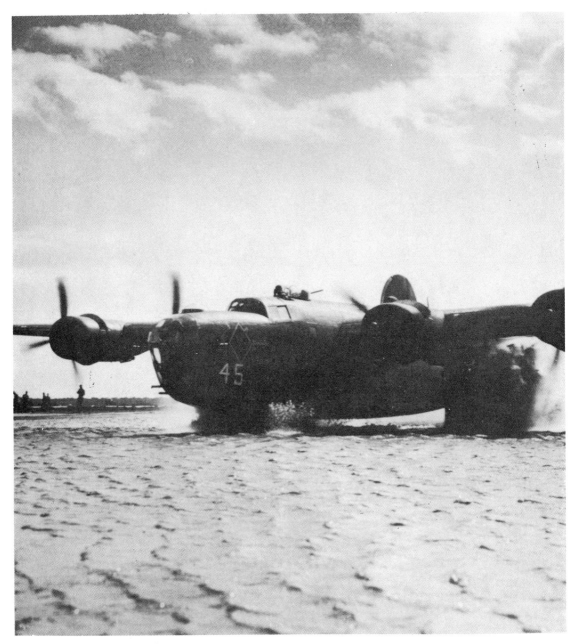

LIBERATOR BOMBER taxiing along flooded runway on one of the airfields in the Foggia area. When the fall rains started in October 1943 most of these fields became muddy and some were flooded. The flying of missions was continued while construction was in progress, runways being lengthed and raised, and fields drained. By the end of 1943 most of the fields had been put into good shape and by that time two heavy bombardment groups, two medium groups, and two fighter groups were operating out of ten airfields in the Foggia area.

AIRMAN BAILING OUT HIS TENT after a rainstorm in southern Italy. This was late fall 1943. As time went on conditions improved. By the end of the year there were 35,000 U. S. combat airmen with their supporting forces in Italy.

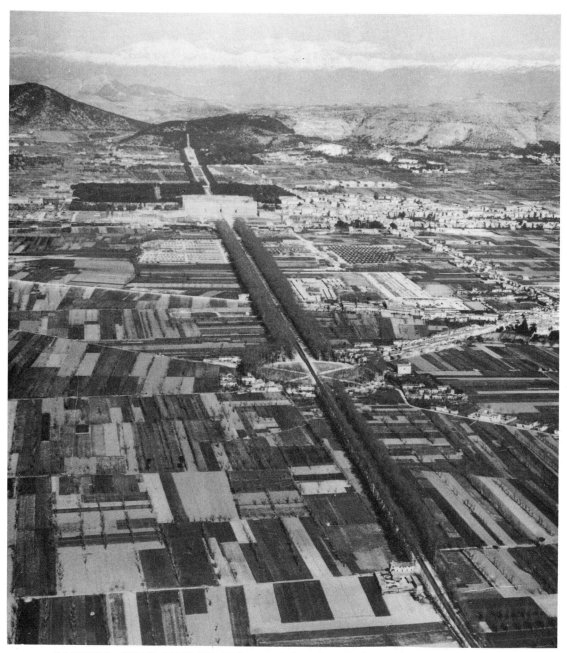

CASERTA, NEAR NAPLES. This area fell to the Fifth Army on 5 October 1943. The palace shown at end of tree-lined road became headquarters of the Fifth Army soon after the building was captured. Later it also became headquarters of the 15th Army Group (Fifth and Eighth Armies) and still later Allied Force Headquarters, the last named having control over the entire Mediterranean Theater of Operations. The German surrender in Italy was signed in the palace.

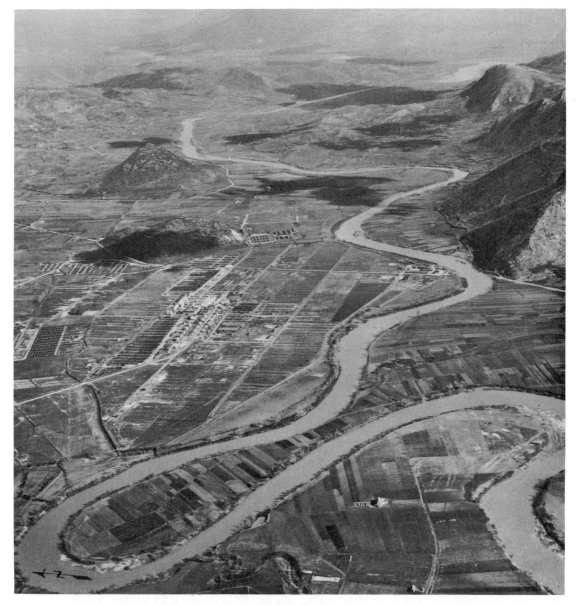

VOLTURNO RIVER ABOVE CAPUA. This was the first natural line of defense north of the Naples area. The Fifth Army had reached the southern bank of this river by 6 October. In the period between the landings on 9 September and the arrival at the Volturno, the Fifth Army had suffered 12,219 casualties of all kinds; 4,947 were U. S.; 7,272 were British. On 13 October the first successful crossing of this river took place above and below the hairpin loop. The river here is from 150 to 200 feet wide, its depth from 3 to 5 feet. U. S. troops crossed in assault boats or on rafts; some used life preservers, and some forded the icy stream with the use of guide ropes.

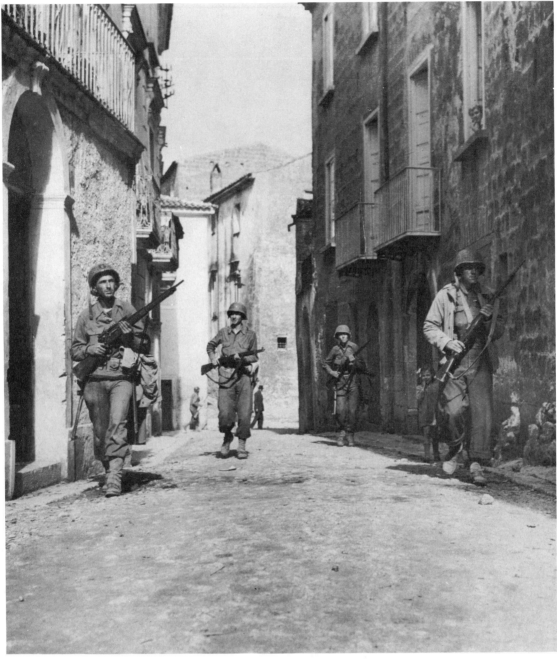

SOLDIERS ENTERING CAIAZZO after crossing the Volturno River. The two men in foreground are carrying the Springfield rifle with telescopic sights; those in rear, the Garand. (The Springfield rifle M1903A4, .30-caliber, bolt-action, manually operated, became the standard U. S. Army rifle in 1903. Garand rifle M1, .30-caliber, self-loading, semiautomatic, is at present the standard U. S. Army rifle.)

LIRI VALLEY MINTURNO TUFO BRIDGE, HIGHWAY 7

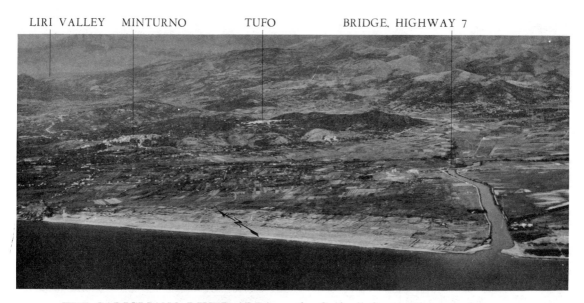

THE GARIGLIANO RIVER AREA on the Golfo di Gaeta. The area shown was the western anchor of the enemy Gustav Line as well as his Winter Line. By 15 November 1943 the Fifth Army was halted in front of the Winter Line, which consisted of well-prepared positions across the waist of Italy from the mouth of the Garigliano River on the west, through the mountains in the center, to the mouth of the Sangro on the east coast. The more formidable Gustav Line was located farther north except along the lower Garigliano where the two defense lines generally coincided. Little fighting took place in the area shown until the British 10 Corps crossed the river on 17 January 1944 to support the main Fifth Army effort to drive up the Liri Valley. Garigliano River is located at right in top picture and at lower left in bottom picture.

GAETA FORMIA HIGHWAY 7 RAILROAD MINTURNO

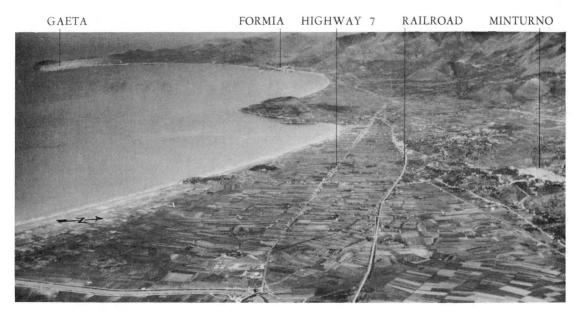

THE CAMINO HILL MASS. Top picture is taken looking toward the northwest from road fork of Highways 6 and 85. Bottom picture shows the hill mass with the Rapido River Valley in distance. The Winter Line continued along the south and east slopes of these mountains. The Camino Hill area fell to British and American troops on 9 December 1943, after several days of severe fighting.

MT. CASSINO MT. TROCCHIO MT. PORCHIA MT. LUNGO

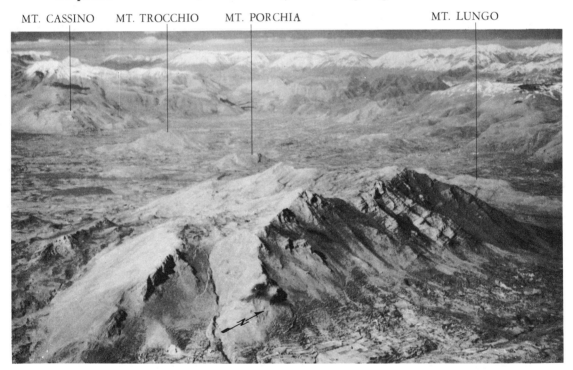

MT. CAMINO HIGHWAY 6 MIGNANO MT. SAMMUCRO

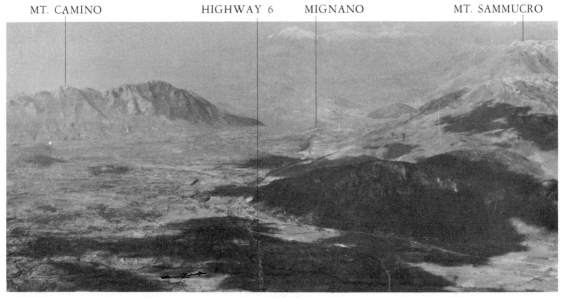

THE MIGNANO GAP. Looking west through the gap toward Monte Cairo, the snow-covered mountain in distance. Cassino is located at the foot of this mountain (top). Looking north from the gap; the village of Mignano, Highway 6, and the railroad are in lower left hand corner (bottom). San Pietro Infine, the village on the slope of Monte Sammucro, was the scene of one of the costliest battles of the Winter Line campaign. Mignano Gap was one of the few breaks in the mountains of the Winter Line and the main effort to breach that line was made at this gap.

S. PIETRO MT. SAMMUCRO MT. CANNAVINELLE MT. CORNO VENAFRO

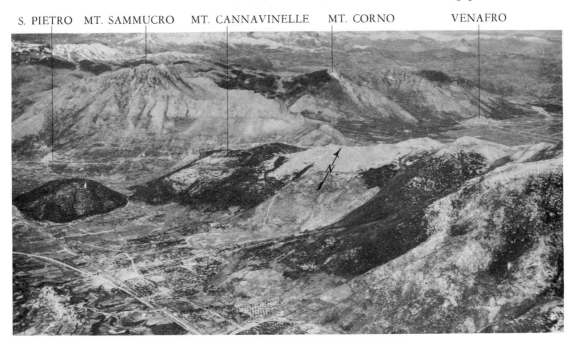

HIGHWAY 85 POZZILLI MT. MONNA CASALE

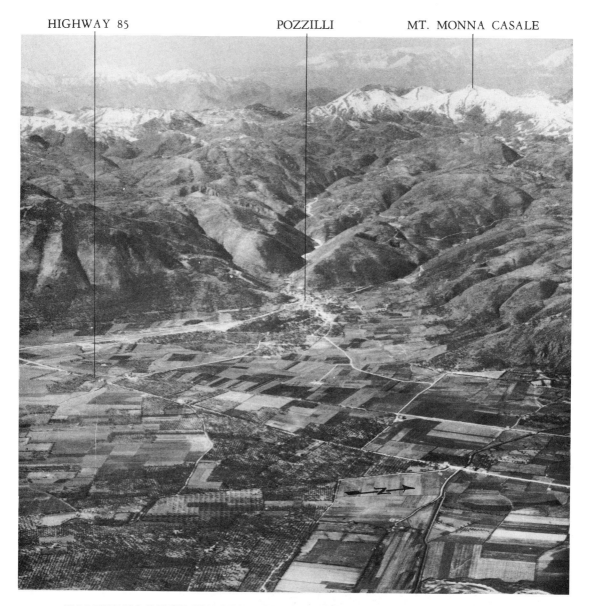

VOLTURNO RIVER VALLEY NORTH OF VENAFRO. River is in foreground. The valley had been cleared of enemy troops by the middle of November 1943. While German rear guards carried out delaying actions, the main enemy forces strengthened the Winter Line defenses in these mountains, which separate the Volturno River from the Rapido River. Hard fighting took place for control of the road leading from Pozzilli through the mountains to San Elia in the Rapido Valley. Initial attempts made by U. S. forces to cross the mountains failed because of the exhaustion of the troops, the difficulty of supply, the unfavorable weather, and the determined resistance of the enemy. The U. S. units were replaced by fresh French mountain troops, who in January 1944 fought their way across the mountains.

MT CASSINO LIRI VALLEY MT. CAIRO MT. MONNA CASALE

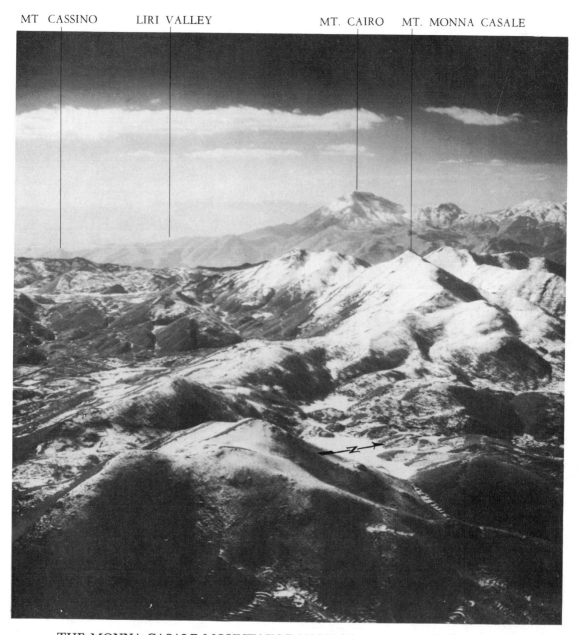

THE MONNA CASALE MOUNTAIN RANGE. These are the highest mountains in the ridge separating the Volturno and Rapido Valleys. Two roads across these mountains connect the two valleys: the Colli al Volturno–Atina road on the north side of the range, the Pozzilli–San Elia road on the south side. Both were relatively poor. Hill mass at lower left is Monte Pantano. The battle for this hill started on the night of 28–29 November and lasted until 4 December. On that day the U. S. forces withdrew with the enemy still in possession of most of the area. French troops seized the rest of Monte Pantano on 17 December.

COLLI AL VOLTURNO. This typical Italian mountain village is located at the headwaters of the Volturno and was on the right flank of the U. S. Fifth Army. The mountains between this area and the left flank of the British Eighth Army fighting along the east coast of Italy were so rugged that no fighting took place there. Both Allied armies merely maintained small patrols to keep in contact. The lower road on the left runs through the mountains separating the Volturno and Rapido River Valleys and leads to Atina north of Cassino.

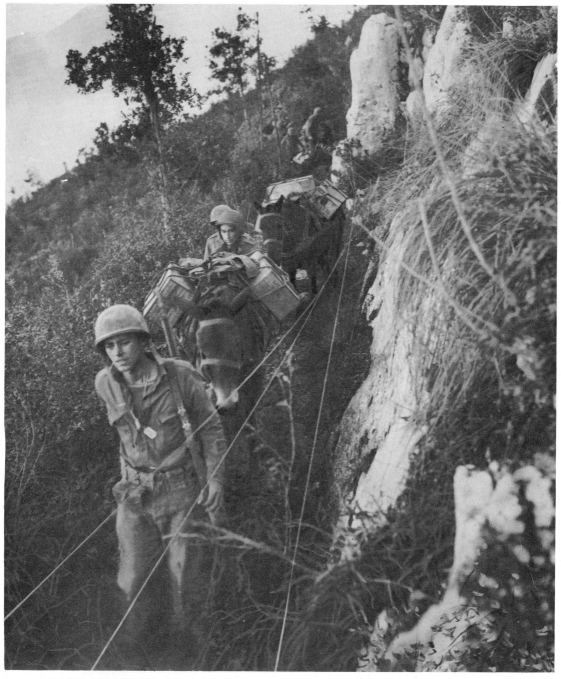

PACK TRAIN IN THE MOUNTAINS. These pack trains consisted mainly of mules, but horses and donkeys were also used. Without the use of pack trains the campaign would have been much more difficult. To supply the basic needs of an infantry regiment in the line two hundred and fifty animals per day were required.

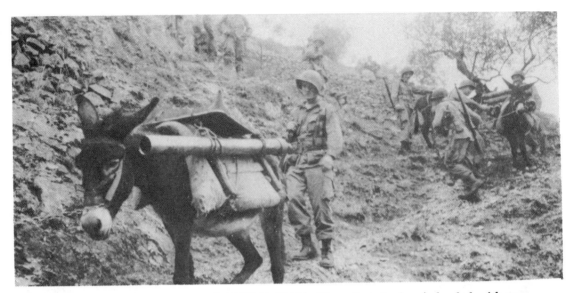

PACK TRAIN IN THE VENAFRO AREA. Top: first donkey is loaded with an 81-mm. mortar, the second carries the ammunition; bottom: strapping a light .30-caliber machine gun on a donkey. The pack animals obtained by the Allies in the Mediterranean area were of varying sizes, generally smaller than the ordinary American mule, and standard U. S. pack equipment had to be modified in the field. Most of the equipment, however, was purchased in Italy.

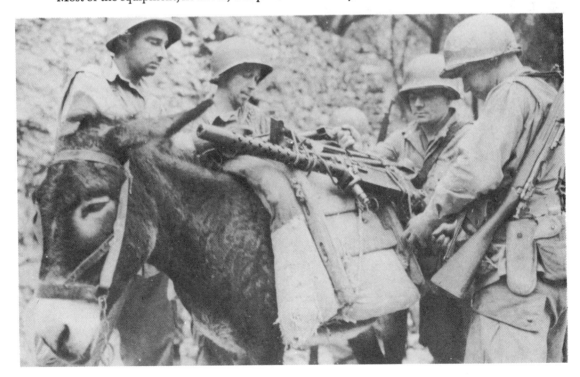

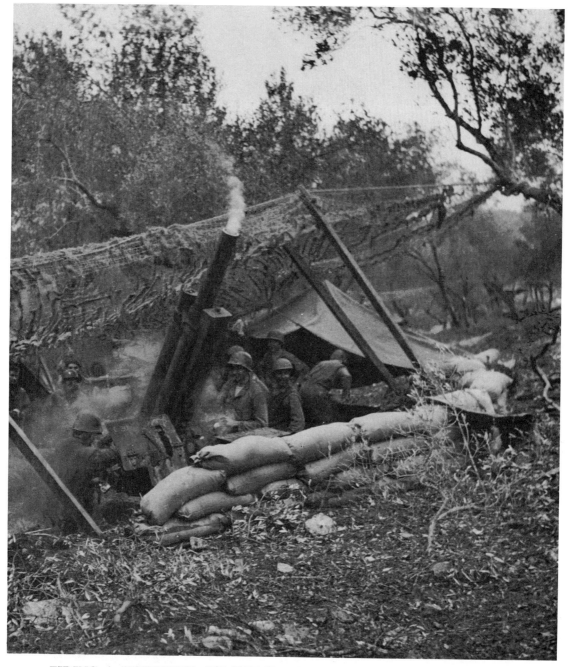

FIRING A HOWITZER ON THE VENAFRO FRONT, with camouflage net pulled back for firing. While the infantry crouched in foxholes on the rocky slopes of the mountains, the artillery in the muddy flats behind them gave heavy supporting fire on enemy positions. To clear the masks presented by the high mountains ahead, barrels had to be elevated. (105-mm. howitzer.)

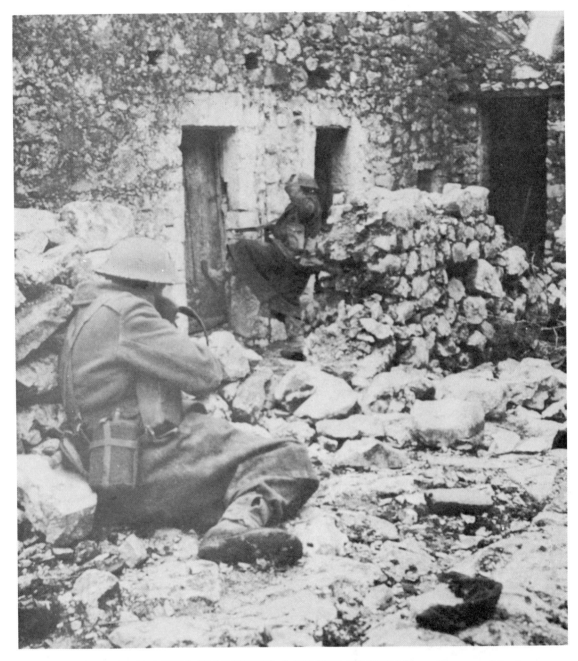

BRITISH SOLDIERS SEARCHING A HOUSE IN COLLE, a village on Monte Camino. Soldier in foreground is covering his partner while the latter kicks open the door. The stone houses, typical of those in the mountain areas, with walls sometimes four feet thick, made fine strong points. They could be reduced by artillery, but in the Camino fighting, a joint British-American operation, there was no close-support artillery.

PREPARING AIR DROP OF FOOD AND SUPPLIES. Packing food parcels into belly tanks of a P–40 (top), and attaching tank to the bomb rack of A–36 fighter-bomber (bottom). The tank is released like a bomb. During the fighting on Monte Camino in December several air drops were attempted, but poor visibility, poor recovery grounds, and proximity to enemy positions combined to defeat the attempts on that occasion.

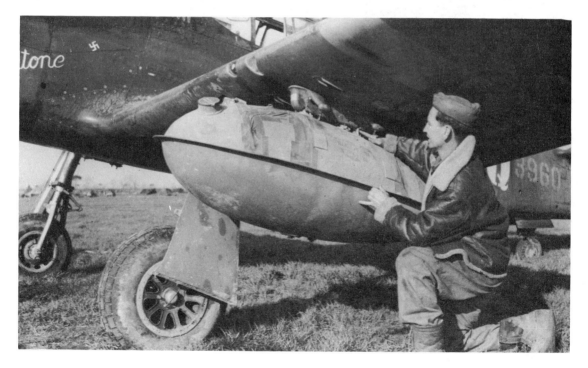

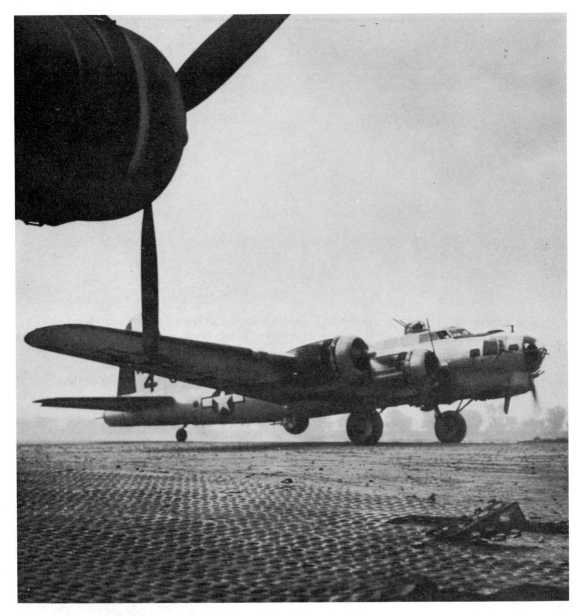

FLYING FORTRESS RETURNING FROM A MISSION. Note part of the pierced steel plank runway in the foreground. The moving of the heavy bombers from their bases in Africa to the Foggia area in Italy was a tremendous undertaking because of the equipment necessary to establish new runways, pumping plants, pipelines, repair shops, and warehouses. The move took place during the late fall and winter of 1943 and required about 300,000 tons of shipping. This was at a critical time of the ground fighting and there was not enough shipping to take care of both the air and the ground fighters. So heavy were the shipping requirements that the build-up of Allied ground forces was considerably delayed.

OBSERVING SMOKE SHELLS FALLING on enemy-occupied Monte Lungo during the second fight for the village of San Pietro Infine on 15 December 1943. The smoke was to prevent enemy observation on the village, which at this time was under infantry attack. The first attacks on San Pietro Infine, 8–9 December, were repulsed by the enemy, as were the attacks of 15–17 December. By this time, however, the Allies had launched an attack and taken Monte Lungo, thus outflanking the Germans in the San Pietro Infine area. This caused the Germans to evacuate the village and withdraw to the next position a few hundred yards back.

HOSPITAL TRAINS taking men wounded in the 1943–44 winter campaign to base hospitals in the Naples area. Until the fighting had advanced beyond Rome, the main Allied hospital area in Italy was in and around Naples. The trains above have German and Italian cars and U. S. locomotives. (Ambulances: truck, ¾-ton 4 x 4, crew of 2 with 4 litter patients or 7 sitting patients.)

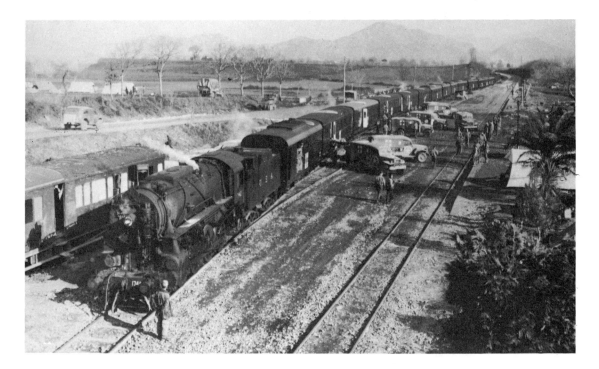

CHRISTMAS TURKEY ON THE HOOD OF A JEEP, Christmas 1943. Every effort was made to give the troops the traditional holiday dinners, complete with trimmings.

VEHICLES CAUGHT IN FLOODWATERS OF THE VOLTURNO. The fall rains of 1943 started early and flooded the rivers and streams between Naples, the main supply base, and the fighting area of the Winter Line. Just behind the lines, mud, traffic, and enemy shelling combined to keep roads and bridges in a condition that required constant work.

FRONT-LINE SOLDIERS BEING BRIEFED on arrival in rest camp in Naples. Because of lack of food and housing in Italy it was found impossible to give a man a pass and let him seek his own recreation. Military rest camps were set up in several localities, where the men could sleep late in clean beds, have good food, and some entertainment.

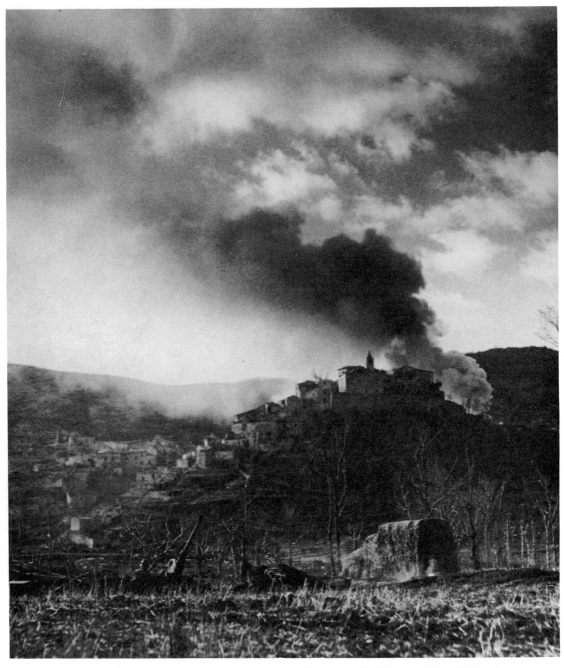

THE TOWN OF ACQUAFONDATA UNDER ENEMY SHELLFIRE. This village
was located on the road between Pozzilli in the Volturno Valley and San Elia, north
of Cassino. The road was on the right flank of the Fifth Army throughout the Winter
Line fighting. Most of the fighting along this road was done by French mountain
troops of the Fifth Army.

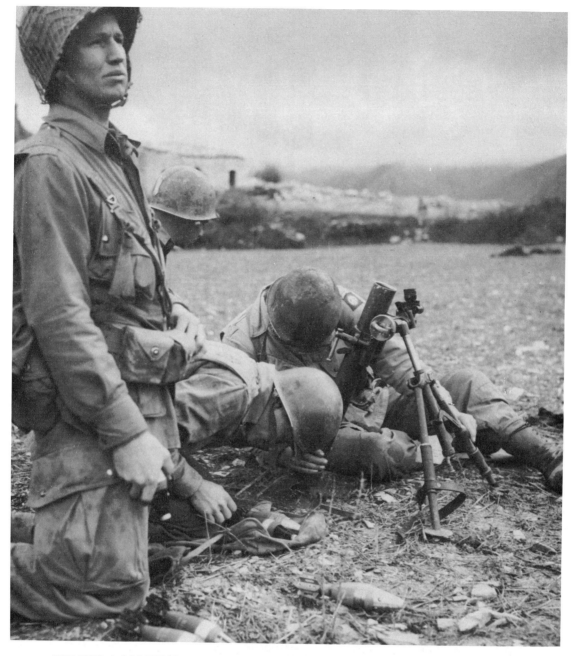

FIRING A MORTAR DURING A TRAINING PROBLEM near Venafro in the Volturno River Valley. Mortars played an important part during the drive through the Winter Line mountains and an intensive training schedule was maintained prior to and during the drive. (60-mm. mortar M2, mount M2, standard, developed by the French, but manufactured in the United States under rights obtained from the French.)

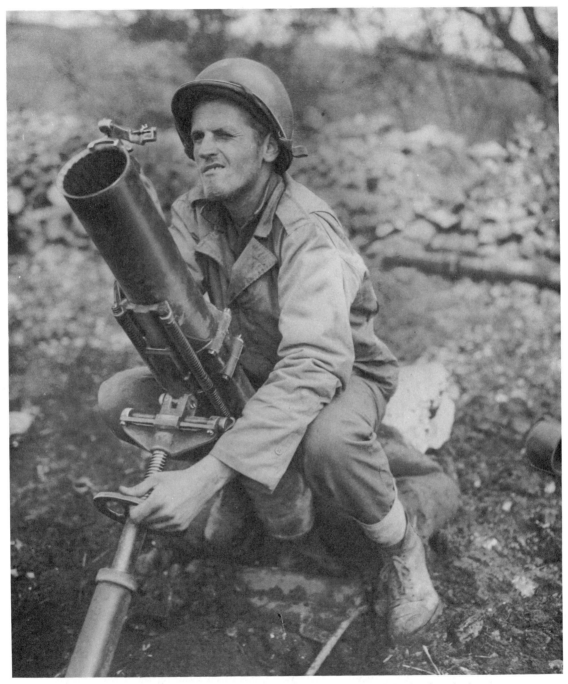

ADJUSTING ELEVATION AND DEFLECTION of 4.2-inch chemical mortar. This mortar had a rifled barrel and was designed for high-angle fire. Because of its accuracy (insured by rifled barrel), mobility, rate of fire, and ease of concealment, it was particularly suited for close support of attacking units.

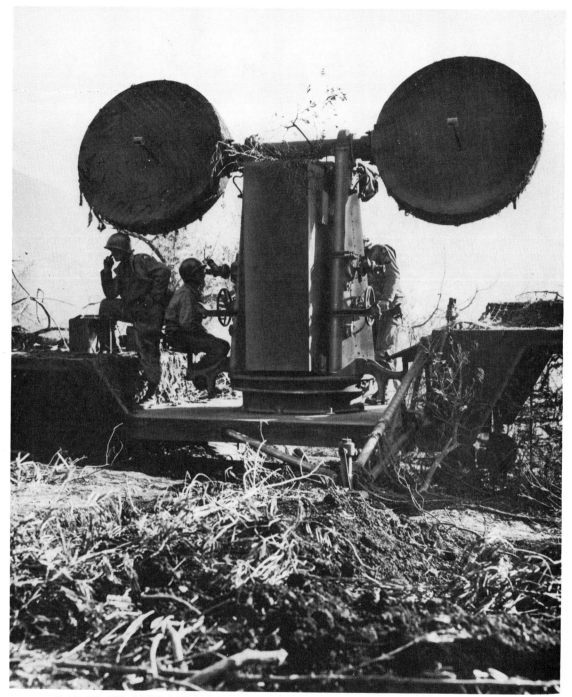

RADAR IN OPERATION NEAR SAN PIETRO INFINE. The operating parts were mounted on a semitrailer towed by a tractor or truck. A van-body truck carried a complete stock of spare parts. (Radar SCR 547.)

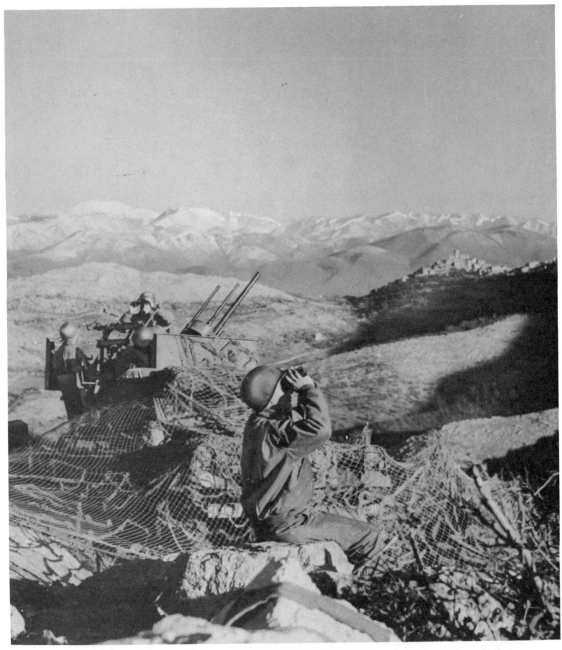

CAMOUFLAGED MOBILE ANTIAIRCRAFT UNIT near San Pietro Infine. Enemy air attacks were not very numerous during the Winter Line fight; the Germans had few aircraft to spare and the weather tended to restrict the use of enemy as well as Allied aircraft. (Multiple-gun motor carriage M15 composed mainly of a half-track personnel carrier with a 37-mm. gun, two .50-caliber machine guns, and M6 sighting system.)

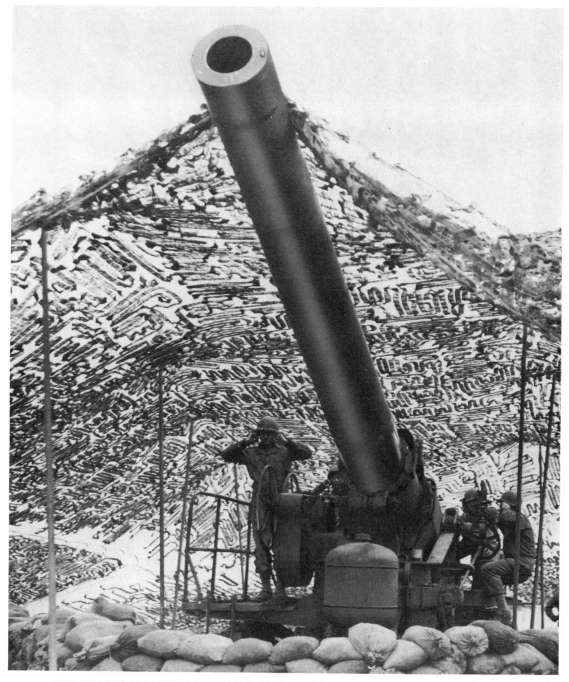

HOWITZER IN THE MIGNANO AREA. This model was the largest U. S. artil-
lery piece in Italy. It and the 8-inch howitzer were rushed from the States to help
reduce the strong enemy fortifications of the Gustav Line; the most heavily fortified
part of this line was in the Cassino area. (240-mm. howitzer.)

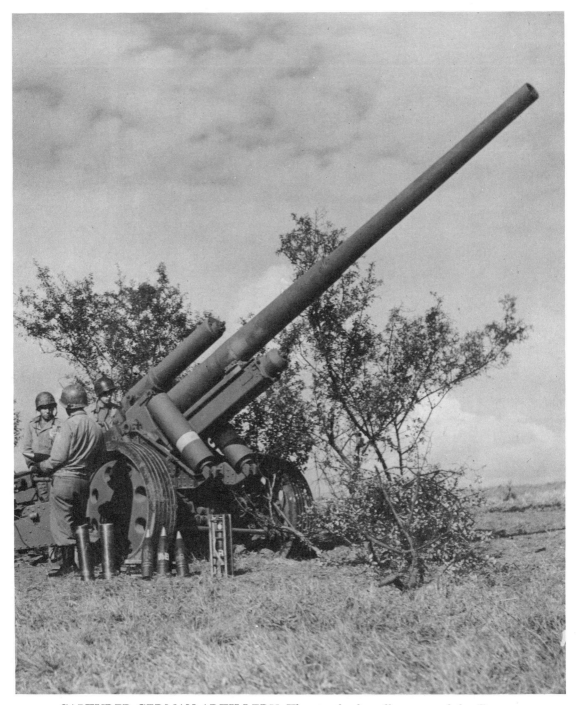

CAPTURED GERMAN ARTILLERY. The standard medium gun of the German Army. It was a World War I model which was used on all German fronts and was part of the corps artillery. The caliber was 10-cm.

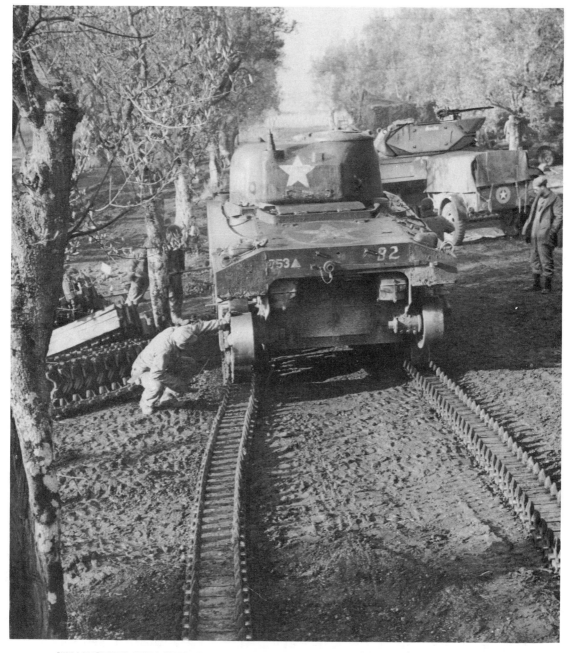

CHANGING TRACKS ON A SHERMAN TANK at Presenzano. This village is located near Highway 6 a few miles behind the lines in Mignano Gap. Tanks had not played a big role during the Winter Line fight because of the mountainous terrain and the muddy lowlands. Tank units were kept ready for use once the infantry had cleared the way through Mignano Gap to Cassino and the entrance to the Liri Valley, the so-called Gateway to Rome.

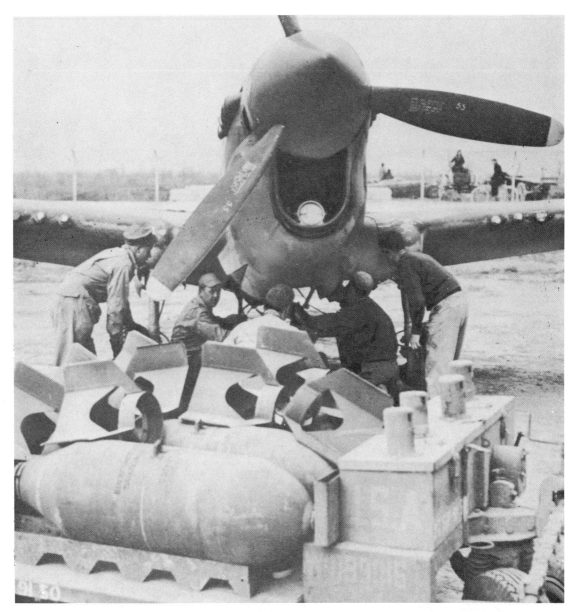

LOADING A CURTISS P–40 Kittybomber for a bombing mission. This was one of the first U. S. fighter types to get into combat. The many variations and modifications of this early fighter of World War II had many names. Those Army planes transported by naval aircraft carrier to the coast of Africa during the invasion there were called Tomahawks, those sold by the United States to the British were called Kittyhawks. Later in the war, as faster fighters arrived to protect bomber formations, the P–40 became a fighter-bomber and was called the Kittybomber. The P–40 groups in Italy were being re-equipped with Republic P–47 Thunderbolt fighters early in 1944.

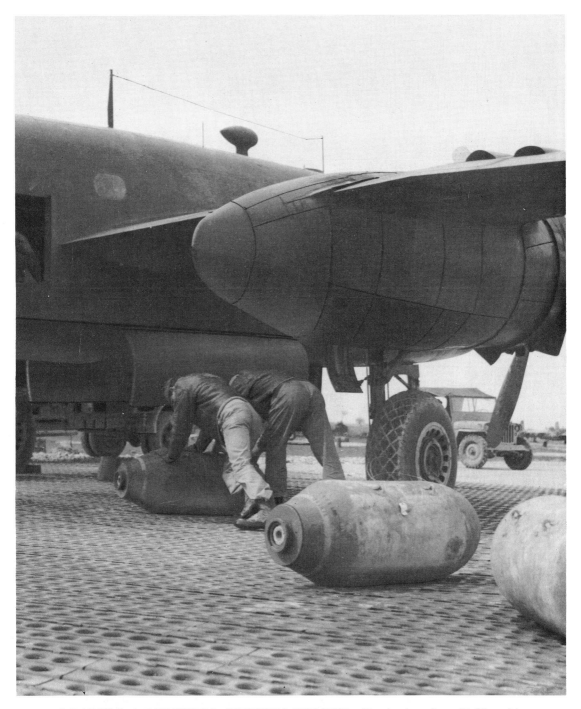

LOADING A MITCHELL MEDIUM BOMBER, North American B–25, with 1,000-pound bombs. Tail fins were attached to the bombs after they were in position in the bomb bay.

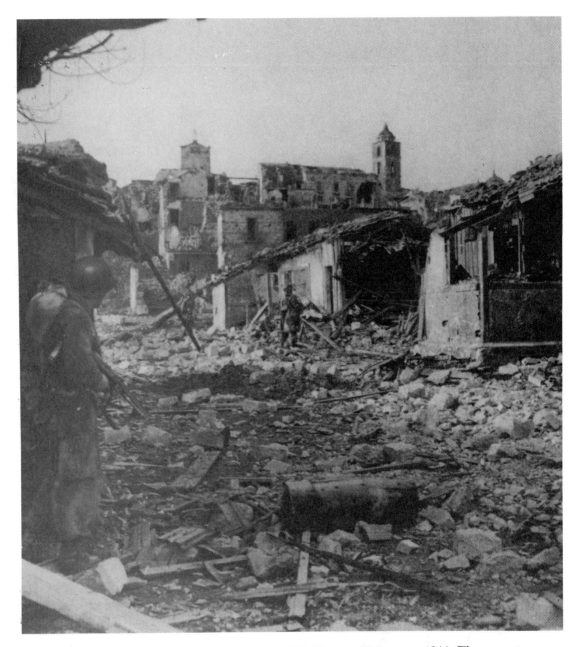

INFANTRY PATROL ENTERING CERVARO on 12 January 1944. The man at left is carrying a tommy gun and covering the two men in front as they hunt for snipers. A few minutes after this picture was made two men of this patrol were killed by Germans hidden in the ruins. Cervaro is on the western slopes of the Rapido Valley. By this time the Fifth Army had fought its way through the Winter Line mountains. Fighting in this area had lasted from 15 November 1943 to 15 January 1944.

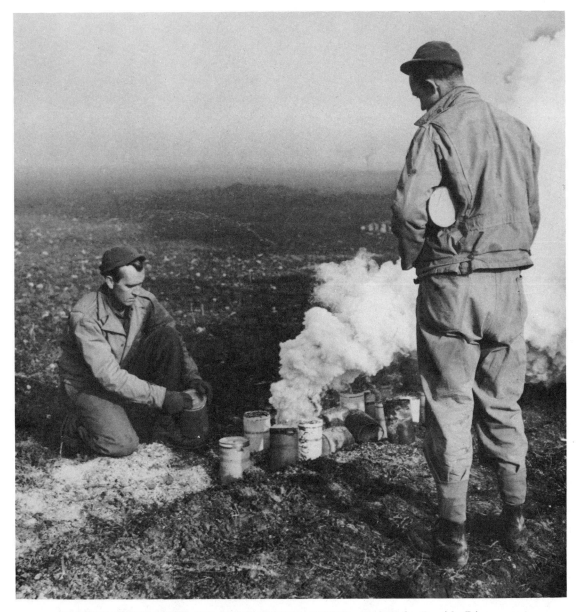

SMOKE POTS USED TO SCREEN INFANTRY crossing the Rapido River near Cassino. The first attempt to cross was made south of Highway 6 by a U. S. division on 20 January 1944. It was a failure. Crossings attempted in the next two days by this division also failed. By afternoon of 22 January all assault boats had been destroyed, efforts to bridge the stream had been unsuccessful, the troops who had managed to cross were isolated, and supply or evacuation had become impossible. On 23 January the attack in the sector was ordered halted. Casualties were 1,681: 143 killed, 663 wounded, and 875 reported missing. On 24 January another U. S. division managed to cross the Rapido north of Highway 6.

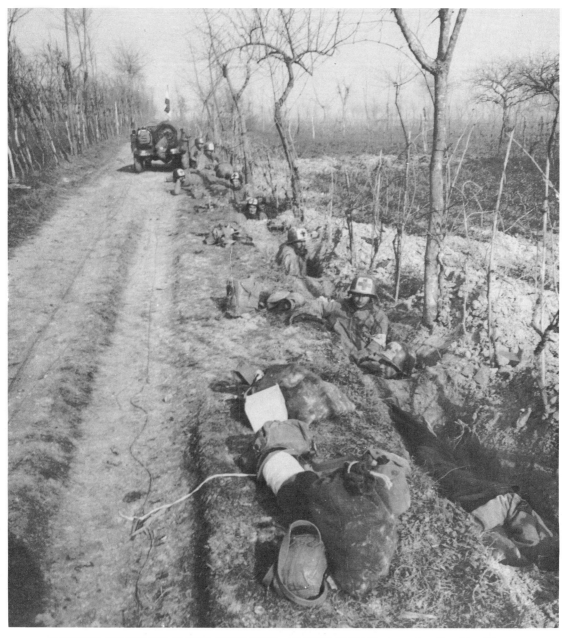

LITTER BEARERS TAKE SHELTER ALONG ROAD near the Rapido River during the first crossing attempt. Casualties among medics were high during the Rapido River crossings. Visibility was generally poor because of mist or artificial smoke and enemy automatic weapons had been zeroed in on likely crossing sites and the surrounding areas. The only means of protection for the litter bearers was the red cross markings on their helmets and sleeves, but at night and during periods of poor visibility in the daytime these identifications were not easily seen.

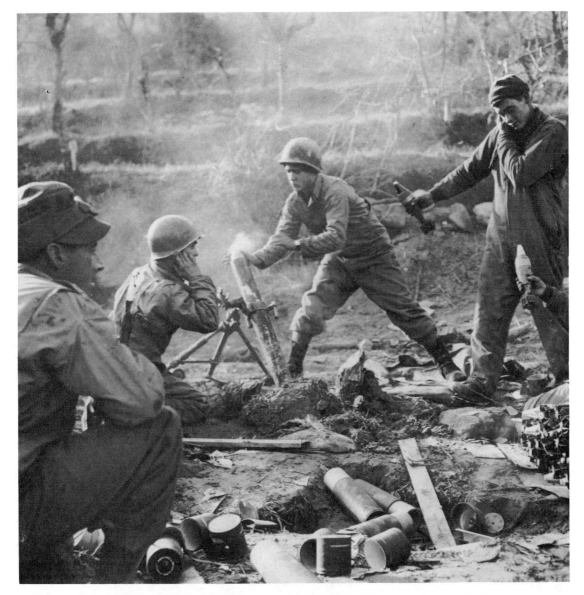

FIRING A MORTAR during the successful Rapido River crossing on 24 January. The attack was made north of Highway 6 and directed toward the mountains north of Cassino. The outskirts of the town were entered for the first time on the morning of 26 January. Tanks were not able to help during the first few days as the ground was too soggy and the engineers were unable to construct bridges. The entire area was under observation from Montecassino and the adjacent hills. Four tanks finally managed to cross during the morning of the 27th, but by noon they were all out of action. Two days later thirty tanks were across, the infantry had taken the village of Cairo high in the hills north of Cassino, and the Allies had made the first dent in the Gustav Line in the Cassino area. (81-mm. mortar.)

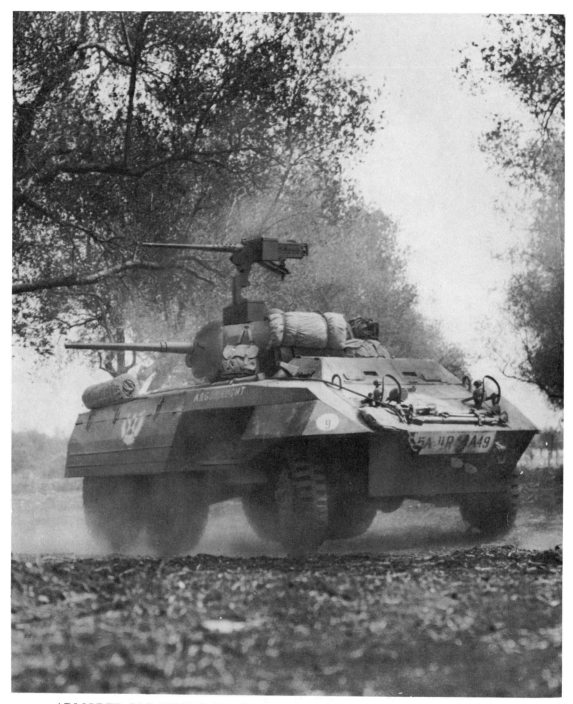

ARMORED CAR FIRING ITS CANNON IN THE CASSINO AREA. (Armored car M8; principal weapon, 37-mm. gun. The one above is also equipped with a .50-caliber M2 Browning machine gun in AA mount.)

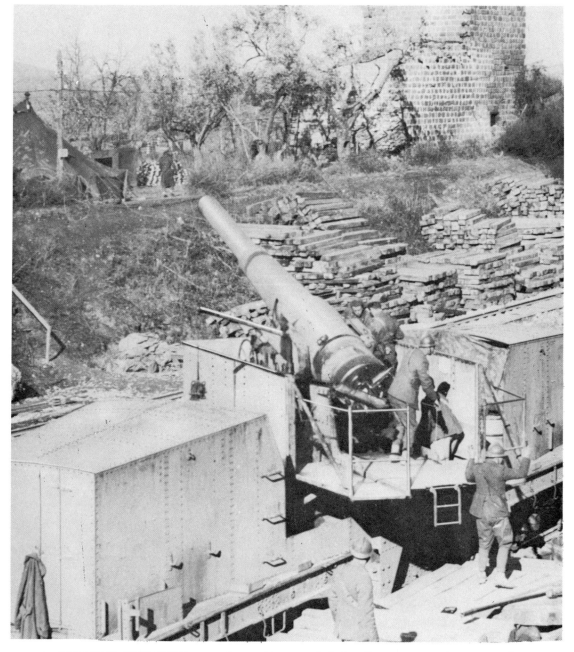

ITALIAN SOLDIERS preparing to fire one of their railway guns against targets in the Gustav Line. On 7 December 1943, Italian units first entered the fight on the side of the Allies under command of Fifth Army. The Italians took over a narrow section in Mignano Gap with 5,486 combat troops. In addition to the combat personnel the Italians also provided various service companies and pack units which proved valuable in solving the difficult supply problem in the mountains.

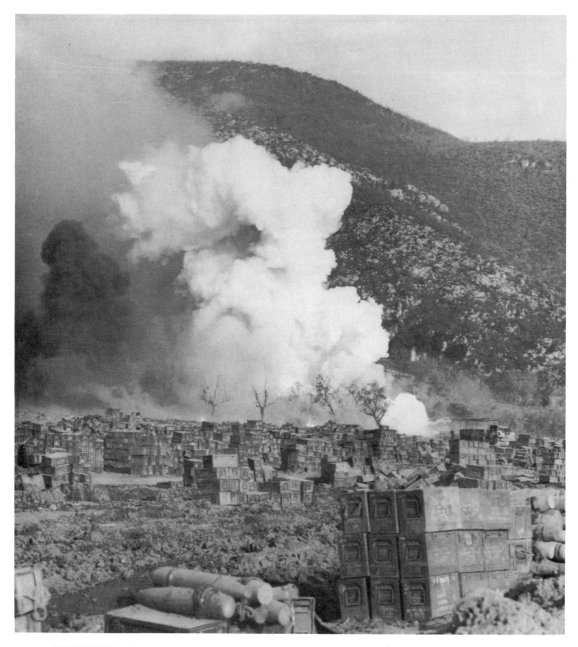

BURNING AMMUNITION DUMP in the Mignano Gap area near Highway 6. The dump was located about seven miles behind Cassino front. The fire was accidental and not due to enemy action. Dumps in this area were not camouflaged because they were too large and Allied air forces had most of the enemy air grounded. Huge quantities of ammunition were needed to reduce the defenses of the Gustav Line. Dispersion was difficult because of the muddy ground. Vehicles became mired as soon as they left the road.

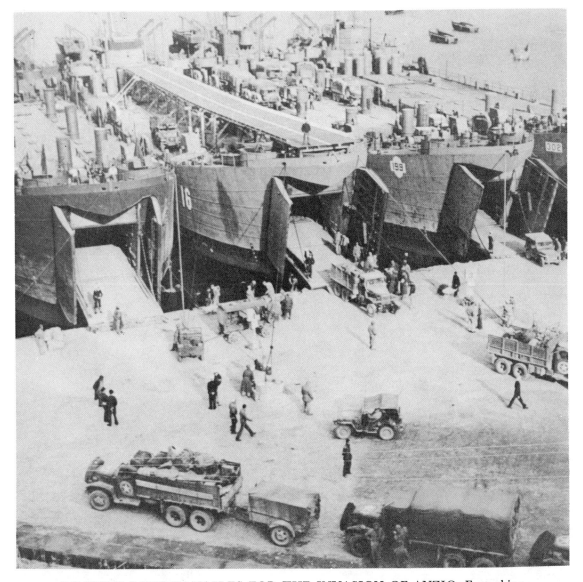

LOADING LST'S IN NAPLES FOR THE INVASION OF ANZIO. Everything was combat-loaded for quick removal, as plans required the convoy to be unloaded in twenty-four hours. The slow advance of the Allies late in 1943 led to the revival of plans for an amphibious operation south of Rome. Early in January 1944 the Allies broke through the Winter Line and unless some movement could be devised to breach the more formidable Gustav Line they faced another difficult mountain campaign. Enough landing craft for Anzio were finally assembled, though resources were limited by requirements for the coming Normandy invasion. (Note LST in center, with take-off runway for cub observation planes. Planes could not land on these runways. Two ships were thus equipped with six planes each which landed on the beachhead shortly after dawn on D Day, 22 January 1944.)

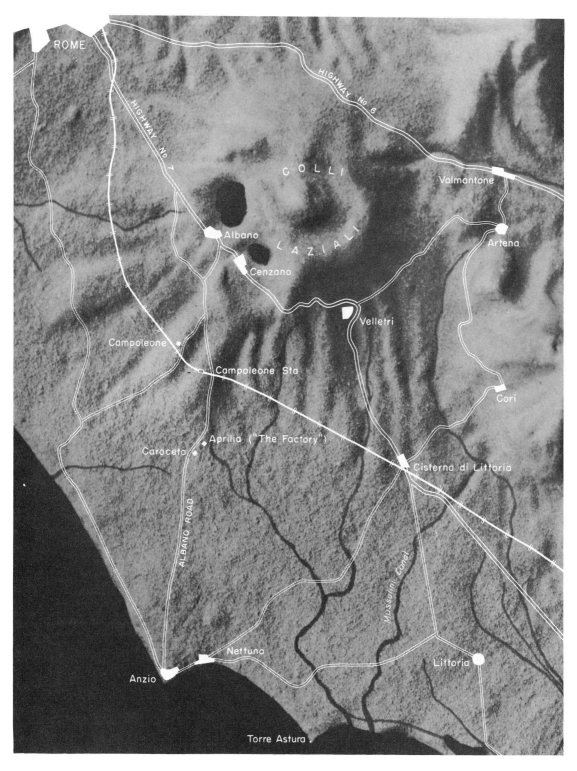

THE ANZIO BEACH AREA. Top: looking westward, Astura tower lower right; bottom: looking eastward. The beach shown in these pictures was the U. S. zone of the landing area. The British landing beach, about six miles northwest of Anzio, proved too shallow for unloading supplies. It was closed soon after the British forces had landed there, and supplies were handled mostly through the port of Anzio. The Anglo-American assault force consisted of almost 50,000 men and 5,200 vehicles.

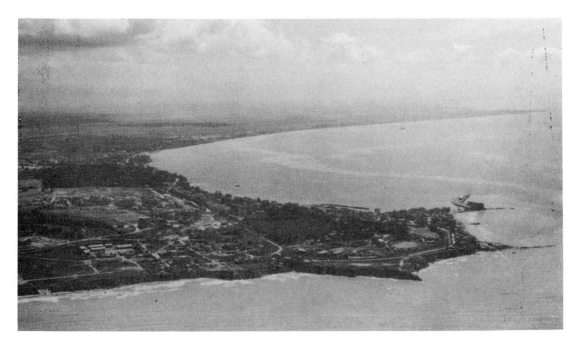

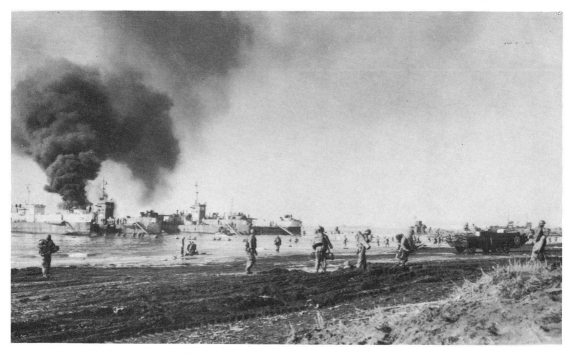

MORNING OF D DAY. Top: men coming ashore from LCI's. Enemy air raids started at 0850 and consisted of three separate attacks by an estimated 18–28 fighter-bombers. One LCI was hit and is shown burning. Bottom: LST backing away from portable ponton causeway after having unloaded. Bulldozer is holding causeway in place. In background is an LCI with a deckload of soldiers waiting to go ashore.

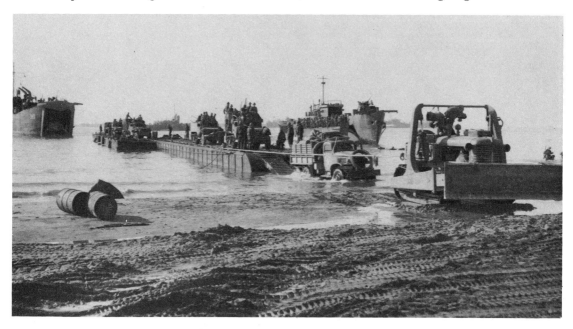

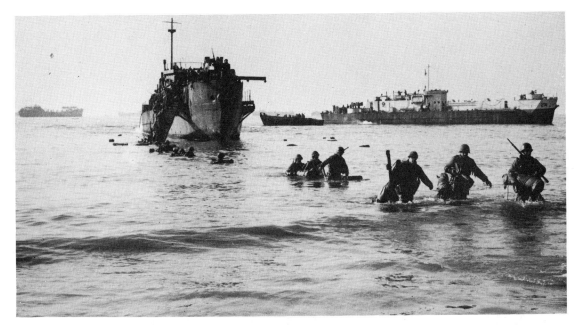

MEN AND EQUIPMENT COMING ASHORE on Anzio beaches on D Day morning. The first assault craft hit the beaches at 0200, 22 January 1944. There was practically no opposition to the landings as the enemy had been caught by surprise. Men with full equipment wading ashore from LCI (top); in foreground are two DUKW's near beach, at right is LST unloading equipment over portable causeway pontons (bottom).

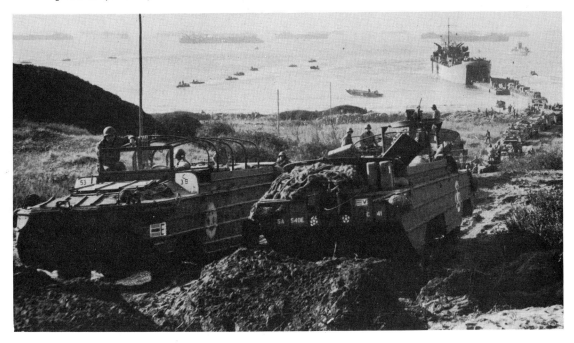

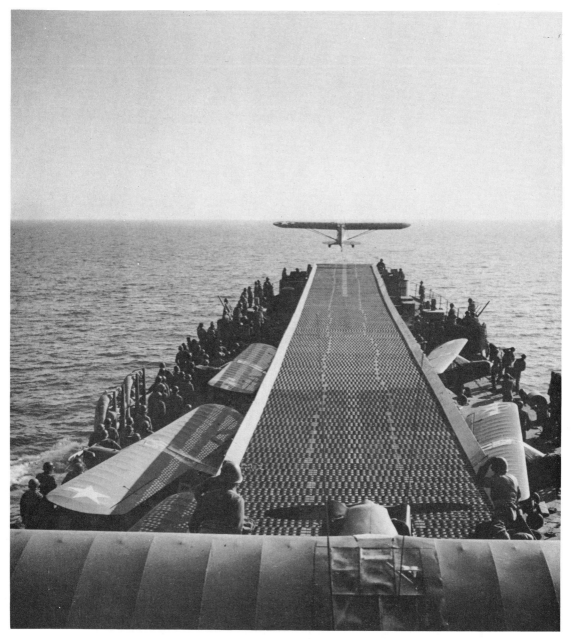

ARTILLERY OBSERVATION PLANE taking off from LST carrier to land at Anzio beachhead shortly after dawn on D Day. The first use of an LST carrier for this purpose was during the invasion of Sicily. Two planes were launched and directed naval fire to the vicinity of Licata, Sicily. Cub planes were to play an important part at Anzio. The area of the beachhead and surroundings is generally flat and featureless and in such terrain observation was at a premium and it was vital to secure or deny that observation.

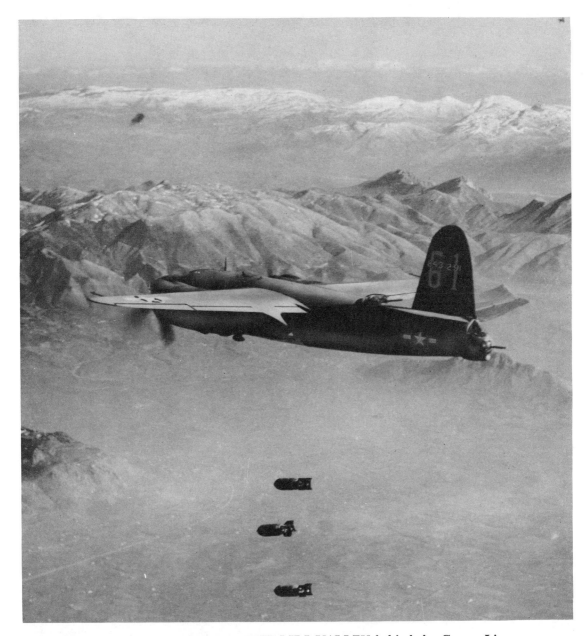

B–26 BOMBING ROADS IN THE LIRI VALLEY behind the Gustav Line on 22 January 1944 in order to hamper the enemy in sending troops to the Anzio area. The hill at lower left is Montecassino. The mountains immediately above the plane were the scene of bitter fighting during the winter of 1943–44. While the Anzio landing was still in preparation the Allied air forces had been bombing airfields and communication centers, and the army had started its drive (on 17 January 1944) to penetrate the Gustav Line. By the 22d, the date of the Anzio invasion, the attempt to penetrate the Gustav Line had bogged down in front of the Cassino defenses.

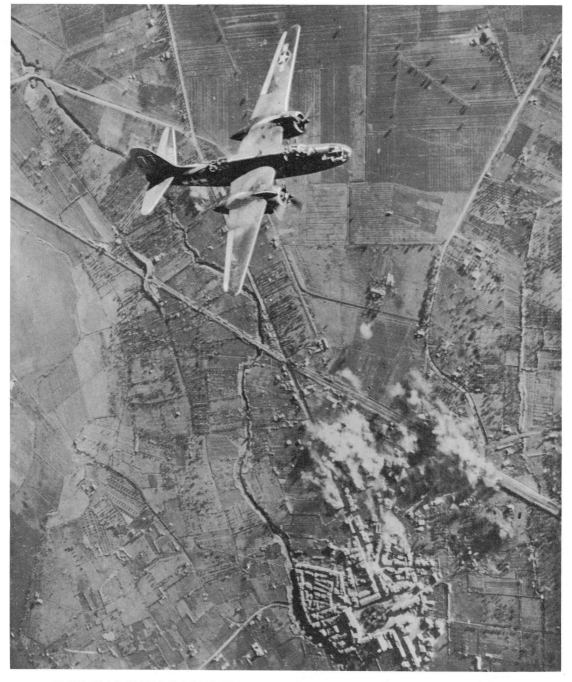

DOUGLAS HAVOC BOMBING RAILROAD BRIDGE and enemy installations at Cisterna di Littoria. This town became one of the enemy strong points surrounding the beachhead. It was shelled and bombed for months, and when it finally fell, on 25 May 1944, it was nothing but a mass of rubble.

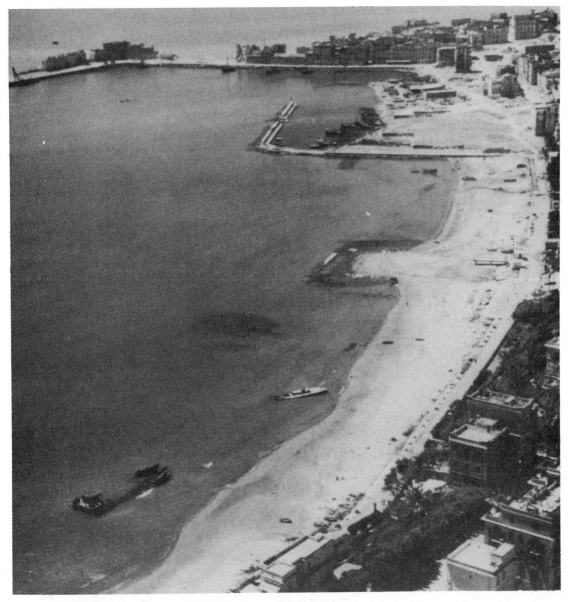

THE PORT OF ANZIO, which was taken intact with very little opposition on the morning of D Day, 22 January 1944. The enemy had placed demolition charges to destroy the port and its facilities, but the assault was so sudden and unexpected that there was no opportunity to set off the charges. By early afternoon the port was ready to receive four LST's and three LCT's simultaneously. By midnight on D Day 36,034 men, 3,069 vehicles, and large quantities of supply had been brought ashore, either through the port or over the beaches. The unloading area of the port (upper right) was not suitable for Liberty ships or other freighters; these continued to be unloaded offshore, mostly by DUKW's.

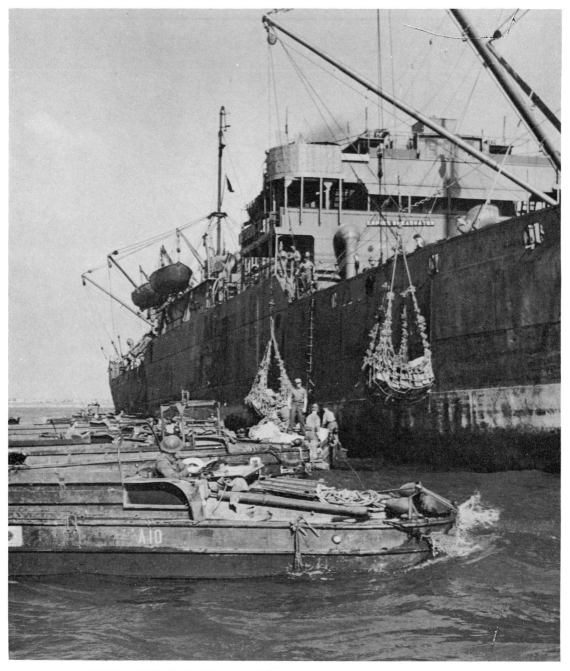

FREIGHTER UNLOADING CARGO INTO DUKW'S. Supplies for Anzio were carried by two methods: in truck-loaded LST's from Naples and in bulk-loaded Liberty ships or other freighters from Africa. After its capture, the port of Anzio sustained regular shelling by enemy artillery. The LST's docked at the port and the freighters unloaded into smaller craft or DUKW's offshore.

MEN WORKING ON A BARRAGE BALLOON. A number of balloons were used at the beachhead, chiefly in and around the port area. Floated at the end of a steel cable, their purpose was to prevent low-level strafing and dive-bombing attacks and to force the bombers high enough to give the antiaircraft gunners time to get on the target. Up to forty balloons were flown at one time over the port. These were filled with highly inflammable hydrogen gas, which was manufactured in the field. Helium gas was sometimes used but was harder to obtain.

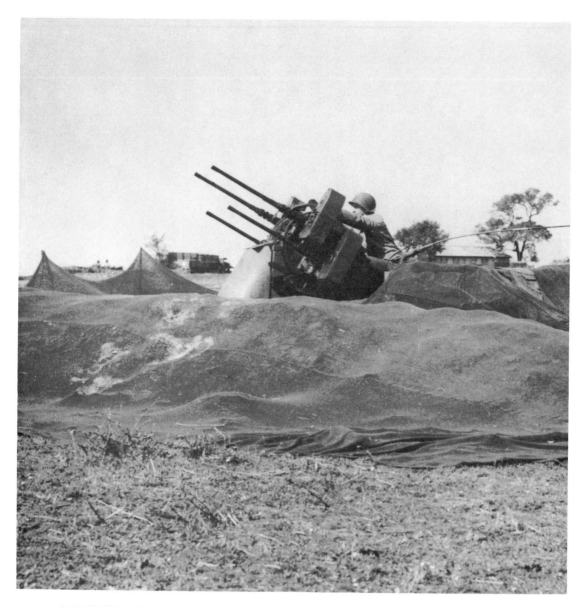

CAMOUFLAGED MULTIPLE-GUN MOTOR CARRIAGE M16 mounting four .50-caliber machine guns in Maxson turret. Allied antiaircraft artillery faced its first major test in Italy with the establishment of the beachhead. The enemy air force now started on a large-scale, continuous offensive. The offshore shipping, port, and beach congestion in the Anzio area offered easy targets. Allied fighter aircraft were based about one hundred miles to the south and they found it difficult to counter the enemy's quick sneak raids and night attacks. Antiaircraft artillery units were mainly responsible for combatting these attacks and keeping the flow of supplies constant. By May 1944, 1,051 pieces of antiaircraft artillery were on the beachhead, including sixty-four 90-mm. guns.

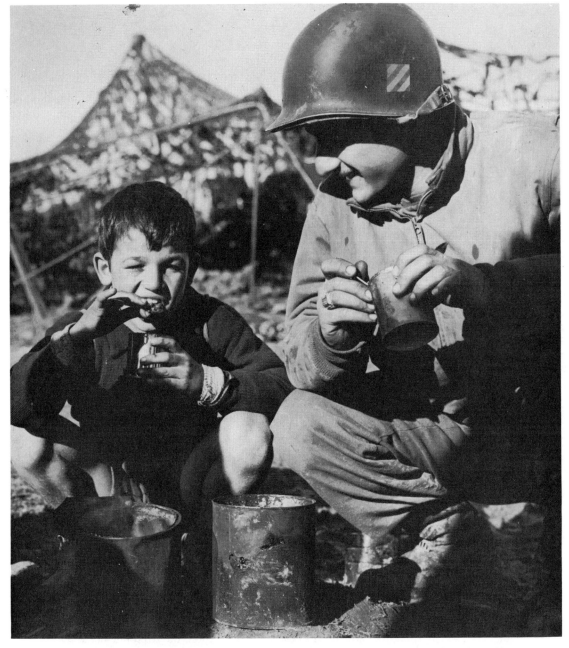

SOLDIER SHARING HIS C RATION WITH NATIVE BOY. A few days after the landing most of the civilian population, about 22,000, were evacuated by sea to Naples, leaving only about 750 able-bodied civilians. Later, as the need for workers increased, an office was set up in Naples to recruit Italian civilians for work at the beachhead. (Soldier is wearing a combat jacket, initially issued with trousers to members of armored units.)

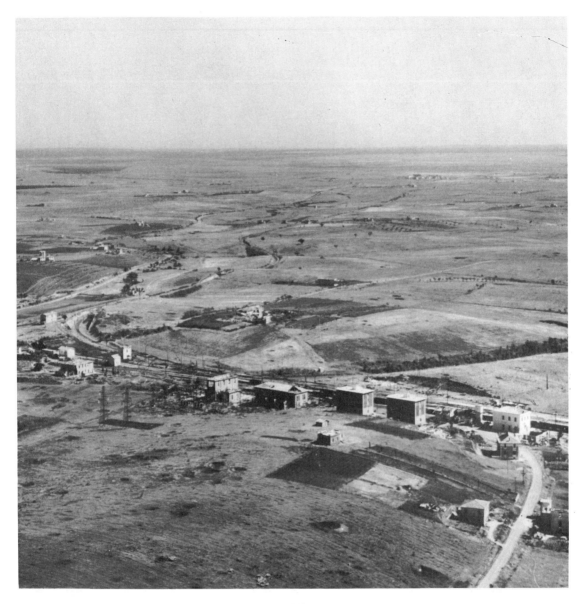

CAMPOLEONE STATION near the Albano highway leading from Anzio to the Colli Laziali, the mountain mass overlooking the plains of the beachhead. By 31 January 1944 the Allies had advanced to Campoleone station, the front line being the railroad bed in foreground above, but the available forces could not hold the area. The enemy was bringing reserves toward the Gustav Line where the Allied drive had stalled. These enemy reserve troops were rerouted to contain the Anzio beachhead and, if possible, force the Allies back to the sea. The picture above, looking toward the sea, gives an idea of the flat, featureless terrain in the area. The group of buildings in the distance at right is the "Factory," scene of hard fighting.

CISTERNA DI LITTORIA. A thrust toward Cisterna di Littoria was made by the Allies on 25–27 January 1944, but was stopped about three miles southwest of the town. Another attempt made on 30 January–1 February met even less success. In the distance are the Colli Laziali overlooking the beachhead. Below the mountains is the town of Velletri. Highway 7 through Cisterna di Littoria leads past the mountains to Rome. Attempts to extend the beachhead failed: the first attempt along the Albano road was stopped at Campoleone; the second, the effort to cut Highway 7 at Cisterna di Littoria, was stopped within sight of the village. By this time the enemy outnumbered the Allies and the latter consolidated their positions and waited for the counterattacks.

CAMOUFLAGED FOXHOLES AND ARTILLERY POSITIONS along the Mussolini Canal. On 2 February 1944, after the unsuccessful attempt to extend the beachhead, the Anzio force received orders to dig in and prepare for defense. By this date casualties totaled 6,487. Allied troops were on the defensive in Italy for the first time since the invasion at Salerno.

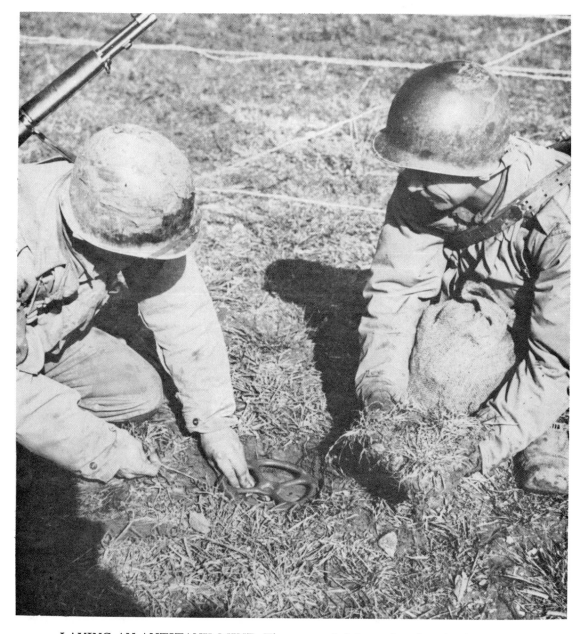

LAYING AN ANTITANK MINE. The man at left is arming the mine by pulling the safety fork. This type of mine contained 6 pounds of cast TNT and had a total weight of 10⅔ pounds. The pressure of a man stepping on the mine would not detonate it, but any vehicle hitting it would set it off. Mines were generally laid at night or on foggy days behind a smoke screen. The task of laying mine fields at night in the open, almost featureless terrain resulted at first in many improperly marked fields causing accidents. The practice was finally adopted of first marking a field, then recording it, and only then laying the mines. (Antitank mine M1A1.)

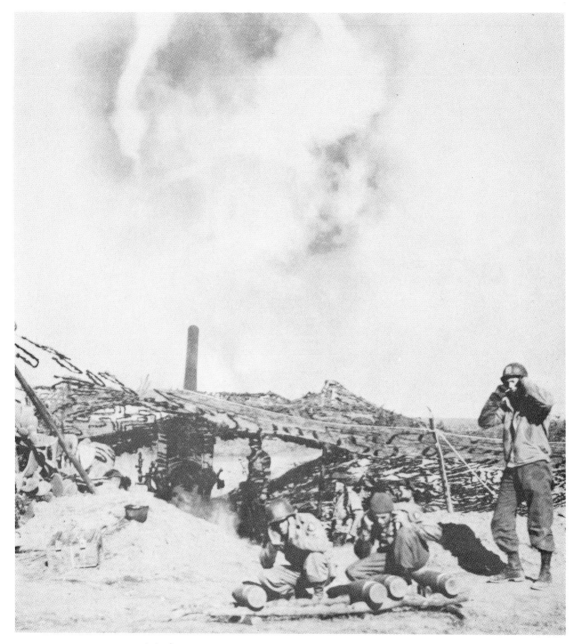

LONG TOM FIRING AT GERMAN POSITIONS. On 3 February 1944 the enemy started a series of counterattacks to wipe out the beachhead. There were three main attacks: 3–12 February, 16–20 February, and 28 February–4 March. The stalemate began on the latter date and lasted until the offensive to break out of the beachhead got under way on 23 May 1944. Enemy prisoners taken during the February fighting always commented on the heavy artillery fire, which caused numerous casualties, shattered nerves, and demoralized many enemy units.

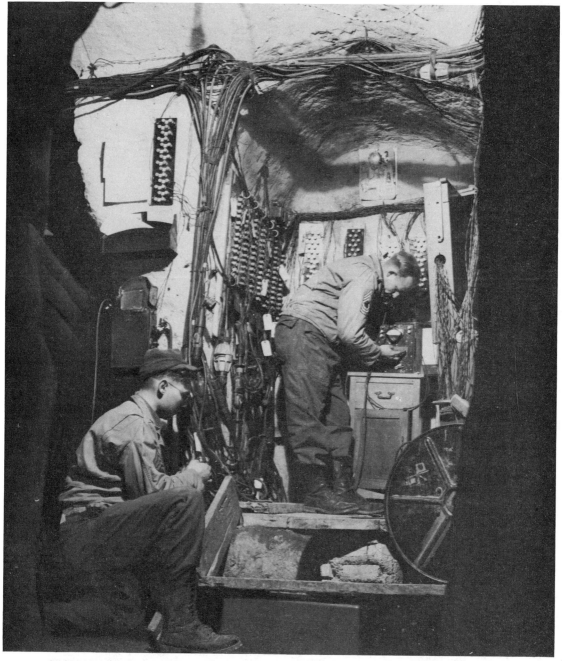

SIGNAL CORPS MEN working in the main frame room of headquarters switchboard installation. The beach area at Anzio–Nettuno was on a slightly higher level than the rest of the beachhead area and was honeycombed with tunnels and caves so far underground that they were bombproof. Wherever possible the installations along the shore were put underground.

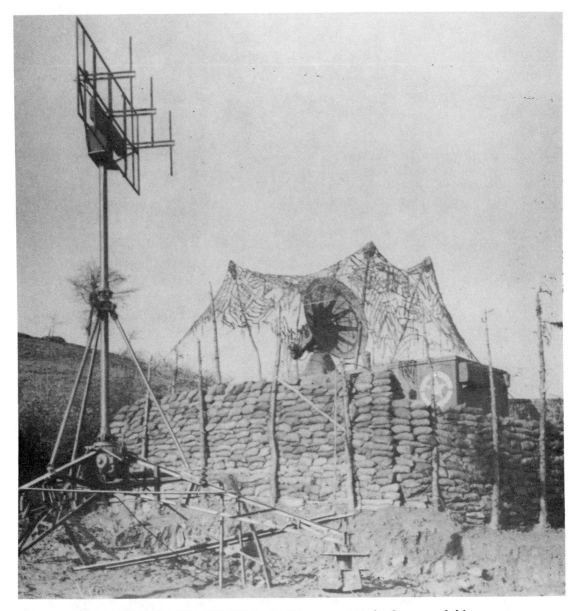

RADAR SET IN OPERATION. By 24 February 1944 the first sets of this type were in position on the Anzio beachhead. They were brought in to cope with enemy jamming techniques and "window" (small strips of metallic paper dropped from attacking planes) which had reduced the effectiveness of earlier types of radar. During the night of 24 February a flight of twelve bombers approached in close formation, using the "window" method of jamming. Forty-eight 90-mm. guns directed by radar of the improved type caught them at extreme range over enemy territory and brought down five with the first salvo. The remainder of the formation jettisoned their bombs and fled. (Radar SCR 584.)

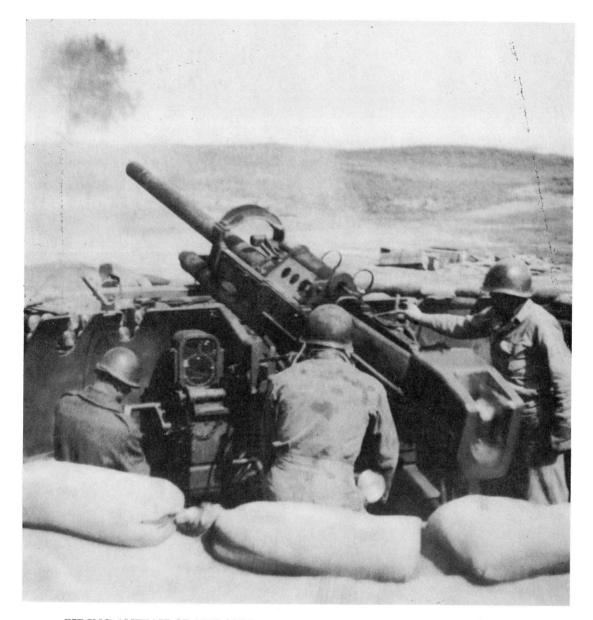

FIRING ANTIAIRCRAFT GUN at ground targets. The enemy counterattack down
the Albano road on 16–20 February 1944 was the most severe and dangerous of the
three main attacks the Germans made on the Allies at Anzio beachhead. On the 17th
it looked as if the enemy might succeed in driving down the Albano road from the
Campoleone area to Anzio and thus split the beachhead forces. To aid the hard-
pressed infantry, all the artillery in the area was brought to bear on the enemy. In
addition to 432 guns representing corps and divisional artillery and three companies of
tanks, four batteries of 90-mm. antiaircraft guns were employed against ground targets.
Two cruisers assisted with fire on the flank of the beachhead.

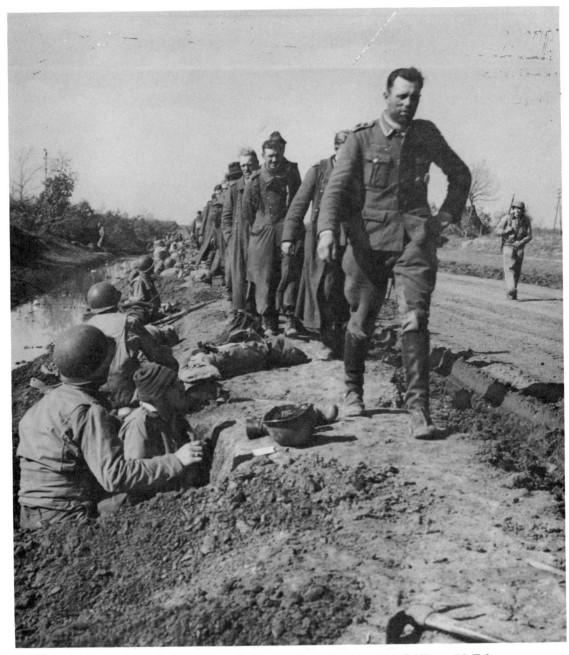

GERMAN PRISONERS TAKEN NEAR THE ALBANO ROAD on 19 February 1944. The German attack started in the morning hours of 16 February and relied on smoke to conceal the advancing troops. By 18 February the enemy infantry, strongly supported by tanks, had pushed the defenders back about three miles. The next day the Allies counterattacked and halted the advance. Never again was the enemy to come so close to rolling up the final beachhead line.

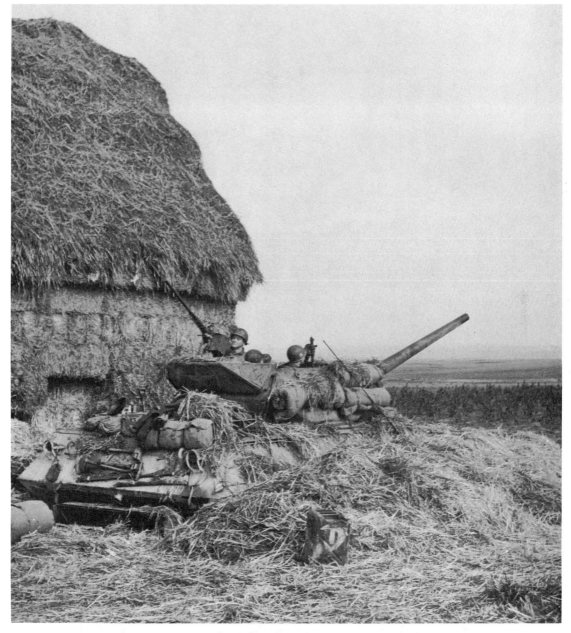

TANK DESTROYER DUG IN BEHIND HAYSTACK. These weapons were used well forward, sometimes dug in, but more often placed behind a house or other means of concealment. Tanks were also used well forward, particularly after the front became somewhat stabilized at the beginning of March. The distribution was about one company of tanks to one regiment in the line. This practice violated the principle of employing tanks in mass, but their usefulness in support of the infantry outweighed the loss of mobility and dispersion of strength.

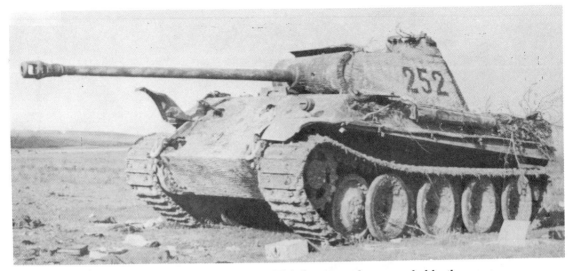

THE GERMAN PANTHER TANK. This heavy tank was probably the most successful armored vehicle the Germans developed, having relatively high speed and maneuverability, combined with heavy armor and a rapid-fire, high-velocity gun. It first appeared on the Russian front in the summer of 1943, and soon thereafter on the Italian front. No U. S. tank comparable to it appeared. The frontal armor could not be penetrated by Sherman tank guns at ordinary fighting range. In constructing this vehicle the Germans were influenced by the Russian tank, the *T34*. The corruguated surface (top picture) is a plastic coating to prevent magnetic mines from sticking to the metal. (*Pz. Kpfw.* Panther, 7.5-cm. *Kw. K. 42 (L/70)* gun. After Action Reports indicate that there were a total of 165 enemy tanks surrounding the beachhead as of 28 February 1944. Of these 32 were Tigers and 53 Panthers, the rest being mostly Mark IV.)

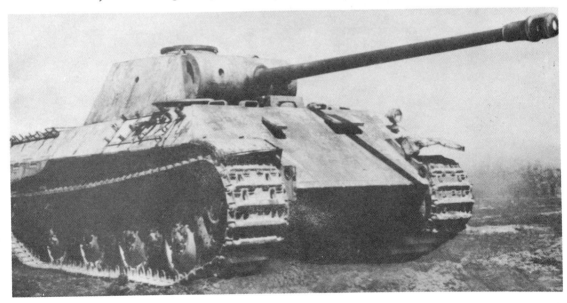

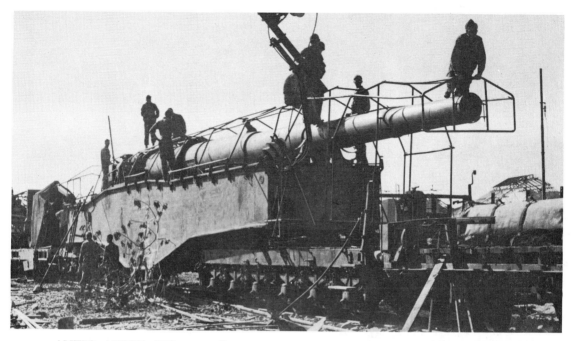

ANZIO ANNIE, 280-mm. railway gun (top). The beachhead faced a heavy concentration of German artillery. During enemy attacks in February this was employed mostly in direct support of the infantry. Standard German divisional medium howitzer (bottom). The caliber was 150-mm. (15-cm. *s. F. H. 18.*)

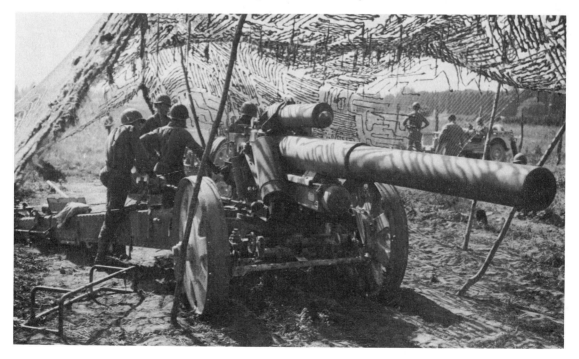

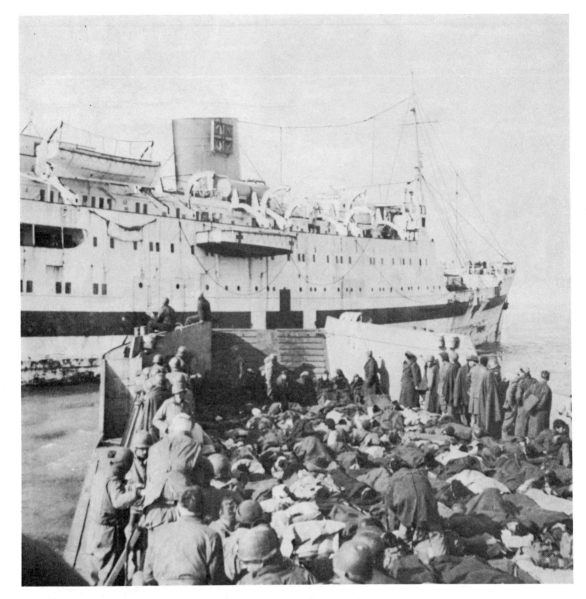

LANDING CRAFT BRINGS WOUNDED TO HOSPITAL SHIP in Anzio bay. On the night of 24 January 1944 a fully illuminated and marked British hospital ship was bombed and sunk while taking wounded on board. All evacuation from the beachhead was by sea. Air transportation could not be used, since the dust raised by planes landing or taking off brought on enemy shelling. Hospital ships were used whenever possible, but as these could not dock in the shallow port, LCT's were used to transfer patients from shore to ships. When storms and high seas interrupted this procedure the wounded were loaded on board LST's at the Anzio docks for the 30-hour trip to Naples. For the period 22 January to 22 May, 33,063 patients were evacuated by sea.

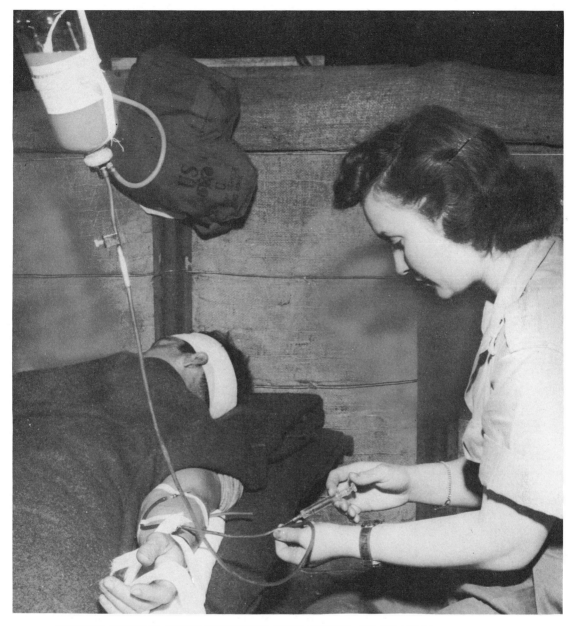

NURSE GIVING INTRAVENOUS INJECTION OF PLASMA to a wounded soldier. In the period 22 January to 22 May 1944, 18,074 American soldiers suffering from disease, 4,245 from injuries, and 10,809 battle casualties—33,128 in all—were given medical care and attention in evacuation hospitals at the beachhead. If recovery required fourteen days or less, the casualty remained in the evacuation hospital; if the recovery period was estimated to take more than two weeks, the patient was evacuated to one of several base hospitals in the Naples area as soon as he was strong enough to be moved.

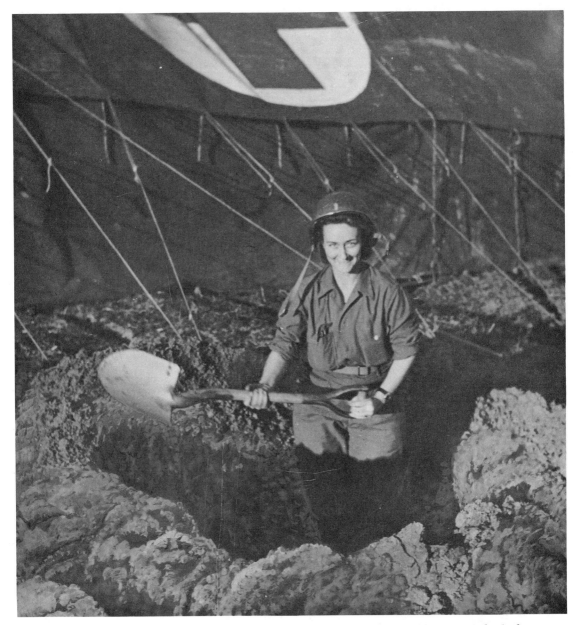

NURSE DIGGING FOXHOLE. The confined area of the beachhead and the lack of distinction between the front lines and rear areas were nowhere more noticeable than in the locality of the U. S. evacuation hospitals. For more than sixteen weeks medical personnel healed and comforted the sick and wounded in an area within range of enemy artillery. Soldiers called the hospital zone "Hell's Half Acre" and admitted their preference for the protection of a front-line foxhole to a cot in a hospital tent. Of the medical personnel at the beachhead, 82 were killed in action, 387 were wounded, 19 were captured, and 60 were reported missing in action.

WRECKAGE OF EVACUATION HOSPITAL ON THE BEACHHEAD. Most of the hospitals were located in the vicinity of Nettuno, and all were within easy range of enemy artillery. It was impossible, within the confined area of the beachhead, to locate hospitals in an area out of reach of enemy artillery.

MECHANICAL SMOKE GENERATOR IN ACTION. Generators of this type were used at ports to prevent accurate bombing and in the field to conceal movements of troops. Large quantities of oil, about two 53-gallon drums per hour, were consumed. The generator was capable of converting hydrocarbon oils of low volatility into a fog of relatively great persistence. The special oil, usually referred to as fog oil and used for the generation of large area screens, was a petroleum by-product. The fog would frequently extend five miles or more downwind. (Smoke generator M1.)

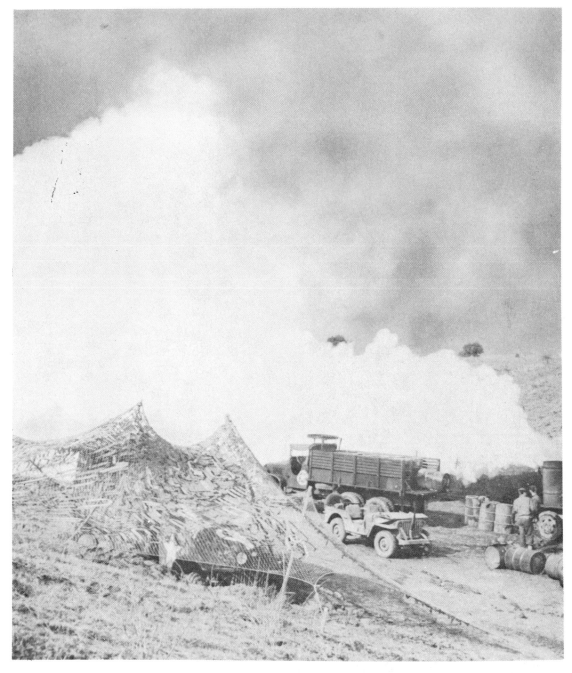

SMOKE SCREEN SHIELDING ALLIED POSITIONS. Smoke was used to a great extent on the beachhead because the flat terrain which the Allies occupied was under constant observation from the enemy-held Colli Laziali. The harbor area was screened by smoke starting one-half hour before sunset, the time the enemy bombers usually appeared, and on every air raid alarm.

BATHING FACILITIES at the beachhead were limited but those available were used to the fullest extent.

PRIMITIVE SHOWER BATH. Some of the more hardy souls took their showers directly from the well in winter.

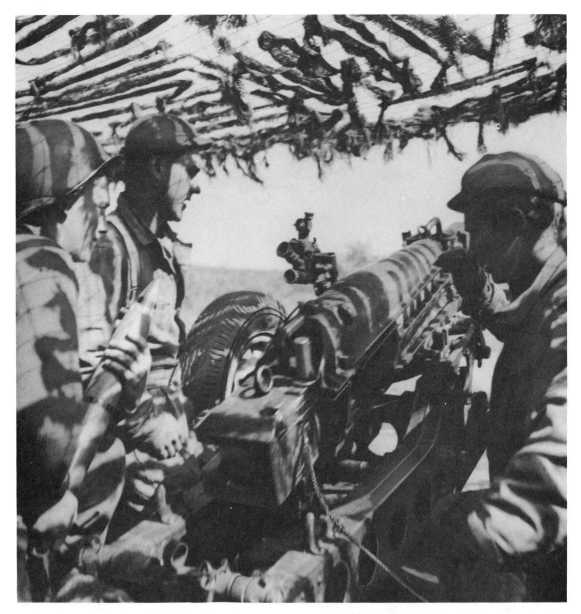

FIRING A PACK HOWITZER. From the establishment of the beachhead the Allied artillery surpassed that of the enemy. Even with limitations imposed on some types of ammunition, the artillery was firing about 25,000 rounds per day. At the same time the enemy fire falling in the port and the rest of the beachhead was estimated to be not more than 1,500 rounds. The amount of Allied artillery increased month by month. At the end of March a battalion of 8-inch howitzers was brought in with the primary mission of demolishing houses used by the enemy as observation posts and strong points. In April a battery of 240-mm. howitzers was added to the beachhead forces. (75-mm. pack howitzer.)

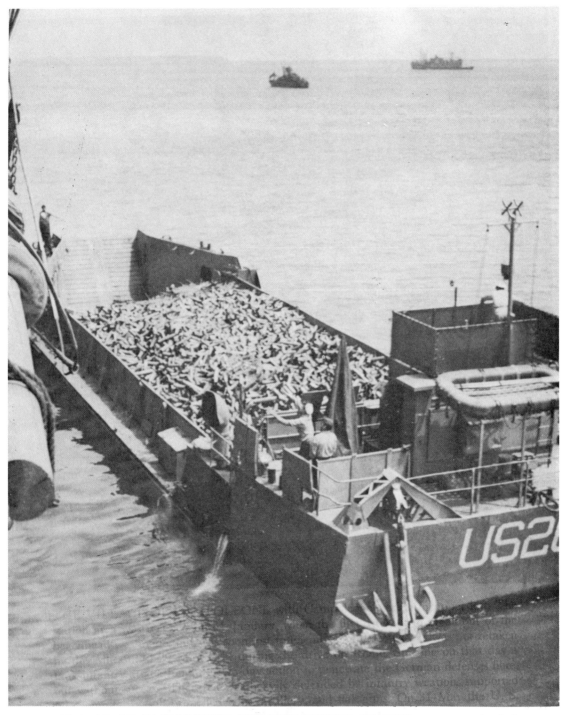

USED SHELL CASES BOUND FOR THE UNITED STATES as scrap are loaded
into a freighter from an LCT.

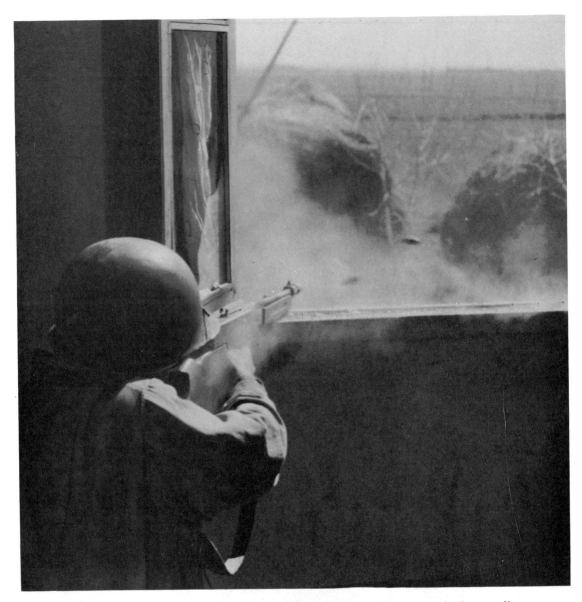

SOLDIER FIRING A SUBMACHINE GUN at a haystack suspected of concealing enemy soldiers. After the last German attempt to reduce the beachhead had died out during the first days of March 1944 there began a period of stalemate on the Anzio plain. This did not mean the end of fighting; it meant the end of pitched battles by large numbers of men and armor. Artillery duels still continued and enemy aircraft bombed and strafed positions as before. There were frequent clashes and fire fights between infantry patrols. To provide protection against enemy infantry attacks, stress was laid on the development of self-sustaining, mutually supporting points of resistance, usually centered on Italian farmhouses. (.45-caliber Thompson submachine gun.)

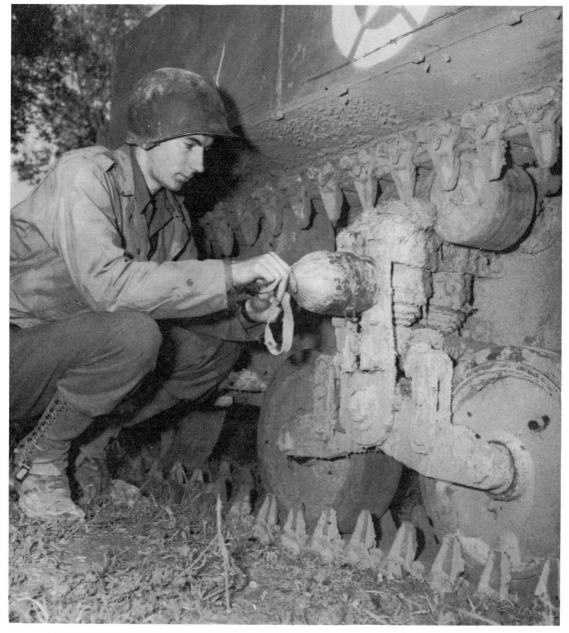

SOLDIER TESTING "STICKY GRENADE" on an armored vehicle. This was a British weapon used against tanks. It had a hollow-type charge, and was held to the metal by magnets. Unlike the real sticky grenade which could be thrown and which stuck to the target by means of a glue substance, this antitank grenade had to be hand-placed. During the stalemate period the front-line troops were equipped with this type of grenade in addition to bazookas. The charge was a delayed action type and the grenade was set off by pulling the string attached to it.

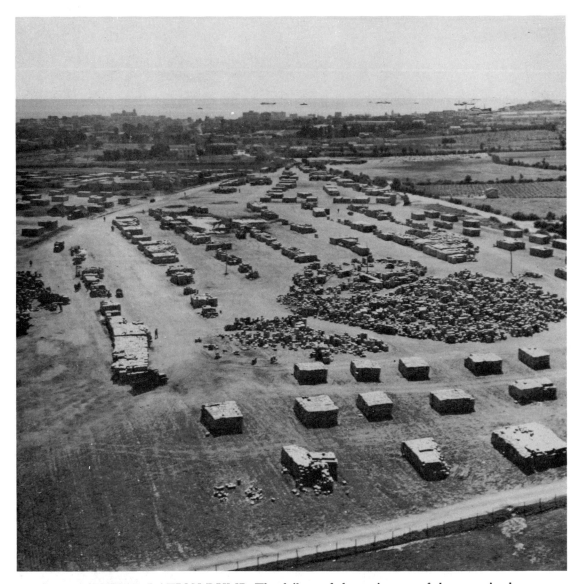

BEACHHEAD RATION DUMP. The failure of the main part of the army in the south to break through the Gustav Line and join the troops at Anzio necessitated maintaining the beachhead by sea for a longer period than planned. Shipping schedules were revised to take care of the gradually growing forces and to build up a reserve of food, fuel, ammunition, and other supplies. Food could be kept in a large dump, but fuel and ammunition presented problems. The beachhead area was so small that fuel and ammunition dumps, no matter where placed, were within enemy artillery range. These dumps were kept small and dispersed in order to keep losses to a minimum. Between 22 January and 10 March 1944 a little more than 1,000 tons of ammunition were destroyed, mostly by enemy bombing. Losses never became critical.

SOLDIERS BUTCHERING A COW. Cattle and sheep would frequently wander into mine fields and be wounded or killed. The carcasses presented a welcome change from regular rations. During the stalemate some soldiers had their own chicken pens, others bought fresh eggs from the few remaining farmers. Foraging patrols for homeless livestock and poultry were as carefully planned as patrols against the enemy.

LISTENING TO A CONCERT BY A SOLDIER ORCHESTRA. This is in a recreation area established by one of the divisions on the beachhead in March 1944. Only a limited audience could attend because of the ever-present danger of enemy artillery fire. During the critical period of enemy counterattacks in February all troops were needed for defense, but as soon as the front had become stabilized 750 men every four days were sent by LST to the rest center at Caserta.

OPEN AIR BARBERSHOP AT THE BEACHHEAD located in one of the few wooded sectors of the area. Barber service, because of its uplifting effect on morale, was made available whenever possible.

MALARIA CONTROL. Soldier pouring diesel oil in water-filled bomb crater to kill mosquito larvae. The Pontine Marshes near the beachhead had for centuries been notorious for the prevalence of malaria. In April 1944 large-scale draining projects were started, and patrols were sent out to dust or pour oil on canals, ditches, and pools. This activity was even carried right into no man's land at night. The program, combined with preventive measures taken by the individual soldier, such as the use of head nets, mosquito bars, insect repellents, and atabrine, kept malaria from becoming a medical problem. The division stationed in the worst area did not develop a single new case of the disease.

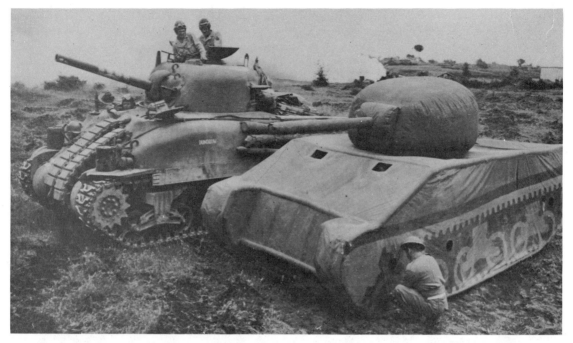

INFLATING RUBBER DUMMY TANK (top). Placing dummy tank in camou-
flaged position which had been vacated by a tank moving toward the front for the
coming offensive (bottom). The dummy tank was designed by the British and
manufactured in the United States.

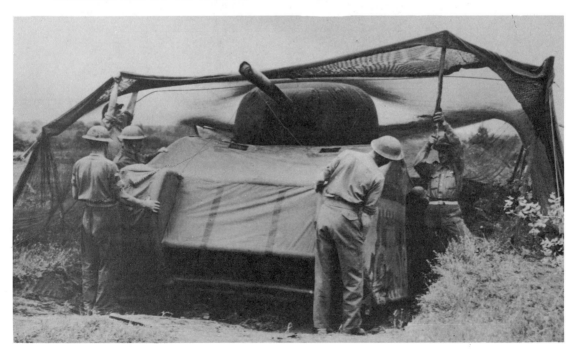

WATCHING THE BATTLE FROM OBSERVATION POINT. The offensive from the beachhead started at 0545, 23 May 1944, when the artillery began firing. Allied medium and fighter bombers strafed and bombed enemy positions. At 0630 the infantry and tanks moved out. The artillery preparations, the most intensive thus far at the beachhead, had searched out command posts, assembly areas, and dumps, with the result that enemy communications and supply lines were severely damaged. The Germans recovered and put up a strong fight, but they could not make up for the initial disorganization.

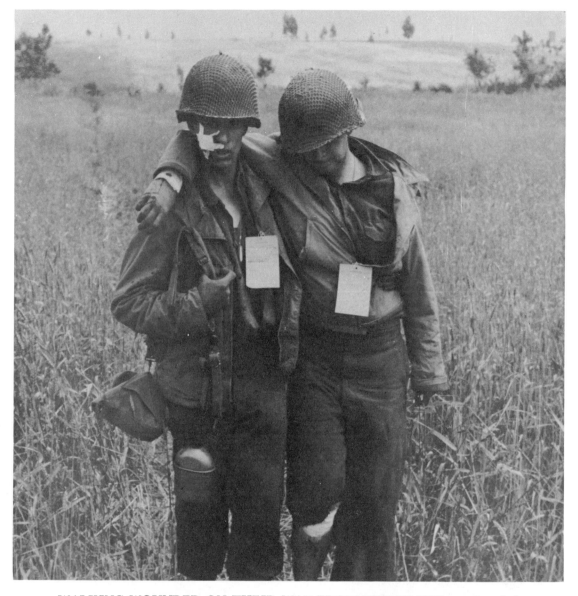

WALKING WOUNDED ON THEIR WAY FROM THE FRONT to a hospital. Tags tell the nature of the wound and what has been done for it in the field or at the first aid station. On the first day of the fight to break out of the beachhead, the Allies suffered the heaviest casualties of the Anzio Campaign. American combat casualties for the whole army on that day were 334 killed, 1,513 wounded, and 81 missing, a total of 1,928 and the high point in the entire Italian campaign. The U. S. and British combat casualties at the beachhead between 22 January and 22 May numbered about 30,000, including at least 4,400 killed and 18,000 wounded. The enemy captured about 6,800 prisoners. The noncombat casualties during this period amounted to about 37,000.

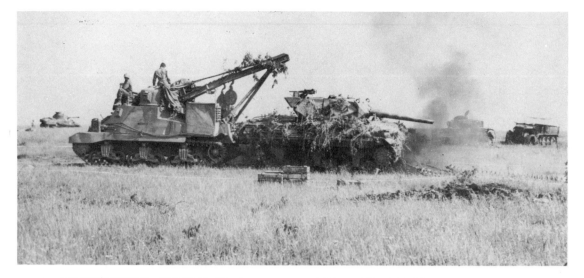

RECOVERING ARMOR. Tank recovery vehicle pulling disabled tank destroyer M10 out of mine field near Cisterna di Littoria (top). Many Allied tanks were disabled by running into their own mine fields. Front of tank destroyer is still smoking from effect of mine blast. In the left background is a disabled Sherman tank. To the right are a ruined German Mark IV tank and a personnel carrier. During the first day's attack the Allies lost heavily in tanks and tank destroyers. Those that ran on mines were generally repairable, those lost as a result of enemy fire were often wrecked beyond repair. Tank recovery vehicle M31 (same as at top) towing German 75-mm. assault gun (bottom).

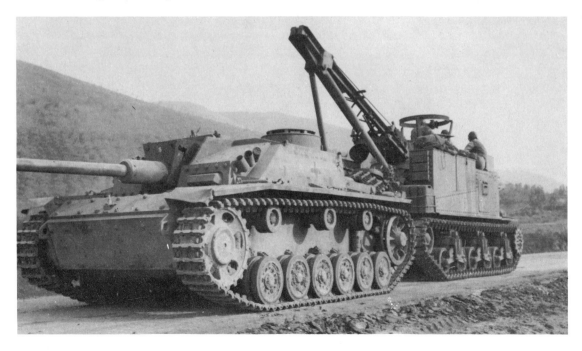

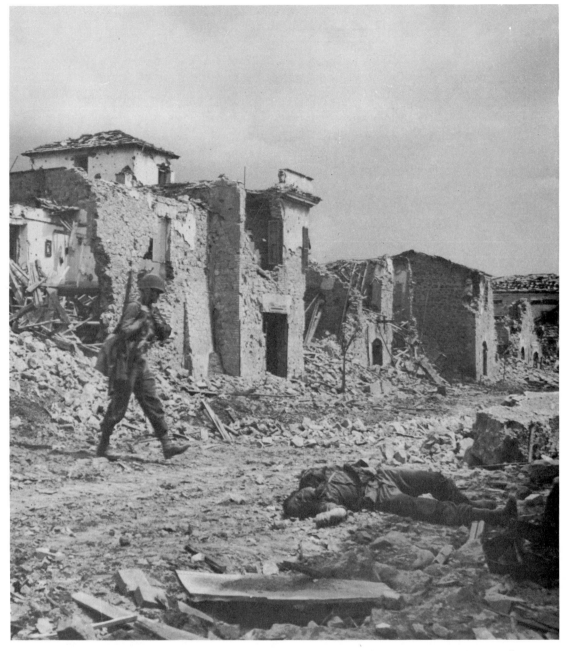

INFANTRY SOLDIER IN CISTERNA DI LITTORIA. This town on Highway 7 had been one of the German strong points facing the beachhead forces. It fell to tanks and infantry on 25 May. The main Allied drive had been launched in the direction of Cisterna di Littoria with the object of continuing straight north to capture Valmontone on Highway 6 and cut off the enemy forces retreating toward Rome from the shattered Gustav Line defenses.

THE VILLAGE OF CAMPOLEONE with Campoleone station in upper left. The station area was reached on 31 January, when the first attempt to break out of the beachhead was made, but was soon lost to enemy counterattacks. It was not retaken by the Allies until 29 May 1944 during the drive on Rome. Starting on that day a tank-infantry attack fought a two-day action to penetrate the German defenses here, but without success. The area was heavily defended by infantry weapons supported by enemy tanks, self-propelled guns, artillery, and flak guns. On 31 May the U. S. armored division making the attack was withdrawn for maintenance purposes. Losses in both tanks and personnel had been severe. The break-through, when it came, was made across the eastern side of the Colli Laziali.

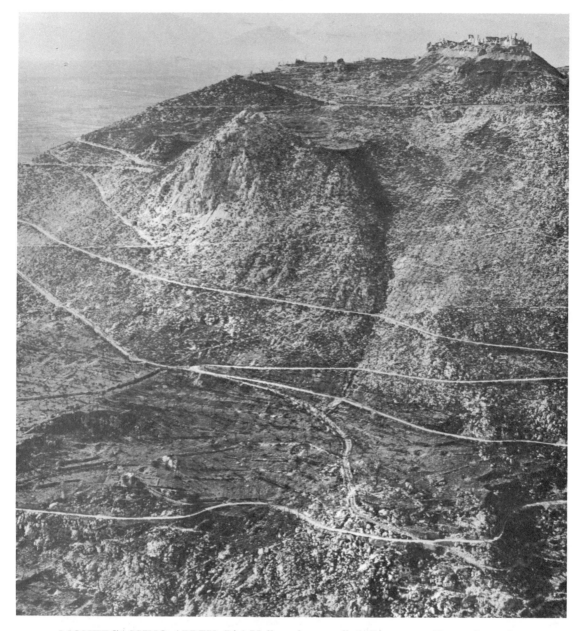

MONTECASSINO ABBEY. Liri Valley, the so-called Gateway to Rome, is on the left. On 15 February the abbey was bombed and shelled for the first time. Before that Allied soldiers had orders not to fire even a rifle shot at the structure. Enemy ammunition dumps were located close to the building, and gun emplacements in the vicinity were numerous. It had become a legitimate military objective. The bombing and shelling destroyed the abbey as a work of art, but its usefulness to the enemy was scarcely impaired. The rubble caused by the destruction of the upper parts of the building only served to strengthen the remaining lower parts.

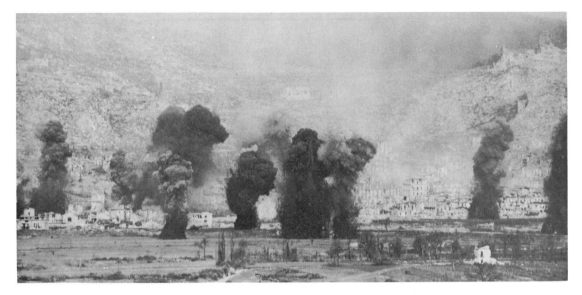

THE BOMBING OF CASSINO on 15 March. Although it had been repeatedly bombed before, the town was heavily bombed and shelled that day in preparation for the attack by the New Zealand Corps, at this time part of the Fifth Army. About 1,200 tons of bombs were dropped and 195,969 rounds were fired by artillery ranging in size from 3-inch guns to 240-mm. howitzers. The enemy's defenses were not destroyed. Protected by cellars, steel and concrete pillboxes, caves, and tunnels, the German troops suffered comparatively few casualties. The bombing and shelling neither overcame the enemy's resistance nor noticeably reduced his morale. When the infantry moved in for the attack they were met by heavy mortar fire; when the Allied tanks appeared they could not advance because of bomb craters and debris. The attack was repulsed.

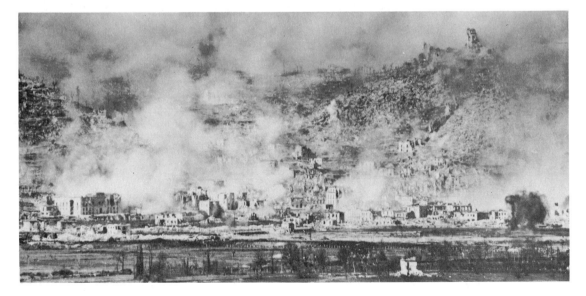

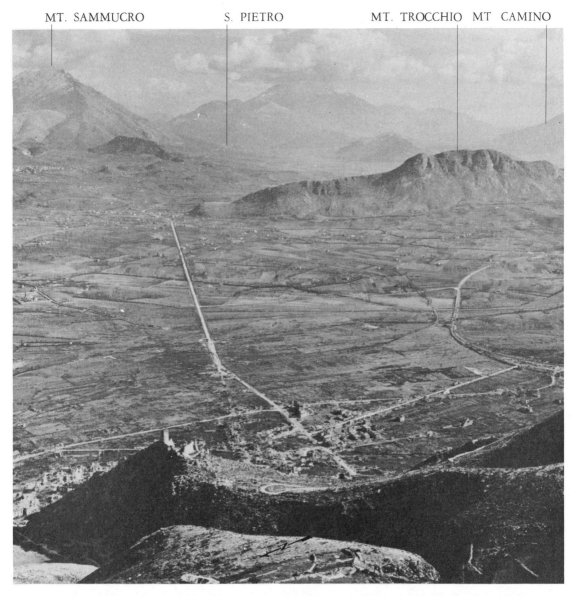

MT. SAMMUCRO S. PIETRO MT. TROCCHIO MT. CAMINO

CASSINO AREA, looking along Highway 6. "Castle Hill," in left foreground topped by tower, was in Allied hands for weeks before the town of Cassino fell. Below cliff are ruins of the town. The picture, made from the vicinity of the abbey, gives some indication of the enemy's observation over Allied positions. The main drive through the Winter Line defenses started above San Pietro Infine. U. S. forces began the advance on 15 November 1943 and had fought their way to the outskirts of Cassino by 26 January 1944, a distance of eight miles in seventy days. The town fell on 18 May to the Eighth Army after several unsuccessful attacks. The drive on the southern front, to penetrate the Gustav Line, started on 11 May 1944, while that out of the Anzio beachhead started on 23 May.

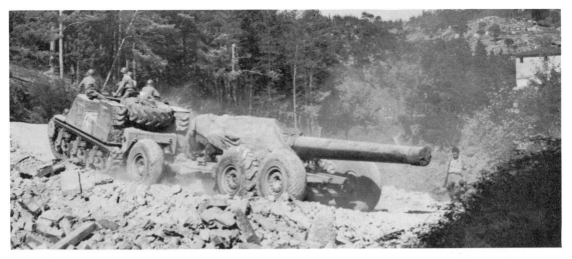

HOWITZER. These pieces fired their first mission in Italy in Mignano Gap, 30 January 1944. They were used with good effect during the Gustav Line fight in and around Cassino. Vehicle towing weapon is converted General Grant tank M3 (top). Howitzer in position near San Vittore del Lazio, five miles southeast of Cassino (bottom). (240-mm. howitzer.)

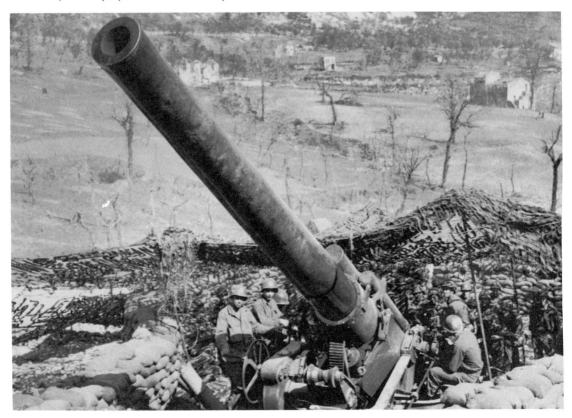

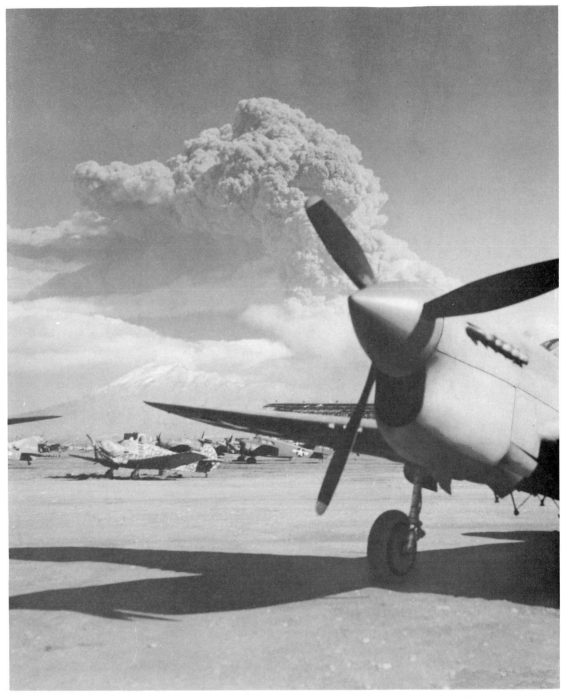

THE ERUPTION OF VESUVIUS in March 1944 damaged a number of aircraft on fields in the vicinity. Fuselages and wings were pierced by fragments of rock hurled from the volcano. In foreground is a P–40 fighter-bomber.

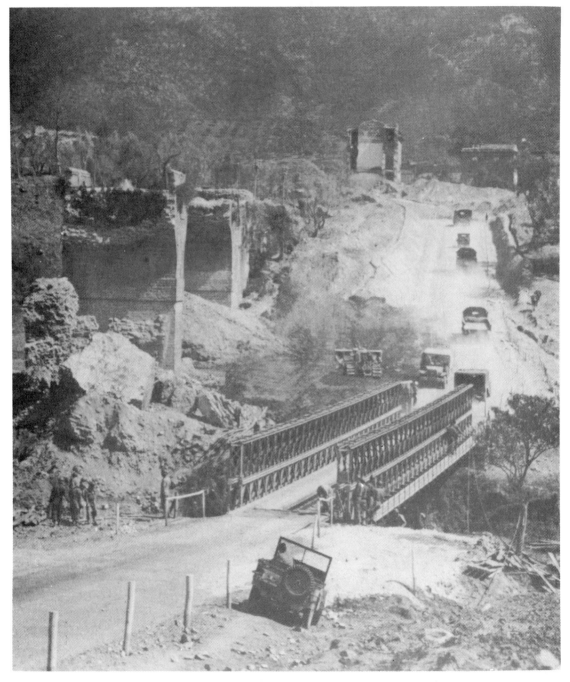

BAILEY BRIDGE over bypass on Highway 7 near Sessa Aurunca. This is the coastal road between Rome and Naples; the inland road, through the Mignano Gap, past Cassino and up the Liri Valley to Rome, is Highway 6. The Bailey bridge was invented by the British, from whom the U. S. forces obtained it.

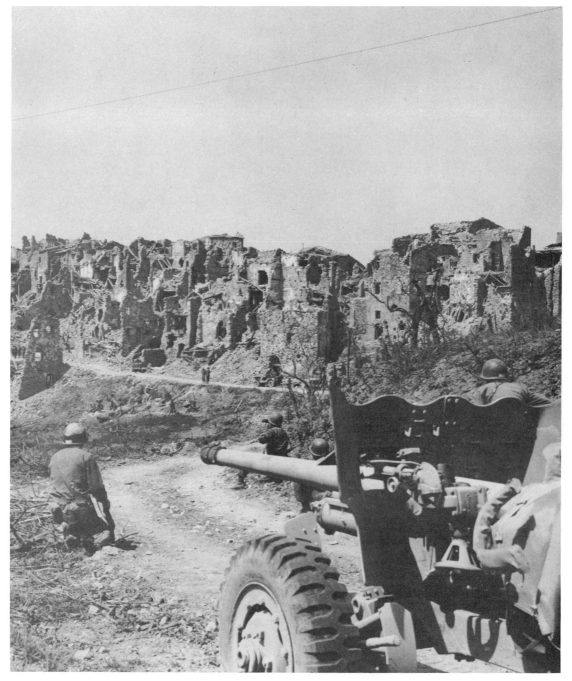

THE RUINS OF SANTA MARIA INFANTE. This village between the Aurunci Mountains and the Golfo di Gaeta fell to U. S. forces on 14 May, three days after the attack that was to carry the Allies to Rome started. The village had been demolished by air and artillery bombardment. (57-mm. antitank gun.)

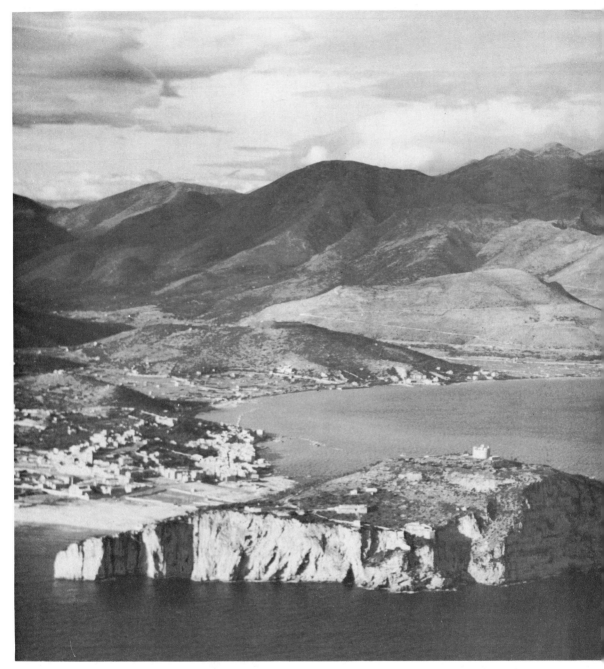

GOLFO DI GAETA. The high mountain at the right is Monte Petrella, which is 4,600 feet high; the one in the center is Monte Ruazzo, which is 4,000 feet high. The drive through the Gustav Line, started by the left flank of the Fifth Army, had reached Monte Petrella by 15 May and had advanced to the Itri Valley on the left of the picture. U. S. forces in general advanced along the slopes facing the sea.

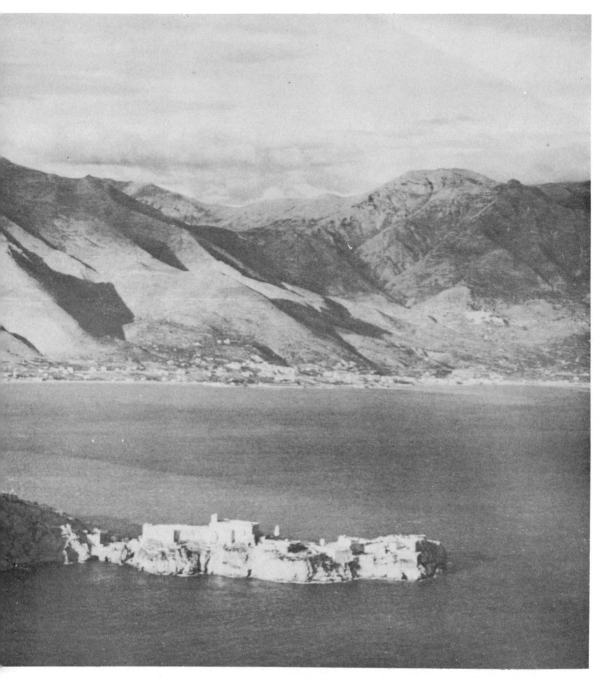

The French mountain troops advanced across the mountains farther to the north, then turned right into the Liri Valley on the other side and threatened to cut off the German forces around Cassino and in the lower part of Liri Valley. This action by the French made the German position untenable and the enemy started a general withdrawal from the Gustav Line.

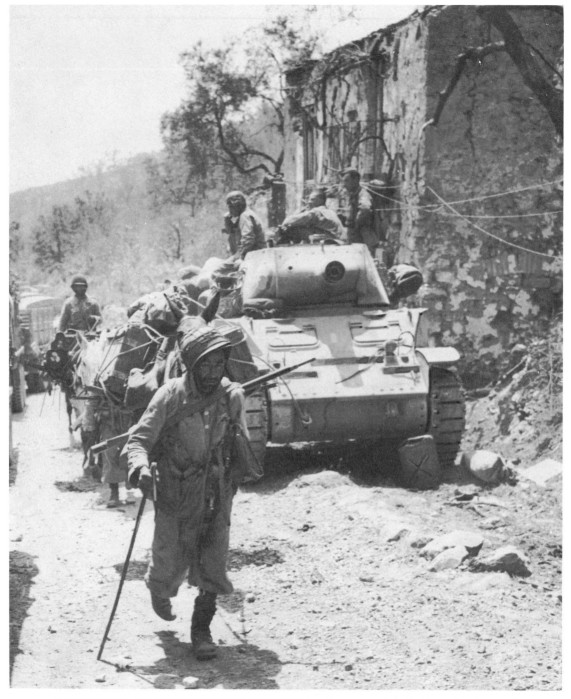

GOUMIERS OF THE FRENCH FORCES leading a pack train into the Aurunci Mountains during the drive that started 11 May. Tank is U. S. M5 light tank manned by French crew, and armed with a 75-mm. howitzer.

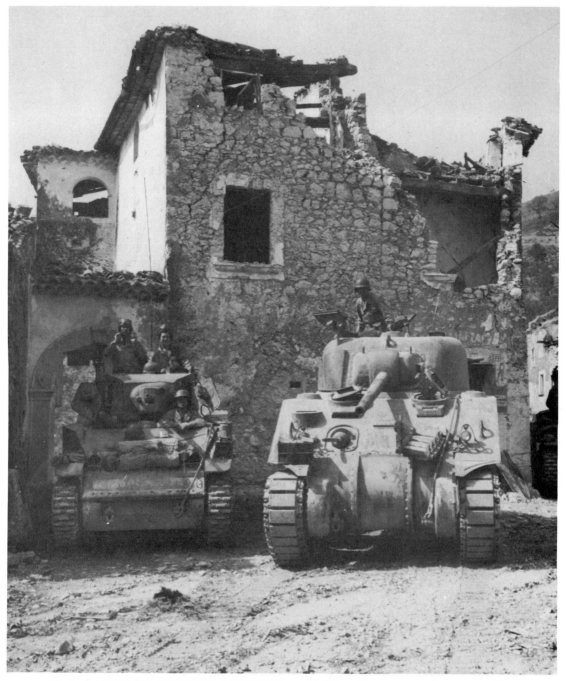

U. S. TANKS IN CORENO AUSONIO on 14 May. The same tanks, manned by
Americans, were attached to the French mountain troops making a drive from the
Castelforte area on the right flank of the Fifth Army, through the Aurunci Moun-
tains and into the Liri Valley. (Left, light tank M5; right, medium tank M4.)

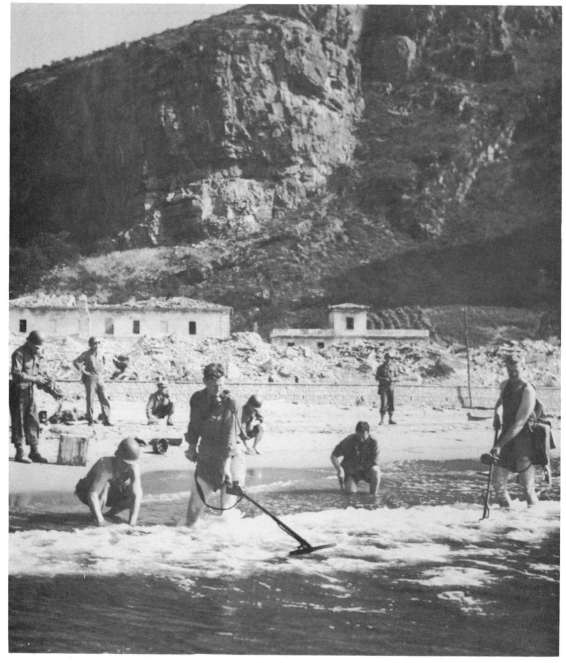

SWEEPING THE TERRACINA BEACH FOR MINES. Terracina is located on Highway 7. During the drive the road became so overcrowded that some supplies had to be shipped by sea. Since the small harbor was cluttered with wreckage of ships, the beach had to be cleared for landing and unloading. (Mine detector SCR 625.)

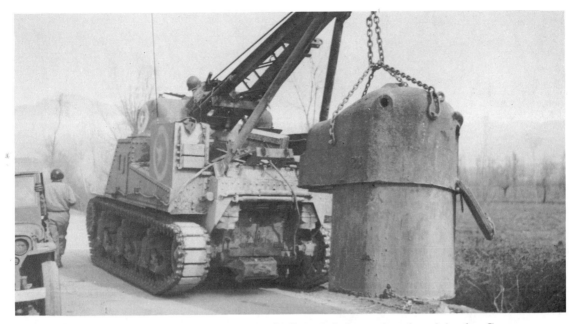

GERMAN PORTABLE PILLBOXES. Some of these were found in the Gustav Line around Cassino and others were later found in the Hitler Line in the Liri Valley. These steel pillboxes, camouflaged and usually connected by communication trenches to well constructed bunkers, were impregnable to all but direct hits from artillery fire. (German mobile steel pillbox, being removed by tank recovery vehicle M31.)

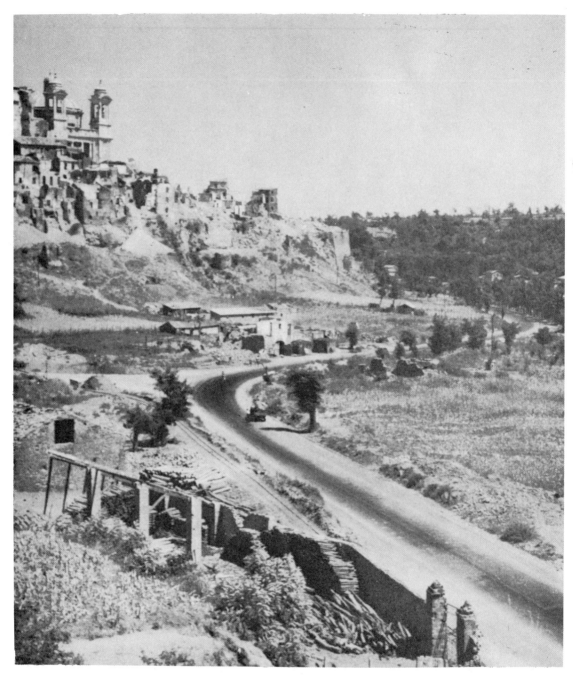

VALMONTONE ON HIGHWAY 6, twenty-five miles southeast of Rome. This was the main escape route of the enemy forces trying to retreat toward Rome from the Cassino–Liri Valley area. The enemy kept the road open until 1 June. U. S. forces found the village unoccupied on the morning of 2 June when a battle patrol entered the town.

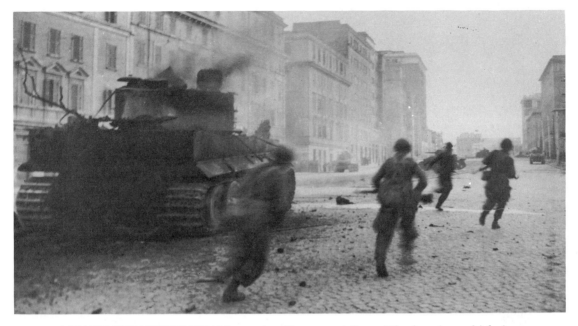

A TANK-INFANTRY TEAM entering Rome on 4 June. The burning vehicle is a German Tiger tank. The enemy had been evacuating the city for several days, but had left a strong rear guard equipped with tanks and artillery to hold the Allies in and below the city as long as possible. Since the streets of Rome were not suitable for conventional infantry attacks, small tank-infantry teams entered the city from several directions and by early morning of 5 June were in possession of the bridges across the Tiber.

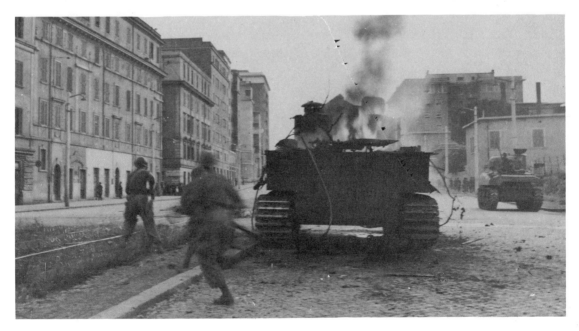

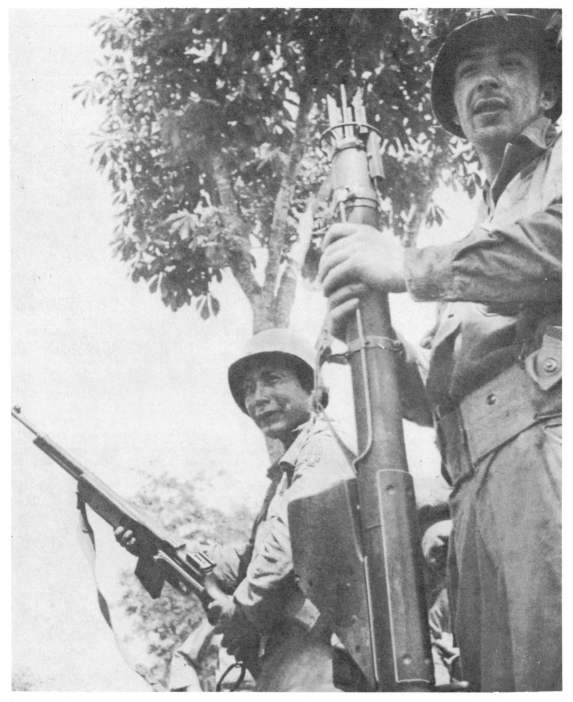

INFANTRYMEN OF ONE OF THE TANK-INFANTRY TEAMS to enter Rome on 4 June. Soldier on left has a Browning automatic rifle. The one on right holds a bazooka (rocket launcher M1).

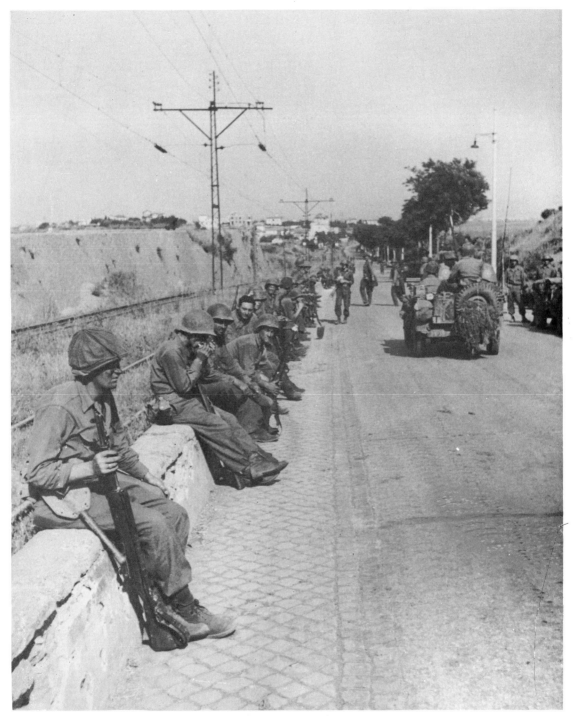

INFANTRY AWAITING SIGNAL TO ENTER ROME on 4 June. At this time the city was being cleared by small tank-infantry teams.

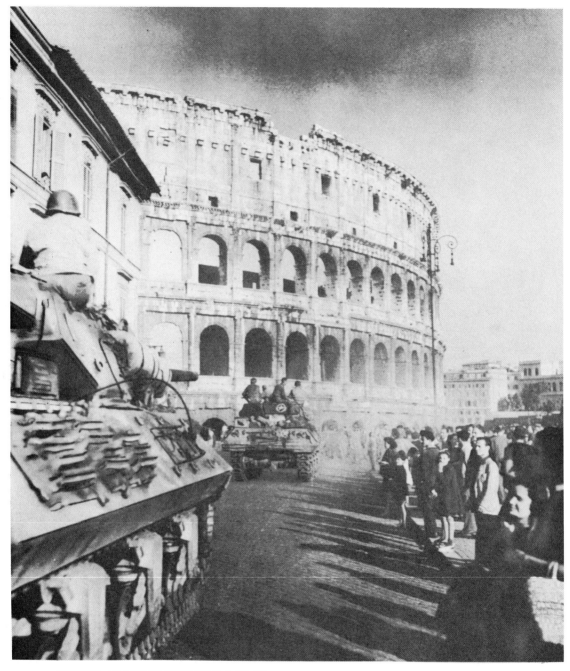

FIFTH ARMY ENTERING ROME on 5 June only to continue through the city in pursuit of the enemy retreating along the roads north of Rome. During this retreat the Germans were under constant bombing and strafing attacks by Allied air forces. The roads of retreat were littered with vehicles of all kinds. (3-inch gun motor carriage M10.)

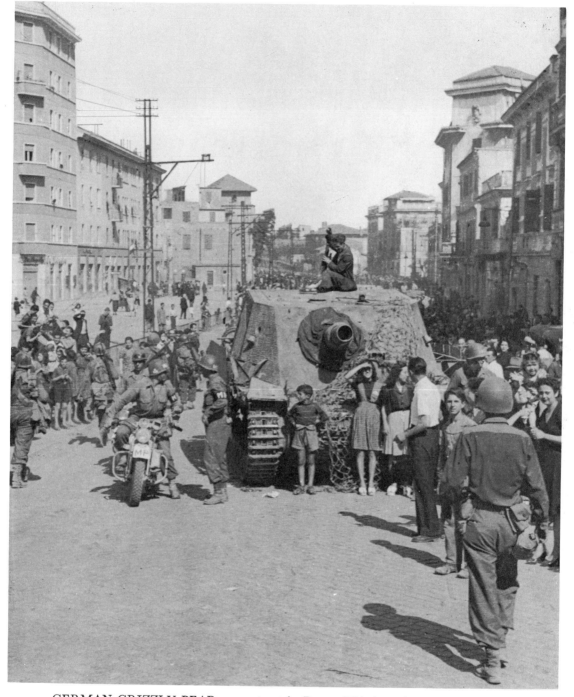

GERMAN GRIZZLY BEAR on a street in Rome. This is a close-support weapon and mounts a short-barreled howitzer in a high, armored superstructure. (15-cm. *Stu. H. 43* on *Pz. Kpfw. IV* chassis.)

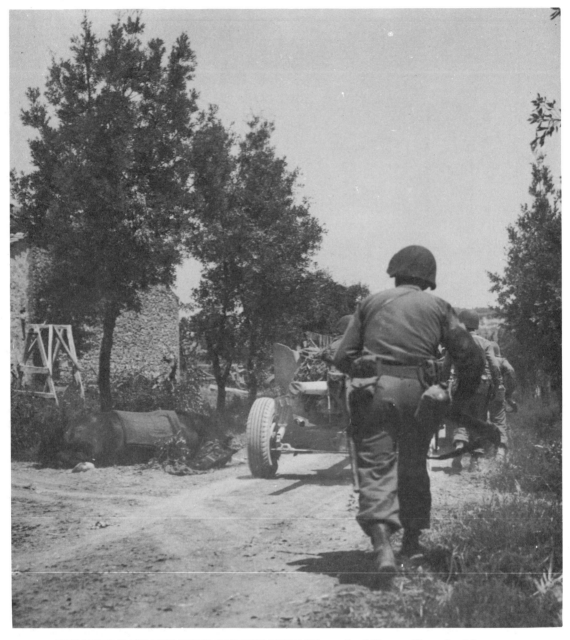

INFANTRY IN PURSUIT OF THE ENEMY north of Rome. Note dead horse on left. Much of the German equipment was horse-drawn, limiting the speed of withdrawal. During the pursuit of the enemy from Rome to the Arno River whole divisions both American and French were gradually withdrawn from the Fifth Army to train for the coming invasion of southern France. Army strength dropped from 248,989 on 1 June to 153,323 on 1 August 1944. Three U. S. divisions, veterans of the Italian campaign, were sent to the Naples area for invasion training. (57-mm. antitank gun.)

SOUTHERN FRANCE

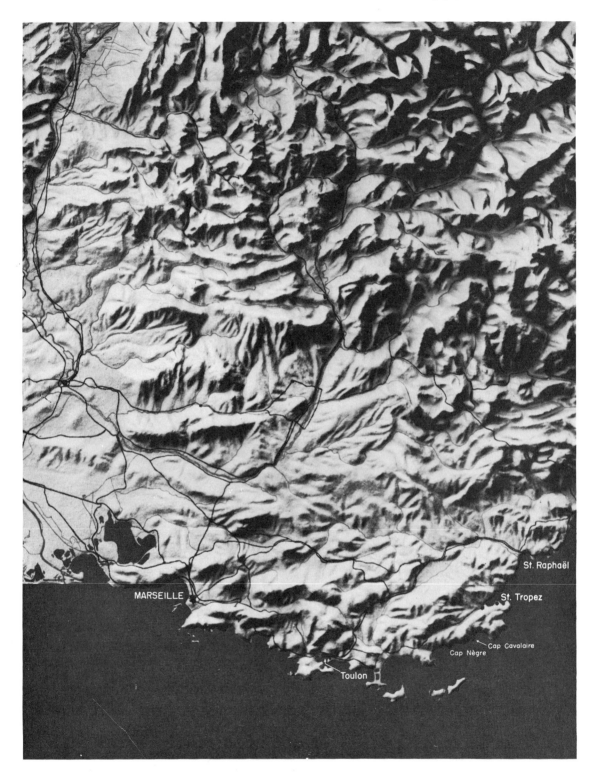

SECTION IV

Southern France[*]

The offensive operation in southern France, originally scheduled to be executed simultaneously with the Normandy landings, was conceived with the aim of pushing northward from the southern coast, creating a diversion of enemy troops from the northern assault, and generally weakening the German Army in France. This operation was given the code name ANVIL.

A serious shortage of landing craft delayed the invasion until 15 August 1944. Meanwhile preparations for such a landing served as a threat and held a large number of German forces on the southern coast. Craft, used first for the Normandy landings, were then rushed to the Mediterranean for use in mounting ANVIL.

During June and July three divisions which formed the bulk of the U. S. VI Corps were withdrawn from the battle in Italy and sent to port areas for training and for participation in Operation ANVIL. At the same time all the French troops with U. S. Fifth Army were withdrawn to prepare for the invasion. The Allied strategic air forces began the process of neutralizing vital enemy communications and installations in southern France. As D Day approached, a large naval force was amassed in the Mediterranean, and the ground forces, American and French troops, were embarked from Italy, North Africa, and Corsica.

An airborne task force of American and British units, with the mission of preventing the enemy from reinforcing the coastal defense, successfully jumped astride the Argens River behind the German lines before H Hour. Landings took place on 15 August 1944 in the Cannes–Toulon sector against scattered and disorganized resistance from the enemy. The assault forces, assisted by members of the French Resistance forces, pressed their attack rapidly, defeated the enemy along the coast line, and pushed inland. The troops were met with enthusiasm by the French population.

[*]See James D. T. Hamilton, Southern France and Alsace, a volume in preparation for the series U. S. ARMY IN WORLD WAR II.

Toulon and Marseille were captured by units of the French forces. By the end of August the combined American and French forces had broken German resistance in southern France, destroyed and put to flight the enemy, and advanced to Lyons. On 11 September 1944 they made junction with the Normandy forces west of Dijon, thereby sealing all of southwestern France.

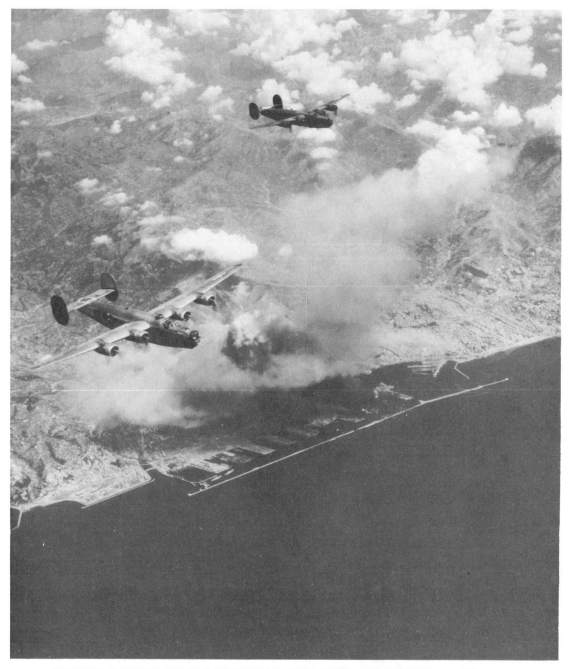

SMOKE RISING FROM WATERFRONT INSTALLATIONS as Liberators bomb Genoa, Italy, prior to the invasion of southern France. This was part of a plan to keep the enemy guessing as to where the assault would come. At the time of the Normandy landings most of the Allied troops intended for the simultaneous invasion of southern France were fighting in Italy.

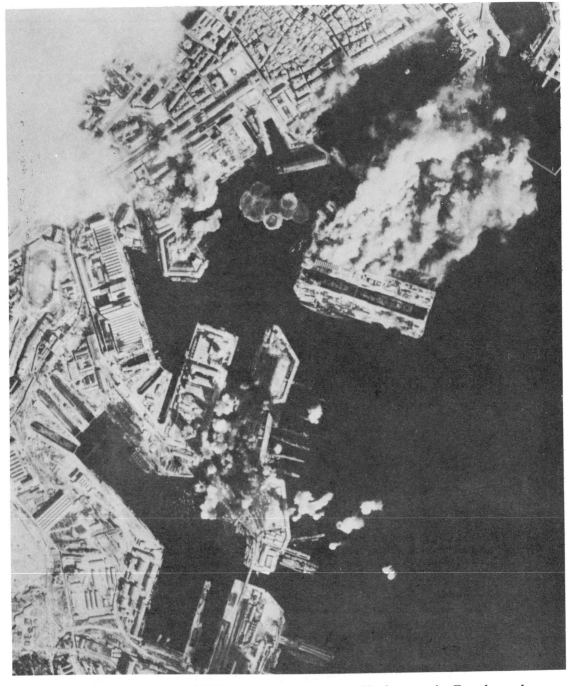

DOCKS AND U-BOAT PENS during an air attack at Toulon, a major French naval
base. Allied air attacks destroyed U-boats awaiting repairs in their pens and crippled
production facilities. By the end of July 1944 the Mediterranean Sea was almost
cleared of German naval power.

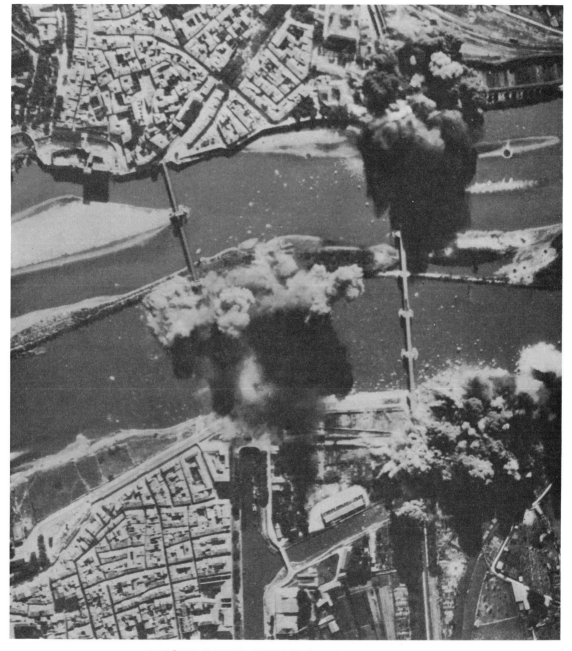

BOMBING OF RHÔNE RIVER BRIDGES at Tarascon by Allied planes. Pre-D-Day bombardment wrecked all but one bridge across the Rhône, which helped to hamper large-scale movement of enemy troops. The Allied forces were to advance through the Rhône River Valley which passes between two mountain masses, the Massif Central and the Alps, and forms a great natural corridor connecting the Mediterranean coast with the Paris basin.

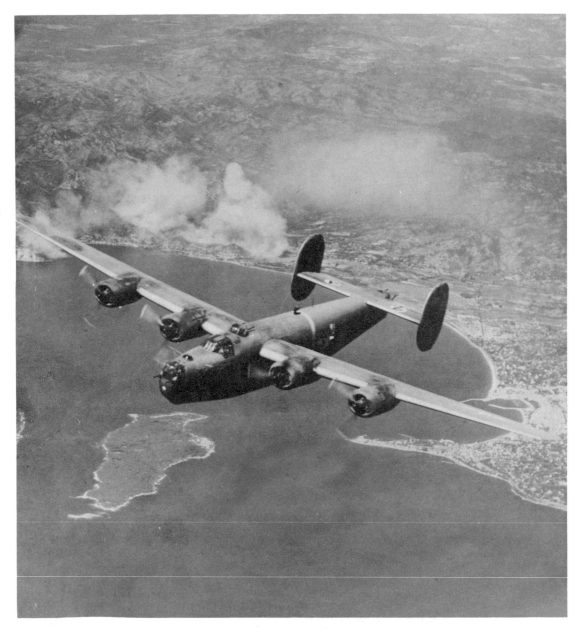

B–24 OVER THE GOLFE DE LA NAPOULE. Smoke rising in distance, near village of Théoule-sur-Mer, is caused by bombing of railroad, highway, and bridges. At right is Cannes. The air offensive in support of the invasion actually began as early as 28 April 1944 when heavy bombers attacked Toulon. Between that time and August, the Mediterranean Allied air force dropped more than 12,500 tons of bombs on southern France. Beginning on 10 August the offensive was continued by attacking coastal batteries and radar stations, harassing coastal defense troops, and isolating the target area by destroying bridges across the Rhône.

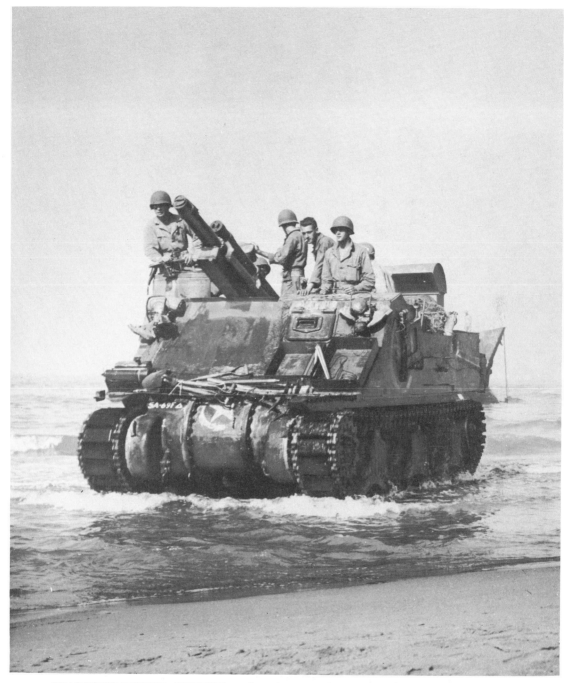

WATERPROOFED PRIEST undergoing test in preparation for the invasion. The invasion training center at Salerno, Italy, established a school of one week's instruction in waterproofing vehicles for the coming assault. The 105-mm. howitzer motor carriage M7 was the principal artillery weapon of the U. S. armored division.

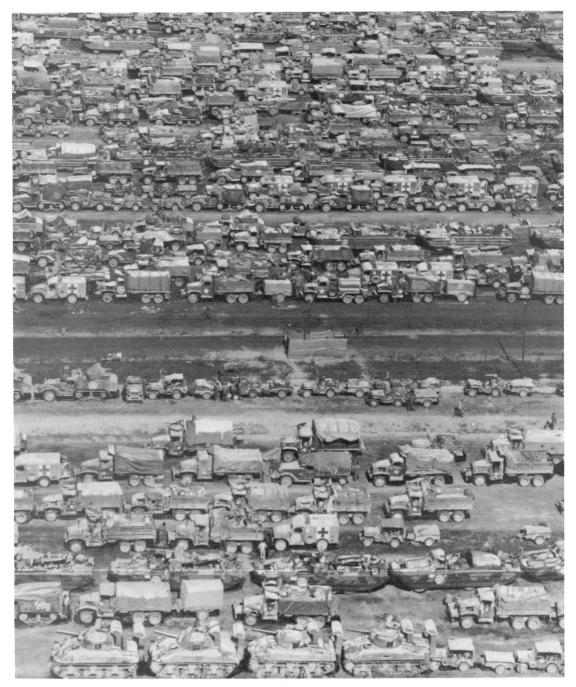

VEHICLES ASSEMBLED AT THE PORT OF NAPLES for the invasion of southern France. The troop list of those landing during the first four days included over 155,000 personnel and 20,000 vehicles of all types, including personnel and cargo carriers as well as armored vehicles.

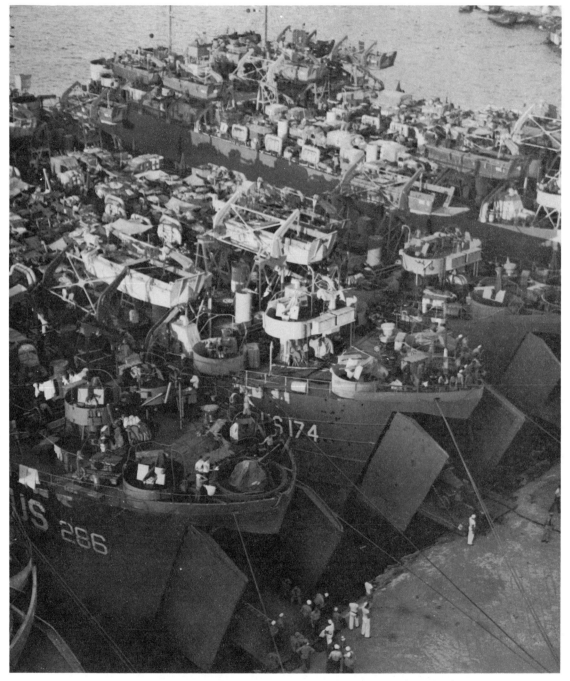

LOADED LST'S IN NAPLES HARBOR in August 1944 before the invasion. By this time the Germans had been pushed north of Florence, their air force had been greatly reduced, and their airfields in the Po Valley were under constant air attacks by medium and heavy bombers.

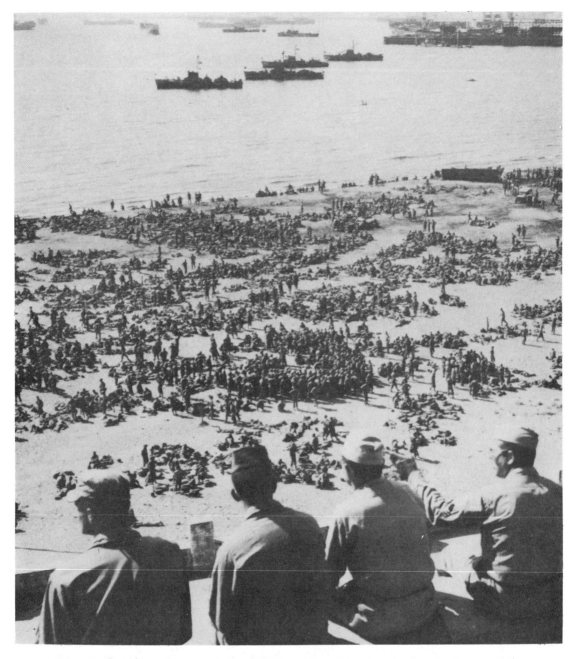

MEN ON A BEACH NEAR NAPLES waiting for water transportation to take them to near-by landing craft and transports in the Bay of Naples. This was the final loading before the invasion. Although the Germans were aware of the concentration of troops and shipping and knew that the invasion was in preparation, no enemy bombings interfered with the loading operations. The Allied air forces had rendered most of their airfields within range of Naples inoperative for all practical purposes.

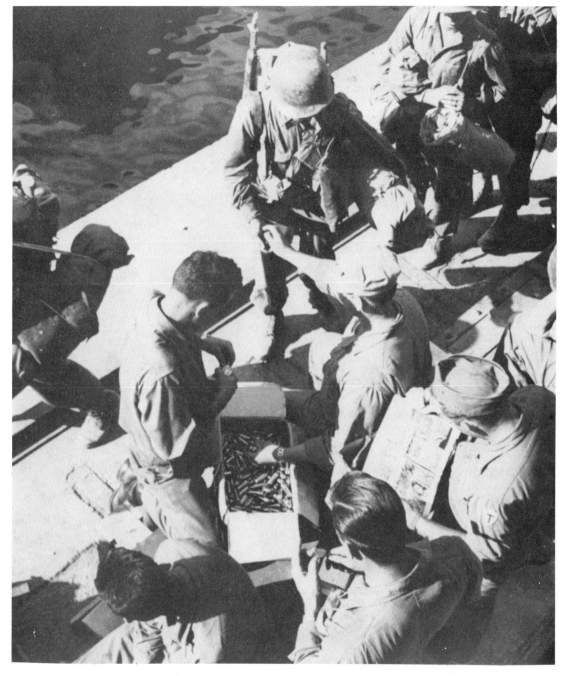

MEN RECEIVING CARTRIDGES OF CARBON DIOXIDE for their life preservers, prior to boarding ships for the invasion. Rations for the first days were also issued, each man receiving one K ration, one D ration, one small bottle of Halazone tablets to purify water, one bottle of salt tablets, and two packages of cigarettes.

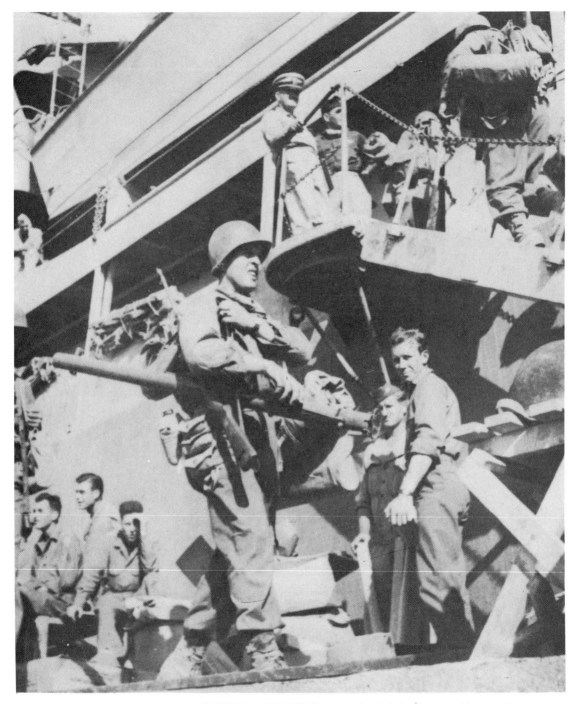

FULLY EQUIPPED INFANTRY SOLDIER, armed with both a carbine and a rocket launcher, boarding a transport. (2.36-inch rocket launcher M1A1, known as the bazooka.)

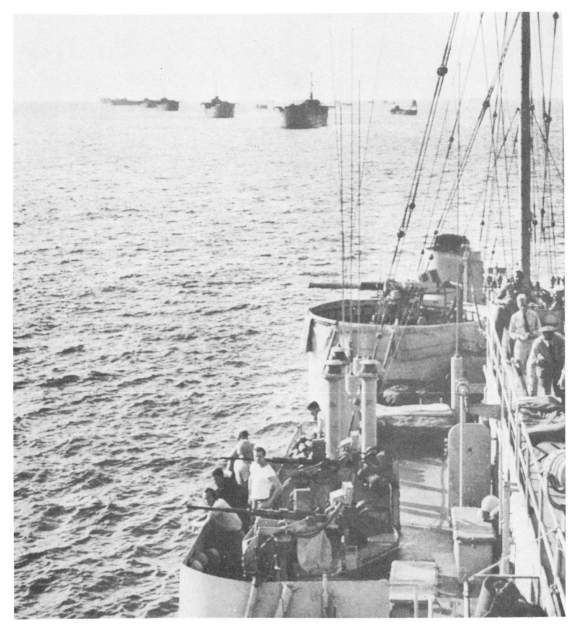

LST'S APPROACHING THE COAST OF FRANCE. Ships carrying men and equipment for the invasion sailed from ports in Africa, Italy, and Corsica, the most important loading port being Naples. In all, 853 vessels from the Allied navies formed the task force with an additional 1,267 small landing craft, deck-loaded. Several hours prior to the main assault amphibious landings were made on both flanks of the invasion area and airborne landings were made in the rear in order to isolate the beachhead from the enemy. French commandos landed at Cap Nègre and French marines landed near Cannes.

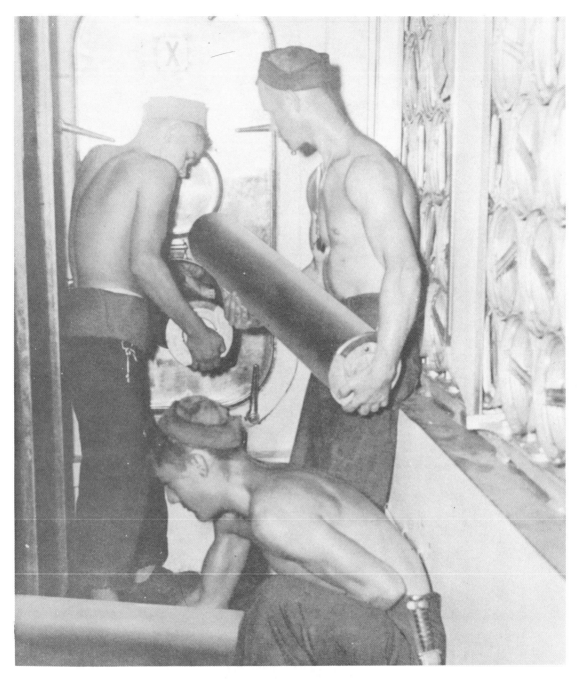

ON BOARD AN AMERICAN CRUISER men pass ammunition to gunners firing on the beaches of southern France. Naval ships commenced long-range bombardment of prearranged targets at 0530 on D Day. Until 0800 this fire was almost continuous, lifting only when Allied bombers were over the targets. In all, naval guns fired over 15,900 projectiles into the beach area prior to the assault landings.

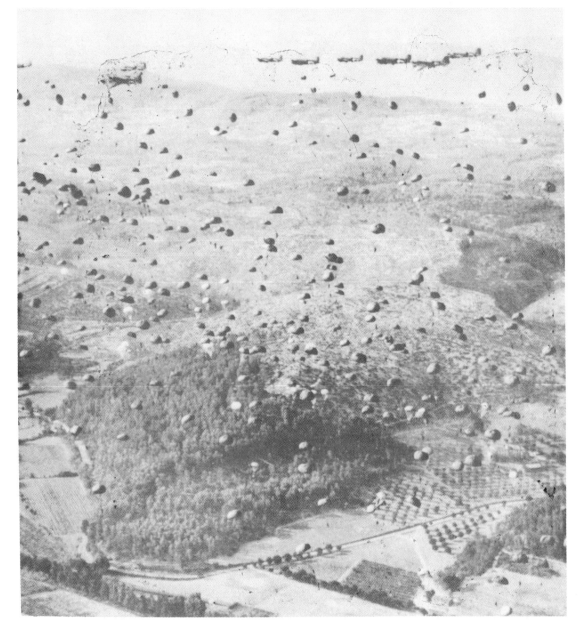

DROPPING SUPPLIES TO PARATROOPERS on D Day, 15 August 1944. An Anglo-American airborne task force landed at various hours on D Day beginning at 0430 near le Muy and le Luc to establish road blocks, to prevent enemy movement toward the beaches, and to help reduce the defenses in the Frejus area. No air opposition was encountered and the paratroopers landed and came in contact with the enemy immediately, but resistance was light, primarily small arms fire. Preparations were made by the paratroopers for the landing of the glider-borne elements.

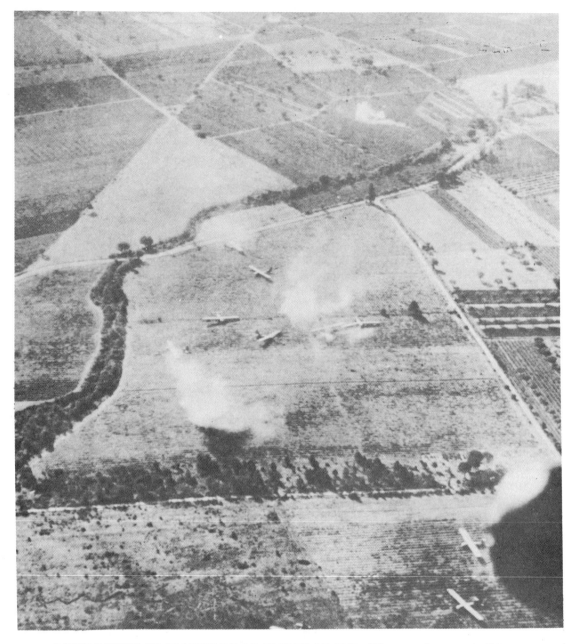

DUST RISING FROM FIELDS AS GLIDERS LAND. The tow planes and gliders took off from airfields in the Rome area. No gliders were lost from enemy action, but many were wrecked in landing, causing some casualties. The first glider serial landed about 0930 on 15 August 1944, and by late afternoon the whole force had landed. By nightfall four small villages had been occupied and 103 prisoners taken. A protective screen was established over the road net connecting the invasion coast with the interior.

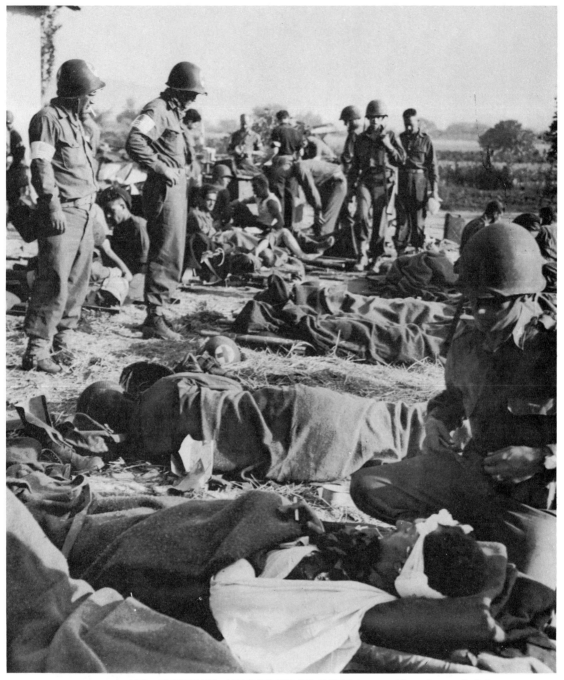

WOUNDED AND INJURED AIRBORNE TROOPS in an aid station at la Motte.
The enemy opposition to the Anglo-American air drops and glider landings was rela-
tively slight but this method of warfare, in itself dangerous, resulted in unavoidable
accidents such as broken arms and legs and, in some cases, more serious injuries.

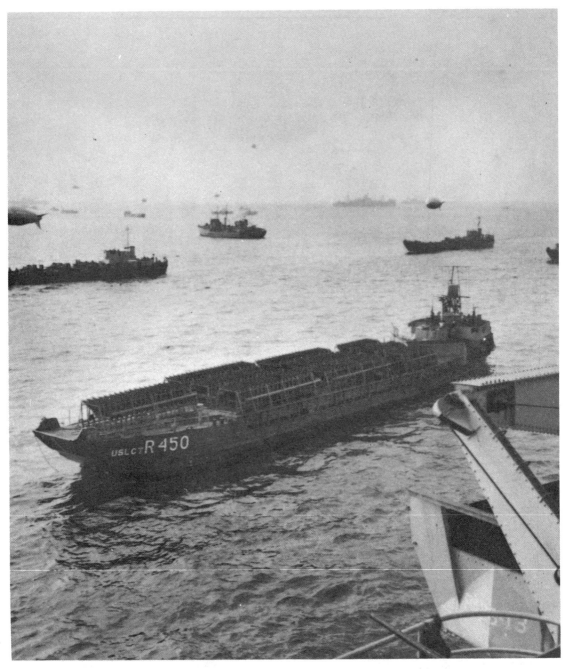

ROCKET SHIP CONVERTED FROM AN LCT. Ahead of the first wave of assault troops in landing craft were rocket ships mounting tiers of rocket launchers. As these drew within range of the beach defenses they discharged their rockets. The first troops landed immediately afterward. Rocket ships were equipped with launchers for up to 1,000 rockets.

SOLDIERS DESCENDING A LADDER into waiting assault craft. Climbing down along the high vertical side of a transport into a heaving and swaying assault craft while loaded down with ammunition, equipment, and rations was in itself a difficult task. The ladder shown here, constructed of chains separated by wooden pieces, was a great improvement over the old rope nets. The latter tended to bunch and stretch, making the descent extremely difficult and slow.

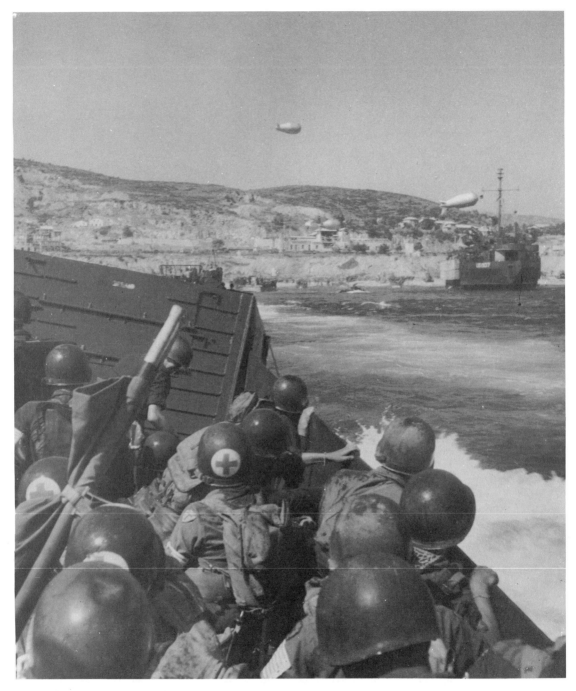

INFANTRYMAN AND MEDICS in the LCVP nearing a beach. Advancing at full speed, the assault craft approached the beaches in the immediate wake of the rocket ships. Other landing craft can be seen on the beach. At right is an LST. Overhead are three barrage balloons.

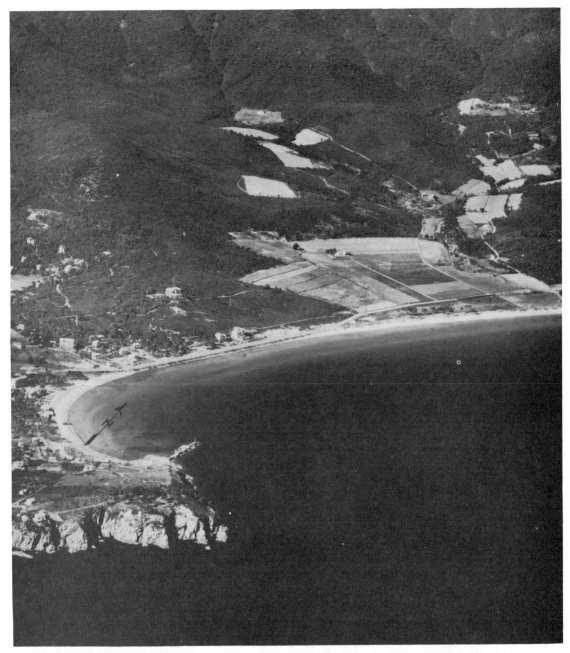

PART OF THE BEACH ON BAIE DE CAVALAIRE. On the left of the invasion coast in the U. S. sector, one division was to assault the beach area from Cap Cavalaire to the Cap de Saint-Tropez, including the town of Saint-Tropez. One battalion landing on the beach shown above advanced along the coastal road and cleared the town of Cavalaire-sur-Mer (portion of town is at left in photo), and by 1330 on D Day reached a road block, in the vicinity of Cap Negre, held by the French.

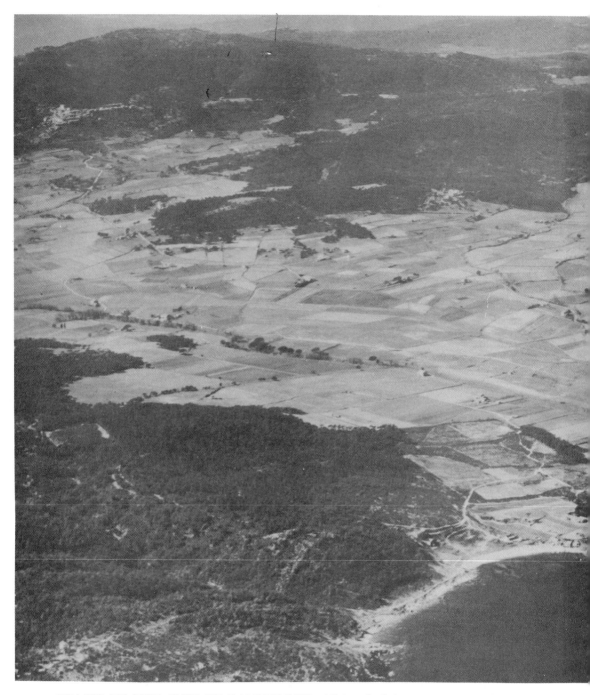

BEACH ON THE ANSE DE PAMPELONE. All beach defenses were reduced in forty minutes after landings were made. The engineers started clearing the beaches of mines and laying beach pontons since the gradient was too shallow for ships to come

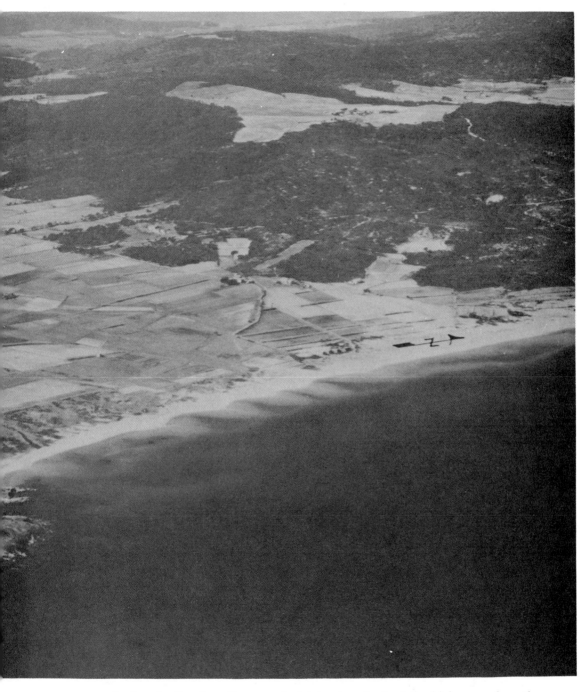

up on the beach. One battalion attacked inland and seized the high ground north of the town of Ramatuelle (upper left). Two battalions moved north and northeast and seized the hills (upper right). Saint-Tropez is just behind these hills.

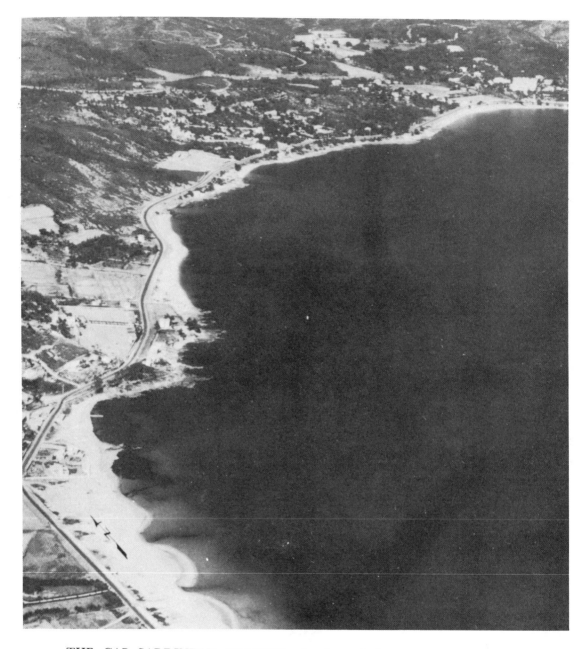

THE CAP SARDINEAU BEACHES. Another of the three assault divisions landed here in the center of the corps invasion area at H Hour (0800) on D Day. The three small beaches (shown above) lay along a curving bay between Cap Sardineau and Pointe de l'Arpillon. The divisional area extended inland 15 to 20 miles to le Luc and le Muy where the airborne troops had previously landed. After clearing the beaches, the division's mission was to contact the paratroopers to the north and the divisions on each flank.

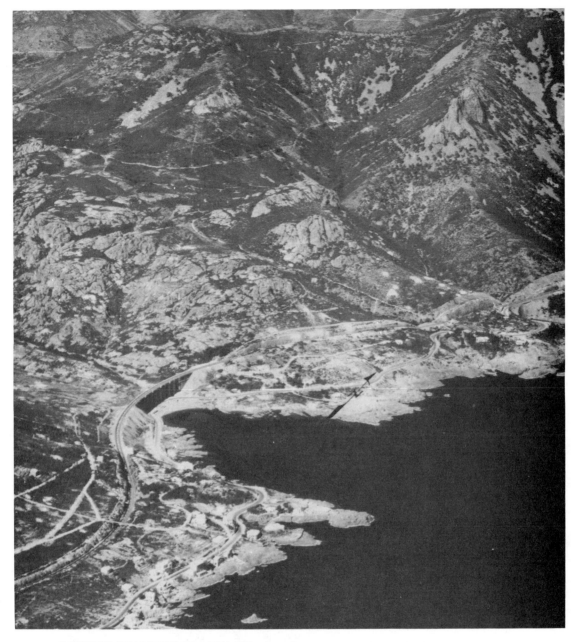

POINTE D'ANTHÉOR BEACH. On the extreme right of the invasion coast, this beach at an inlet near Pointe d'Anthéor was small and not well suited for a major landing. The landings took place on the beaches on both sides of the inlet which ends where the highway runs beside the railroad bridge. Here the Germans directed their fire upon the assault boats and made several direct hits, causing casulties. The assault troops placed a road block across the coastal highway and occupied the ground northwest of Rade-d'Agay.

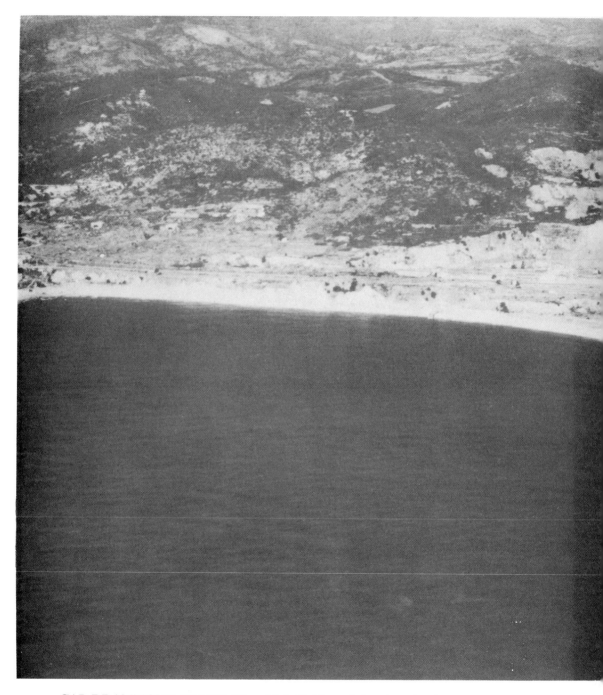

CAP DRAMMONT BEACH. The third division of the three in the U. S. assault area had the mission of securing the right of the invasion beaches. The divisional area extended from Pointes de Saint-Aygulf along the coast line to Théoule-sur-Mer on the Golfe de la Napoule. The first assault was over this beach west

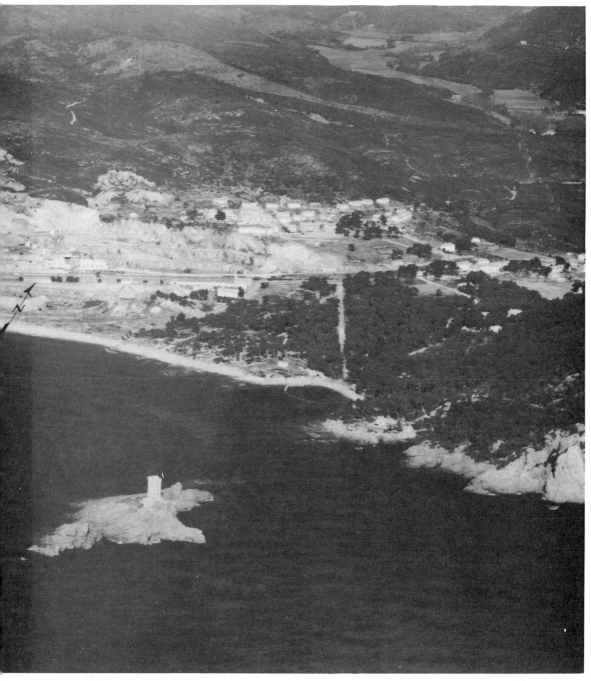

of Cap Drammont and was considered large enough only for the initial operations. The beach consisted of narrow strips of rocky shale between the water and steep embankments.

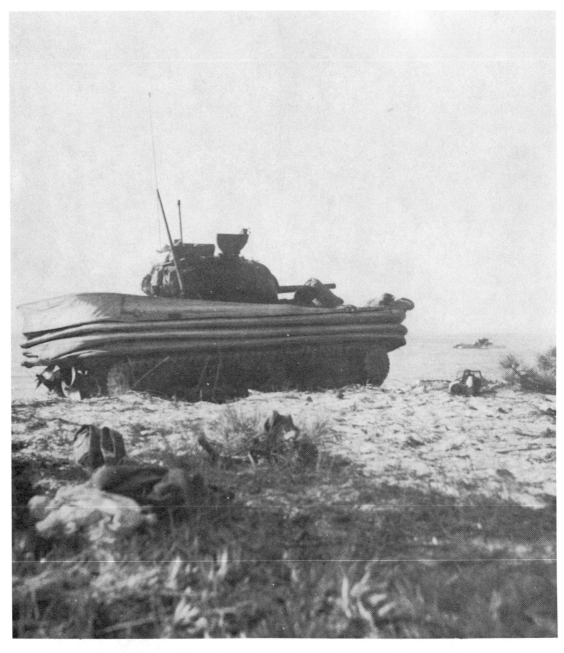

DUPLEX-DRIVE TANK. Amphibian tanks were launched from LCT's about 2,000 yards offshore to support infantry on the Saint-Tropez peninsula assault. By means of the duplex drive a regular medium tank was converted into an amphibian. When the canvas screen was raised and held in place by mechanical means the tank floated. The DD tank was vulnerable to mines and underwater obstacles. Offshore at right an amphibian 2½-ton truck is bringing a 105-mm. howitzer to the beach.

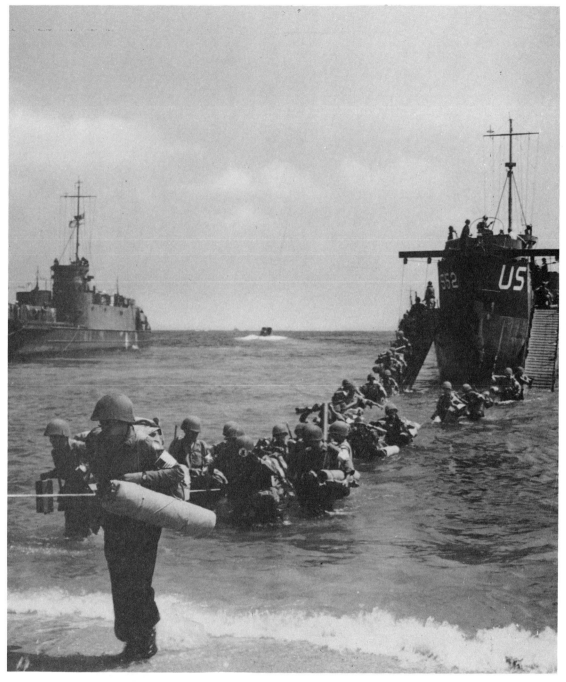

INFANTRYMEN LANDING ON BEACH FROM AN LCI. In the center of the U. S. assault area troops landed under almost ideal amphibious conditions, four battalions abreast with little hindrance by mines and underwater obstacles and with light enemy resistance.

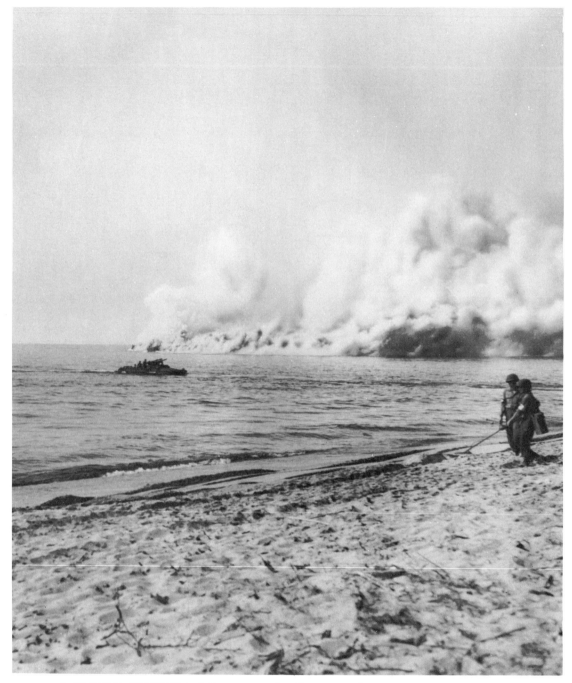

A SMOKE SCREEN is laid to cover landing operations on the left flank of the American assault area. While engineers, using a mine detector (SCR 625), clear the beach of enemy mines, a DUKW with a 105-mm. howitzer approaches the shore.

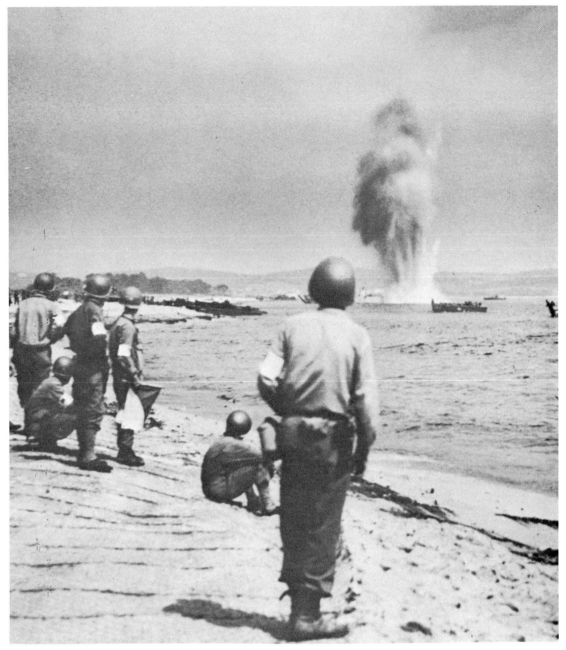

EXPLODING MINE. On D Day morning no fire on ships or craft from coast defense guns was reported, and on the beaches resistance consisted mostly of small arms and mortar fire. Underwater obstacles and land and marine mines were insufficient to delay the landings materially. The first waves of assault troops located and removed many of these obstacles. Note wire matting in lower left used to form a roadbed over loose sand.

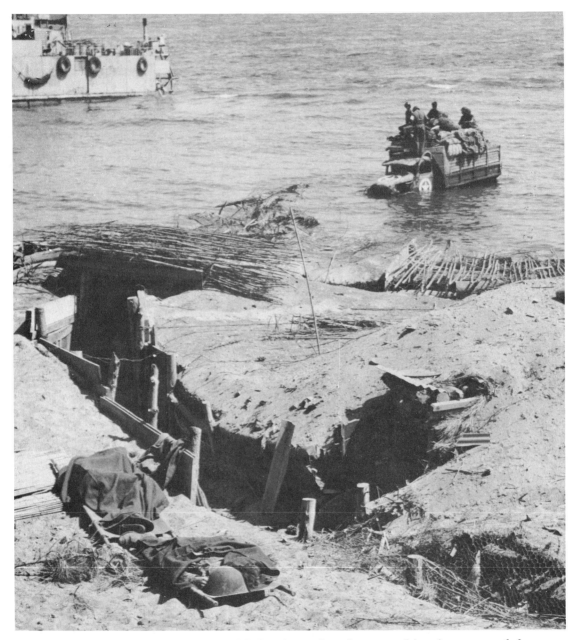

ENEMY TRENCHES ON BEACH and two American casualties. A waterproofed
2½-ton 6 x 6 truck offshore. Shortly after U. S. troops landed the enemy came
out of shelters and opened fire with small arms and mortars. However, amphib-
ian tanks, tank destroyers, and howitzers which had landed from DUKW's were in
position to meet this fire, and the infantry continued to advance inland against
scattered and light opposition. The first enemy prisoners seemed dazed and well
shaken by the preliminary naval and aerial bombardment.

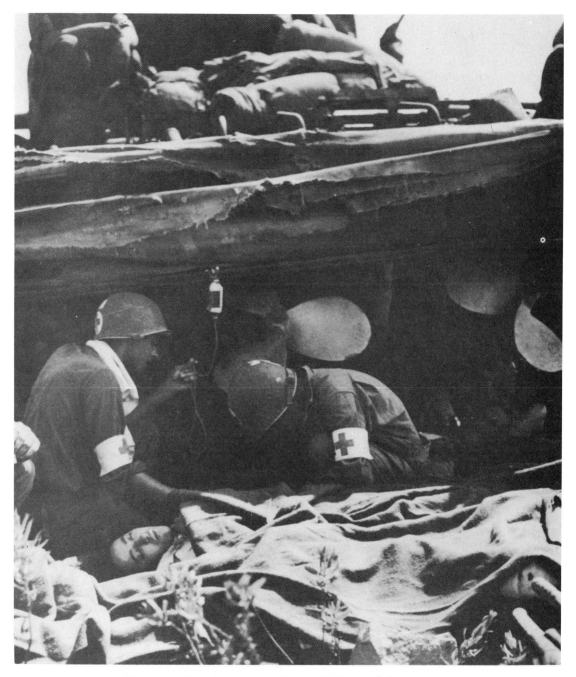

AID MEN ADMINISTER PLASMA TO A FRENCH WOMAN wounded during the invasion, using the rear of a DD tank for shelter. Men and women of the French Forces of the Interior assisted the advancing troops and made the countryside untenable for the isolated enemy detachments. By midnight, the corps reported that 2,041 prisoners had been taken.

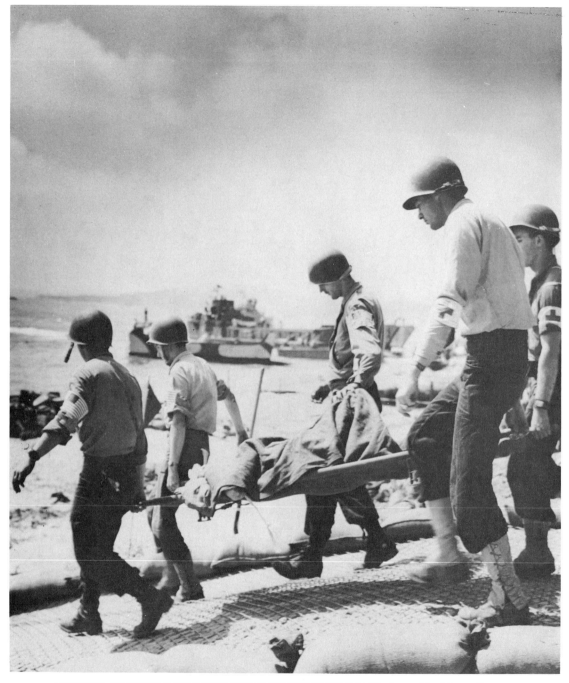

LITTER BEARERS EVACUATING WOUNDED MAN. A medical battalion attached to the beach group set up collecting, clearing, and aid stations. The wounded were evacuated from the beach by Army and Navy medical personnel to hospital ships by LCVP's. The casualty rates were low and the inland advance of troops rapid.

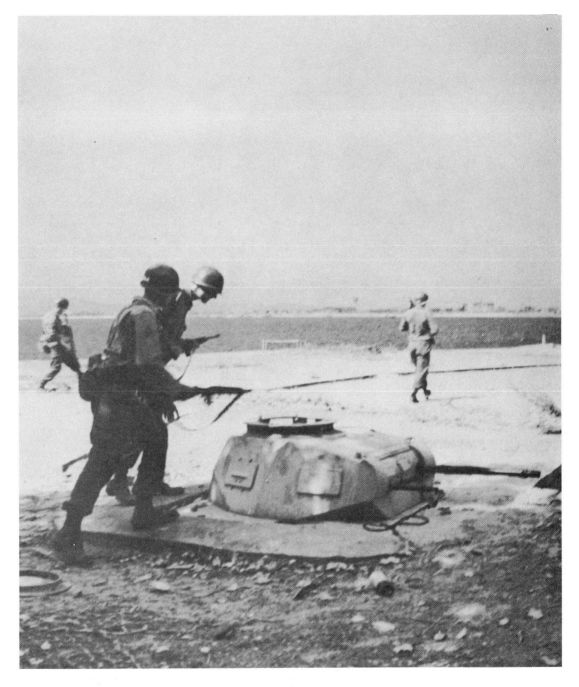

ENEMY PILLBOX. On the morning of 16 August 1944 troops moved through Saint-Raphaël clearing most of the resistance. There was considerable improvisation on the part of the enemy, such as the mounting of tank turrets on concrete to form pillboxes. (*Schmeiser* machine gun and 20-mm. cannon mounted in pillbox.)

THE FIRST FRENCH PARTISANS (French Forces of the Interior) to meet the invading U. S. troops at the beach in the Saint-Tropez area. The partisans had been given a list of priority targets to be attacked on and after D Day. They were to intensify their activities in the rear of the enemy forces, with special emphasis on the destruction of bridges, cutting and blocking highways and railroads, and seizing or controlling telephone and telegraph centers.

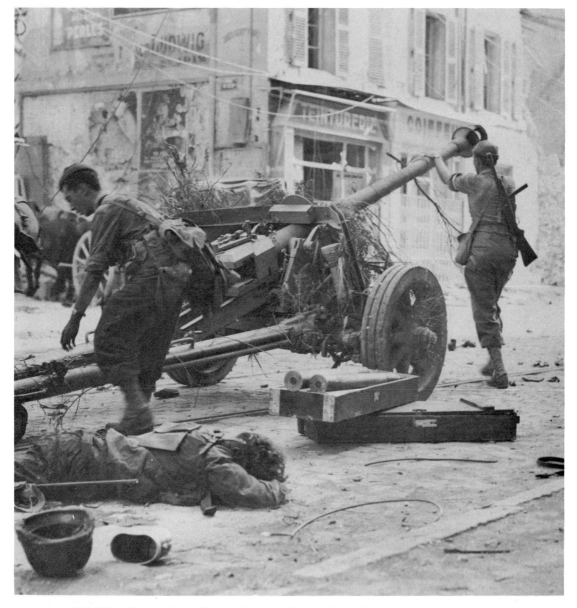

FRENCH TROOPS TAKE OVER A GERMAN GUN IN TOULON. At 2000 on D plus 1 a French army, consisting of seven divisions, began landing on the beaches in the Saint-Tropez area, with the initial mission of capturing the port cities of Toulon and Marseille. The divisions assigned the taking of Toulon began the encirclement of the city on 20 August. Because of formidable enemy defenses, the combined efforts of the French army, the tactical air command, and the Allied naval task force were required before complete occupation of the city was accomplished. The German garrison surrendered to the French army on 28 August 1944. (German gun, 7.5-cm. *Pak. 40.*)

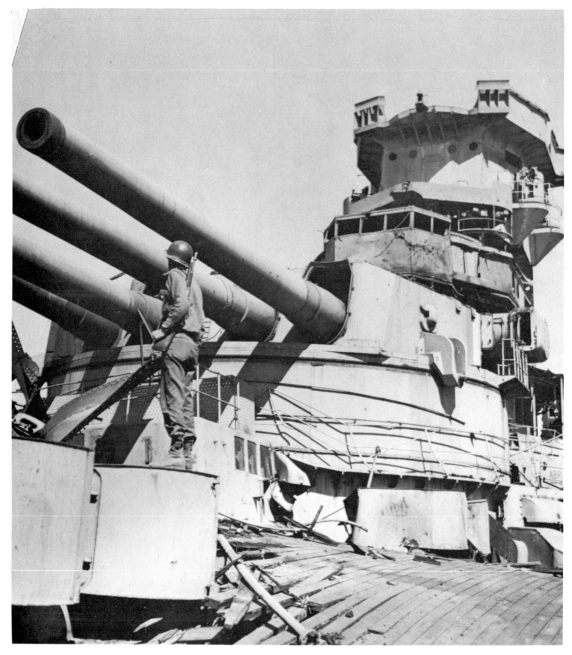

THE FRENCH BATTLESHIP *STRASBOURG*. This ship was scuttled and then damaged by Allied bombing on D plus 3, 18 August 1944, in Toulon harbor. The enemy made maximum use of artillery for coastal defense purposes. Batteries included railway guns, heavy coast artillery, German field pieces, old French and Italian equipment, and even naval guns transferred from French warships scuttled in Toulon harbor.

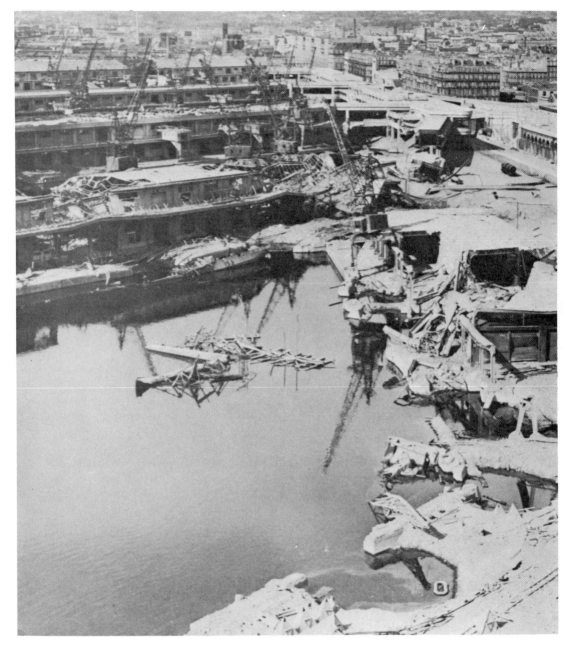

DAMAGED DOCKS AT MARSEILLE, the second largest city in France, the most important port on the Mediterranean, and one of the three cities in southern France with facilities for handling 10,000-ton Liberty ships. (The others are Toulon and Nice.) Marseille capitulated to the French army on 28 August 1944, particular emphasis being placed on preserving port installations which the Germans had hoped to render useless by large-scale demolitions.

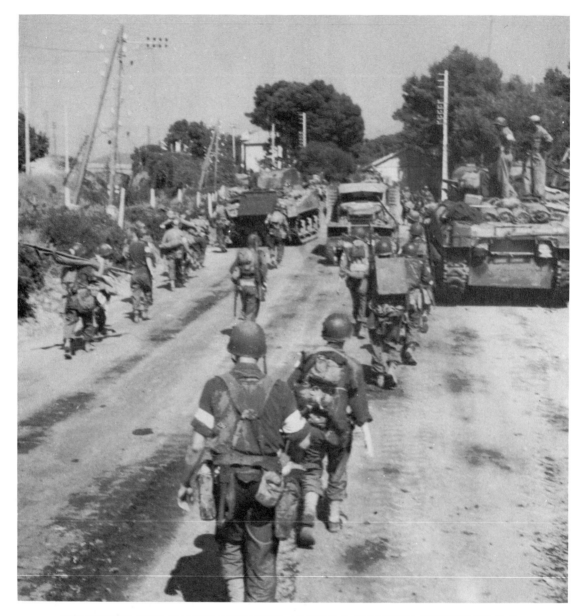

INFANTRY AND TANKS ADVANCE ALONG A COASTAL HIGHWAY. Failure of the defending forces to hold the invaders in the immediate coastal area was due to several facts: the enemy had disposed his divisions too far west; additional troops were committed in a piecemeal fashion; coastal units in general were weak, and lacked air support, armor, and heavy artillery. It is also estimated that about half the enemy troops were Russian, Czech, Turkish, Polish, and other non-Germanic people who were not inclined to put up a determined stand. The German corps headquarters, near Draguignan, became isolated from its command. The French Forces of the Interior constantly harassed the defending troops from the rear.

INFANTRYMEN PATROL NORTH OF MONTELIMAR (top). An American tank passes wrecked German equipment north of Montelimar (bottom). American troops advanced on Montelimar from the south and northeast in an attempt to cut off and destroy the German army in that area. After eight days of hard fighting the town was taken, but a large portion of the enemy troops had succeeded in escaping north from the triangle formed by the Rhône, Drôme, and Roubion Rivers, along Highway 86 west of the Rhône River and Highway 7 east of the river.

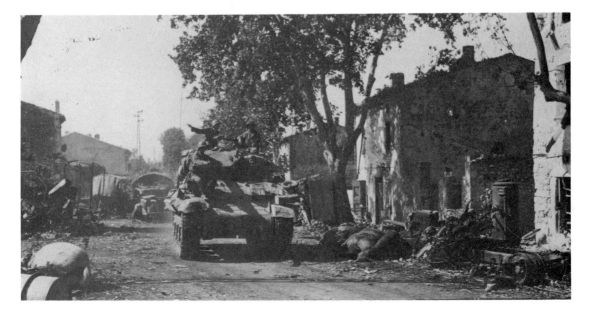

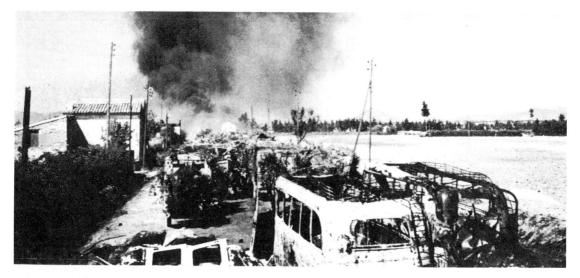

GERMAN EQUIPMENT BURNING IN THE MONTELIMAR AREA as U. S. artillery shells enemy convoys attempting to withdraw to the north (top). Wreckage of enemy vehicles after being hit by artillery fire (bottom). By the end of August the Germans had succeeded in withdrawing the greater part of their personnel north of the Drôme River, but left behind were destroyed vehicles, guns, and heavy equipment, which reflected the eight days of heavy fighting. American destruction of enemy equipment included between 2,000 and 3,000 vehicles, over 80 artillery pieces, and 5 large-caliber railway guns.

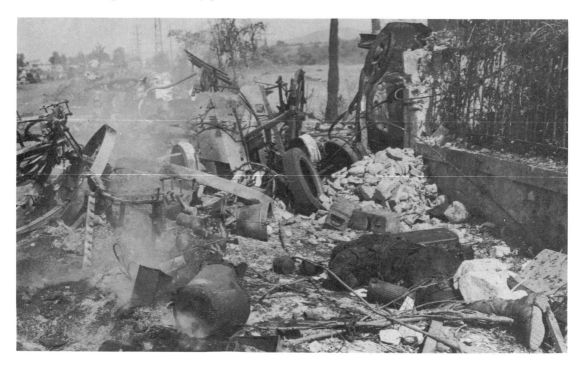

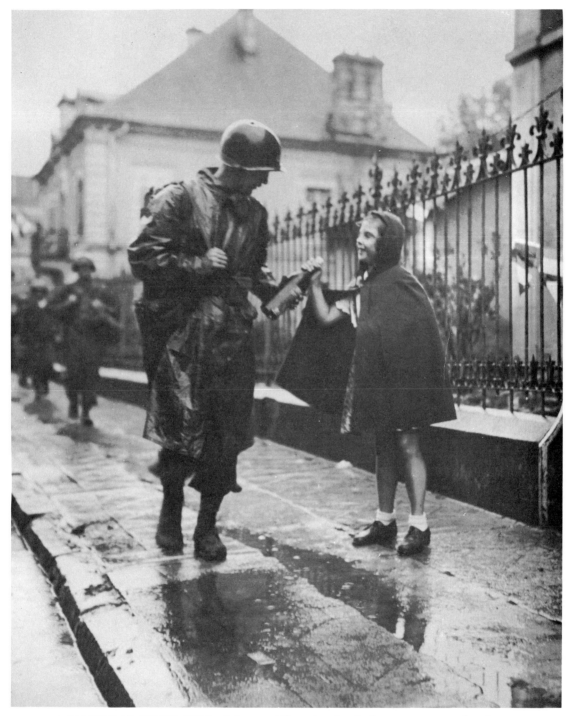

A LITTLE FRENCH GIRL giving a soldier a bottle of wine as a gesture of welcome as U. S. troops march through the streets of a liberated French town.

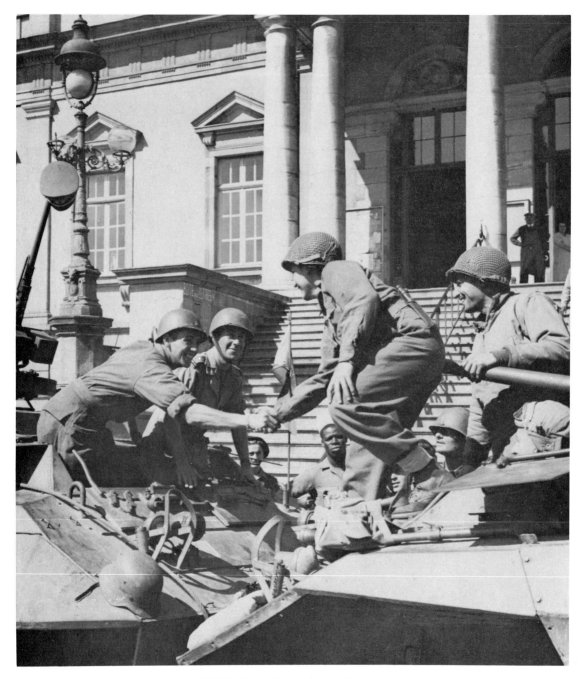

SOLDIERS OF THE SOUTHERN INVADING ARMY meeting soldiers from the northern invading army. At 1500, 11 September, elements of a French armored division of the southern forces made junction with a French armored division near Sombernon, 150 miles southeast of Paris. The two invasion forces thus joined to form a continuous Allied front from the North Sea to the Mediterranean.

ITALY

(5 June 1944–2 May 1945)

SECTION V

Italy

(5 June 1944–2 May 1945)*

The Allies did not halt after taking Rome, but their northward progress was soon slowed by skillful delaying tactics of the retreating enemy and by the fact that all the French and some of the American divisions were being withdrawn from the U. S. Fifth Army for the operation in southern France. The Germans speeded construction of the Gothic Line in the north Apennines, and early in August 1944 the Allies paused for reorganization on a line running approximately from ten miles north of Ancona on the east through Pisa to the west coast. The Fifth Army held the territory south of the Arno River from the sea to a few miles east of Florence; the British Eighth Army was north of Ancona on the Adriatic.

During August preparations were made by the Allied armies in northern Italy to penetrate the heavily fortified Gothic Line. This defensive system of the enemy extended in general from southeast of La Spezia through the mountains to Rimini. After regrouping and building up supplies, the Allied armies started their offensive on 26 August. They succeeded in breaching the Gothic Line in the center and along the coast, but fierce enemy resistance, bad weather, and a shortage of ammunition and replacements halted the offensive south of the Po River plain by the late fall of 1944. The winter of 1944–45 was spent in the mountains overlooking the Po Valley.

The spring drive by the Allied armies started on 9 April 1945. Bologna fell on 20 April, and armor and infantry overran the plain and divided the German forces. On 2 May 1945 the enemy in Italy surrendered unconditionally.

*See Sidney T. Matthews, The Advance to the Alps, a volume in preparation for the series U. S. ARMY IN WORLD WAR II.

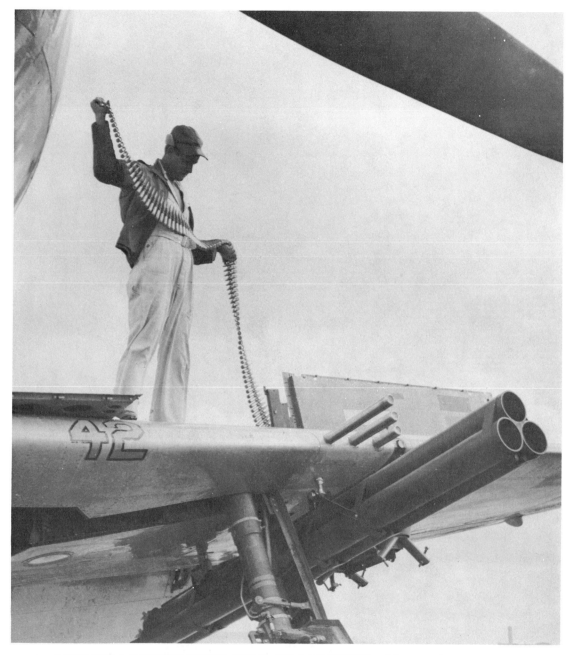

SOLDIER LOADING WING GUNS OF A FIGHTER with .50-caliber ammunition. In Italy these tough and maneuverable fighters were used for a variety of purposes, particularly after other fighter planes with a higher speed and longer range were available for escorting and protecting bombers. The P–47's became fighter-bombers, and were also equipped to use rockets. (4.5-inch 3-tube AC rocket launcher M15 of a P–47.)

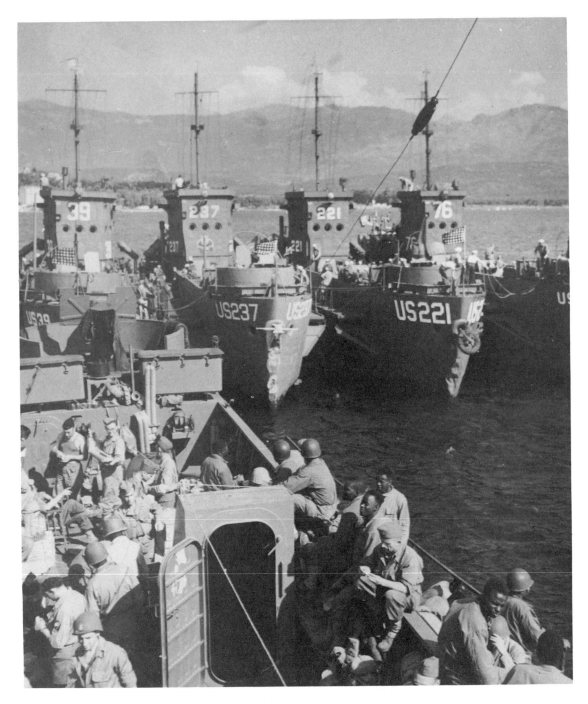

FRENCH COMMANDOS AND SENEGALESE TROOPS on an LCI in a Corsican harbor prior to the attack on the island of Elba. The troops were taken to Elba on 17 June 1944 in U. S. landing craft and in two days the island had been secured.

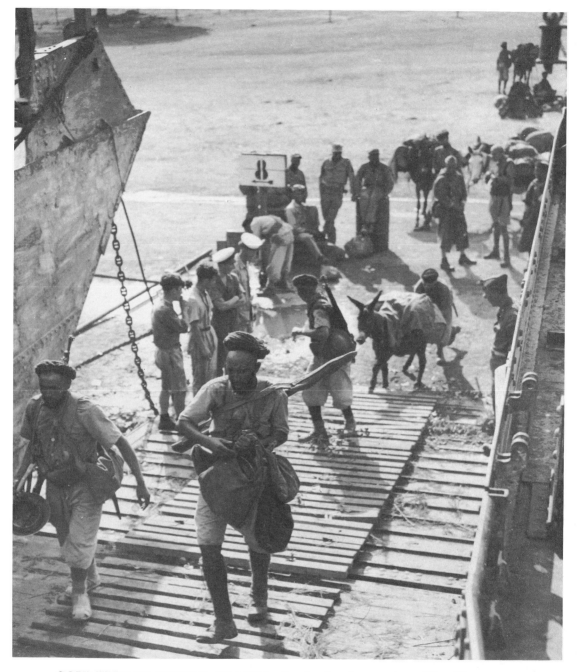

GOUMIERS BOARDING AN LST in Corsica for the attack on Elba. The attack, though not carried out by Fifth Army troops, was co-ordinated by Allied Force Headquarters with the advance on the Italian mainland and was launched when the forces driving up the mainland were nearly opposite the island. The attacking force consisted of French, goumiers, and Senegalese.

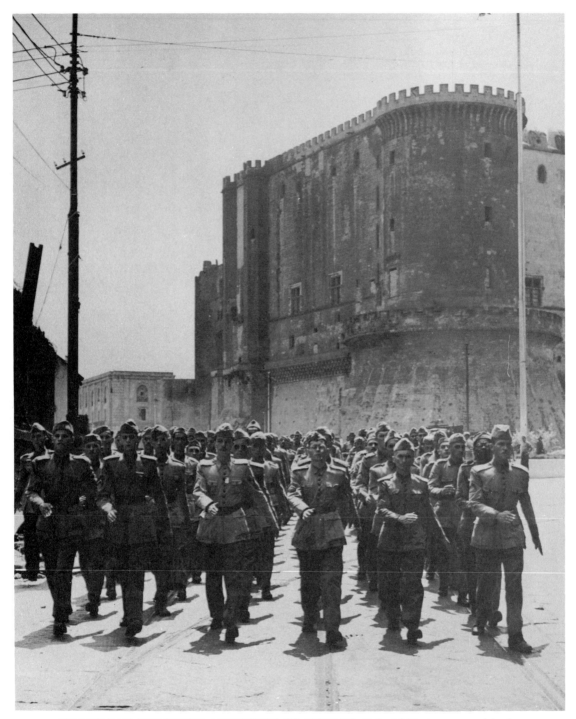

BRAZILIAN SOLDIERS ARRIVING IN NAPLES, July 1944, to serve with the Fifth Army during the 1944–45 winter campaign in the northern Apennines.

GASOLINE DISTRIBUTION POINT. Oil tankers brought gasoline into major ports. From there is was transported to storage tanks at distribution points by pipeline, trucks, or tankers where it was transferred to five-gallon cans for pickup.

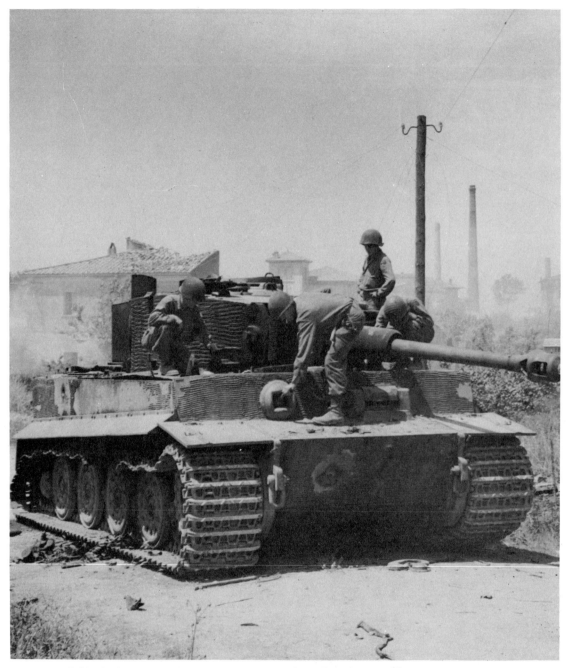

A TIGER TANK, such as was encountered in Tunisia and Sicily, but with a non-magnetic plastic coating. It is believed that most of the tanks thus coated were originally destined for the Russian front where the Germans were greatly troubled by delayed-action magnetic mines which were stuck onto the armor of their tanks by Russian infantry.

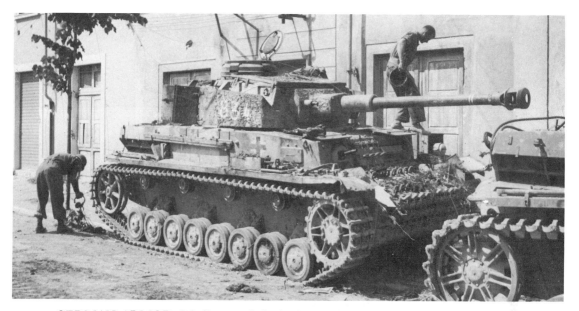

GERMAN ARMOR. Medium tank is the Mark IV (top). Of the four tank types with which the Germans started the war, only this survived in service until the end. Originally it had a short-barreled 75-mm. gun which changed its role from a close-support vehicle to a fighting tank. Assault gun (bottom). The Germans used this in great numbers, and it was often called a tank, but was actually an assault gun and tank destroyer on the chassis of a Mark III tank. (Top: *Pz. Kpfw. IV* tank with 7.5-cm. *Kw. K. 40 (L/43)* gun; bottom: *Stu. G. III* with 7.5-cm. *Stu. K. 40* gun.)

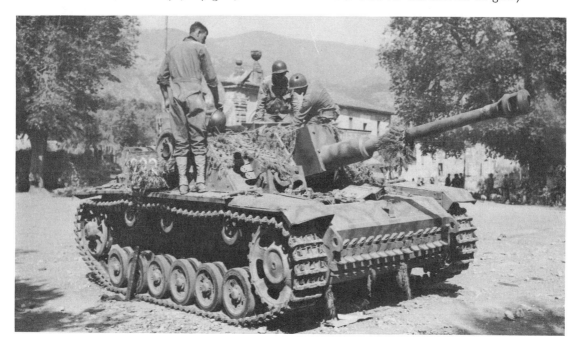

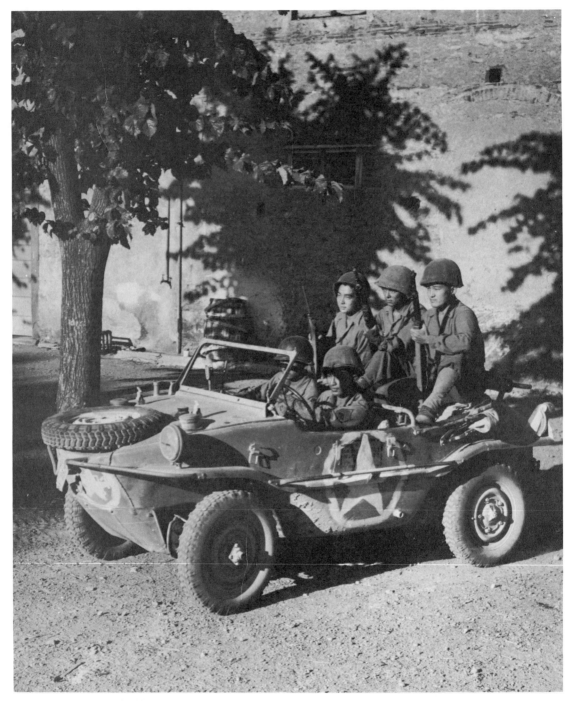

GERMAN AMPHIBIAN JEEP, a version of the light Army car, *Volkswagen*. Both versions were inferior in every respect to the U. S. jeep except in the comfort of the seating accommodations. (*Schwimmwagen, le.P.Kw.K.2s.*)

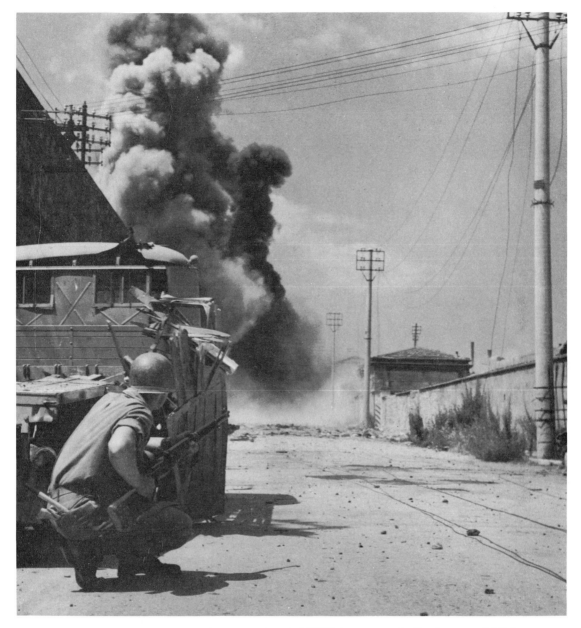

ENGINEERS SETTING OFF ENEMY MINES in a street in Leghorn on 19 July 1944, the day the city fell. The soldier at left is guarding engineers against snipers. The Germans had destroyed all the port facilities, mined the buildings in the harbor area, and made the latter unusable by blocking the entrance with sunken ships. The drive from Rome to the Arno River was a pursuit action in which the Germans, by skillful delaying tactics, slowed the Allied advance so that completion of the Gothic Line defenses in the northern Apennines could be expedited. The mouth of the Arno River was reached by 23 July 1944.

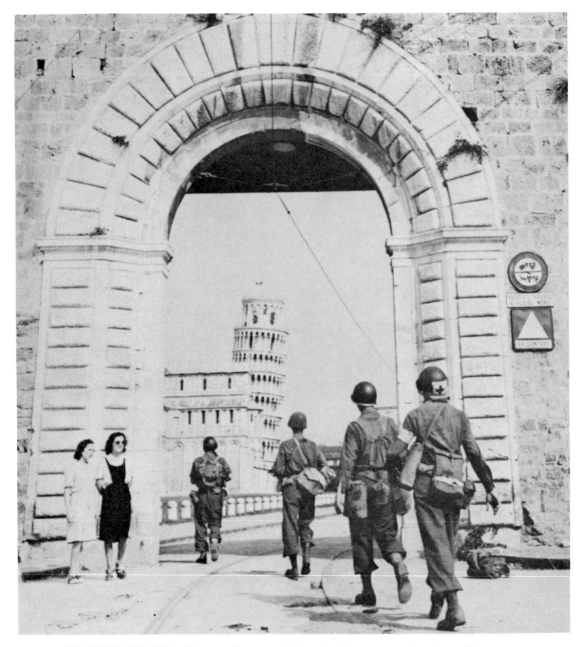

TROOPS IN PISA. The southern outskirts of this town on the Arno River were entered on 23 July 1944. The enemy had destroyed all bridges across the river and when the infantry entered the town they were met by heavy fire from across the river. The southern half of the city was found heavily mined and booby-trapped. During the approach to the Arno River plans were being completed for introduction of anti-aircraft units into the lines as infantry since enemy air activity had decreased to the extent that many AA units could be more profitably used as infantry.

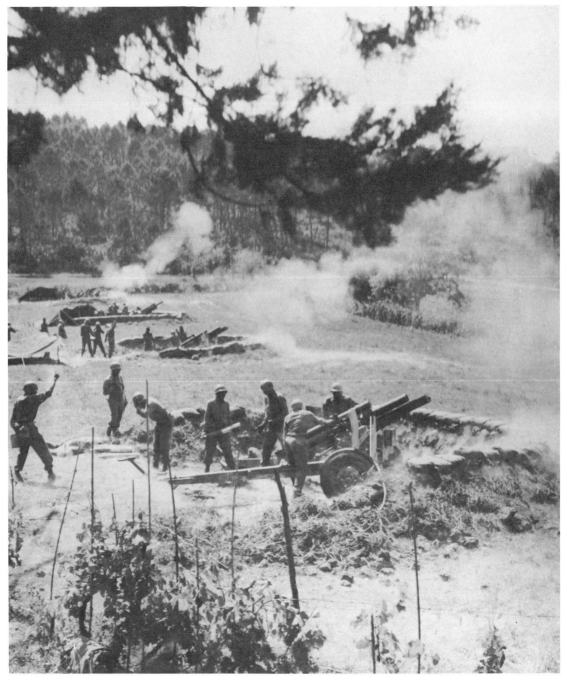

FIRING HOWITZERS across the Arno River in August. The men of this unit were part of an American all-Negro regimental combat team, the first to appear in Italy. They entered the line south of the Arno on 23 August. A few weeks later an entire Negro infantry division was at the front. (105-mm. howitzer.)

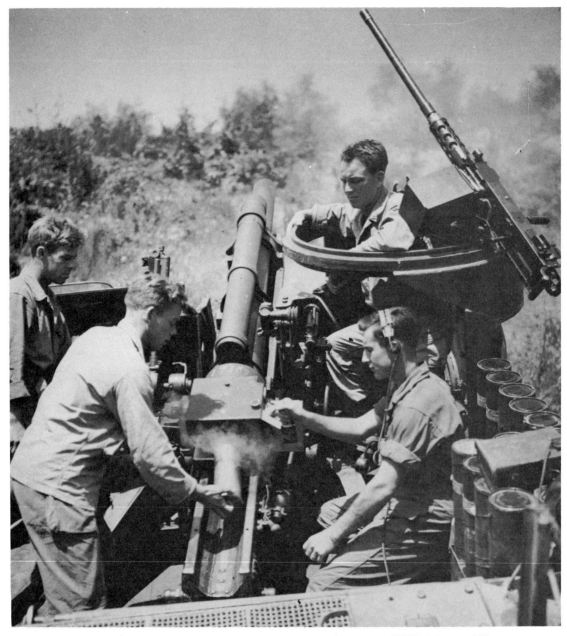

MEMBERS OF AN ARMORED FIELD ARTILLERY UNIT firing a 105-mm. howitzer during training south of the Arno River. The howitzer is mounted on a Priest. The Fifth Army reached the Arno at Pontedera on 18 July and the first week in August found the forces grouped along the southern bank on a thirty-five-mile front reaching from the sea on the west to Florence. The month of August was used for resupplying, resting, and training the units. (105-mm. howitzer; M7 gun motor carriage.)

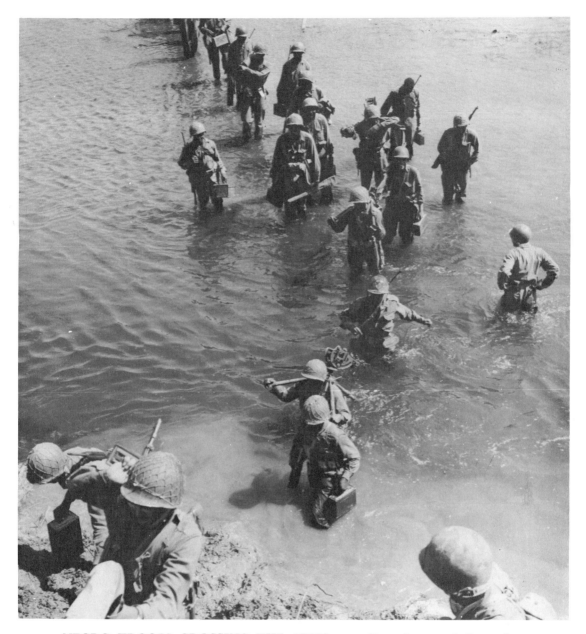

NEGRO TROOPS CROSSING THE ARNO near Pontedera on 1 September, during the drive toward the Gothic Line. The attack on this line was started by the Eighth Army along the east coast on the night of 25–26 August. On 1 September the line had been breached in that sector but by the 6th the advance had been stopped a few miles below Rimini on the Adriatic coast. This advance by the British caused the German High Command to shift three divisions opposing the Americans to the British sector. The forces directly opposite the Arno drew back into the Gothic Line, a distance of about twenty miles.

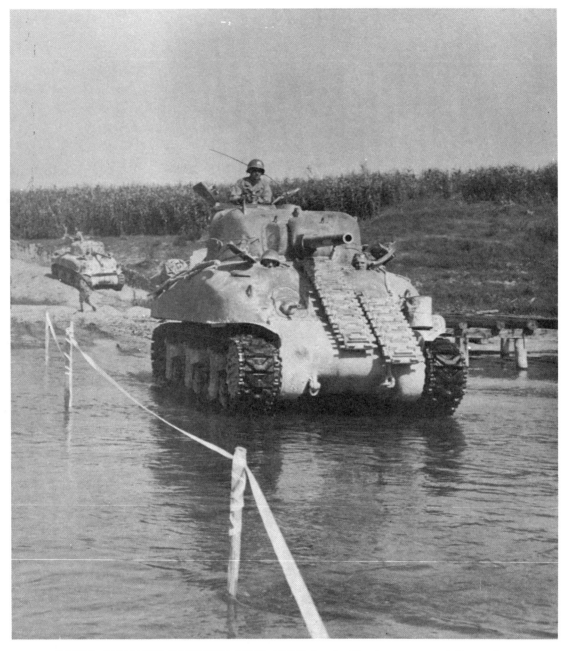

SHERMAN TANK FORDING THE ARNO in the Cascina area on 1 September. Little opposition was met until the Gothic Line was reached. The Germans had started to withdraw into this line during the last days of August. Before the withdrawal, it was estimated that the area between the Arno River and the Gothic Line contained about 350 enemy tanks, half of which were Panthers and Tigers. (Sherman tank M4A1.)

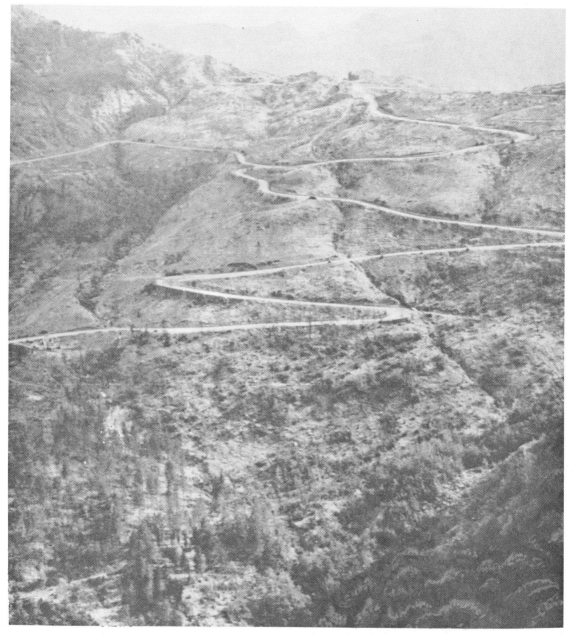

TOP OF IL GIOGO PASS IN THE GOTHIC LINE, looking toward the north. The Fifth Army broke through this pass in the Gothic Line defenses outflanking the heavier prepared fortifications at Futa Pass on Highway 65. The scarcity of roads through the mountains made it possible for the Germans to concentrate their defensive works at a few key points such as the Futa and Il Giogo Passes. Highway 6524 branches off Highway 65 thirteen miles north of Florence, winds through Il Giogo Pass, and ends at Highway 9 in Imola (Po Valley).

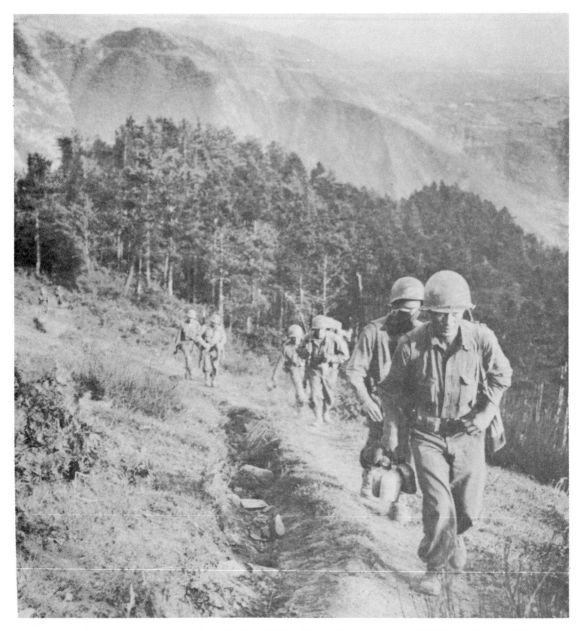

INFANTRY ADVANCING OVER THE HILLS in the area of Il Giogo Pass on 18 September, the day the pass was taken. The fight for the area started on the morning of 12 September. The mountains on each side of Il Giogo Pass are too steep to require antitank defenses other than road blocks, but other defenses such as underground fortresses were numerous and well prepared. Barbed wire and antipersonnel mine fields guarded approaches. Many of the hills were covered with pine woods which made it difficult to locate enemy defenses by the use of aerial photographs. Some information was obtained from partisans who had worked on the Gothic Line.

PACK MULE TRAIN approaching the Gothic Line in the area of Il Giogo Pass. For the difficult task of supplying their troops through the mountains the Allied forces had 9 Italian Army mule pack companies, each containing 260 mules. (2½-ton U. S. truck overturned.)

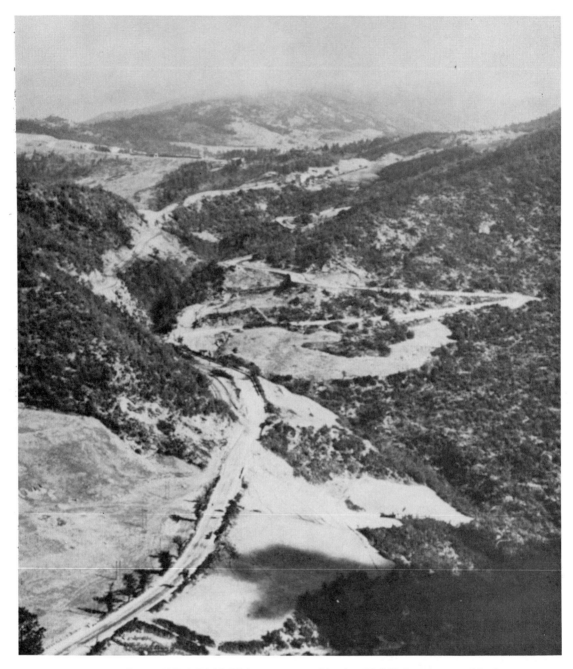

HIGHWAY 65 AT FUTA PASS. This pass, at an altitude of 2,962 feet, is one of the lowest through the northern Apennines. Highway 65, the most direct route to Bologna and the Po Valley, became the main supply route and a principal axis of advance in the Fifth Army area, although the breach in the Gothic Line was not made here. Futa Pass fell on 22 September.

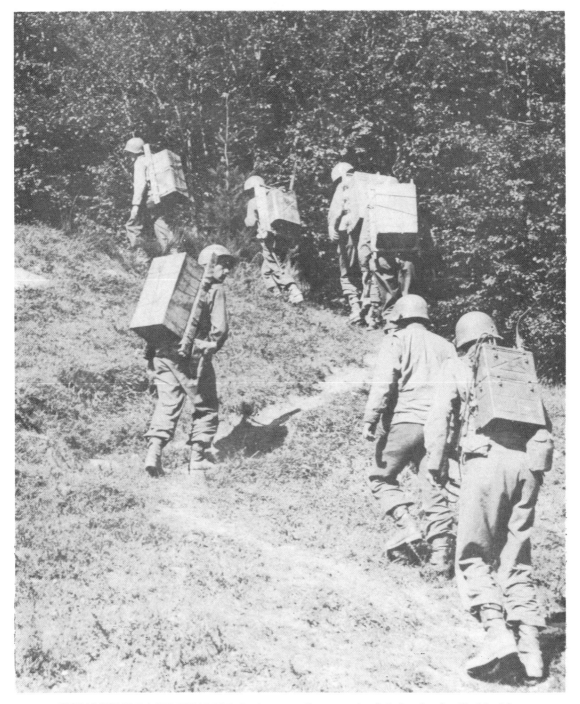

INFANTRY PACK TEAMS bringing supplies to units fighting in the Gothic Line near Futa Pass. Mule pack teams were available but some of the paths were too steep even for pack animals.

ANTITANK DITCH AT FUTA PASS. This ditch, about three miles long, crossed the road south of the pass. The ditch was covered with a network of infantry positions and bunkers for antitank guns. The area in front of the ditch was mined. Two of the bunkers in this area were topped by Panther tank turrets with long-barreled 75-mm. tank guns.

A PANTHER TURRET CASEMATE in the Gothic Line near Futa Pass. The turret could not be penetrated by the guns of any of our tanks, but was vulnerable to artillery fire.

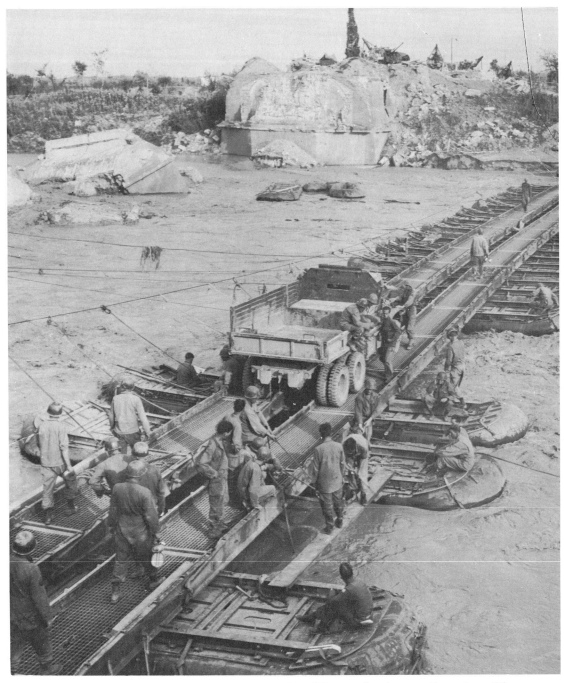

REPAIRING PONTON TREADWAY BRIDGE over the Arno at Pontedera. The supply situation of Fifth Army troops at the Gothic Line was made difficult by fall rains which raised the Arno River to flood level and washed out most of the bridges between Florence and Pontedera.

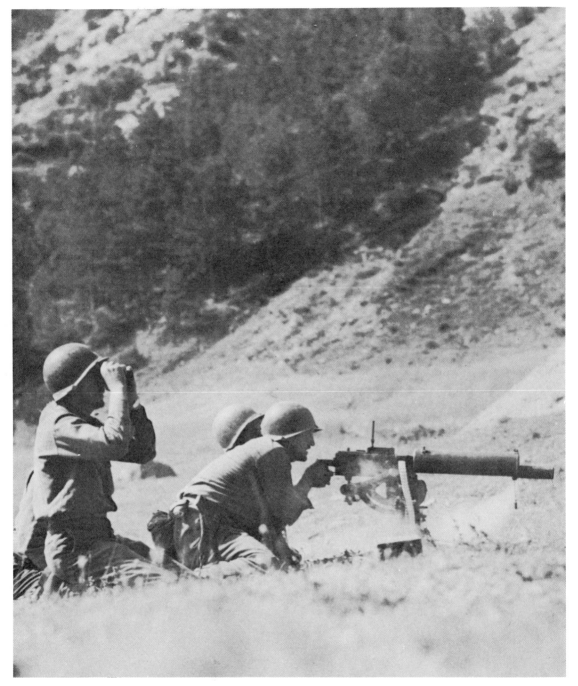

MACHINE GUNNERS FIRING AT GERMANS in the Monticelli area near Il Giogo Pass. Note flash hider attached to front of machine gun. The Americans occupied Firenzuola on 21 September. (.30-caliber Browning machine gun M1917A1, a development of the M1917 which proved its worth in World War I.)

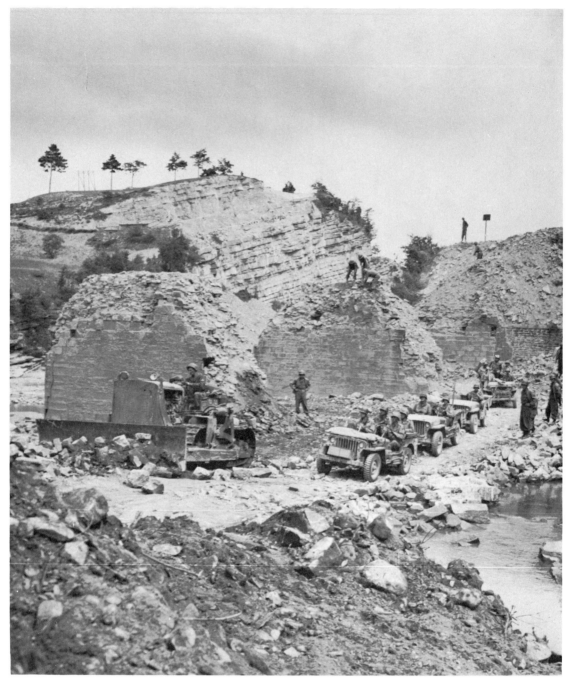

AMERICAN ENGINEERS CONSTRUCTING A BYPASS in the Firenzuola area
during the pursuit of the Germans. The combat engineers, prepared to bulldoze a by-
pass or to install temporary bridges, followed closely behind the leading elements
of the infantry and armor. (Jeep; crawler type diesel tractor with angledozer.)

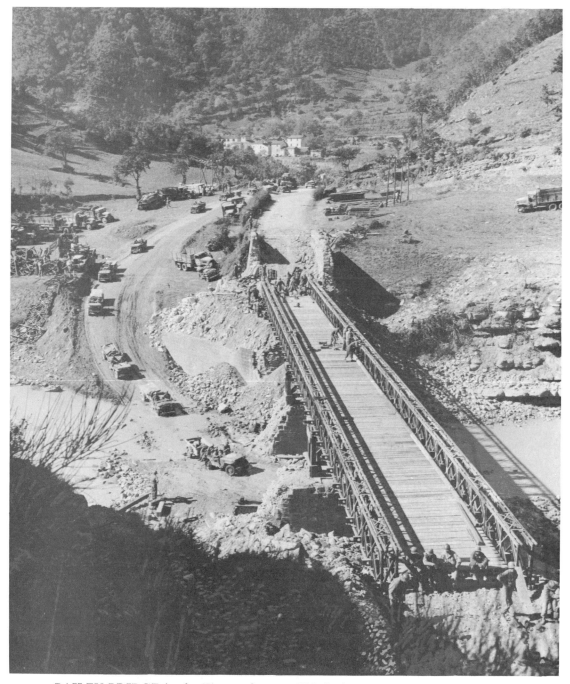

BAILEY BRIDGE in the Firenzuola area. This is the same site as the scene of the bulldozer constructing a bypass, the picture being taken two days later. The Bailey bridge was particularly suitable for operations in the mountains of Italy where sudden rains would swell the rivers and wash out ponton bridges.

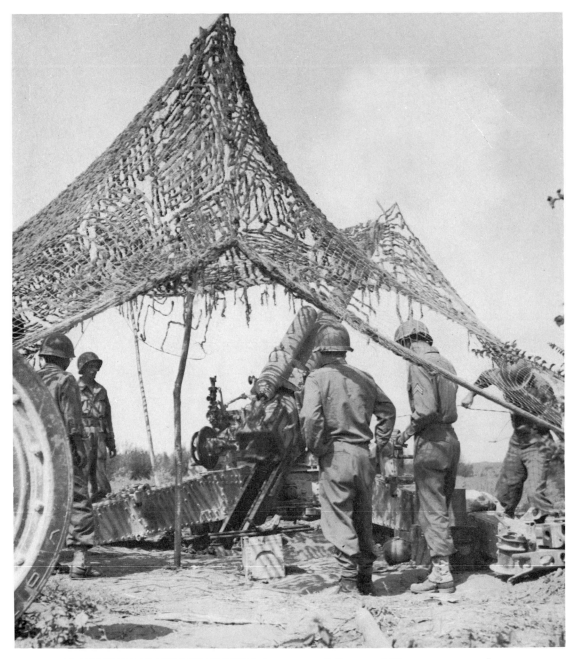

AMERICAN ARTILLERYMEN firing captured German 150-mm. gun near Lucca. Note small amount of smoke. German ammunition was charged with smokeless, flash-less powder which in both night and day fighting helped the enemy tremendously in concealing his fire positions. All U. S. guns, from the rifle to the large howitzer, left telltale puffs of smoke during daytime or showed relatively large and brilliant muzzle flashes at night.

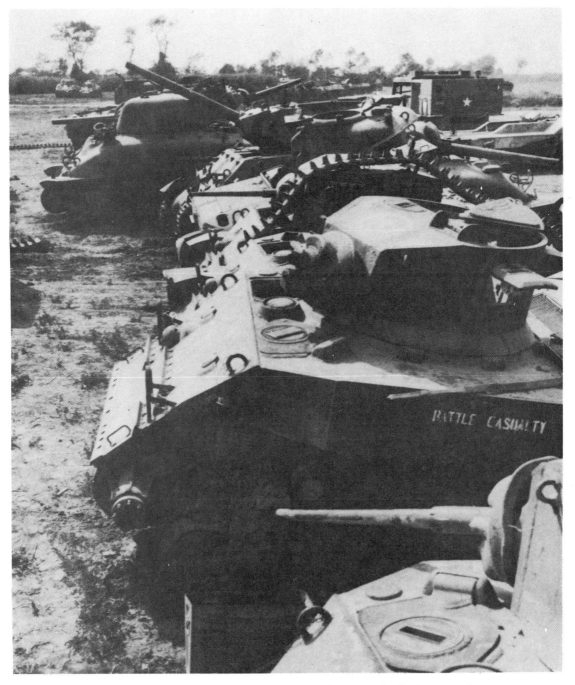

A GROUP OF ARMORED VEHICLES at a salvage yard of a heavy maintenance company in Italy. (1, 2, and 3, light tanks M5; 4, medium tank M4; 5, gun motor carriage M10; 6, medium tank M4. A tractor and tank recovery trailer are partially visible, upper right.)

SOLDIERS IN THE APENNINES receiving an issue of woolen underwear, September 1944. Some of the peaks in the northern Apennines rise to well over 5,000 feet and the weather is unpleasantly cold in winter. Fall rains, often turning to sleet, start in September and the higher peaks are usually snow-covered by late October. Highway 65, the main axis of advance, runs mostly on top of the mountain ridges. Here the cold is particularly severe. There is nothing to break the winter winds and part of the road is so high that it is often cloud-covered.

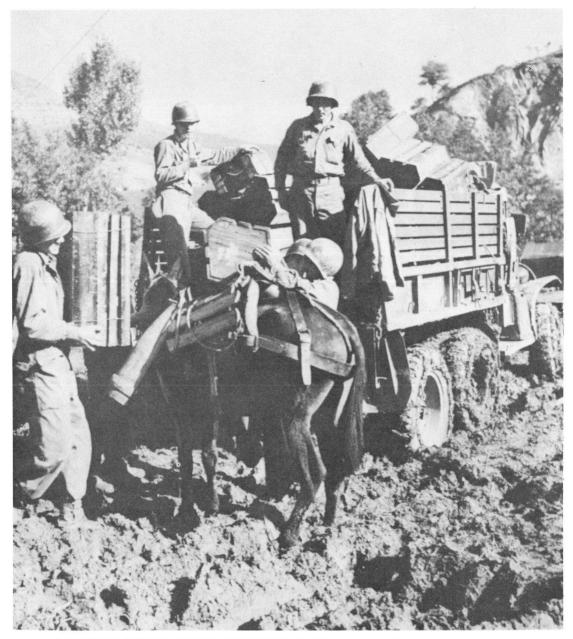

LOADING MULES WITH AMMUNITION for 155-mm. howitzers in the Castel del Rio area on Highway 6524, between Firenzuola and the town of Imola in the Po Valley. After breaching the Gothic Line at Il Giogo Pass an attempt to reach the Po Valley at Imola was made along the route above. Because of the exposed salient and stiff enemy resistance, the axis of attack was changed to Highway 65. On 1 October, the day the picture was made, bloody fighting for possession of the controlling height of Monte Battaglia, east of Castel del Rio, was in progress.

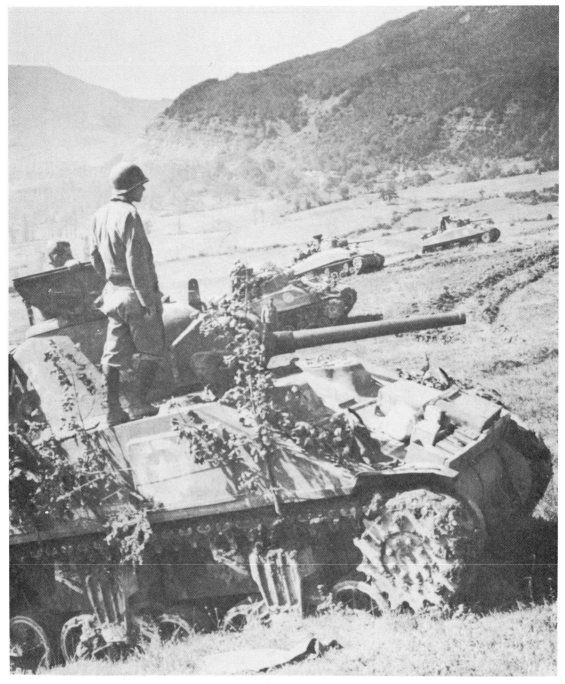

A TANK BATTALION PREPARING TO ATTACK along Highway 65 toward the village of Monghidoro. The attack started on the morning of 1 October and by evening of the 2d the village was securely in Allied hands. The Sherman tanks pictured here are all armed with 76-mm. guns.

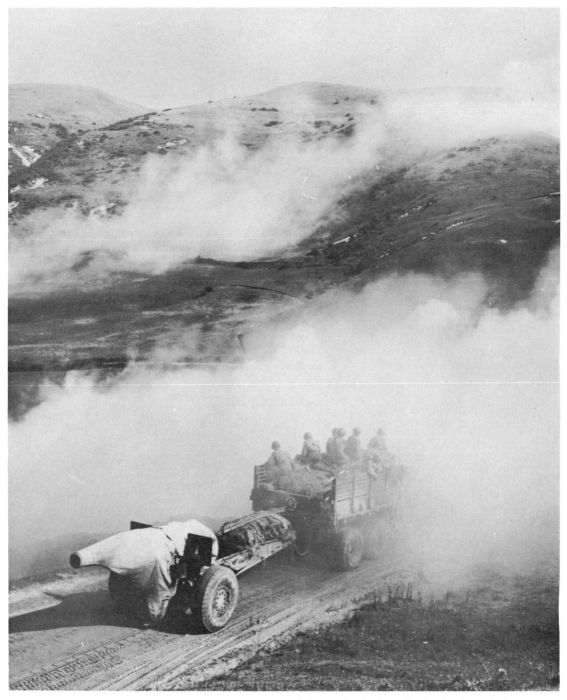

TRUCK TOWING HOWITZER along Highway 65 during the beginning of the
1 October drive. Smoke is from M2 smoke generators. (6-ton truck; 155-mm.
howitzer.)

TERRAIN OF THE WINTER STALEMATE in the northern Apennines, looking toward the southeast. The high mountain peak in distance is Monte Vigese. This mountain was taken by the South Africans of the Fifth Army on 6 October 1944 after a three-day fight. The territory in the foreground was in enemy hands until the beginning of March 1945 when it was taken by American and Brazilian troops in a limited offensive to obtain better jumping off places for the main attack toward the Po Valley.

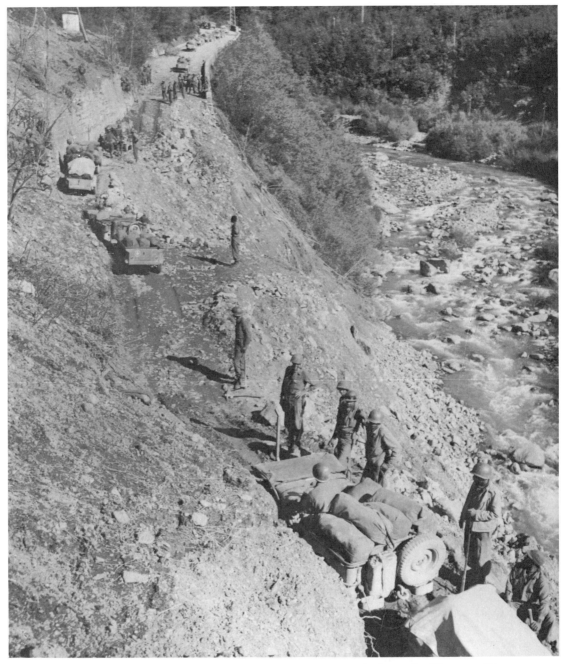

NEGRO TROOPS ADVANCING ON HIGHWAY 12 along the Torrente Lima. Jeeps with trailers were used and in danger areas the windshields were folded forward and covered with canvas to prevent light reflection. The sort of road demolition shown was common during the fighting in the northern Apennines. Valley roads were subject to natural landslides, and large-scale destruction was easy to accomplish.

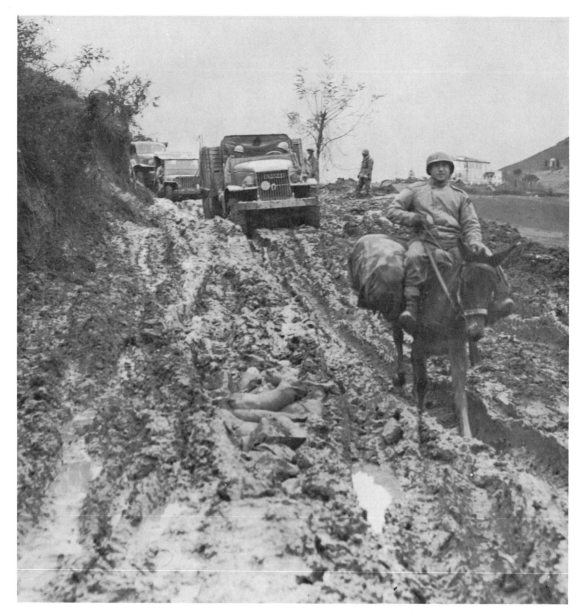

ROAD IN THE APENNINES during the October drive. After the first week, weather was a contributing factor to the slow pace of the offensive. Rainy and foggy days worked almost entirely to the benefit of the enemy. Artillery observation planes were grounded and few of the planned air missions could be flown. Finally, with each mile that the troops advanced over the rain-soaked trails and dirt roads, the problem of keeping supplies moving forward increased. Engineers kept working night and day pouring gravel and crushed rock on the roads. They managed to keep highways open for all types of vehicles and side roads passable for the four-wheel-drive jeep and the powerful 2½-ton truck. (Jeep; 2½-ton truck.)

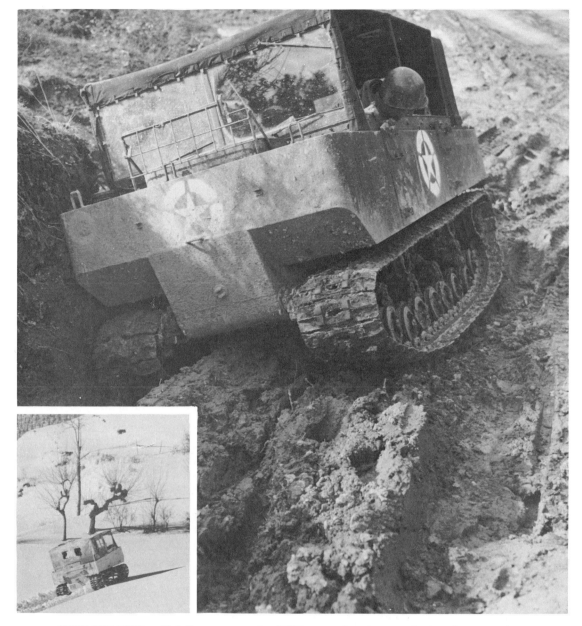

THE WEASEL, officially cargo carrier M29, came into its own during the campaign in the northern Apennines. It operated satisfactorily off the roads under mud or snow conditions and helped to provide lateral communications. Most roads in the Fifth Army sector of the Apennines ran more or less parallel in a northerly direction; the area of the winter fighting was almost completely devoid of east-west roads. The Weasel, originally designed for use over snow and ice, had low ground pressure and proved suitable for operation across fields or poor trails. It had a crew of two and a pay load of approximately 1,000 pounds.

JEEPS ALONG THE SUPPLY ROADS in the northern Apennines. This vehicle was capable of operating over unimproved roads and trails and could be shifted into four-wheel drive for steep grades and muddy or sandy terrain. It could climb a 60 percent grade and attain a speed of 65 miles per hour over level highways. The jeep could also ford a stream 18 inches deep while fully loaded and a deeper stream when especially equipped with exhaust and air-intake extensions. The jeep, truck, and pack mule were always important in the advances made.

APPROACH TO LIVERGNANO ON HIGHWAY 65, looking from the south along the highway. The village is the small cluster of ruined houses below cliff on left. The Germans occupied the houses as well as the tops and sides of the two hills. The latter were honeycombed with caves which the enemy had enlarged and strengthened. The fighting lasted from 9 to 14 October. On the 14th the enemy was still in possession of most of the village and the two hills but retreated because he had been outflanked from the west.

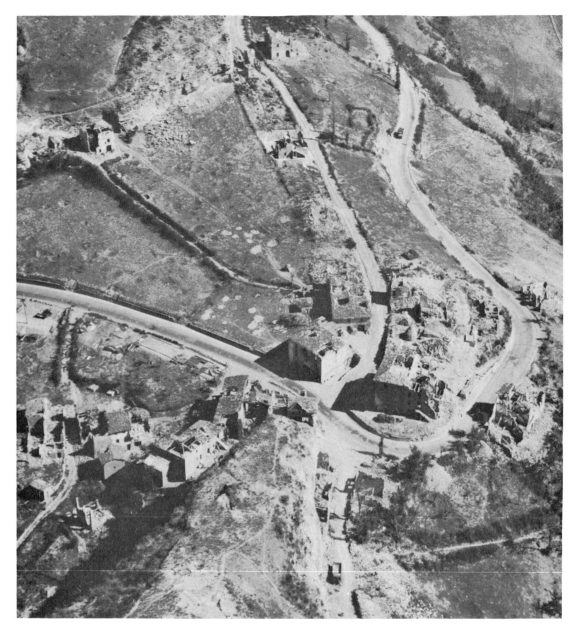

THE RUINS OF LIVERGNANO. The main highway through the village runs to Florence (upper right), and to Bologna (center left). Livergnano, taken in a five-day fight, became known as "Liver and Onions." During the final attack of this fall offensive toward Bologna, which started on 16 October and bogged down in mud toward the end of the month, the enemy concentrated his artillery fire on this village in an attempt to demolish the houses along the road and thus block the highway, the supply road for the area. The enemy managed to knock down some of the houses but did not succeed in stopping traffic. Bulldozers filled the craters in the road and pushed aside the rubble.

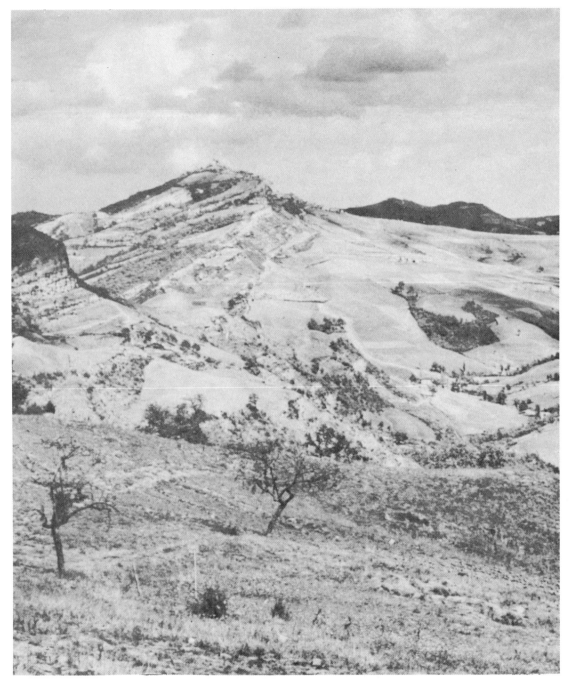

MONTE DELLA FORMICHE, taken after a three-day fight starting on 10 October. This mountain, located east of Highway 65, is 2,092 feet high, the highest of the terrain features in the chain of enemy defenses stretching east and west across Highway 65 through the village of Livergnano.

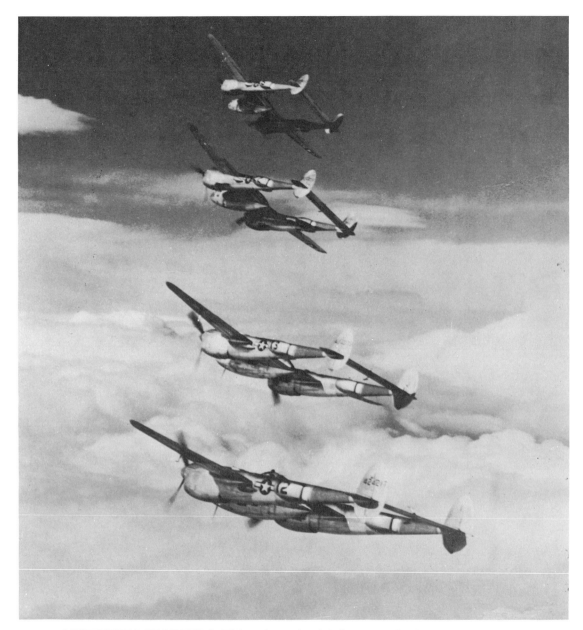

LIGHTNING FIGHTERS. This twin-engined fighter was the first successful long-range bomber escort developed by the United States. Most Allied fighter planes in Italy gradually came to be used as fighter-bombers as the need for protecting bomber formations from hostile aircraft diminished. In August 1943 the Germans had only about six hundred combat aircraft, mostly fighters, in Italy. About a third of these were of limited use. Demands for fighters on the Russian front and the need for protecting production centers in Germany from Allied bombings caused some withdrawal of enemy fighters based in Italy. (P–38.)

THUNDERBOLT FIGHTER-BOMBERS over the northern Apennines. Note belly tank to increase range, and bombs under wings. Beginning in October 1944, extensive use of the 110-gallon fuel tank incendiary bombs containing a jelly-like mixture called napalm was made for the first time on the Italian front. The bombs proved particularly effective against enemy bivouacs and troop installations in wooded areas where the highly inflammable fuel, scattered over a wide area, could start numerous fires. Fighter-bombers co-operated closely with the ground forces. (P–47.)

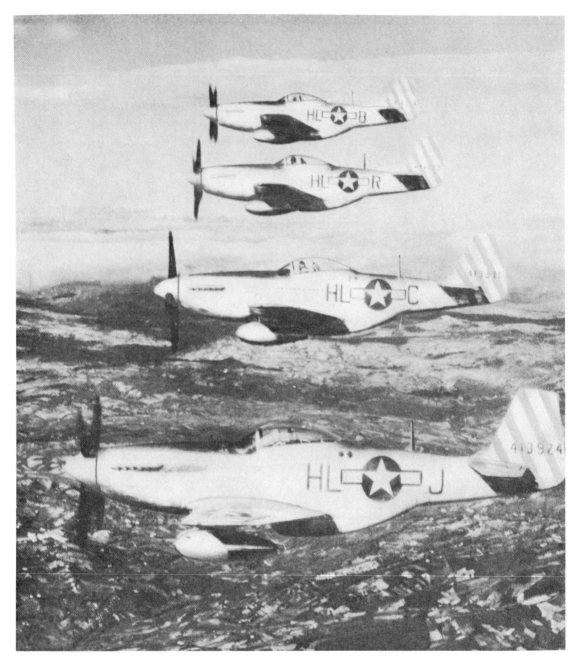

MUSTANG FIGHTERS. This plane, the P–51, was originally made for the British and was used by the Royal Air Force as early as November 1941. The Army Air Forces started to use it in July 1942. The A–36 version of the P–51 was a fighter-bomber, and except for diving brakes and differences in armament, the two ships were alike. With the addition of wing tanks the P–51 became a long-range fighter used to escort bombers.

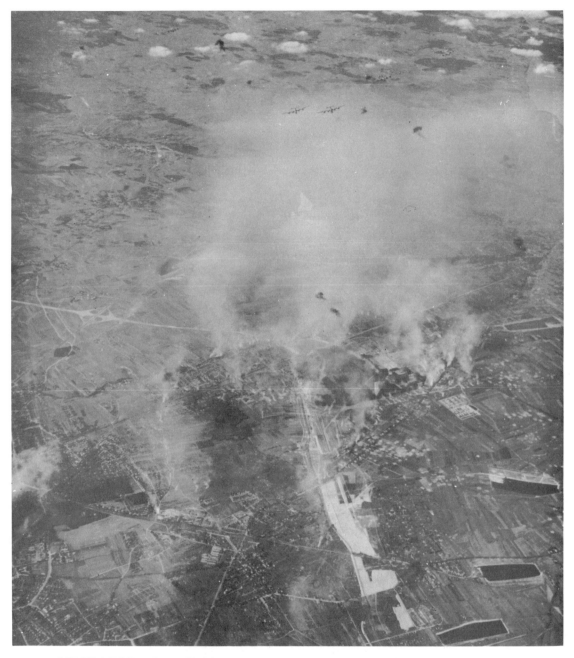

LIBERATOR BOMBERS from Italian bases bombing the Munich area in southern Germany. Smoke-making generators in operation to blanket vital areas. Note black bursts of antiaircraft fire. Heavy bombers from Foggia could easily strike at the passes in the Alps and attack enemy installations and factories in southern Germany and Austria as these targets were closer to Allied bases in Italy than they were to those in England.

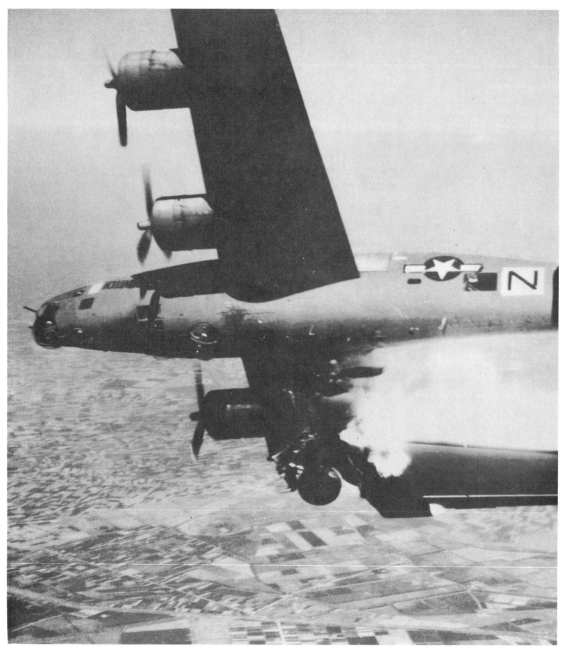

LIBERATOR BEING SHOT DOWN by flak over the Po Valley in northern Italy. As the war in the Mediterranean progressed the size and effectiveness of the enemy air forces decreased, while the antiaircraft defenses increased and became more and more concentrated around the remaining enemy targets. As various enemy targets were damaged beyond usefulness, antiaircraft units defending them were sent to strengthen defenses around industrial plants still in production.

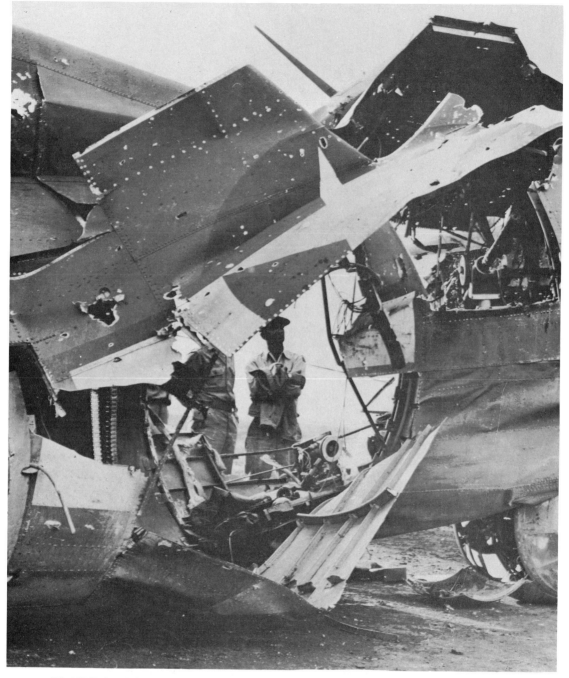

FLAK-DAMAGED FUSELAGE OF A FLYING FORTRESS. This plane received
a direct antiaircraft shell hit while on a mission over Hungary but managed to fly
back to Italy where it collapsed on landing. In spite of damage to the bomber none of
the crew was hurt.

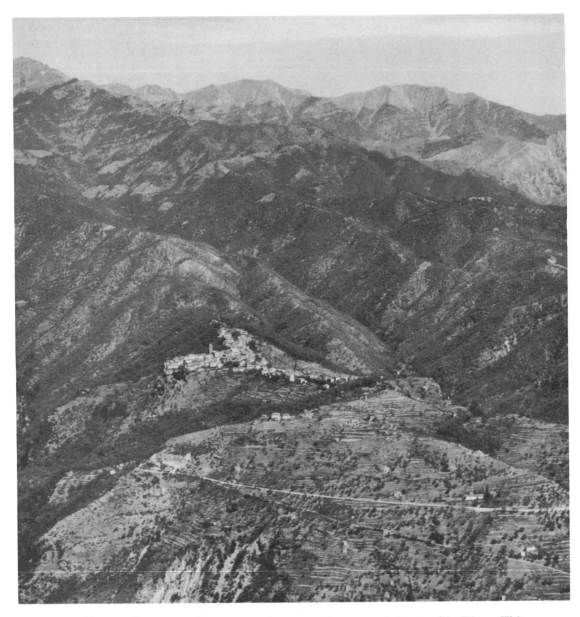

COREGLIA ANTELMINELLI in the mountains west of the Serchio River. This region was being held by an American Negro infantry division. On the morning of 26 December 1944 a mixed enemy force of Germans and Italians started an attack in this vicinity and pushed the division back several miles. An Indian brigade was rushed up to halt the advance of the enemy. Since it was feared that the enemy might break through and threaten the Allied supply base at Leghorn, reinforcements were rushed to the area to protect the vital base. On the night of the 27th the Indians made contact with the enemy who started to retreat. By 31 December almost all the lost territory had been regained and the line was again stabilized.

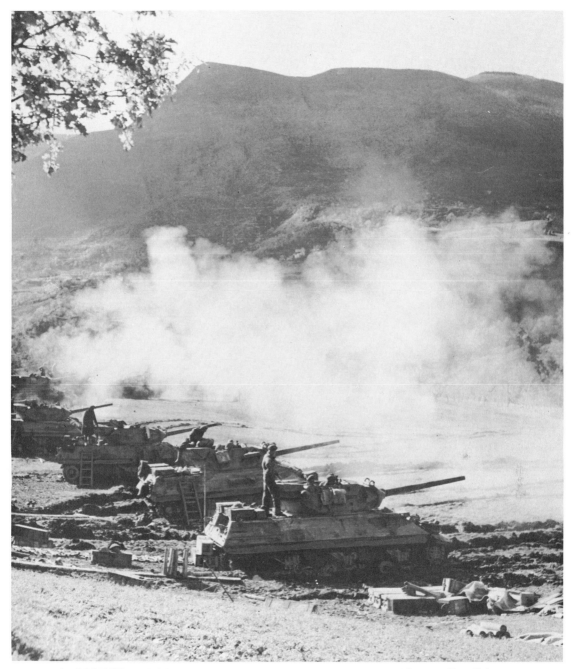

A SOUTH AFRICAN ARMORED UNIT in the Reno River valley firing at German positions across the river, November 1944. Combat action in the Fifth Army sector during November and the first half of December was largely confined to patrol activities and artillery duels. The South African armored division had been transferred from the Eighth Army to the Fifth Army in late August 1944.

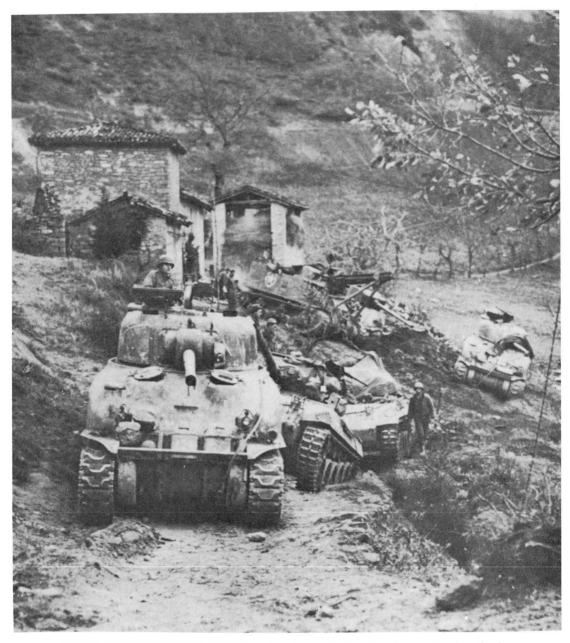

TANK MAINTENANCE POST in abandoned Italian farmhouse. During the long winter stalemate time was utilized to make major repairs on armored vehicles. Minor repairs, such as thrown tracks, were made at forward maintenance posts such as the above which was located only about 400 yards behind the front lines. (1, medium tank M4A1; 2 and 3, 76-mm. gun motor carriage M18; 4, medium tank M4A1; 5, medium tank M4, with 76-mm. gun (note different gun mount); 6, tank recovery vehicle M31.)

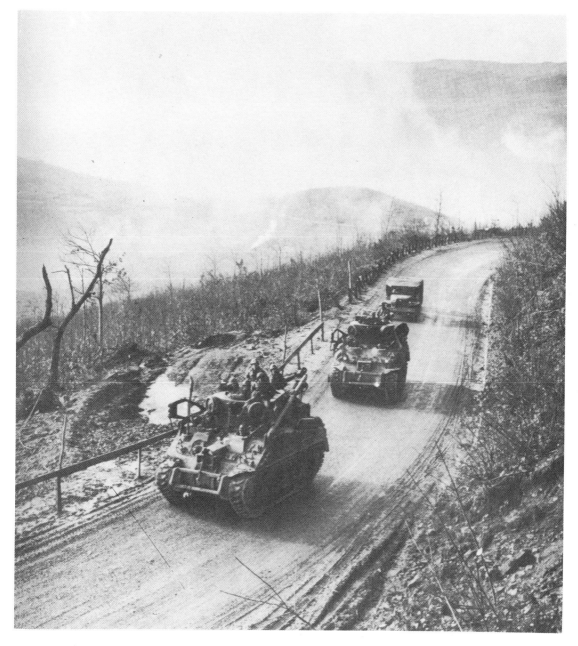

MOBILE FIELD ARTILLERY MAINTENANCE UNIT near the front. These units were used a great deal during the winter. Artillery off the main roads could be moved only with difficulty after the rains started and repairs that were normally made in shops behind the front had to be done in the field. The first two vehicles shown above are tank recovery vehicles M32, and are modifications of the M4 designed primarily for recovery of tanks from battlefields. The fixed turret replaces the customary tank turret. Third vehicle is weapons carrier, ¾-ton 4 x 4 truck.

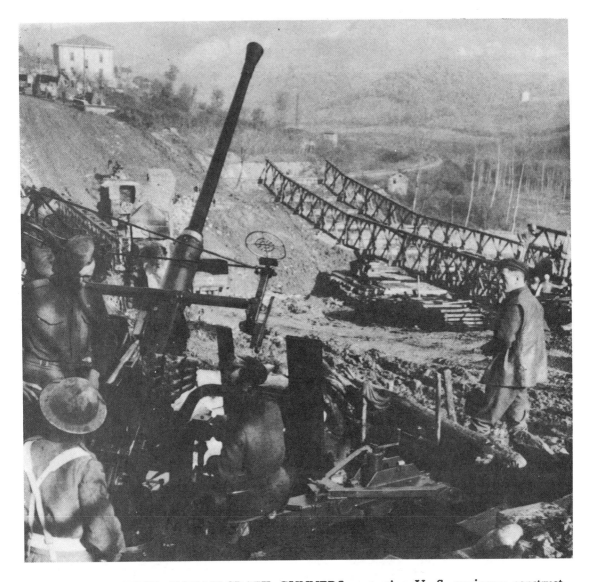

BRITISH ANTIAIRCRAFT GUNNERS protecting U. S. engineers construct-
ing a Bailey bridge on Highway 64 crossing the Reno River. This was in prepa-
ration for an attack on Monte Belvedere west of the highway. The 3,600-foot
mountain was taken on 24 November 1944 by elements of a U. S. Negro infantry
regiment and members of British and U. S. antiaircraft units serving as infantry.
The enemy counterattacked for five days and the Allies had to give up the position.
During the fall and winter of 1944 most U. S. and British antiaircraft units were
being trained for infantry duty as rapidly as training and the issuance of appro-
priate weapons would permit. (The gun shown is the 40-mm. automatic antiaircraft
type, originally made in Sweden and used by the Allies and the enemy. The gun
could be towed at 50 miles per hour and transferred from traveling to firing position
in 25 seconds.)

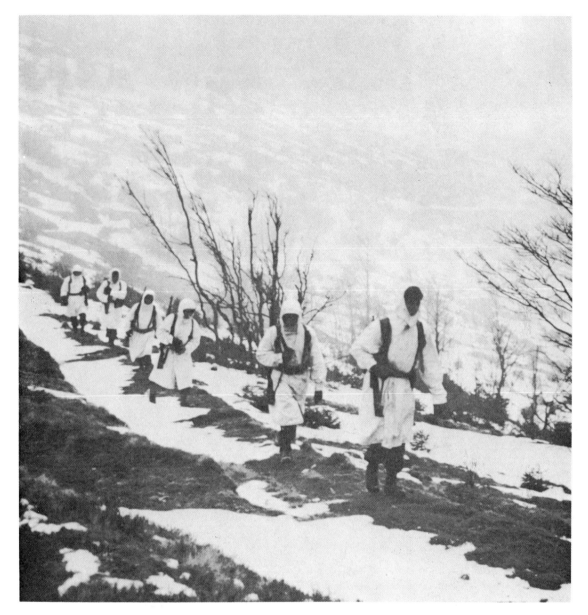

PATROL ACTIVITY, December 1944. During the relatively quiet period of the first half of December, both sides sent patrols to probe the front lines and bring back prisoners. When the cold weather set in, winter clothing was issued, including the reversible, hooded coat known as the parka shown above. One side was the conventional olive drab, the other side white for camouflage in snow. New type shoepacs, combination wool sweaters and cotton field jackets, and sleeping bags left the troops better prepared for inclement weather than they were during the previous winter, but there would be no possibility of keeping dry at the front during an attack when the rain lasted for days on end.

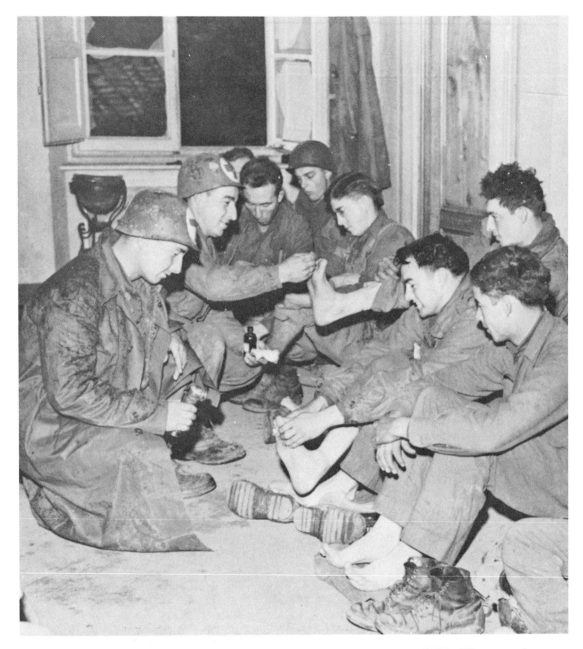

INSPECTING FRONT-LINE TROOPS FOR TRENCH FOOT. The second winter of fighting in Italy found the Allies better equipped to handle the trench-foot problem which in November 1943 accounted for 20 percent of the casualties at its peak incidence. Units were gradually being equipped with shoepacs, an important item in the prevention of trench foot. The shoepac consisted of a moccasin-shaped foot of rubber, and a laced, waterproofed leather top, which extended well up the calf of the leg. It was worn with felt inner soles or woolen ski socks.

PIPELINE PUMPING STATION AT LEGHORN. Construction of this line started soon after the capture of the port. By 23 November 1944 the pipeline had reached Highway 65 just a few miles behind the front, eliminating the trucking of gasoline over this already overcrowded road.

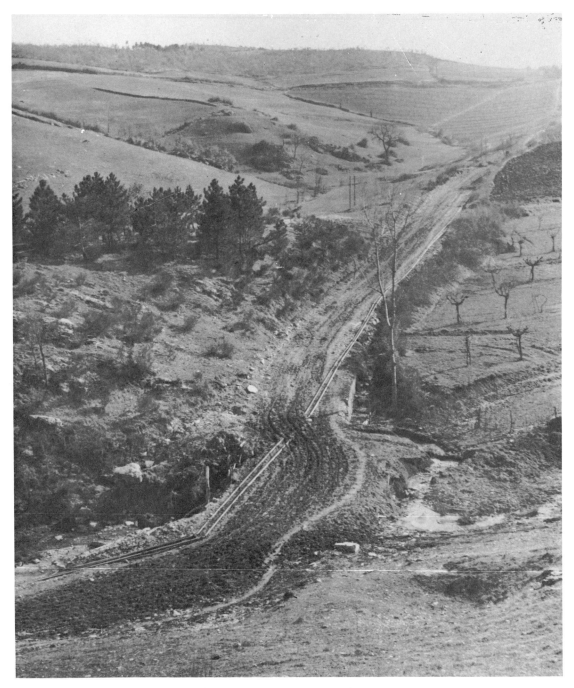

DOUBLE PIPELINE which carried gasoline from the port of Leghorn to the army front in the Apennines. "Pipeline walking" to inspect for leakage was done by jeep whenever possible. Because of hilly terrain several booster pumping stations were necessary. (4-inch double pipline.)

FILLING CANS WITH GASOLINE at the Raticosa Pass on Highway 65, terminal of the pipeline from Leghorn. These cans were picked up by truck and distributed to individual units. As the front moved, the pipeline was extended to keep up with the troops. (Five-gallon gasoline cans.)

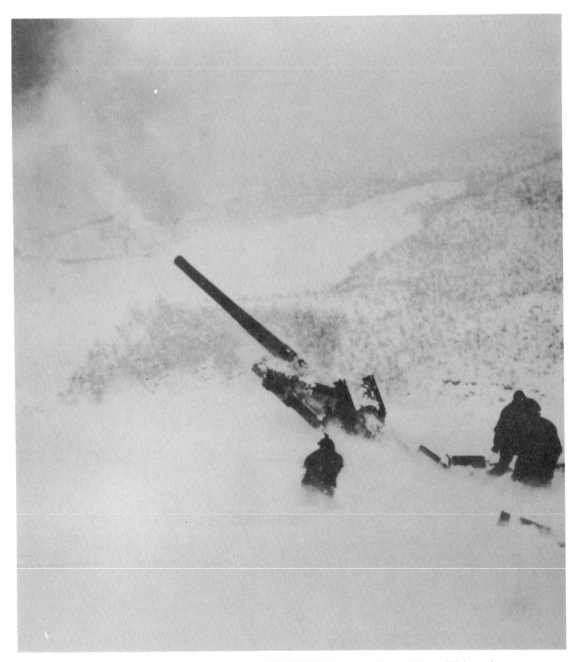

MEMBERS OF A SOUTH AFRICAN UNIT firing a Long Tom. This unit was stationed along Highway 64. During the winter of 1944–45 the U. S. Fifth Army roster included Brazilians, South Africans, British, and Italians as well as U. S. white and Negro troops, while the British Eighth Army along the east side of the peninsula contained New Zealanders, Canadians, Poles, Indians, Italians, and Jewish troops from Palestine in addition to United Kingdom units.

TRUCK WITH ROTARY SNOWPLOW clearing Highway 64 near Collina. The first snow fell in the mountains on 11 November. Snow, rain, sleet, and ice-coated curves on the roads leading to the front made the supply situation a difficult one. The constant work by snowplows and the hand labor of thousands of soldiers and Italian civilians kept the main roads open throughout the winter.

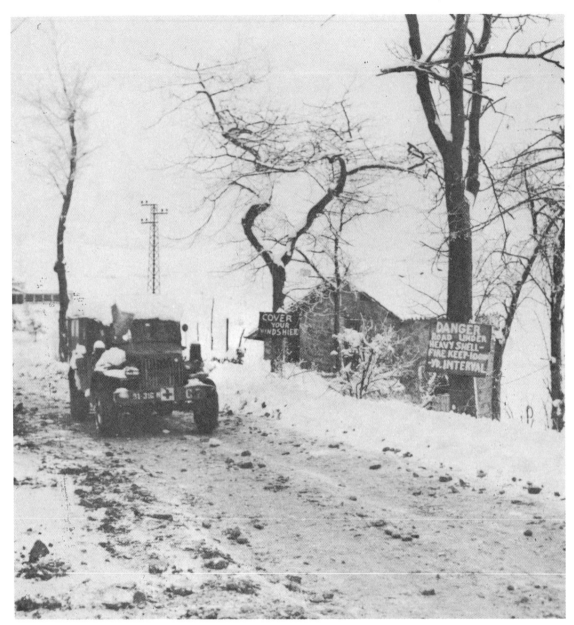

AMBULANCE EVACUATING WOUNDED from the front lines near Highway 65, between Loiano and Livergnano. The flow of wounded from the battlefield was carefully controlled. Evacuation hospitals were kept as free of patients as possible, thereby affording immediate facilities for the most urgent cases. It was found desirable in daylight hours to direct the main stream of casualties to hospitals located farther in the rear, while during the night most of the patients were brought to the forward hospital units in order to reduce the delay caused by blackout ambulance driving over icy roads. (¾-ton 4 x 4 ambulance.)

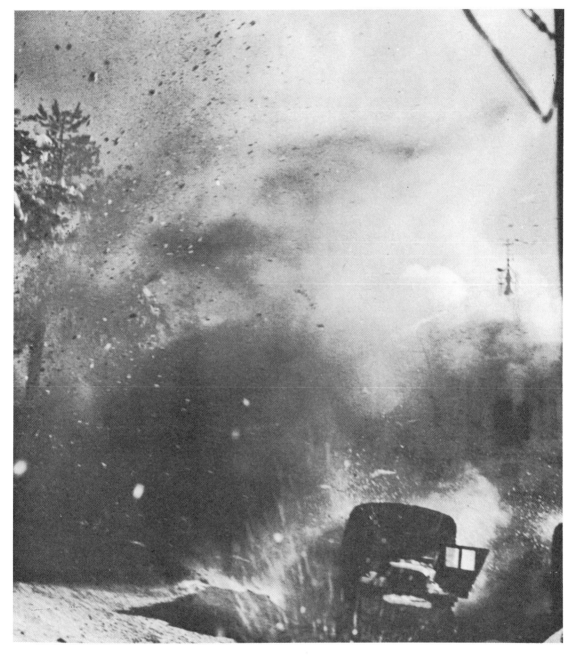

TRUCK ON HIGHWAY 65 near Loiano receives near miss, January 1945. This
highway had been the main axis of advance during the October offensive in the
U. S. sector and was the only good road in this area. During the winter stalemate
and build-up for the spring offensive, a period of about five months, this road was
under observed enemy artillery fire directed from Monte Adone, a commanding
position between Highways 64 and 65.

MEN RESTING IN THEIR QUARTERS in an old barn after a day in foxholes at the front. During cold weather, winterization of living quarters was carried out on a large scale, although men in the extreme forward positions usually had to improvise with a raincoat and a blanket in a foxhole.

TROOPS IN A DEFENSE POSITION near Highway 65. This area was thinly populated and houses were few and far between. Those still standing drew fire, and troops in support or reserve positions would dig in on the reverse slope of hills and make their foxholes as comfortable as possible. Roofs and walls were constructed from empty shell cases, food containers, and the like and reinforced with sand bags. Keeping warm was a problem: the area is almost bare of trees; most of the heating of the foxholes was done by gasoline stoves, sometimes issued, often improvised.

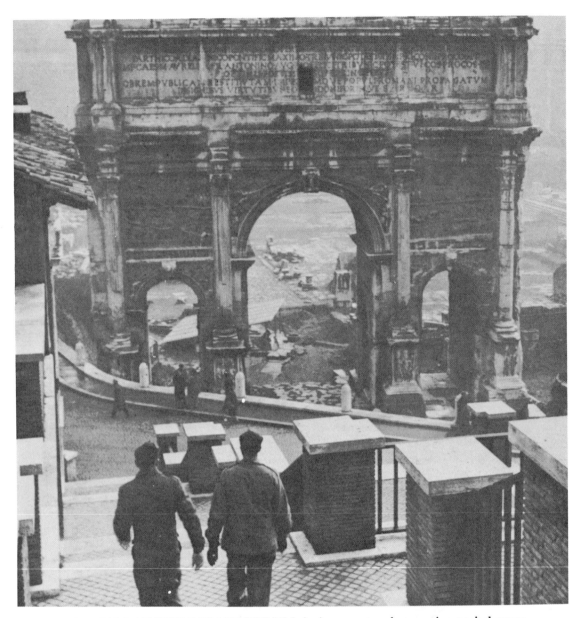

SOLDIERS AT THE ROMAN FORUM during a rest and recreation period away from the front. The rest-center idea, which had proved highly successful during the winter fighting of 1943–44, was carried out on a much larger scale in Rome and in the cities of the Arno Valley in the fall and winter of 1944–45. Hundreds of thousands of troops were rotated through the rest and leave centers set up under military supervision to provide a place of relaxation where men could forget the rigors and dangers of the front line, sleep in beds, take baths, visit places of historic interest, and generally indulge in the pleasures and entertainment of civilization, if only for a brief period.

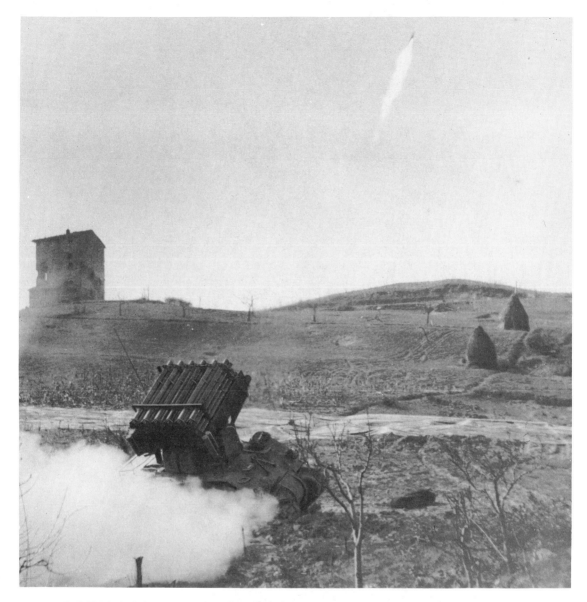

FIRING ROCKET PROJECTILES from a tank mount. Experiments were carried out in January 1945 in the Arno Valley. Of the several different mounts tested, one had 54 tubes placed on top of a medium tank turret, another had 18 tubes mounted on the same carriage as a towed 37-mm. gun. Because of the great variation in deflection and range the weapon was not practical against a point target and the smoke and flame given off when fired tended to disclose its position. It proved effective for a heavy concentration over a wide area for a short period. The short range of the rocket, slightly less than 4,000 yards, was a limiting factor. (Each cluster of 3 magnesium tubes is a rocket launcher, aircraft M15, mounted on M17 (T40) modified rocket launcher frame. 4.5-inch rockets were used.)

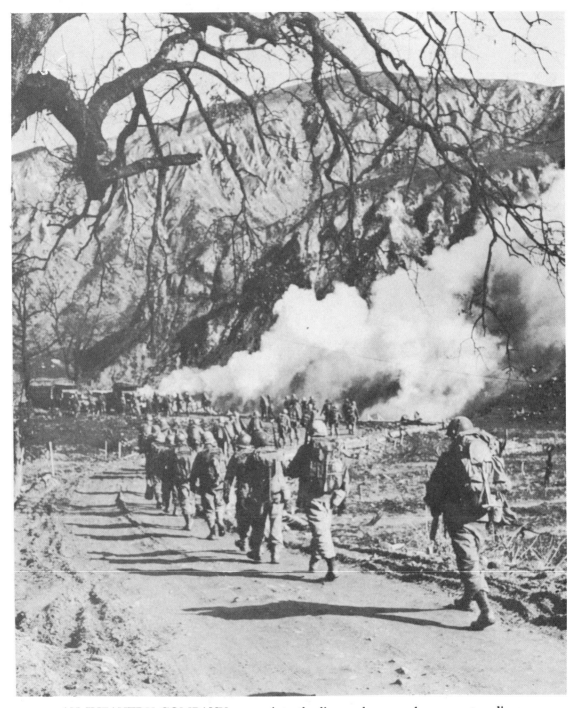

AN INFANTRY COMPANY moves into the line under a smoke screen to relieve
another company. During the five-month static period starting at the beginning of
November 1944, rotation of units for rest and recreation was a regular procedure.

JEEP PASSING A TRAFFIC CONTROL POINT in the northern Apennines. Rigid supervision of transportation over the crowded mountain roads was necessary if proper supply was to be made, tactical movements carried out, and vehicles conserved. To accomplish this, traffic control points were set up. Road movement approval was required for all convoys of ten or more vehicles. The traffic posts also served as a check on unnecessary or unauthorized use of military vehicles. Military police operated "chain points" where vehicles going into the mountains were stopped and beyond which the use of chains was mandatory.

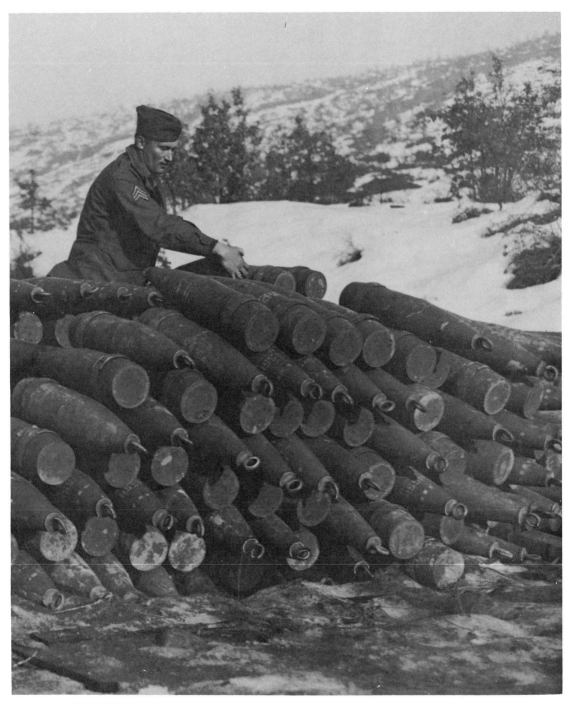

RESTACKING HOWITZER AMMUNITION. German air activity by this time
was so slight that dumps a few miles behind the front were not camouflaged. (Am-
munition for 155-mm. howitzer.)

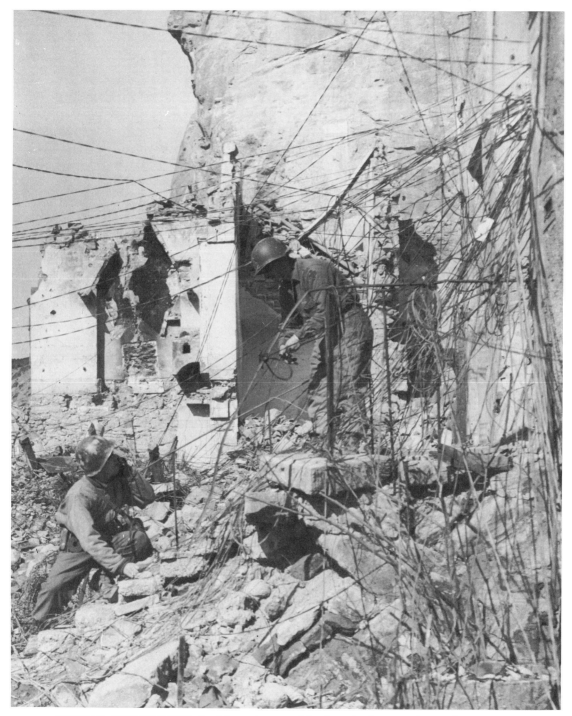

SIGNAL CORPS MEN checking wires outside the telephone exchange in a cave at Livergnano.

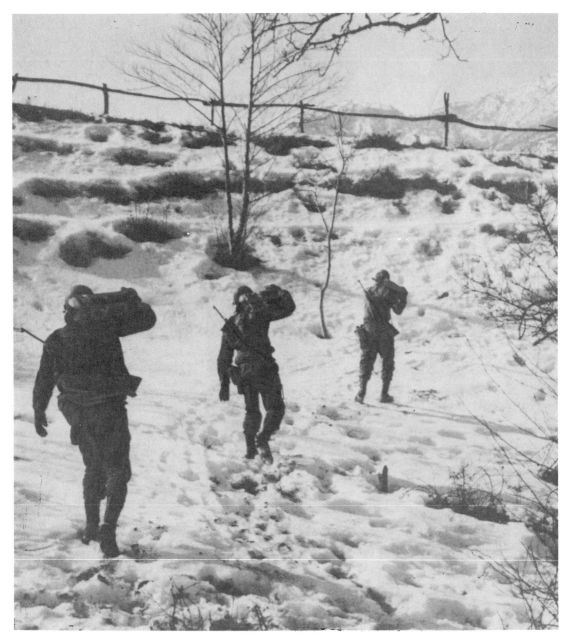

MAN CARRYING HOWITZER AMMUNITION to a battery high in the hills. These men were members of a division especially trained for mountain fighting. On 18 February 1945 this division, together with the Brazilian division under Fifth Army command, started an assault on German positions in the Monte Belvedere area west of Highway 64. The Monte Belvedere area dominated about ten miles of this highway. After severe fighting that lasted until 5 March 1945, the mountain mass was in Allied hands. (Ammunition for 75-mm. howitzer.)

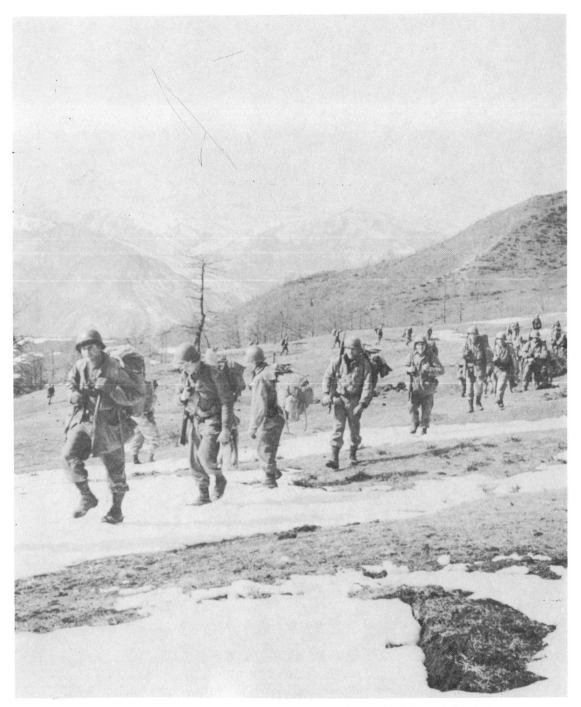

REINFORCEMENTS MOVE UP toward the fighting in the Monte Belvedere area. The men are equipped with M1 rifles and carbines, special shoes, and rucksack type pack.

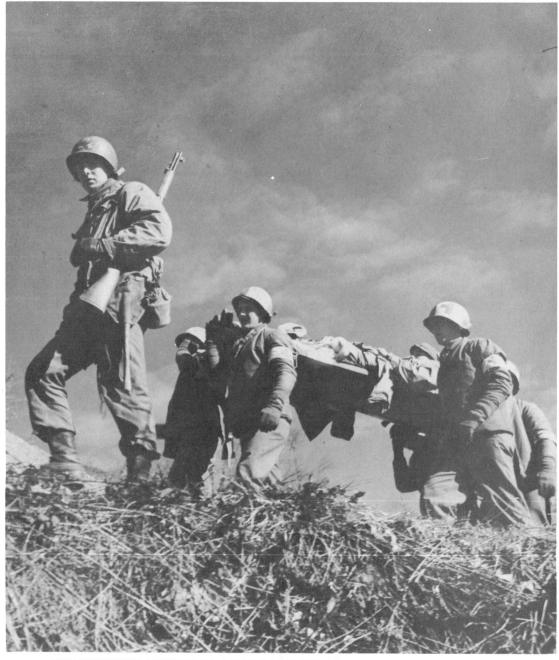

EVACUATING WOUNDED FROM MONTE BELVEDERE. As vehicles could not negotiate the mountain trails, stretcher bearers had to carry the wounded. Casualties from mines were numerous as the enemy had been in position on this dominating hill for several months and had mined and booby-trapped every likely avenue of approach as well as many of the farmhouses on the mountain slopes.

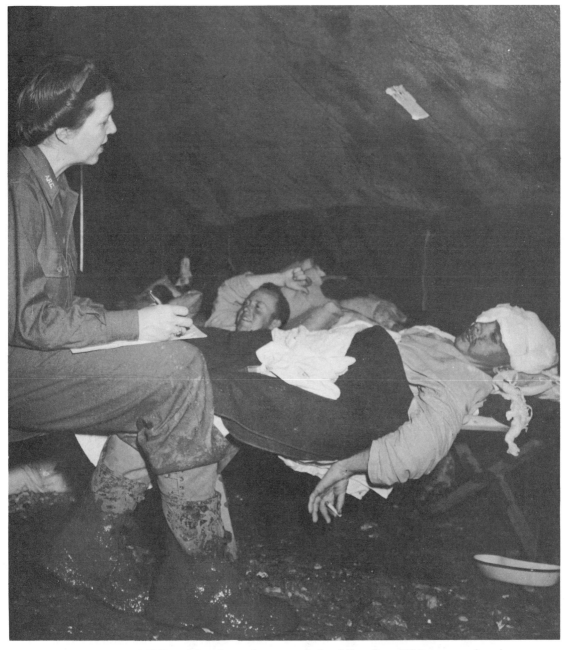

RED CROSS GIRL writing letter for wounded soldier. In addition to performing duties such as this, the American Red Cross operated clubs and motion picture theaters for the soldiers. The clubs served coffee, doughnuts, and ice cream, and sponsored musical programs, vaudeville shows, and dances. All was free of charge. The estimated attendance at the Red Cross clubs in the Arno Valley during February 1945 was 896,000.

SOLDIERS DURING A LULL IN THE FIGHTING on Monte Grande which was taken on 20 October 1944 after a tough two-day fight. The city of Bologna was only about nine miles away and could be plainly seen from the summit. Because of its commanding position, the Germans made several local attacks during the winter to recapture the mountain but were repulsed each time.

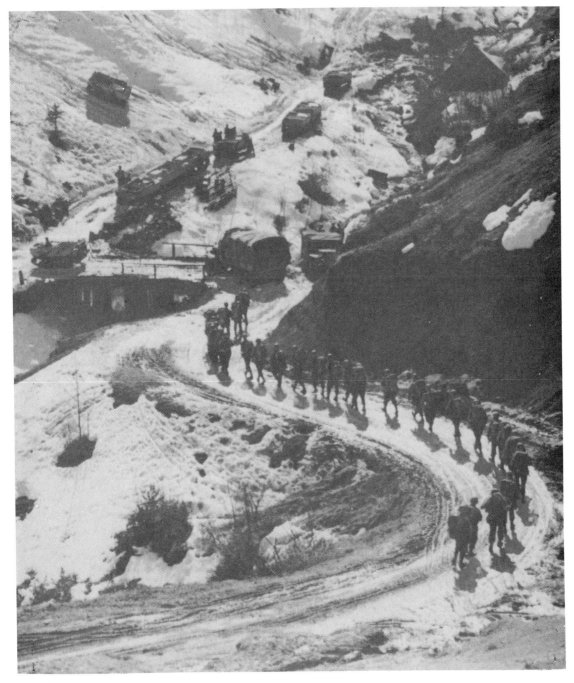

INFANTRY COLUMN passing a supply-transfer point in the Monte Grande area east of Highway 65, February 1945. Supplies were transferred from trucks to the tracked Weasels at this point. Higher in the mountains the mule pack train took over from the tracked vehicles.

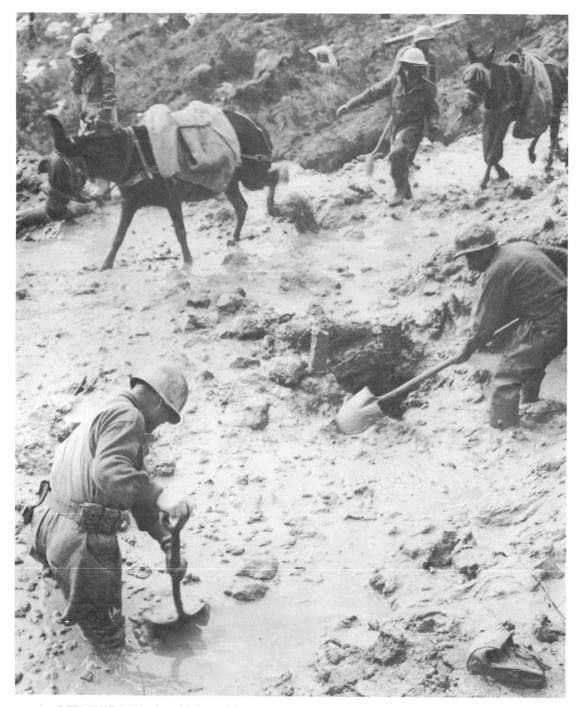

MEMBERS OF AN AMERICAN ENGINEER COMPANY working on a trail in the vicinity of Monte Grande. An Indian pack mule convoy is returning after taking supplies to the front line.

BRIDGING EQUIPMENT. "Ark" with end sections of treadway in raised position (top). Medium tank M4, crossing canal on Ark (bottom). With a total span of 54 feet, the treadway would span a canal about 45 feet wide. After November 1944, when the offensive in the mountains bogged down, most of the armor with the Fifth Army was gradually withdrawn to the Arno Valley where training for the spring offensive took place. New methods and techniques were developed and tried. The Ark above was constructed by an ordnance company for use in crossing canals in the Po Valley.

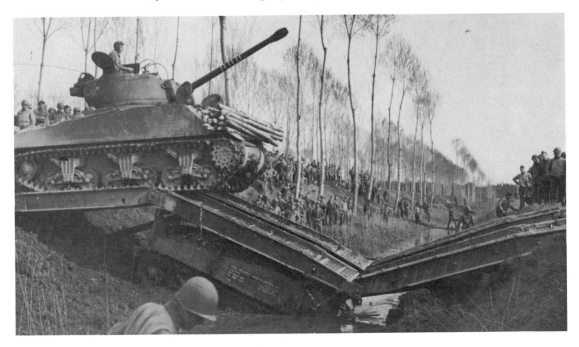

SIGNAL CORPS LINEMEN stringing communication wire in preparation for the coming spring offensive. During the winter stalemate many new lines were strung and hookups were made to the Italian state underground cable system. Circuits linked all units of the Fifth Army and an eight-mile line containing eight open-wire circuits was started in February 1945 from Filigare on Highway 65 near Monghidoro to the village of Lagaro Highway 6620.

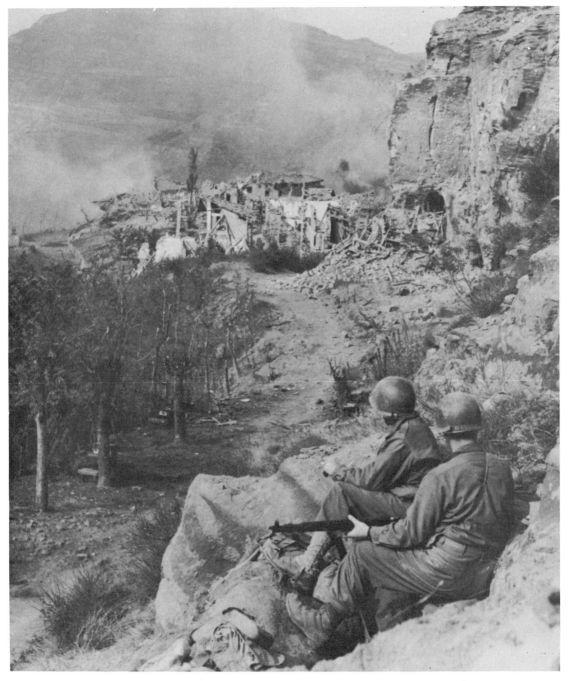

SOLDIERS IN LIVERGNANO watch the shelling of the village by the enemy, March 1945. Livergnano was taken on 14 October 1944 after a five-day fight along Highway 65 in an attempt to break through into the Po Valley. The advance was halted a few miles beyond this village. (Garand M1, .30-caliber rifle.)

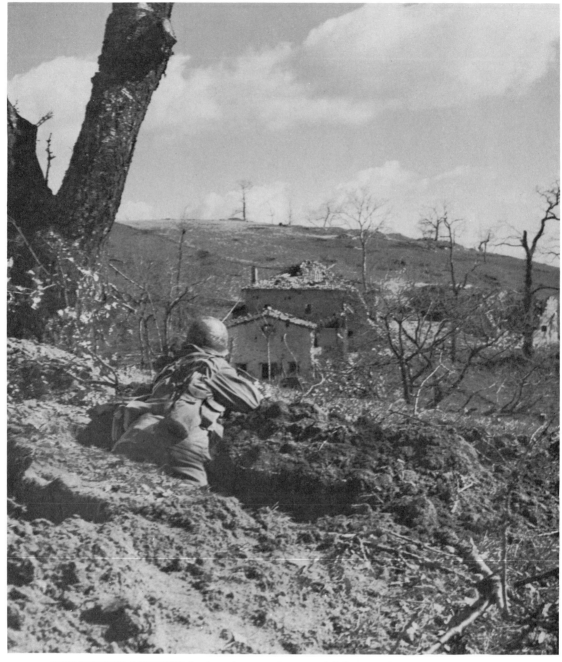

INFANTRY ACTION during the attack toward Monte della Spe. The soldier in the foreground is covering the house with his rifle while the other members of his squad approach it. A few minutes after this picture was made the house and the knoll behind it were taken, netting 57 German prisoners. Monte della Spe, west of Highway 64, was taken on 5 March 1945.

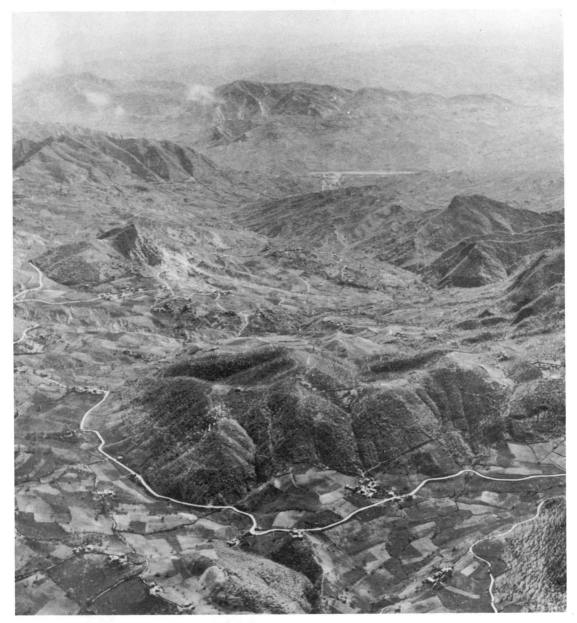

MONTE DELLA SPE AREA, looking toward the east. Highway 64 parallels the Reno River (in distance). The village of Vergato is shown on the west bank of the river. Monte della Spe is the rounded hill in foreground. It was taken on 5 March 1945 during an attack to secure a suitable jumping off place for the spring offensive. Vergato, which was an enemy strong point, and most of the surrounding territory remained in enemy hands after the capture of Monte della Spe. The main offensive, the attack toward the Po Valley, started from here on 14 April 1945 and by the 20th Allied troops had broken into the valley.

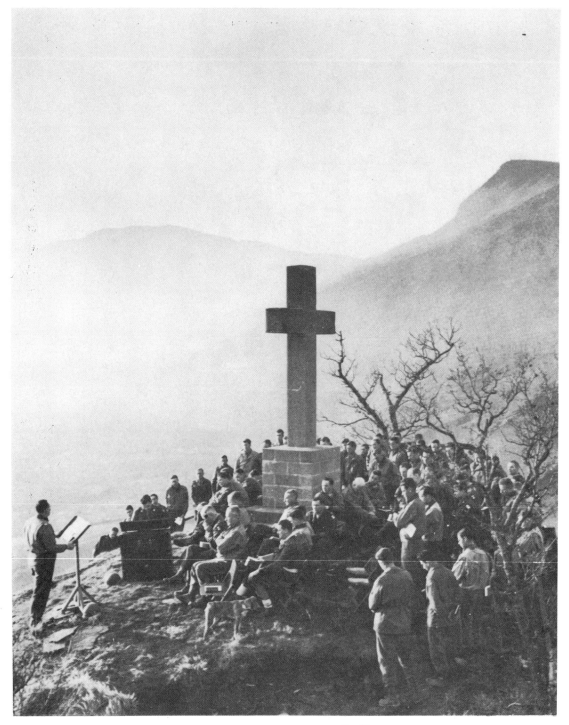

EASTER SERVICE 1 APRIL 1945.

RETURNING PATROL. As the spring offensive became imminent, patrol activities increased.

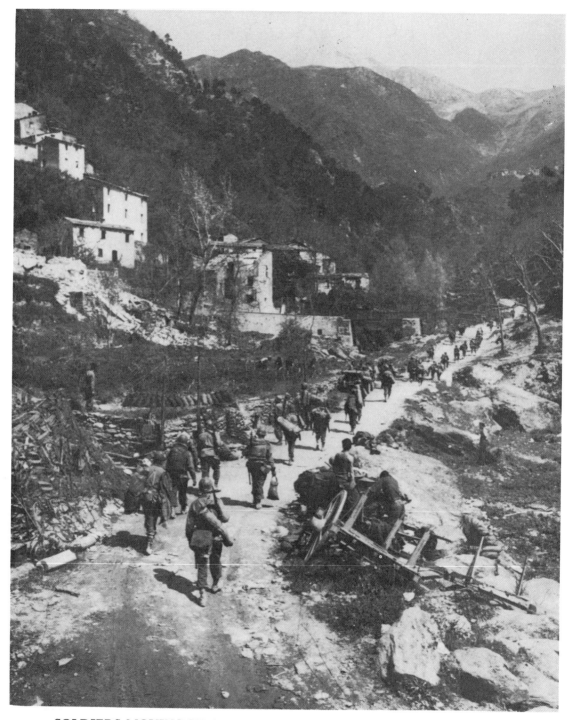

SOLDIERS MOVING UP into the line a few days before the start of the attack toward the Po Valley.

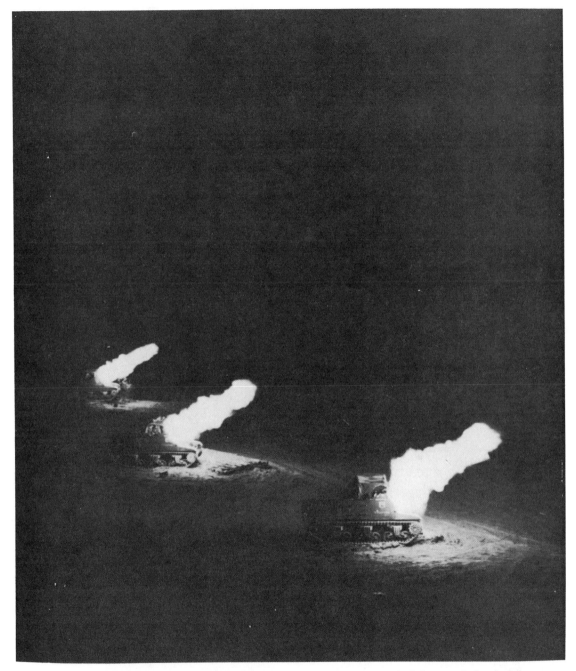

SELF-PROPELLED GUNS of a South African armored unit firing a mission a few days before the attack to break into the Po Valley. These vehicles are American Sherman tanks modified by the British as self-propelled guns. Prior to the jump-off, the units along the Fifth Army front had been engaged in a series of deceptive artillery fires.

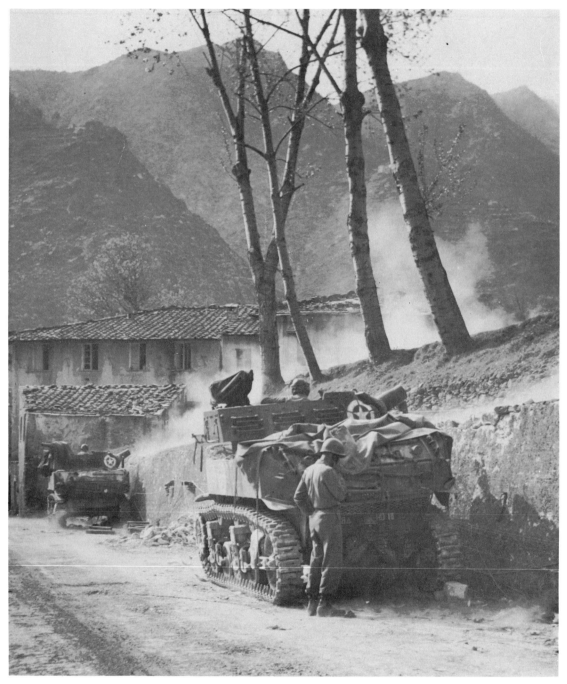

NEGRO SOLDIERS FIRING HOWITZERS in support of the Nisei who were making an attack northward along the mountain ridges toward the towns of Massa and Carrara. The attack started on 5 April 1945. The Nisei were American soldiers of Japanese ancestry. (75-mm. howitzers.)

BODIES OF AMERICAN INFANTRYMEN killed during the opening of the spring offensive. Note stretcher bearer in background looking for casualties. The infantry was making an attack across the mountains toward Massa and Carrara on the west coast.

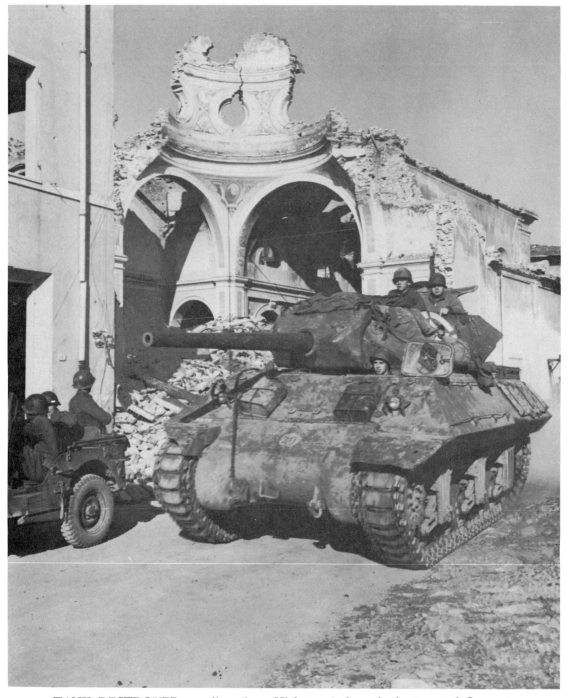

TANK DESTROYER speeding along Highway 1 through the town of Querceta during the spring offensive. The main effort of the army was along Highways 64 and 65.

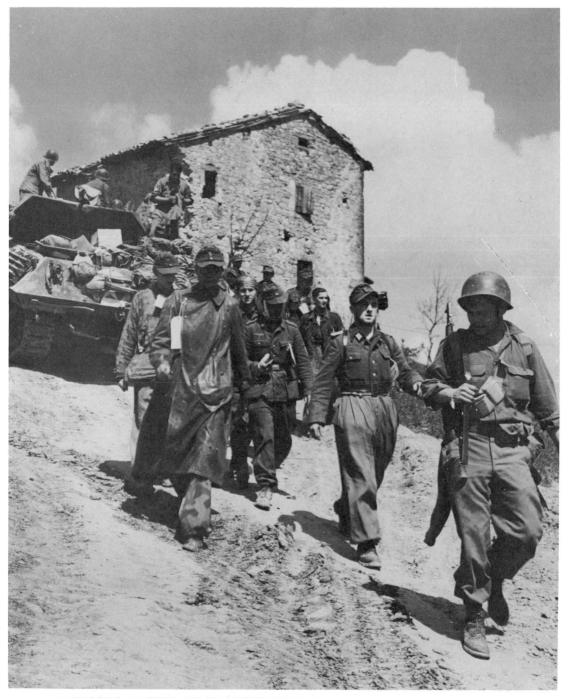

BRINGING IN THE FIRST PRISONERS taken at the start of the main drive to reach the Po Valley. On 14 April at 0945 the offensive was started by U. S. mountain troops in the hills west of Vergato on Highway 64.

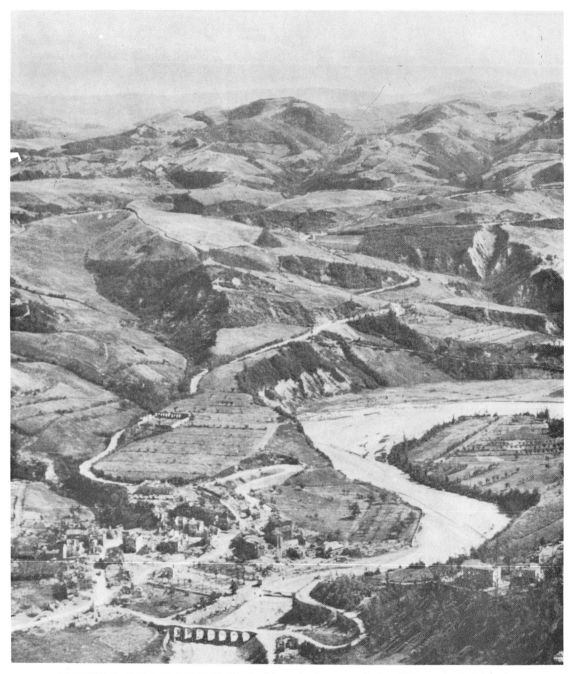

PIANORO ON HIGHWAY 65, looking south toward the hills occupied by the Allies for almost six months. Pianoro, at lower left, was one of the keys of the German defense systems barring entrance to Bologna and the Po Valley. The fight for Pianoro started on 16 April. Entering what was left of the town on the evening of the 18th, the infantry found it booby-trapped.

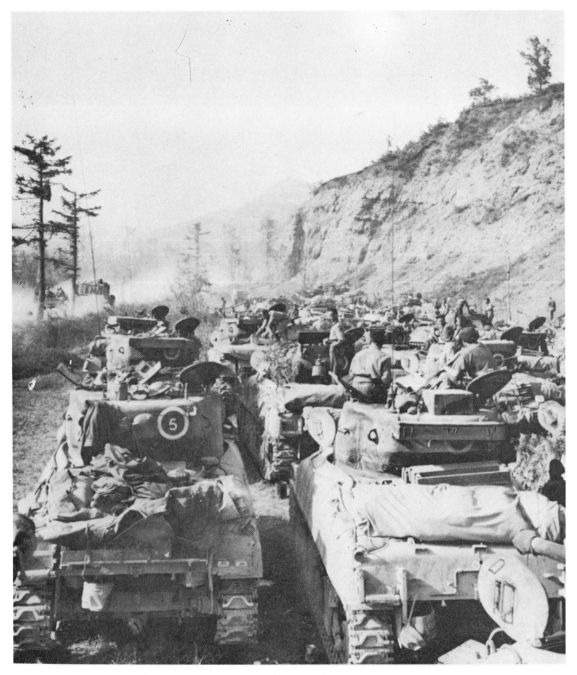

SOUTH AFRICAN ARMOR waiting along Highway 64 for a U. S. infantry division to pass on its way to the Po Valley, 20 April. On this date the troops in the U. S. zone broke through the mountains into the Po Valley just west of Bologna. The two highways in this area, 64 and 65, became congested with troops and vehicles in pursuit of the fleeing enemy. (Sherman medium tanks.)

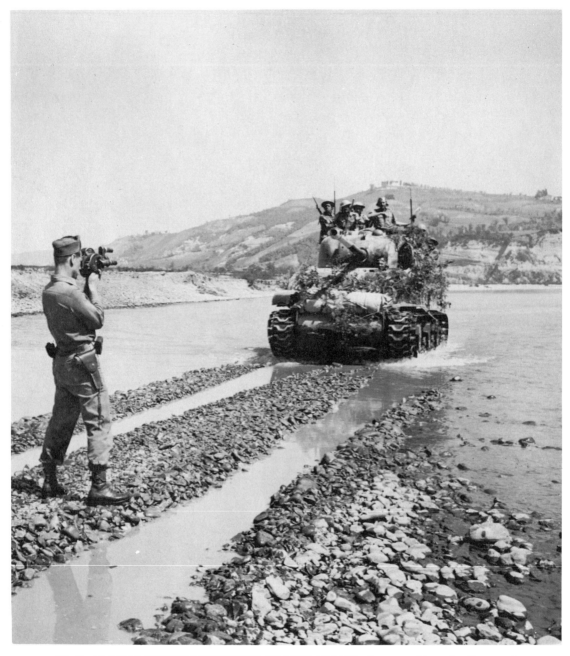

U. S. ARMY MOTION-PICTURE CAMERAMAN photographing the first tank of the South African armored force to cross the Reno River southwest of Bologna, 20 April. The practice of infantrymen riding on tanks while advancing was included in training for armored units in the United States early in 1944. (Sherman M4A3 tank with British 17-pounder; camera: PH–330 (Sig C), Eyemo, Bell, and Howell, 35-mm., three lenses mounted in turret.)

WEARY U. S. TROOPS IN BOLOGNA on the morning of 21 April. The city, entered from the south by U. S. forces and from the east by Poles of the Eighth Army, fell that day. Pressing forward the troops pursued the fleeing Germans.

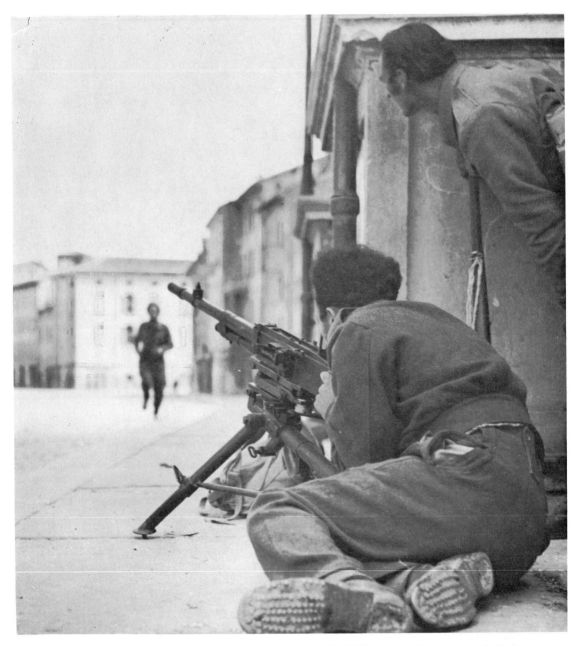

ITALIAN PARTISANS WATCHING FOR SNIPERS. During the winter of 1944–45 Allied officers, arms, and ammunition were dropped behind the enemy lines to assist partisans in the Po Valley. Although partisans, armed with equipment obtained from Italian arsenals or seized from the Germans, first appeared north of Rome, it was not until the Allies reached Bologna that they met the efficiently organized groups from the Po Valley. As troops entered the city, where the Germans were numerous, the partisans struck, seizing government agencies and public utilities.

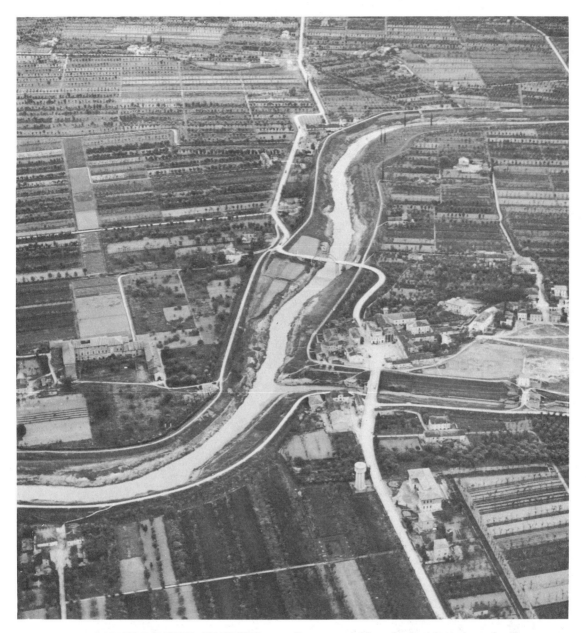

THE PANARO RIVER BRIDGES near Bomporto. After the breakout into the Po Valley, the next objective was the Po River. The area south of this river is broken by small streams and numerous canals. Most of the bridges had been destroyed by the Allied air forces during the winter. Later air reconnaissance found these undamaged bridges at Bomporto. A task force, sent to secure them, passed through the fleeing and disorganized enemy. So sudden was its appearance that, by 1600 on 21 April, it captured the bridges before the Germans could detonate previously laid demolition charges.

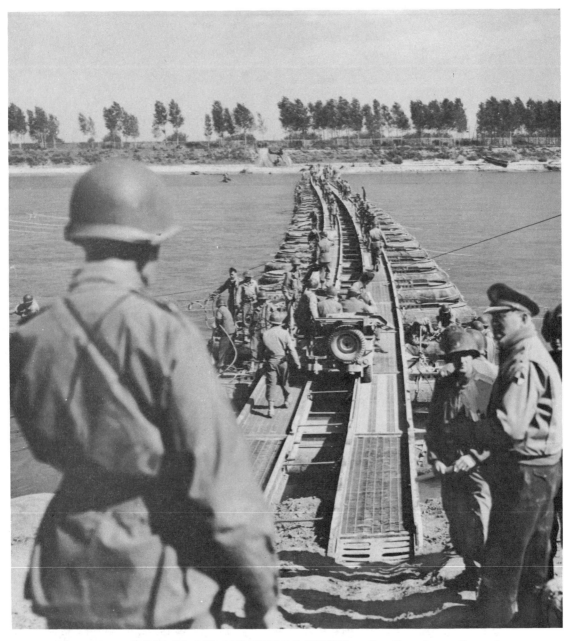

TREADWAY BRIDGE ACROSS THE PO RIVER at San Benedetto. Opened on the afternoon of 25 April, it was the first bridge across the river. The infantry had started to cross in this area on the morning of the 23d in assault boats under heavy machine gun, mortar, and rifle fire as well as fire from enemy antiaircraft guns lowered to fire airbursts on a flat trajectory. Casualties were high, but by 1745 a bridgehead of 2,000 square yards had been established on the north bank of the Po. The bridge above is 915 feet long. (Floating treadway bridge M2, class 18.)

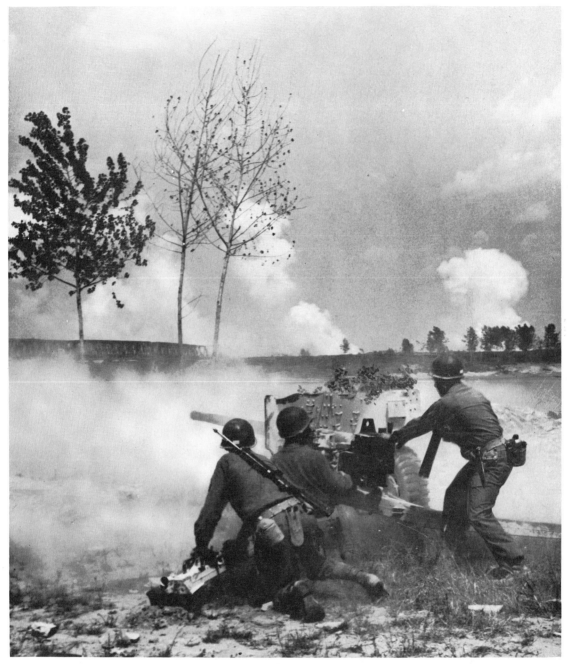

ACTION DURING THE PO RIVER CROSSING at Ostiglia, 24 April. A 57-mm. antitank gun firing in support of an infantry assault across the railroad bridge to the north bank of the river. (The British 6-pounder was the forerunner of the 57-mm. gun. It was adapted for U. S. use and also manufactured for other United Nations under the lend-lease agreement as the 57-mm. antitank gun.)

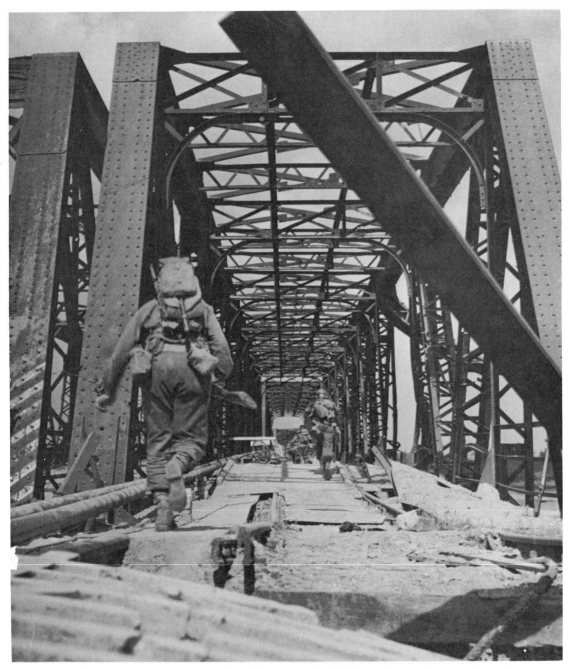

INFANTRY CROSSING PO RIVER UNDER FIRE, Ostiglia railroad bridge, 24 April. The crossing in this zone was opposed by enemy machine guns and 20-mm. automatic weapons. The patrol above worked its way to the other side and knocked out enemy guns and crews. The railroad bridge was partially demolished and unfit for vehicles.

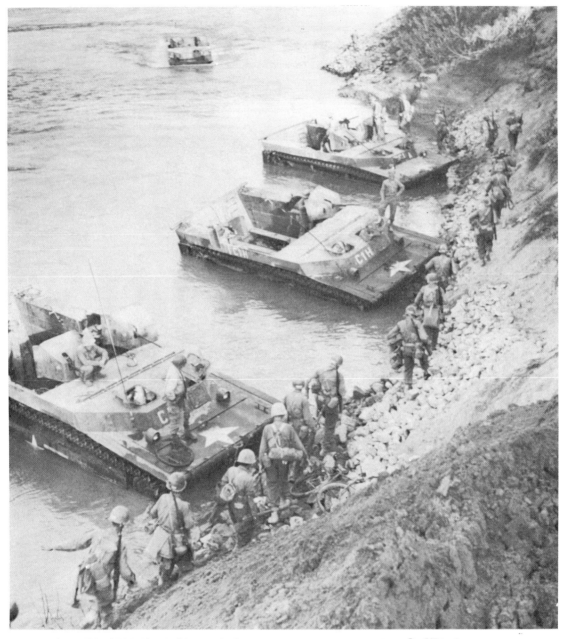

"ALLIGATORS" ABOUT TO CROSS PO RIVER near Ostiglia. Developed by the
U. S. Navy, the first shipment of these amphibian tracked vehicles arrived in
December 1944 and training was begun. Great secrecy surrounded them and they
were kept thoroughly camouflaged before the dash to the Po. They were armored
and each had socket mounts at four locations for either .30- or .50-caliber machine
guns. A stern ramp could be lowered to take on a vehicle. Maximum capacity was
8,000 pounds and a crew of three. (LVT(4).)

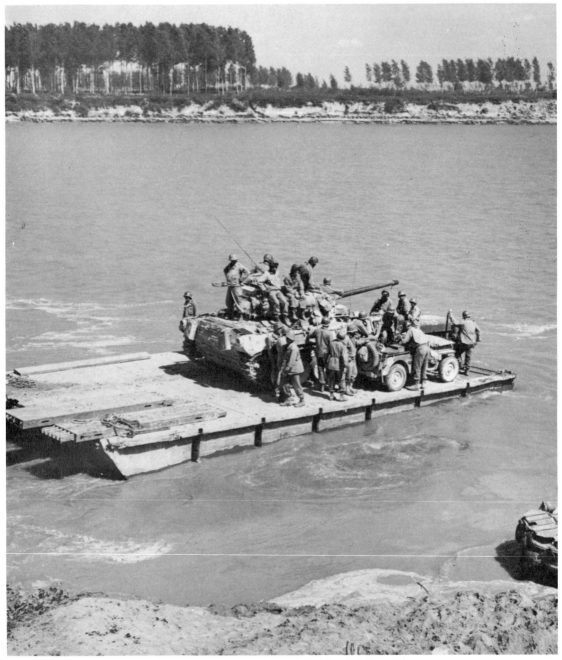

FERRYING EQUIPMENT ACROSS THE PO in support of the infantry assault, Ostiglia, 25 April. The large vehicle is a 76-mm. gun motor carriage M18, designed for tank destroyer use. It was a full track-laying type, using a torsion bar independent suspension, and was front-sprocket driven. The vehicle was lightly armored, had a low silhouette, and was highly mobile.

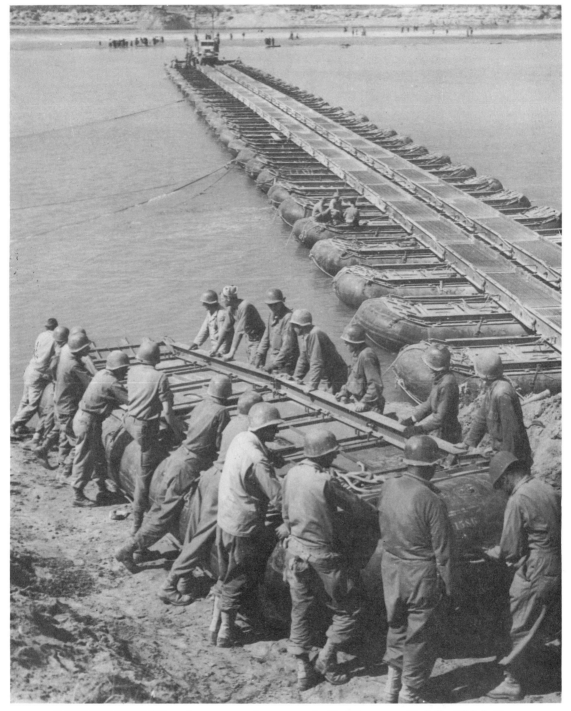

PONTON BRIDGE under construction across the Po River near Ostiglia. This bridge was opened on 25 April. (M2 treadway bridge.)

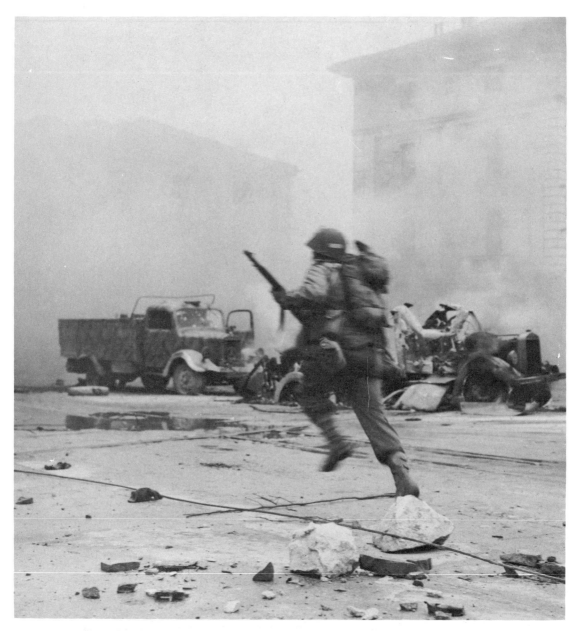

INFANTRY ACTION AT VICENZA, in the foothills of the Alps. The advance of the Allies across the plain was too fast for the Germans to halt, reorganize, and make a determined stand behind either the Po or the other rivers in the Po plain. Speedy thrusts by infantry-armor columns split the enemy forces and severed communications. After the crossing of the Po, the action on both sides developed into a race to the Alps, the enemy hoping to escape into Germany, the Allies determined to prevent them. Many isolated pockets of resistance developed behind the advancing columns and special task forces were organized on 23 April to deal with them.

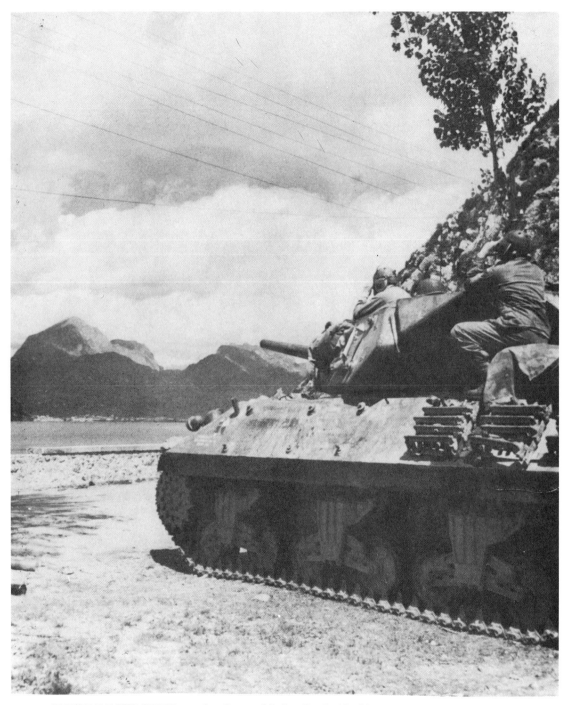

TANK DESTROYER on the shore of Lake Garda blocking one of the escape routes to Brenner Pass. Heavy fighting took place in the demolished tunnels on the road along the east shore of this lake, but on 30 April the area was under Allied control.

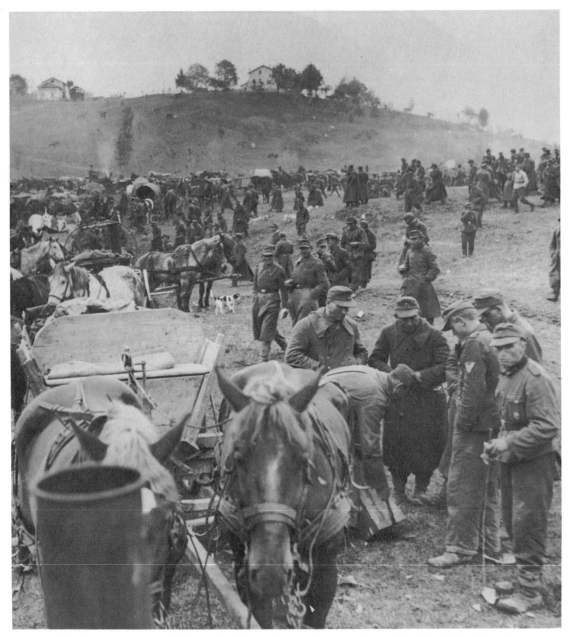

GERMAN PRISONERS and their equipment captured on the Po plain. For the first time in the Italian campaign, the enemy was retreating over terrain suitable for swift pursuit. Since the Germans lacked vehicles and gasoline, they had to rely to a great extent on horse-drawn transportation. They retreated across an open valley having a fine network of roads for mechanized forces and were forced to cross wide rivers by ferries and ponton bridges under constant attack by Allied air forces. The retreat became a rout.

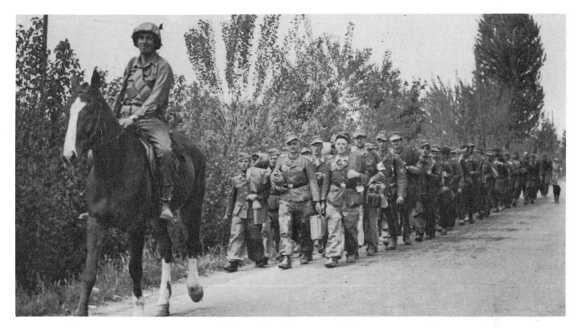

PRISONERS WERE CAPTURED by the tens of thousands in the Po Valley and marched to the rear, often unguarded, or guarded only by one or two men. On 2 May 1945, the Germans signed the terms of the unconditional surrender of their forces in Italy. One week later the war in Europe was concluded with complete victory for the Allies. The Italian campaign had been a bitter one, lasting 607 days (3 September 1943 to 2 May 1945). Casualties of the Fifth Army, including all nationalities serving with that army, totaled 188,546. United States losses were 19,475 killed, 80,530 wounded, and 9,637 missing.

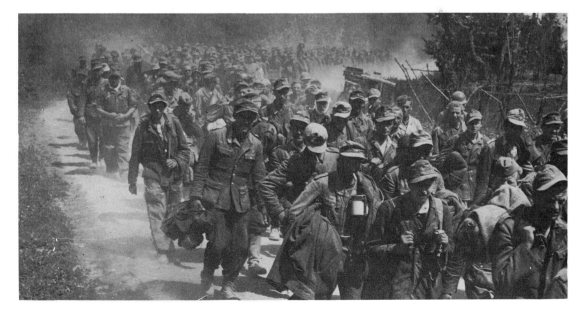

Appendix A
List of Abbreviations

AA	Antiaircraft
AC	Air Corps
AT	Antitank
cm.	Centimeter
DD	Duplex drive
DDT	Dichloro-Dithenyl-Trichloroethane
Flak	*Fliegerabwehrkanone* (antiaircraft artillery gun)
JU.	*Junkers* (designation of airplane built by company of that name)
K.	*Kanone* (gun)
Kw.	*Kraftwagen* (motor vehicle)
Kw. K.	*Kampfwagenkanone* (tank gun)
LCI	Landing craft, infantry
LCI(L)	Landing craft, infantry (large)
LCM	Landing craft, mechanized
LCP	Landing craft, personnel
LCP(R)	Landing craft, personnel (ramp)
LCT	Landing craft, tank
LCV	Landing craft, vehicle
LCVP	Landing craft, vehicle-personnel
le.P.Kw.K.2s	*Leichter Personen Kraftwagen, K.2, Schwimmend* (light personnel vehicle, K.2, amphibian)
LST	Landing ship, tank
LVT	Landing vehicle, tracked
mm.	Millimeter
Pak.	*Panzerabwehrkanone* (antitank gun)
Pz. Kpfw.	*Panzerkampfwagen* (tank)
SCR	Signal Corps Radio
s.F.H.	*Schwere Feld Haubitze* (medium field howitzer)
Sig C	Signal Corps
SOC	Scout Observation Curtis
SP	Self-propelled
Stu. G.	*Sturmgeschuetz* (self-propelled assault gun)

Stu. H.	*Sturmhaubitze* (self-propelled assault howitzer)
Stu. K.	*Sturmkanone* (self-propelled assault gun)
TD	Tank destroyer
TNT	Trinitrotoluene; trinitrotoluol (high explosive)
WAC	Women's Army Corps
USAFIME	U. S. Army Forces in the Middle East
USSR	Union of Soviet Socialist Republics

Appendix B
Acknowledgments

The photographs in this volume come from the Department of Defense. All are from the U. S. Army files except the following:

U. S. Navy: pp. 13, 14, 15, 19, 20b, 21, 22, 23, 24, 28, 30, 77, 107, 116, 122b, 125b, 139, 190, 258, 316, 339, 354.

U. S. Air Forces: pp. 10, 12, 18, 42, 43, 45, 46, 47, 64, 71, 73, 80, 90, 91, 92, 94, 97a, 101, 109, 111, 157, 162, 164, 165, 166, 167, 168, 173, 182, 185, 191, 192, 193, 194, 195, 224, 225, 239, 240, 257, 285, 305, 306, 307, 308, 317, 318, 323, 324–25, 326, 327, 328–29, 351, 390, 391, 392, 393, 394, 395.

U. S. Coast Guard: pp. 117, 118, 126, 181, 183a, 315, 333, 334, 336.

Index

☆ U.S. GOVERNMENT PRINTING OFFICE : 1988 O - 194-423 : QL 3